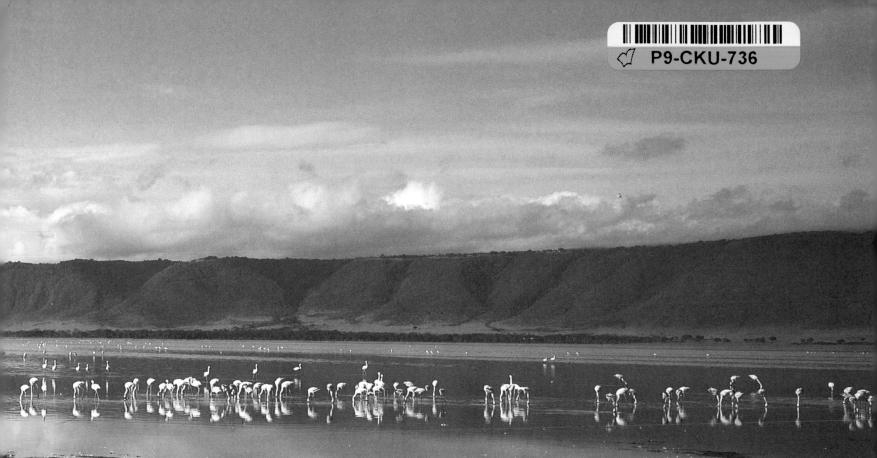

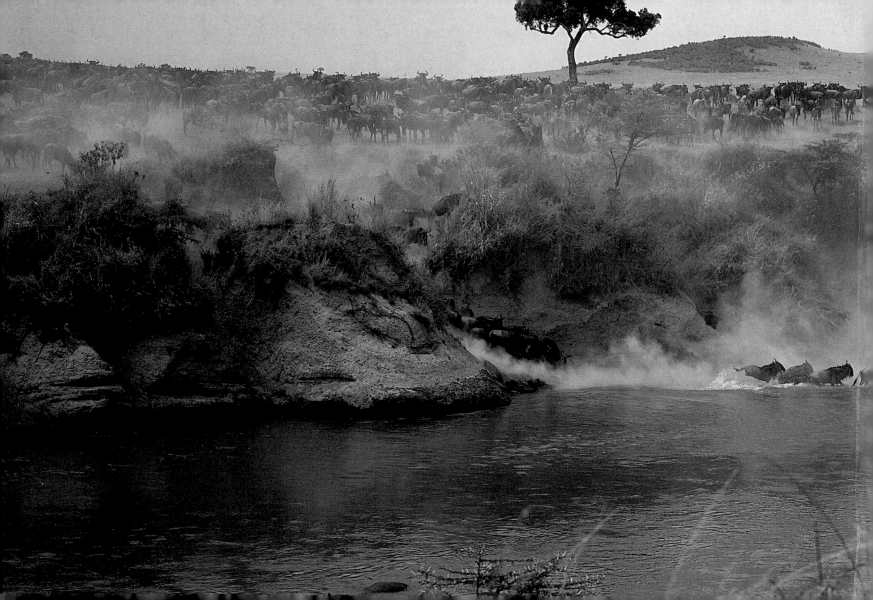

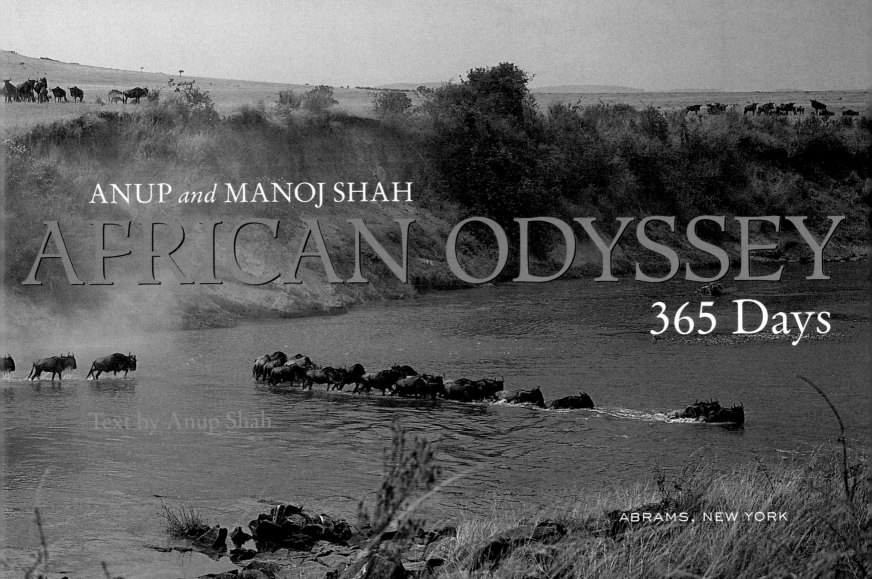

ANUP *and* MANOJ SHAH

AFRICAN ODYSSEY

365 Days

Text by Anup Shah

ABRAMS, NEW YORK

INTRODUCTION

On November 17, 2006, during ABC's *Good Morning America*, a panel of experts selected the Great Migration as one of the Seven New Wonders of the World. As for the Greater Serengeti Ecosystem in which the migration takes place, the panel praised "the uniqueness of the area and the preservation it provides to so many species living in harmony."

The 15,450-square-mile (40,000-square-kilometer) Greater Serengeti Ecosystem (GSE) encompasses the Ngorongoro Conservation Area, Maasai Mara, and a ring of game reserves and game-controlled areas that encircle the 5,700-square-mile (14,763-square-kilometer) Serengeti National Park, all of which lie in East Africa. The GSE remains virtually intact as a self-contained ecological unit in which all of Nature runs free. It is within this ecosystem, whose rhythms remain essentially undisturbed by human intervention, that the Great Migration takes place. In fact, the GSE can also be defined by the dispersion of the migrating animals—around two million grazers, principally 1.1 to 1.5 million wildebeests; 200,000 to 250,000 zebras; and 350,000 to 500,000 Thomson's gazelles. Such a mass movement of mammals does not occur anywhere else on Earth, not even in Africa.

The Serengeti National Park lies in northwest Tanzania atop a great plateau that stretches from the Ngorongoro Crater Highlands to the Kenya border. The altitude ranges between 3,000 and 6,000 feet (900 to 1,800 meters) above sea level. It is a wonderfully varied landscape with

vast short-grass plains, which are sprinkled with ancient granite kopjes (rocky hills and outcroppings on the plains); acacia savannah in the center; and hilly, more densely wooded country to the north. In the west, scattered acacia woodlands and open plains stretch to within five miles of Lake Victoria. Adjoining the southeastern border of Serengeti National Park is the Ngorongoro Conservation Area, with its short-grass plains, the ancient hominid sites of Olduvai Gorge and Laetoli, and the crater highland volcanoes. Directly to the north of Serengeti is the Maasai Mara National Reserve of Kenya, which, very much like Serengeti, has a colorful mosaic of habitats that includes open plains, woodland, and bushland. Much of the year the Great Migration is contained within these three protected areas.

The Great Migration is roughly a circular journey, so there is no real beginning or end to the trek. Moreover, it repeats itself every year, following the annual cycle of the rains. For this reason, no two migrations follow precisely the same path—every year, the migration path is dictated by the pattern of rainfall. Nevertheless, there is a general annual pattern of rainfall, which draws the herds to and fro across the ecosystem and ultimately gives the migration its shape and purpose.

Unlike humans, no wild animal would take the trouble to move such vast distances for the sheer pleasure of it. The quest carries with it great risks, such as injury, drowning, predation, infection, parasites, disease, starvation, and drought. But the migrants simply shrug off adversity

by sheer force of numbers, for the three-quarter million that, on average, fall prey to the hazards of this incredible journey are replaced by the three-quarter million newborn. At its core, the purpose of the migration is the search for superior nutrition with accessible water so as to survive and reproduce more successfully. Although it remains an awfully dangerous trip, perhaps the riskiest any creature could embark upon, it is one that the migrants are winning with nearly two million of them exploiting this unique niche in the GSE, year after year.

Life goes on around the migration as it slowly and inexorably snakes its way through plains, forests, rivers, and bush. The remarkable variety of species found in this ecosystem the size of Switzerland is breathtaking. There are nearly thirty species of herbivores (their biomass exists in the region of approximately 155 million miles, or 250 million kilometers), five species of primates, twenty-six species of carnivores, more than five hundred species of birds, and the countless thousands of invertebrate species, which together probably weigh as much as all the vertebrates put together.

Alongside the migration, there is also a cyclical process at work within the ecosystem itself. Through the alchemy of photosynthesis, grass and trees feed on soil and the sun. The migrants and other herbivores feed on that greenery, which is the fuel that propels the migration, that drives it on across the land. The flesh of the herbivores, enriched by that sweet cud, nourishes the carnivores and scavengers while their excretions replenish the soils. Termites, beetles, and the like also play their part in returning flesh to Earth. In this way, along this chain of events, matter is continually circulating. Thus, the circular, cyclical migration takes place, delicately balanced with the intricate processes that govern all living things here.

It should not be surprising that this account of the Great Migration has five main themes: the seasons, the land, the residents, the migration itself, and the attendant predators and scavengers encountered along the way. The visual narrative in this book takes you, the reader, down the intricate paths that connect these stories by following the migration cycle through the year, revealing the life and the drama of the entire ecosystem. Fundamental themes of life and death, rivalry and coexistence, tranquility and chaos, care and indifference, sex and competition, birth and growth, tragedy and triumph, despair and hope, are played out in stark contrasts with no sentimentality. Ultimately the narrative, like the movement of the herds, is dictated by the rhythm of the seasons.

The text I have written is part nature guide, part travelogue recording events as my brother, Manoj, and I observed them in our efforts to watch these animals, follow them, and capture them on film throughout the course of a year. Thus, it is something of a personal account, a journal even, of our adventures with the animals on the migration trail.

You could say that the Great Migration is a veritable ecosystem on the hoof because it supports a tumult of wildlife from vultures to crocodiles, dung beetles to lions, turtles to elephants. In particular, it is probably the most important food resource for the carnivores—without it their numbers would plummet (as would those of the tourists for whom the big cats are the main draw, and whose money helps keep the parks and reserves of this ecosystem operating and intact).

The Great Migration is a magnificent event; it is incomparable. Gathered in enormous numbers, moving in endless columns, braving river hazards, harried and murdered by predators, the animals of the Great Migration make it truly one of the most remarkable natural events on the planet.

THE SERENGETI ECOSYSTEM

The Serengeti ecosystem comprises Serengeti National Park; the Ngorongoro Conservation Area; Maswa Game Reserve; the Loliondo, Grumeti, and Ikorongo Game Controlled Areas; and the Maasai Mara National Reserve. Not only does this fertile ecosystem have the greatest concentration of animals in Africa, but it also encompasses a wide range of habitats and hence a great diversity of wildlife.

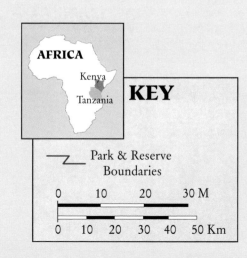

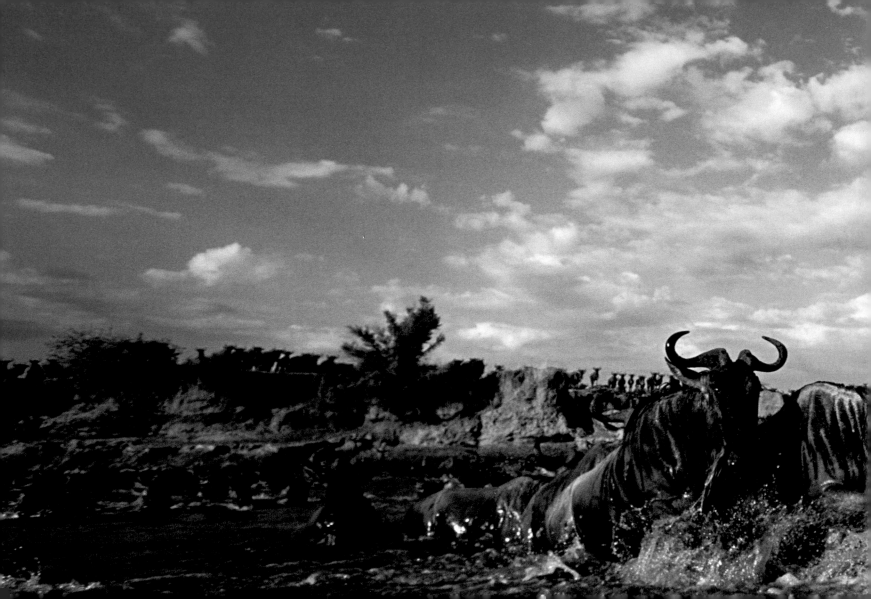

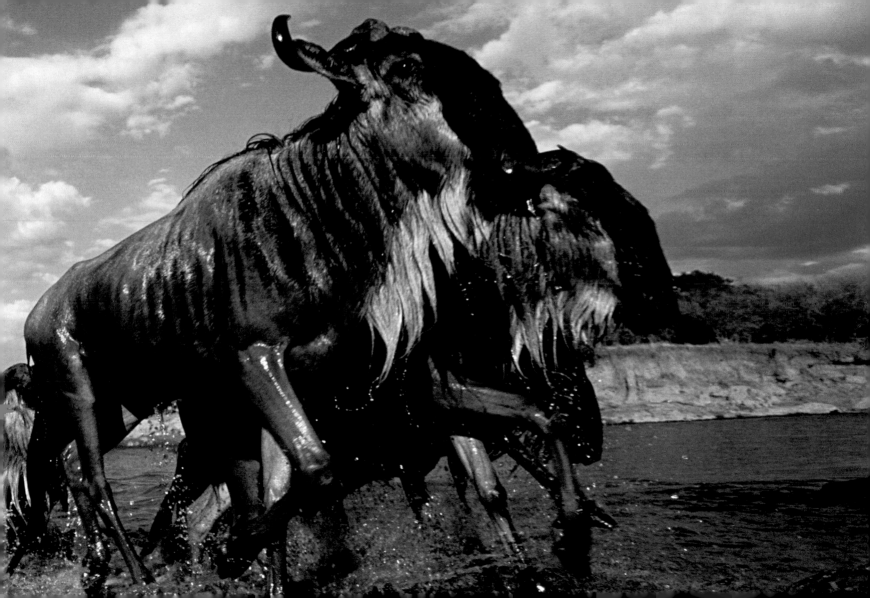

When the Great Rift Valley emerged in Africa, its birth was accompanied by tumultuous volcanic activity. Lava flowed and rich volcanic ash settled on the land that came to be known as the Serengeti short-grass plains. When it rains, the alkaline-rich soils of the plains produce short, nutritious grass that is rich in phosphorous, calcium, sodium, nitrogen, and protein. This has been a magnet for grazers who moved in over a million years ago and, as testified by fossil evidence, the predators that followed them.

Today, of the several volcanoes of the crater highlands to the southeast of the plains, only Ol Doinyo Lengai, seen here, is still active. The pointed hornitos and grayish flows seen at right mark recent volcanic activity. It stands like a sentinel, on the edge of the plains, threatening to erupt once again.

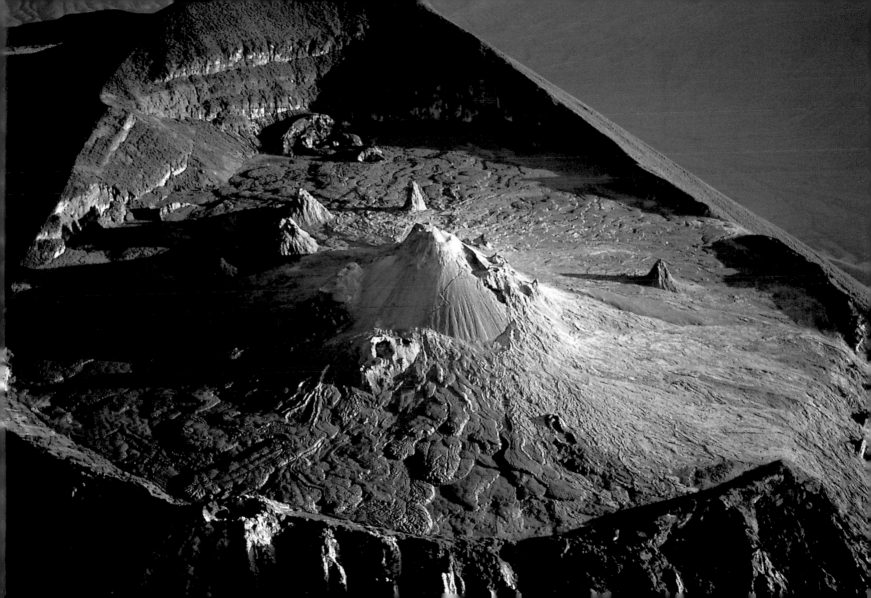

With males standing up to 55 inches (140 centimeters) high at the shoulder and weighing up to 550 pounds (250 kilograms), the wildebeests are smaller than African buffalo, but about the same size as lean cows. It is said in jest that the wildebeest must have been designed by a committee and assembled with spare parts, so strange is its appearance. But looks don't matter in the wild, of course. What matters is how well the animal is adapted to the ecosystem.

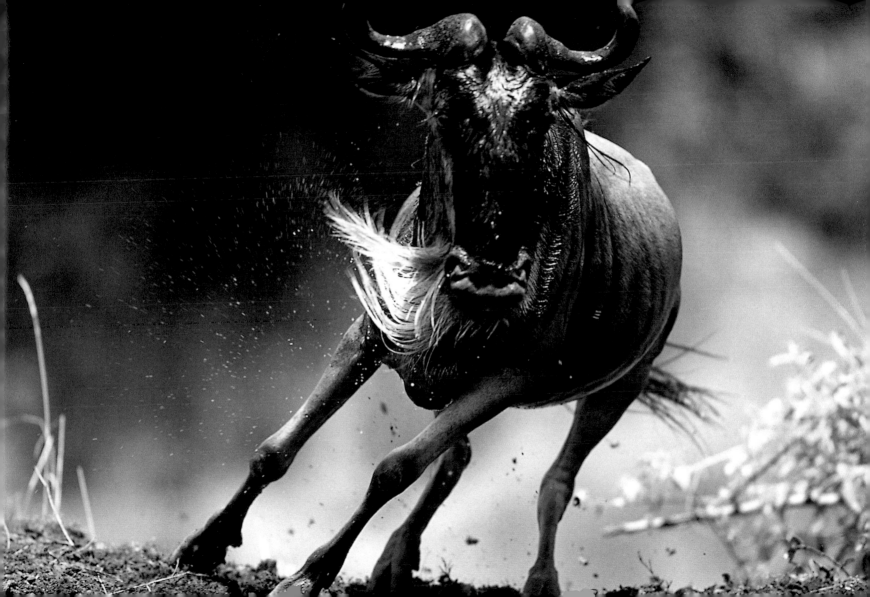

Wildebeests are gregarious and mingle willingly with strangers. They are herd animals that do not form long-term social relationships apart from the one between a mother and its calf. Their mission is the acquisition of food, water, and reproduction, which they just happen to go about in massive herds. Today, there are over a million of them participating in the most spectacular migration of land mammals on our planet. At this time of year, they pass through the woodlands of central Serengeti, on their way to the plains in the south. Willy-nilly they will run the gauntlet of the lion prides clustered along the fringes of the woodlands and the plains. It is the rain falling over the plains that is drawing them out of the woodlands.

The migrants do not move as a single group. Instead, they spread out into smaller constituent herds, with the size and composition of each herd changing constantly. Moreover, each herd sets its own pace. They all move in the same general direction, but it can take a few weeks for all the animals to pass a given landmark.

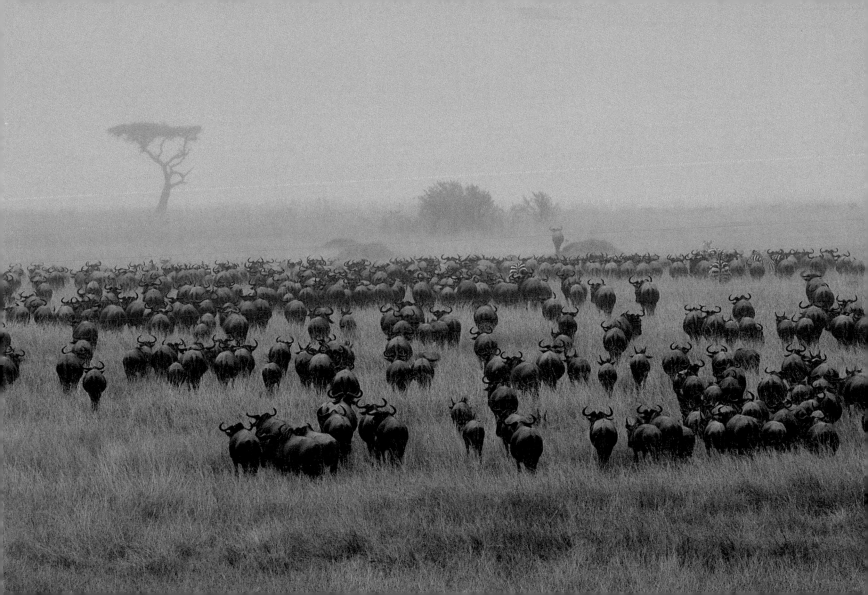

Nearly a quarter of a million zebras also participate in the Great Migration. A little smaller than a horse, the zebra's distinctive characteristic is its black-and-white stripes. It is a creature of keen senses and delicate movements, a powerful animal, yet sensitive, quite unlike a wildebeest.

The wildebeests and the zebras migrate over a huge ecosystem, called the Greater Serengeti Ecosystem, which straddles northern Tanzania and southwestern Kenya. The route they take forms a huge circle. They are not constantly on the move; when the grazing is good and water abundant, they will stay awhile. But in periods of scarcity, they move huge distances in search of grass and water.

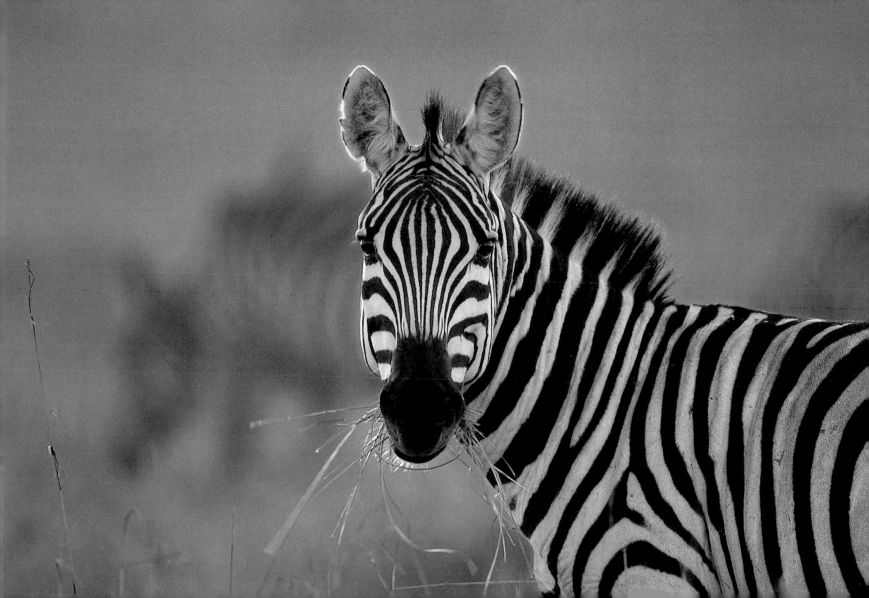

The zebra's teeth have evolved into big molars with hard ridges of dentin to cope with the tough silica that occurs in grass. Zebras have teeth on both upper and lower jaws, whereas the other migrant species possess top teeth only. Their eyes are set high up, to better detect predators while feeding.

The zebras are usually the first migrants to slip into a new grazing area. They feed on the stems, and the wildebeests that follow them take the leafier grasses closer to the earth, leaving an inch or so uncropped. Finally, the gazelles arrive. Their tiny mouths give them the ability to get at the remaining grass closest to the ground. In this way, large portions of the plains are mowed to a fairly uniform height.

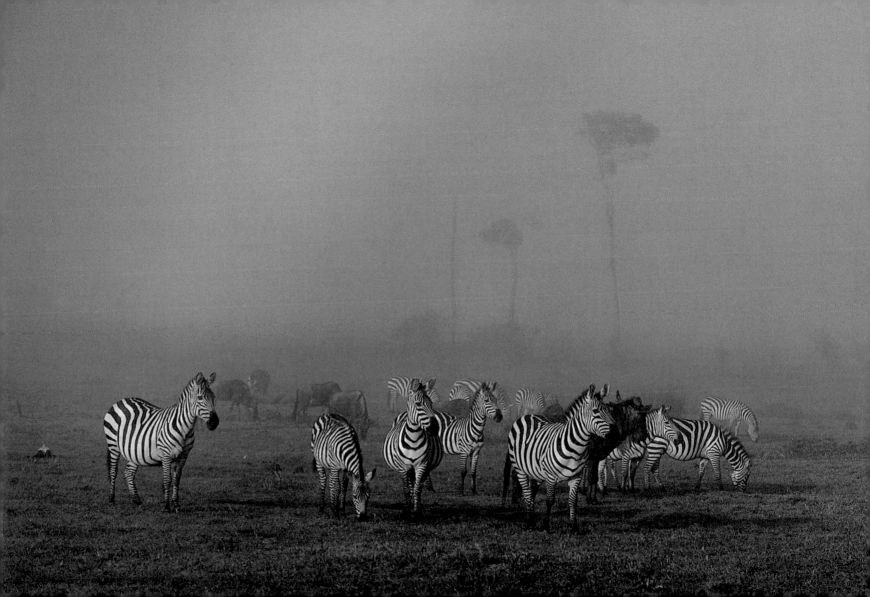

The rains continue at the edge of the woodlands and the plains. A male gazelle stands hunched, his hide streaming with falling water. With his constantly flicking short tail, he manages to convey an air of busyness, even in the midst of an afternoon shower. Thomson's gazelles, with their slender graceful legs; relatively tiny, single-striped bodies; and the male with his short, elegant horns, bring up the rear of the migration. Nearly half a million of them migrate with the wildebeests and zebras, but they avoid the woodlands, so they do not travel the full migratory circuit.

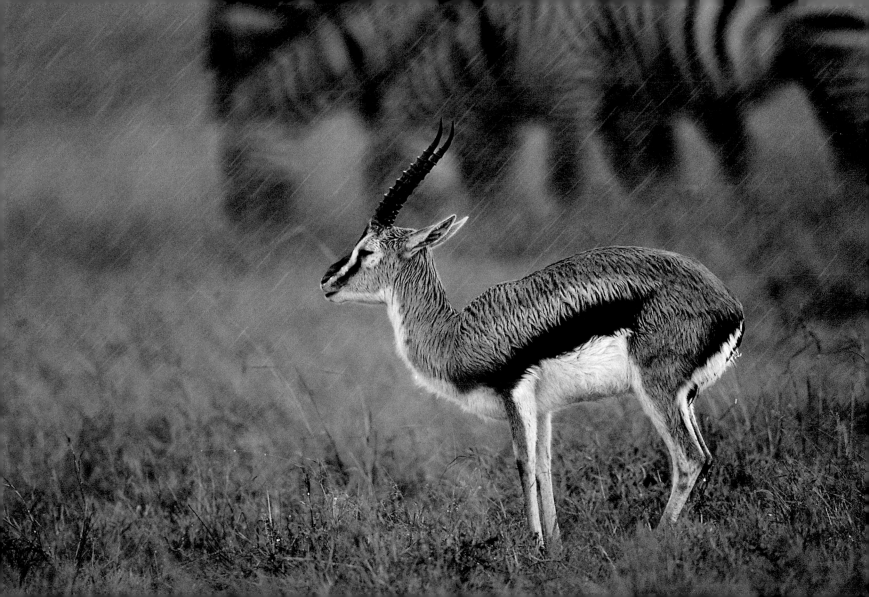

Early-morning mist hangs over the short-grass plains, at the boundary between Serengeti National Park and Ngorongoro Conservation Area. In this vast landscape, individual gazelles appear as insignificant players.

The short-grass plains of the two areas are, ecologically speaking, one continuous unit, extending up to the base of the crater highlands of the Ngorongoro Conservation Area. During the wet season, the migrating animals move repeatedly over these plains, ingesting as much green, succulent grass as their bodies will hold.

The rains first arrived on the short-grass plains in late November in the unique manner of the savannah rainy season: feeble at first then building up to heavy downpours. The migrants have timed their arrival on the short-grass plains to coincide with the fresh growth of grass that never fails to follow the rain. The first herds are at the edge of bushland and grassland, where a pair of secretary birds is perched atop an acacia tree, in the middle of a morning ritual.

As of yet there are no hints of the dramas to come on the migration trail, but this is only the beginning of a year on that path.

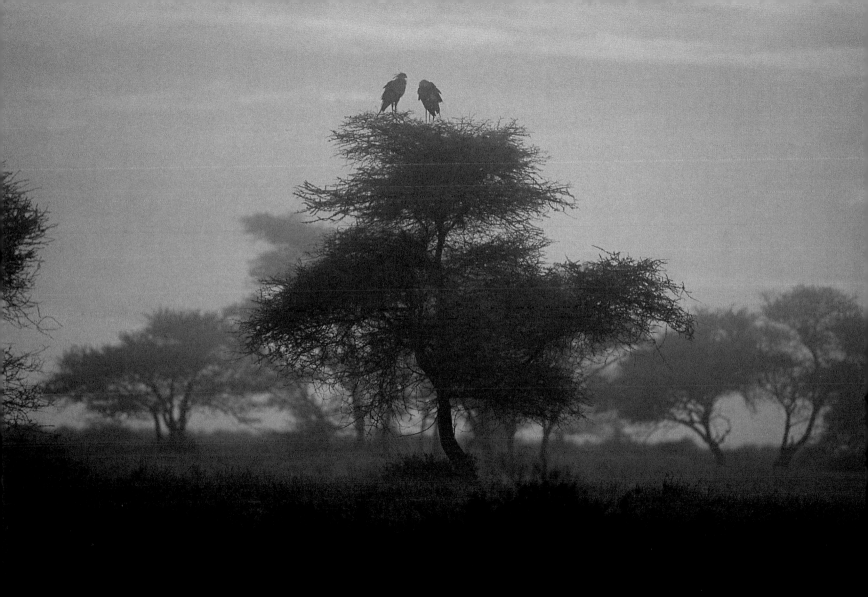

The short-grass plains in the southeast of the ecosystem lie directly in the rain shadow of the crater highlands and receive only 20 inches (500 millimeters) of rain annually, almost all of which falls between December and April. The rains arrive and depart as scattered thunderstorms. This pattern of rainfall implies that not all parts of the plains receive rain at the same time. The herds respond by constantly rotating around their natural paddocks as they follow the rains, revisiting areas every few weeks to recrop the new grass. The migration is driven internally by the genes, guided by the seasons; the genes compel the animals to move, the precipitation shows them where to go.

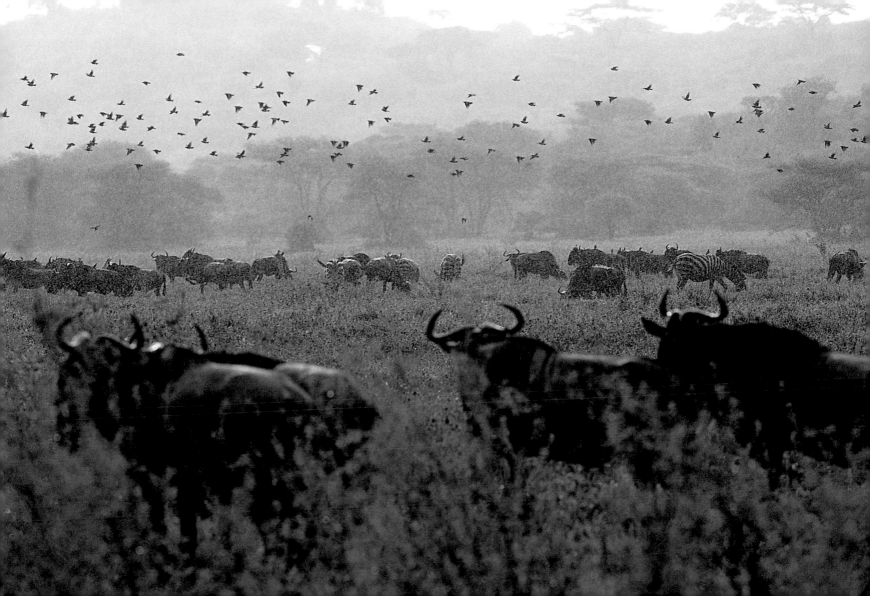

A kori bustard, a large bird that prefers walking to flying, is traversing the plains in search of edibles—insects, seeds, fruits, and flowers. It stops foraging as the afternoon shower gains force, getting soaked to the feathers as it stands in the full force of the rain.

The rains—plural because they do not fall as a single entity but in a series of torrents—are spasmodic and unreliable; they can never be trusted. No rainy season is quite like another.

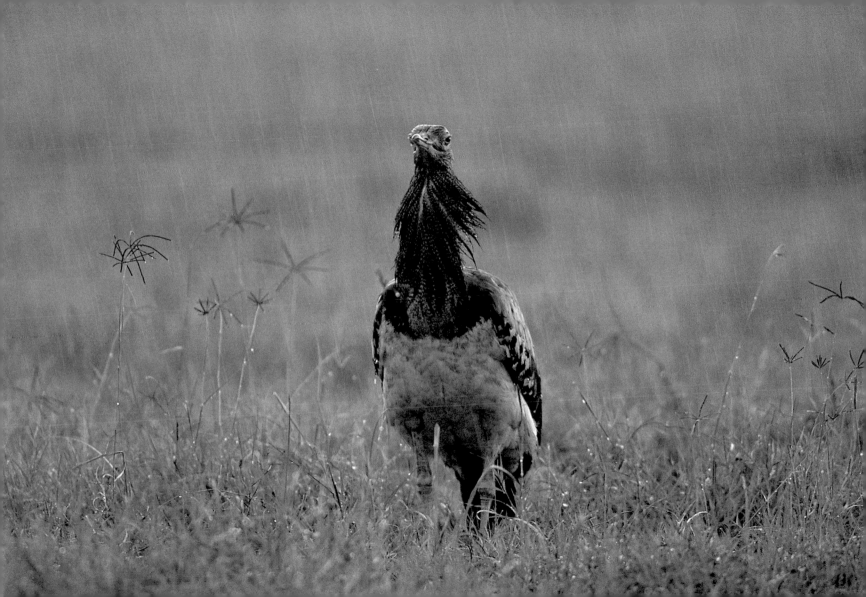

This afternoon it rained near the woodlands, yet the shower is not heavy enough to bring a halt to activity. A European white stork, a large migrant, mingles with the herds, intent on foraging. Thousands of European white storks leave Europe during the winter and migrate south. Many of these join up with the herds on the Serengeti plains and stay awhile, foraging on small fry such as beetles, grasshoppers, and lizards, sweeping portions of the plains clean of its small life.

OVERLEAF

The migrant numbers on the short-grass plains swell to the applause of thunder. The crashing rain forms instant pools. Scuds of rain have blurred the horizon into obscurity. During the heavy downpour, a group of zebras waits for the skies to close so that they can resume grazing.

The rains and the grass: These are the fundamental elements on which the plains depend. The rain feeds the grass and determines its growth, which regulates the number of herbivores the land can support. They in turn, according to their abundance, dictate the number of predators. So it has been for thousands upon thousands of years.

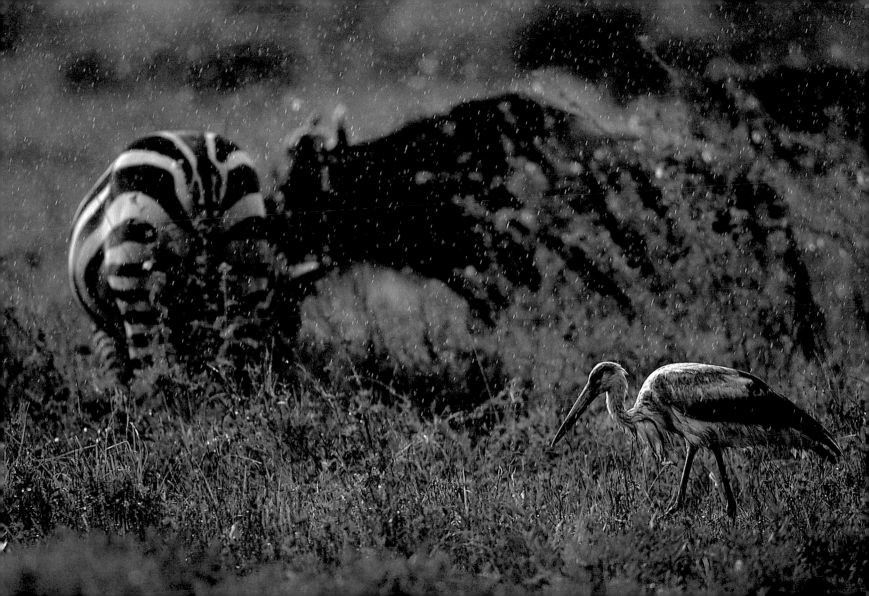

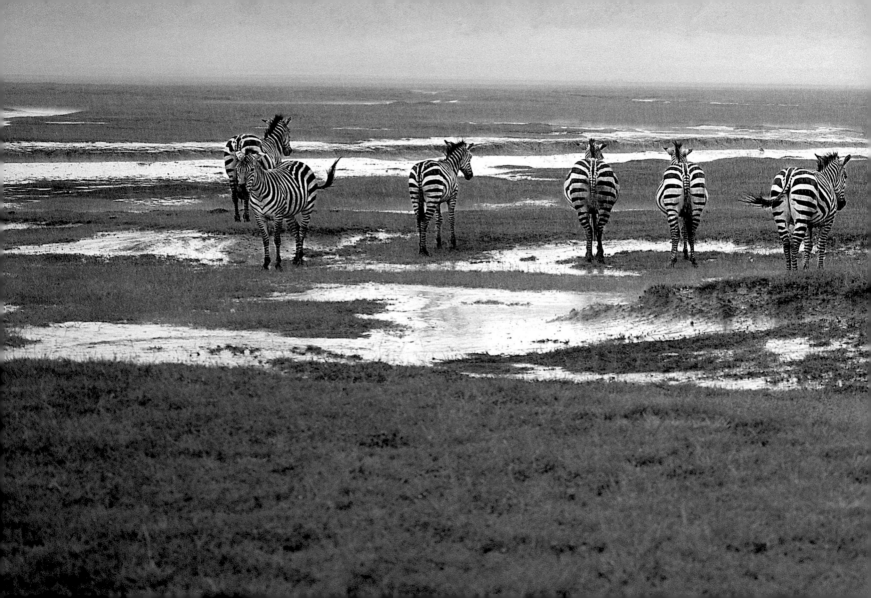

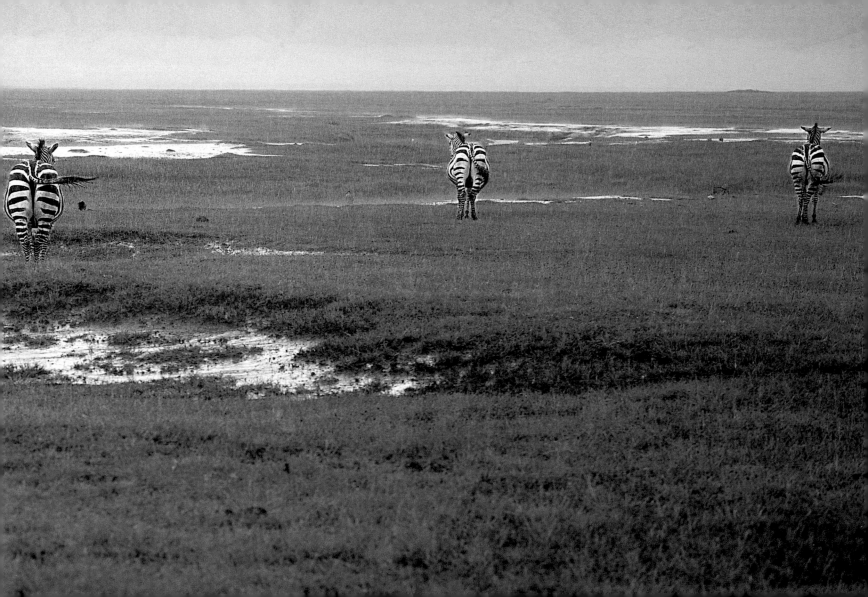

Out on the open plains, a cheetah mother sits the rain out, putting on a brave face despite her predicament. Her two adolescent cubs appear dispirited in the hiss and clatter of the rain. It may seem odd that cheetahs do not take refuge under a bush or a tree when it rains, but their thick fur insulates them from the numbing effects of cold water. The arrival of the migratory gazelles means that the lean times are over for the cheetahs. They can also prey on infant wildebeests. In addition, male cheetahs hunting in coalitions can bring down yearling wildebeests.

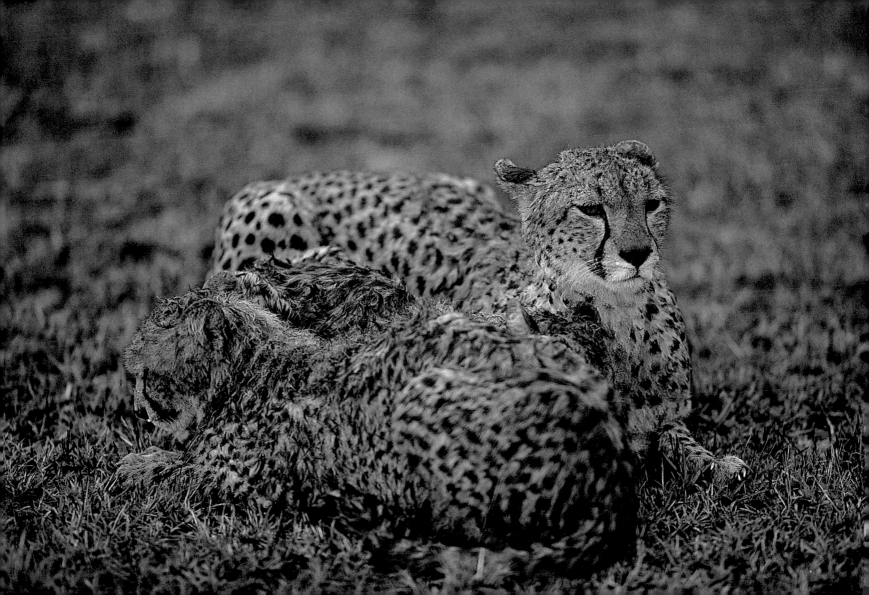

Not far from a place called Barafu Kopjes on the plains, a golden jackal waits for a morning downpour to end, taking the falling water full on. Like cheetahs and lions, it has very thick fur and will sit the rain out without seeking shelter. Once the rain recedes, the jackal will shake off any excess water with vigorous body shakes and go about its business once more, nosing anything remotely interesting.

The jackal has a unique niche in this world but is without special talents or skills. It has no lethal bite, no rapid surge of speed, no safety in pack numbers, no great strength. It is a well-rounded animal with good vision and a decent sense of smell. It survives by hunting small game, scavenging, and digging up dung beetles. You could say that the jackal is a daytime fox in the raiment of a small wolf. A meat-eater, it is also eaten by the usual suspects: hyenas and leopards, but not lions.

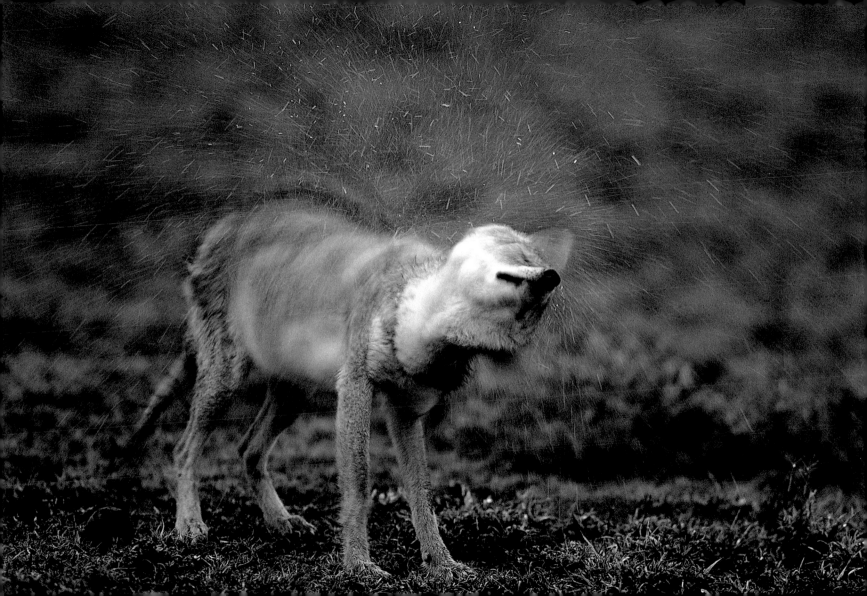

January is typically a strange month weather-wise. There are phases of rain interspersed with periods of dry weather. This day starts misty but the skies are clear. The air warms up quickly once the rising sun starts shining white hot. In the early afternoon a few dark clouds appear, but soon they multiply and finally shed their load. After the afternoon downpour, a massive rainbow appears arching over a wide swath of the plains.

Grazing migrants try to be the first to reach the newly sprouted grass, which is the sweetest and cleanest, as it is uncontaminated by the dung of animals.

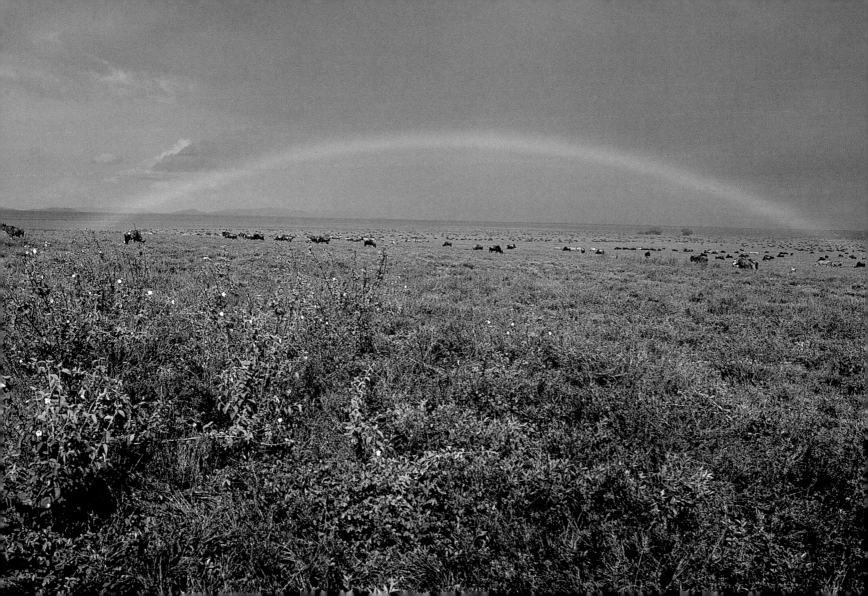

The short-grass plains spread out over southeast Serengeti National Park and the adjoining Ngorongoro Conservation Area. Near Olduvai Gorge, famous for its treasure of hominid fossils, the short-grass plains have taken a pounding from the rain over the last week. The soil is sticky and treacherous for the inexperienced driver of an SUV, but the gazelles move about delicately with the greatest of ease. The grasses on the short-grass plains are delicious and easy to crop. They do not shoot up, lank and unpalatable, when it rains; they can be grazed again and again, because after each cropping they recover, growing back swiftly.

The rains appear to have drenched every space on the short-grass plains. In the wake of the rains come the birds. As each storm fades, flocks of Abdim's storks come spiraling out of the sky to stride through the sodden grass, stabbing at insects.

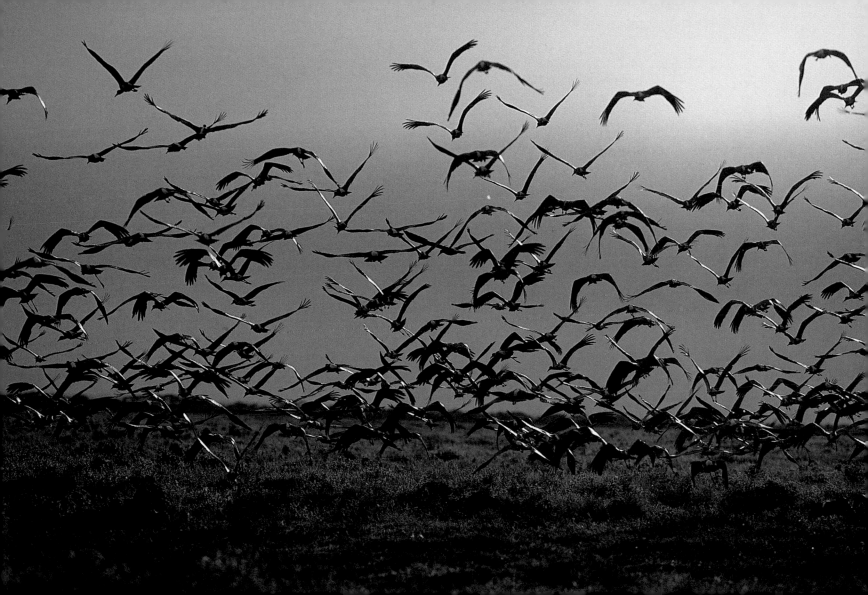

In the continuing sequence of rain, bright sun and heat, then more rain, the grass is thick and rich and luxuriant everywhere so that the herds roam according to no specific pattern.

Near Ndutu, there are marshy pools that attract thirsty animals in the dry season, just waiting to be ambushed by a Ndutu lion pride. At this moment, there are no lions but plenty of water-birds, such as plovers, sandpipers, stilts, ducks, geese, herons, and egrets. Buried in the marsh, the catfish have emerged from their muddy burrows in which they have lain, protectively entombed, through the dry season. This is the sideshow accompanying the main feature of predators preying on the migration. Soon, even the predators, such as storks, will notice the splashing of catfish in the pools and hunt them.

It did not rain today. The clouds dispersed and the sun not only made a comeback, it dominated. Nevertheless, the grass is still growing fast, drawing moisture from the wet soil and, in the short run, will outgrow the capacity of the herds to ingest it. The short-grass plains are so prolific that, after the rains, a single acre can produce eighteen tons of fodder.

Last night the marsh was ringing to the deafening chorus of tree frogs, toads, and bull-frogs—a cacophony of rattling, piping, clinks, and whistles.

Today we get down on our knees and discover the movements of creeping, crawling, and flying insects on the plains. We also discover the hunters of insects: frogs, spiders, and lizards.

The rains herald the season of plenty for the survivors of the dry season. For the herbivores, the plentiful plant material is succulent. But wherever there are so many vegetarians, the meat-eaters are not far behind.

Oblivious to the afternoon shower, two mature lionesses keep a watch on a herd some distance away. As the shower fades, they go through an unhurried ritual of yawning, stretching, shaking off excess water, and self-grooming. Then they make their way unobserved to the preoccupied herd. And then, in typical lion fashion, they lie down to wait for darkness to fall before commencing their deadly work.

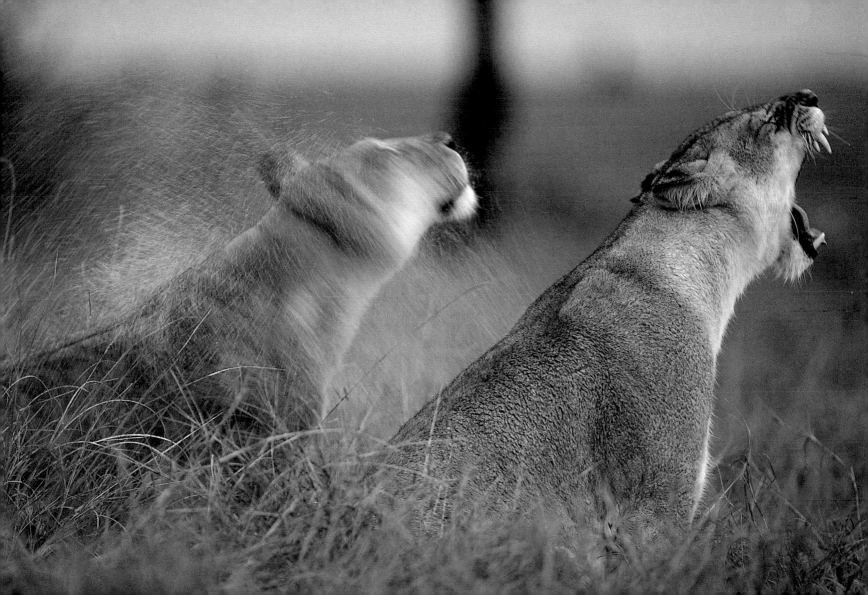

Another day, another lioness. She is traversing the drenched plains, walking exposed and in full view of watching eyes. She is not at all at ease, for her style is to use cover and stealth; the cloak of night suits her best. This one does not belong to a pride and is free from territorial restraints, so she leads a nomadic existence, following the migration. The wildebeests avoid soggy conditions and have left this area already. So she keeps moving, following her mobile food supply, but cautiously, for she has no desire to encounter the combined strength of hostile territorial lionesses. If spotted she would be chased away and if trapped she would be mauled.

Just as night follows day, death stalks life with the same indifference. The grazers are in vulnerable positions on the plains and are easy hunting targets. A zebra foal, running carefree around its feeding mother, runs into the trap set by the Cub Valley lion pride. This pride has several lionesses, two males, and many cubs of varying ages. For the moment the males are elsewhere so the lionesses and cubs have the kill all to themselves. The carcass is soon reduced to ribs, and the lions retire to a shady tree near an ancient rocky outcrop. The physical world seems eternal, the biological world ephemeral.

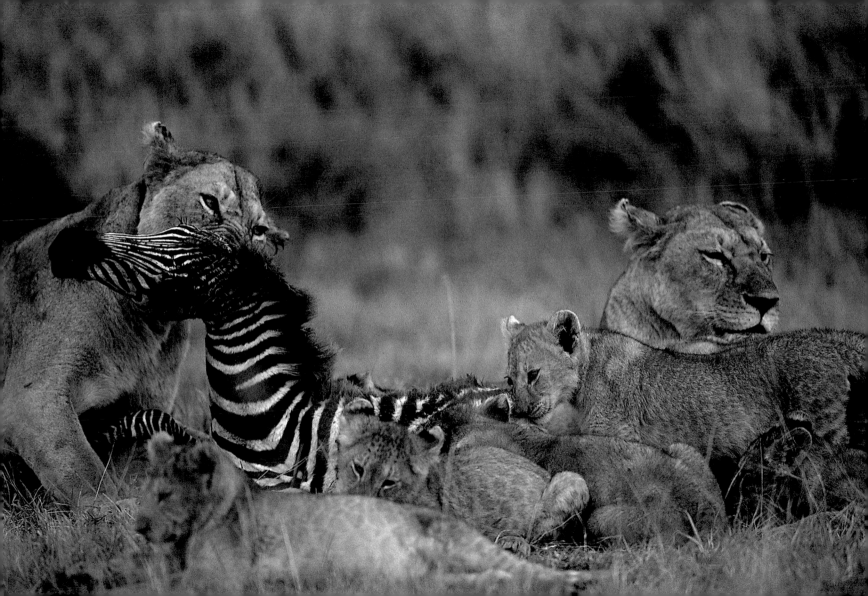

Naabi Hill is a tree-covered island on the plains that provides refuge for the Serengeti's south-ernmost lion pride. No pride of lions can sustain itself in the region between Naabi and Olduvai Gorge, it is so deep in the rain shadow of the crater highlands. It is a waterless landscape for more than six months of the year.

The Naabi pride has always struggled to raise cubs. There are no pools of permanent water in its territory so during the dry season it is a real challenge to hunt successfully, most of the graz-ers having long ago departed to greener pastures. Nevertheless, the birth of the cubs in this pride has been timed with the arrival of the herds. A mother gently closes her mouth around one of the cubs and carries it to higher ground. The cub dangles passively from its mother's mouth, enduring the indignity with resignation. Twice more she transports a tiny bundle. Cats come into estrus 12 to 24 times a year and produce a litter rather than a single offspring, so the potential for increase is enormous, but every year there is a surplus of cubs that die of starvation, usually after the movable feast has left the vicinity. Contrary to the conventional notion of the fearsome predator controlling the number of gentle herbivores, in the Serengeti it is the other way around.

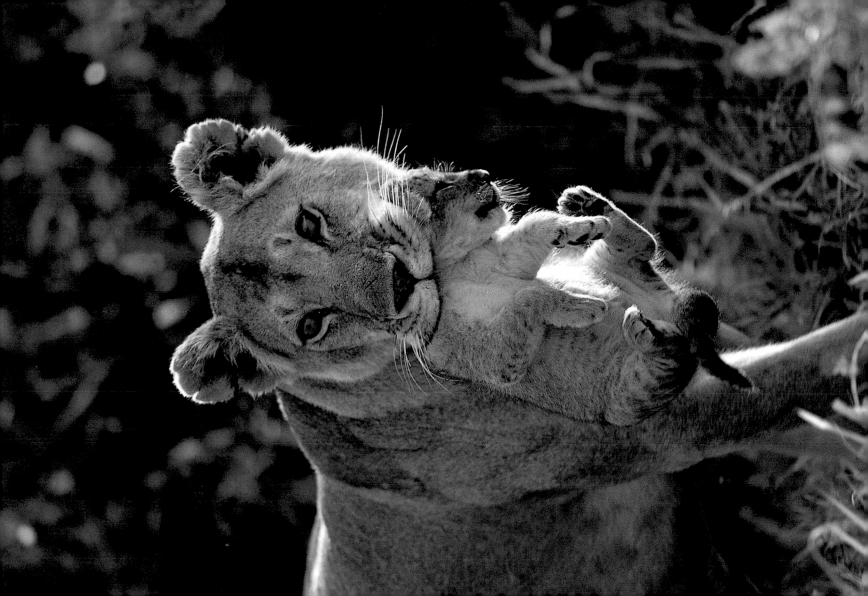

The cubs of the Cub Valley pride are boisterously romping at dawn, pouncing on each other with exaggerated leaps. They also wrestle and tumble among themselves in mock combat. The pride has a large, well-endowed territory with several pools of water that do not run dry until the year is well into the dry season. The chances are great that some of these cubs will survive into next year. Pride lionesses do not breed any more frequently than nomadic lionesses, but they rear many more cubs on average. This is the advantage that a good, stable territory confers.

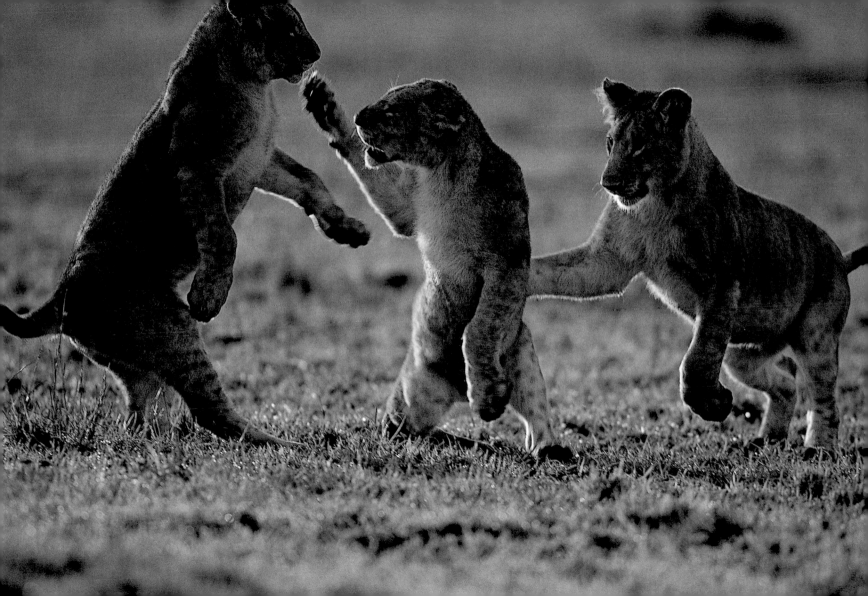

It is an hour before dusk on the plains southeast of Naabi Hill. A pregnant female gazelle stands a short distance from its herd where the grass is long enough to give cover to the fawn that is about to be born. As the newborn drops from its mother's body, she keeps scanning all horizons and the sky itself for any signs of danger. She seems highly aware of her baby's vulnerability to predation. The newborn staggers to its feet only moments after birth, making valiant telltale efforts to walk. The mother circles the tottering baby, licking its body to rid it of the scent of birth. The first rule of survival among breeding gazelles seems to be that no hidden fawn should ever be betrayed by that scent. The migratory gazelles start giving birth in late January and continue until March.

OVERLEAF

We see more newborn gazelles today, suckling from their mothers. Many more must lie hidden. Newborn gazelles are helpless against predators, even those as small as a serval cat. The only way not to become a carnivore's meal is to avoid being seen in the first place. Were a newborn to stand and be spotted, it would arouse the lethal interest of all hunters in the area who understand its vulnerability. But stand it must, if it is to suckle or if it is about to be trampled by a panicked herd.

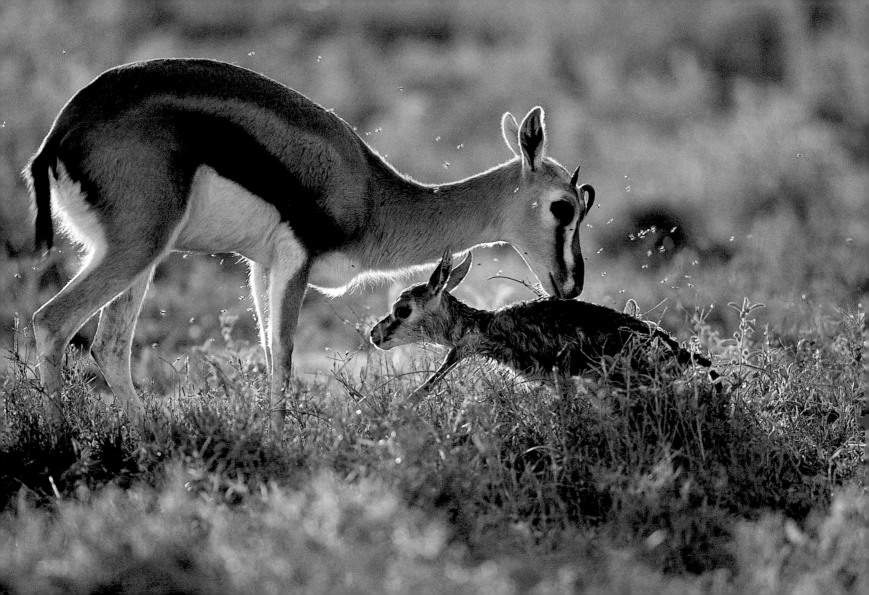

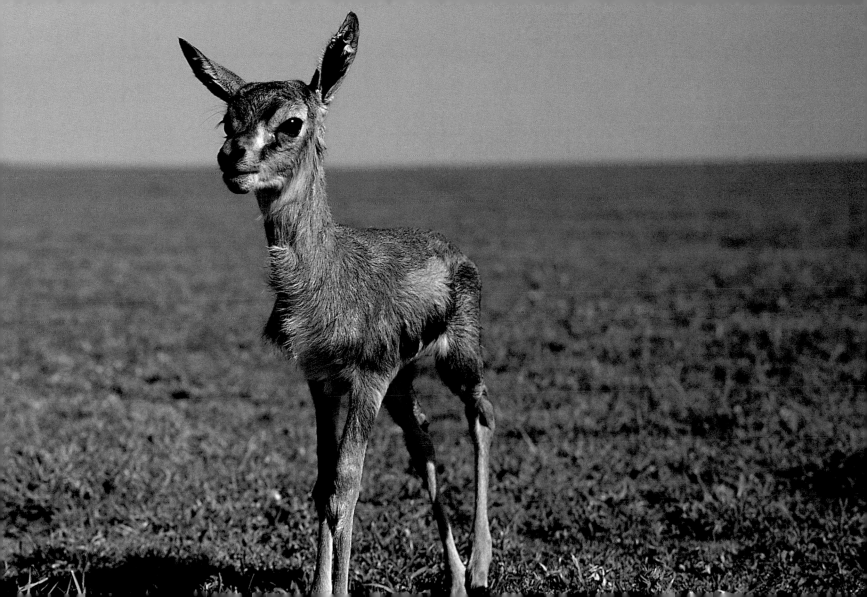

This morning a cheetah appeared on the horizon, and a gazelle instantly became alert. All the other gazelles sensed its concern as every head popped up. The gazelle advanced a few steps and snorted. It can sense the cheetah is keenly interested to hunt. The cat keeps coming on, however, holding the herd mesmerized for a few seconds. The cheetah has its eye on a gazelle fawn lying in the grass. It streaks past the alert gazelles to the very spot where the fawn is hunkered down, frozen still, its chin on the ground, ears lying flat. The second the baby becomes aware of the impending danger, its instinct to run kicks in. It leaps up to run but it's not fast enough. It is a brutal fact that the offspring of the migrants fuel much of the energy of the carnivores.

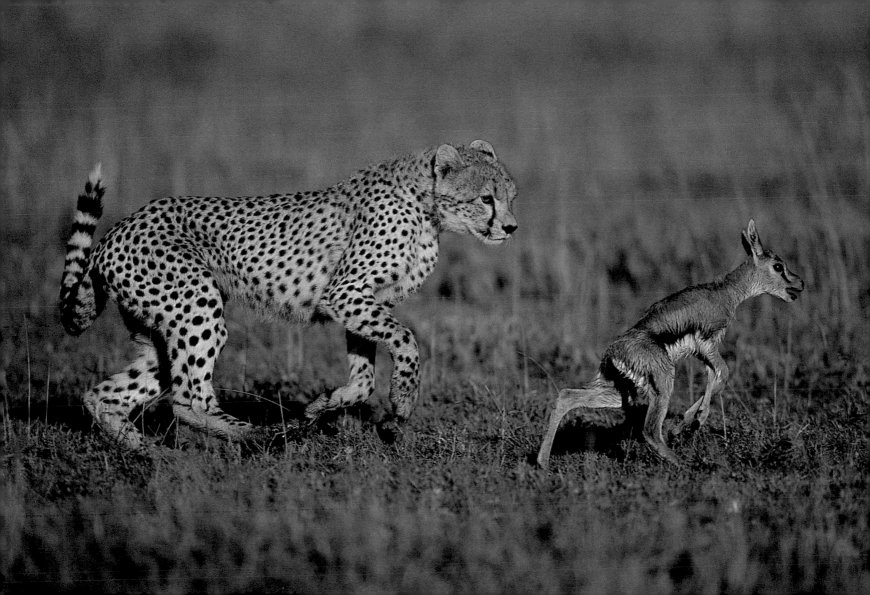

On the way from Gol Kopjes to Barafu Kopjes, you come across a tributary of the seasonal Ngare Nanyuki River. Here, in a makeshift den, a cheetah has deposited her tiny cubs. How strong is the connection between the rhythm of the migration and a cheetah's life cycle? Gazelle fawns are plentiful and easy for a cheetah mother to catch this time of year, so there is a direct correlation.

How ironic that to raise its litter of cubs, the cheetah kills many gazelles, young and old, fifty to one hundred per year. Even more ironic is that many cheetah cubs are killed by lions for reasons we cannot fathom.

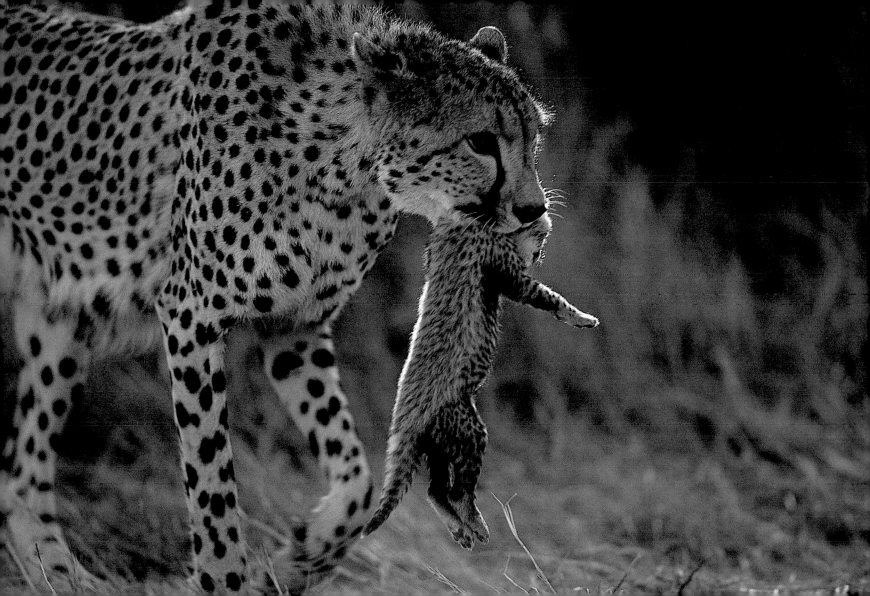

Only several miles east of yesterday's cheetah lair, there is a hyena den. Early this morning, near the den, this high-ranking female had a monopoly on a wildebeest kill. When the group chose this water hole with dollops of slimy mud—hyenas love to escape the scraping, pulling, tugging, biting, itching of parasites in their fur by soaking in such soupy messes—to lounge in for the rest of the day, hierarchy ruled and a lower ranking hyena had to quickly make way for her.

The reigning matriarch is a big animal. Her scruffy coat has begun to lose its spots, showing her to be well into her prime. Her loose swinging skin conceals thick, tough muscles which can drive her to chase an antelope for more than 10 miles (16 kilometers) without slowing down.

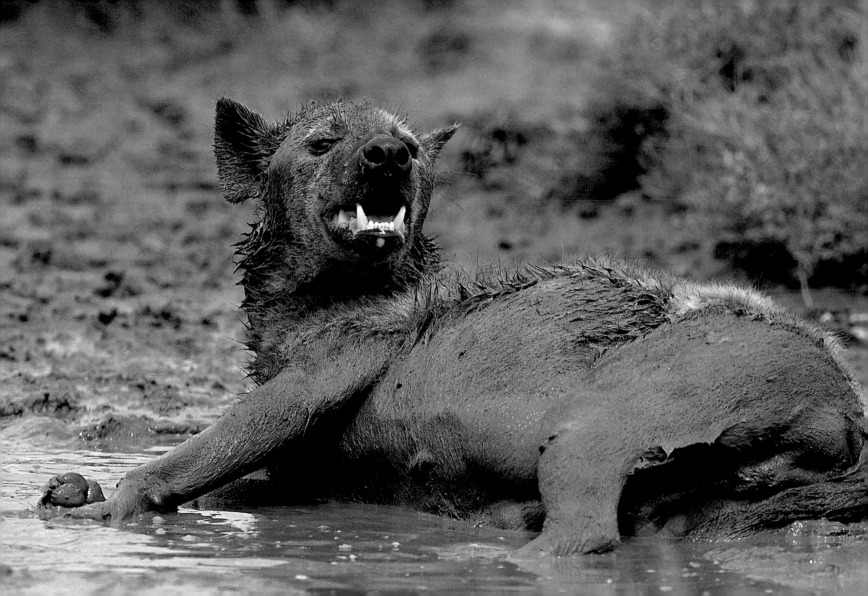

This morning a hyena, alert for any sign that could lead to a meal, gets its chance. A male-female pair of golden jackals has managed to separate a gazelle fawn from its mother and maim it. The hyena muscles in, the jackals give way, and the fawn sits back in a state of shock. The hyena wraps its lethal jaws around the fawn's head and carries it away from the den. The day has just begun and another fawn's life has been snuffed out. At one time or another, gazelle fawns also fall prey to martial eagles, lappet-faced vultures, caracals, serval cats, cheetahs, leopards, and lions. Most often, aggression pays off and the meek perish.

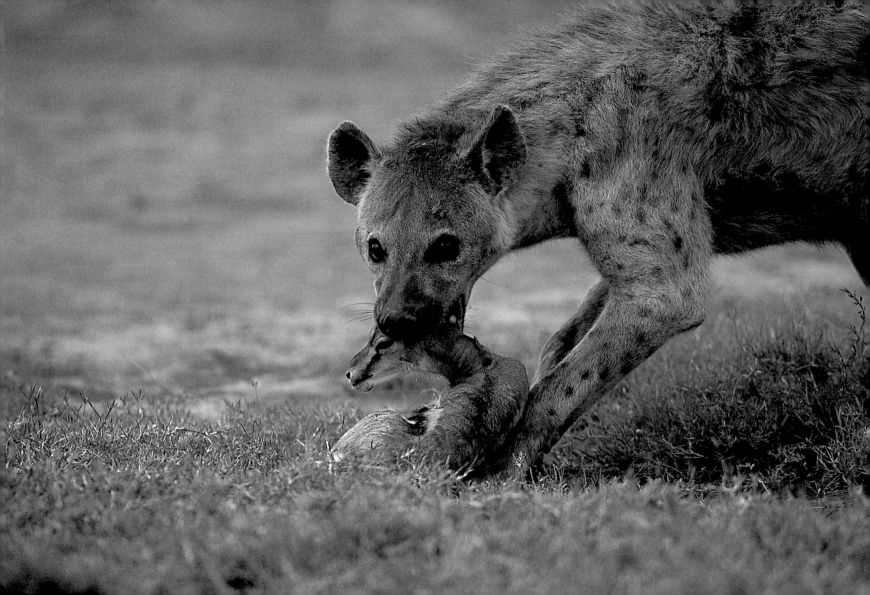

When the migrants are on the short-grass plains, hyenas from the woodlands to the north and northwest commute. This lactating female is far from her den. She has chanced upon a gazelle fawn and caught it after a short chase. Now she carries the fawn to a sheltered spot where she can feed, free from harassment by the local clan. Territorial hyenas are able to range further than territorial lions due in part to an implicit understanding they have amongst themselves: A clan will allow non–clan members to enter their territory, but only if they are on the hunt and merely passing through. Peaceful passage does not include peaceful meals, however, which is why she is anxious not to attract attention.

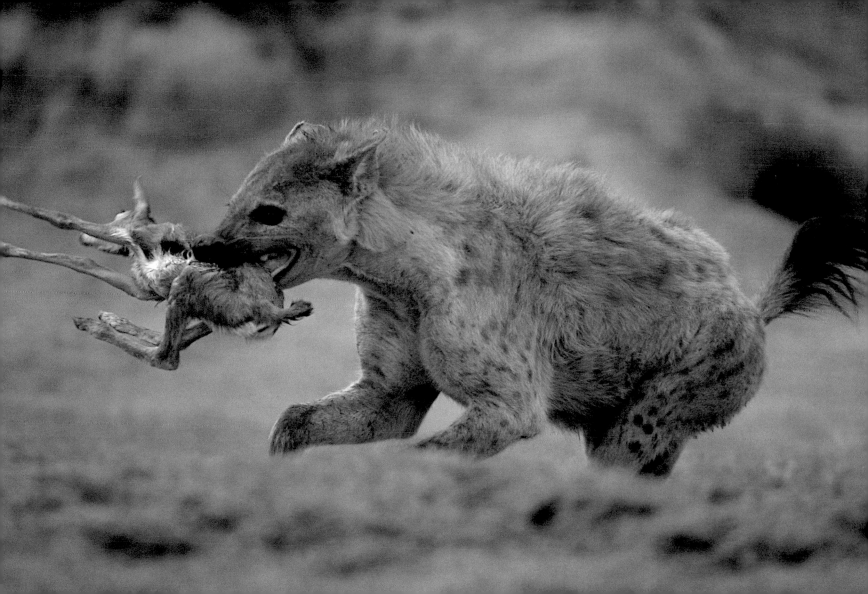

This hyena den is not far from the mud wallow, where three mothers nurse their pups. A subordinate mother approaches a hole in the ground and two enthusiastic pups burst out. Hyena pups have a reputation for sibling rivalry, especially when the twins are females. In some cases, the stronger pup will not allow the weaker sibling to suckle, and over time, the starved pup weakens and dies. This is called siblicide.

The plains hyenas seem to be tuned into the migration, giving birth to coincide with the arrival of the migrants on the plains. Young migrants are hunted, killed, and eaten, the nutrients of which become milk for the hyena pups.

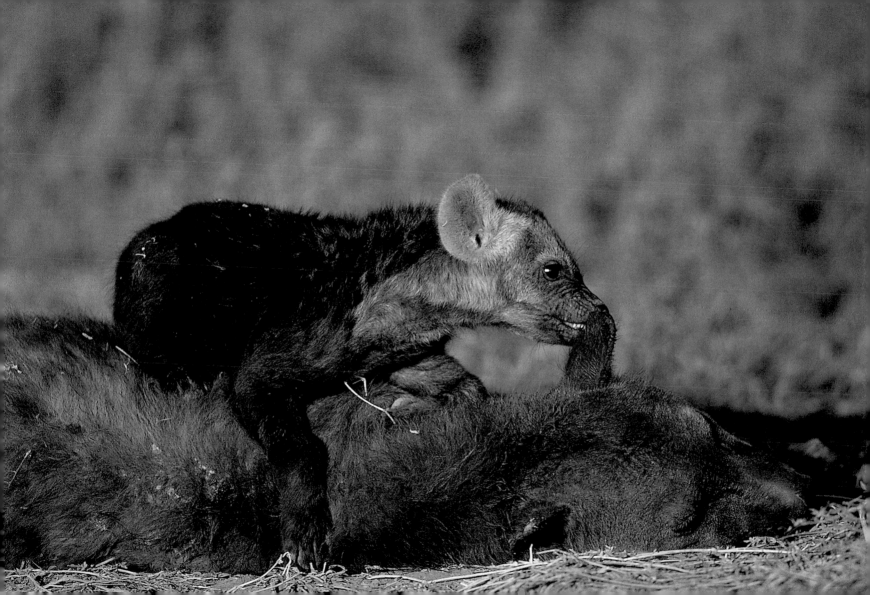

Early morning mist clings to an area of short-grass plains between Naabi and Ndutu known as the Triangle. The incessant grunting of the bulls dominates over all other noises. Here, the wildebeests are in their traditional calving grounds. There is good food, water, and room to congregate. The bits of undergrowth obscure predators, but it's during the night that the predators have a real advantage. The herds clearly prefer this vast landscape to the wooded country to the north and the west. The pregnant wildebeest cows are in small, separate groups, an evolved tendency as the time of mass calving approaches. Almost all wildebeest cows over three years old give birth to single calves.

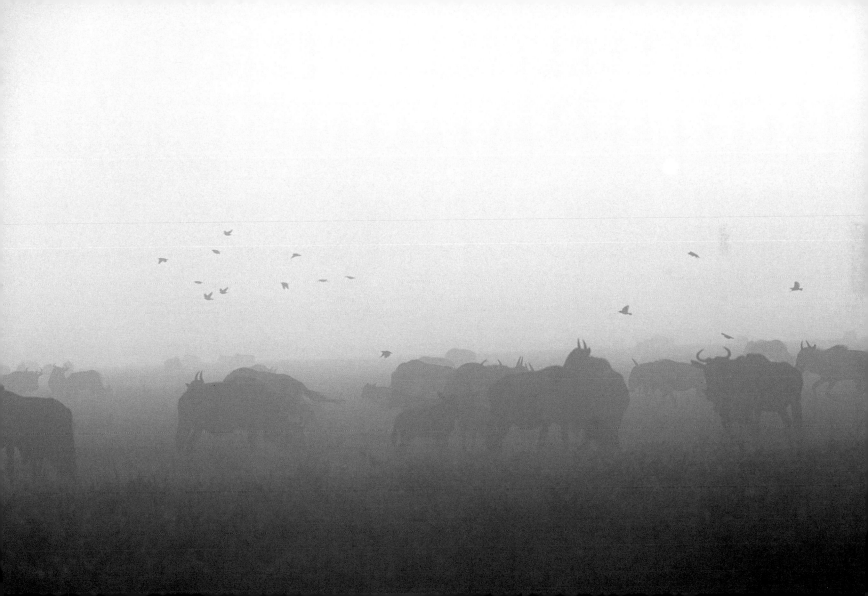

Survival success and failure are commonplace on the plains. The Ndutu lion pride, whose territory includes portions of both woodland and grassland, has brought down a wildebeest at the line where the two habitats meet. Lion predation has a minimal effect on migrant numbers. What matters most is the supply of grass and water. Over the last thirty years, the number of migrants has steadied at two million, which suggests a balance between supply and demand.

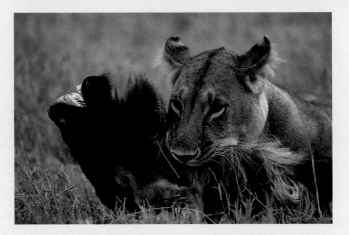

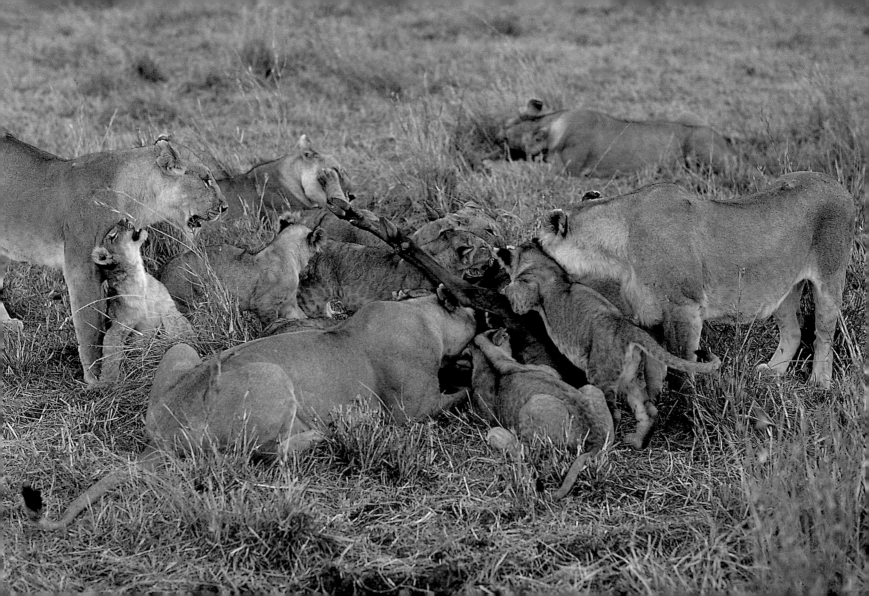

The uproar caused by the calls of thousands of wildebeests was constant last night, shutting out all other sounds. It is the same this morning—there has been no break.

The Ndutu lion pride is feasting again, this time on a heavily pregnant wildebeest. The female in this condition is a shade slower, enough of a margin to make a difference between life and death. While feeding, one of the lionesses dumps the fetus near the kill. A satiated lion cub comes across it and carries it off proudly. Here is a new toy, a trophy to be paraded. Another cub gives chase and soon a game develops over the fetus. The wildebeest birthing season is imminent.

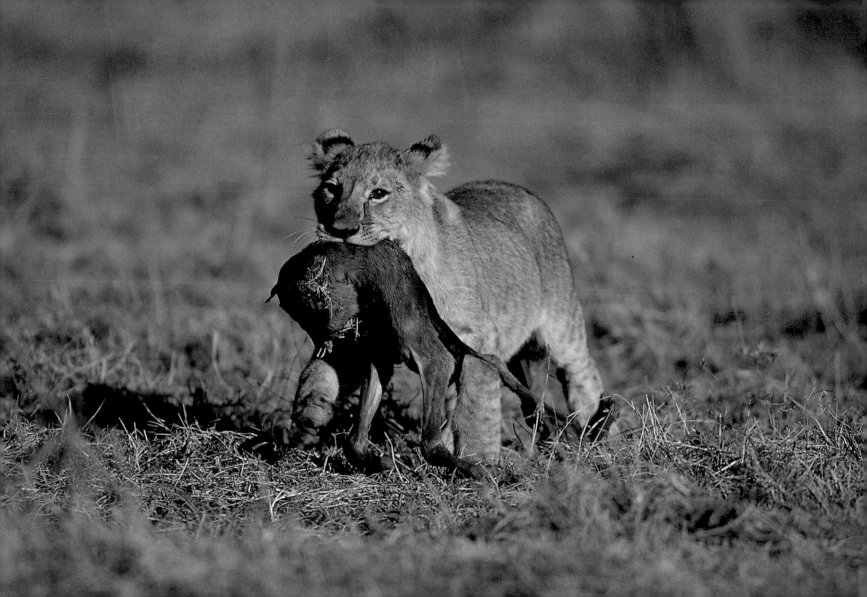

It is mid-morning at the boundary between Serengeti National Park and the Ngorongoro Conservation Area, and a few wildebeests have gathered around a newborn calf lying on the ground. The mother calls, licks, and nuzzles, and the crippled calf responds to her appeals by trying to stand up, but to no avail. Born with deformed legs, it has nevertheless inherited a strong will to survive. It tries again and again but without success. After a couple of hours, the grazing group of wildebeests starts drifting away. The mother is torn. She runs to and fro between her companions and her baby. Invariably, the distance between the baby and the drifting wildebeests increases and finally the mother throws in her lot with the adults. Nature is ruthless with such handicapped creatures. Out on the plains, animals rarely die of old age.

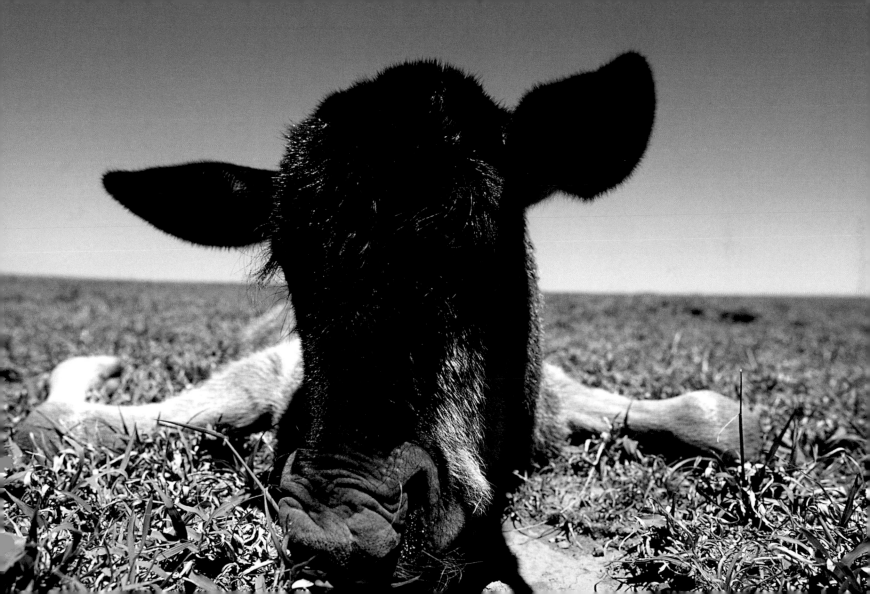

A heavily pregnant wildebeest grazes nonchalantly. Suddenly, a sac appears under her tail followed by tiny hind legs. Only then does she lie down and start to heave. She checks her surroundings and heaves again, stretching her prone body to the full. Gently and smoothly, after minutes of such interval heavings, the calf begins to emerge. The mother then stands up and thereby ruptures the cord that connected them during pregnancy. The mass calving has begun.

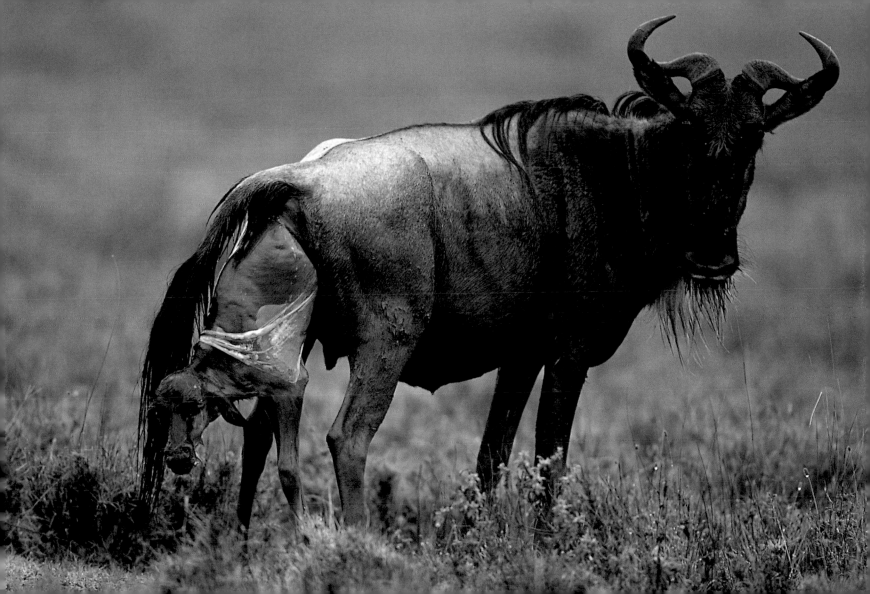

The wildebeest lies on her side, thin legs outstretched, her swollen body convulsing with birth contractions. Her eyes roll and her teeth are bared, in pain it seems, as she struggles to her feet and, in that very moment of rising, drops her calf in the grass. She lowers her head to lick and clean with her broad-lipped muzzle the wet, glistening bundle that is already jerking its spindly legs. She nibbles away the enveloping membranes, stimulating the calf to stand on its own. This licking also eliminates the telltale odor, which would be sure to draw hungry predators. The moments after birth are critical as it is then that by sound, sight, and taste the mother and baby are imprinted in each other's memory.

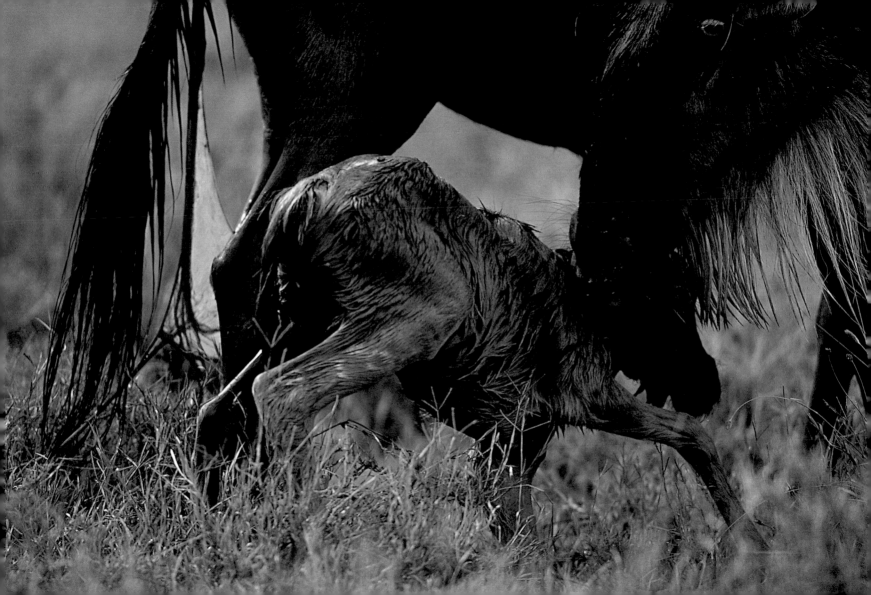

On average, a wildbeest calf can walk within five minutes of birth, quicker than any hoofed mammal. This newborn is struggling to its feet. It falls over in its first of three attempts to stand. But with each try its leg muscles are getting their act together. On the fourth attempt it manages to stand on shaky limbs, precariously swaying from side to side, back legs splayed wide. As it tries to step forward, it unceremoniously pitches forward onto its chin. The anxious mother looks on but, for now, there are no predators in the vicinity. The calf struggles up again, still tottering, but with improved balance, and this time it stays up. It walks on unsteady feet toward its mother and is soon happily suckling.

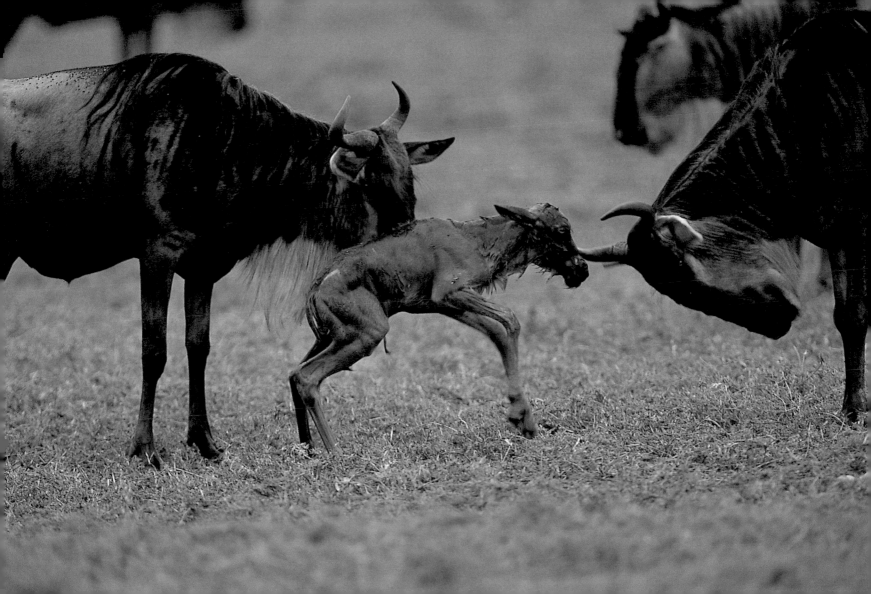

In just over three weeks over 80 percent of all wildebeest calves will be born for the year. The wildebeest numbers grow by 250,000–500,000 during the month of February. It is as though the herds possess a communal womb. But an average of about one thousand wildebeests die each day, keeping their population size steady. The mass calving continues. A tottering newborn ambles over to its mother. She walks away. Unsteadily, the calf follows. Within the regulatory seven minutes, it is galloping alongside her, shaking its head. Together they dissolve into a herd. The trick is to give birth and stay on the run.

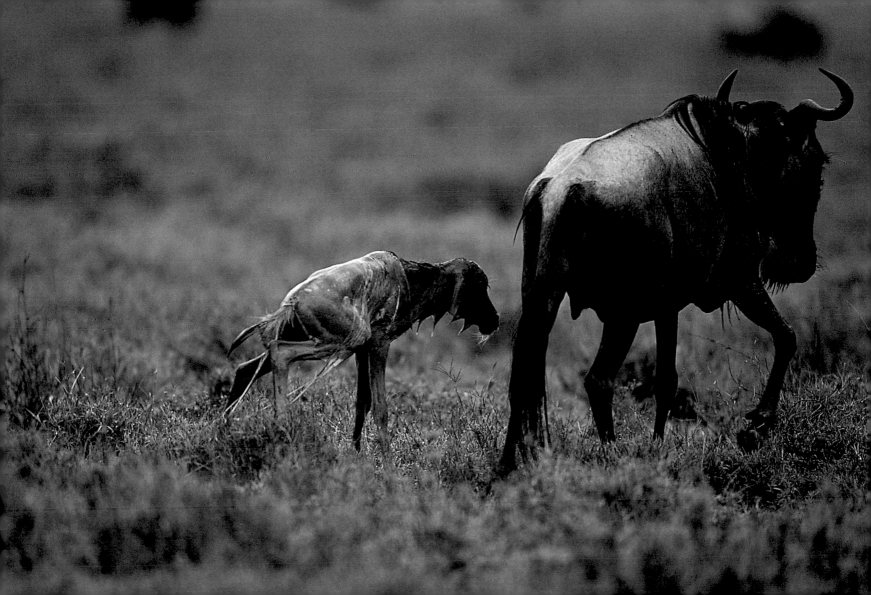

This early morning a hyena is barreling across the plains and stops half a mile from a group of female wildebeests. It patiently sits and watches, entirely hidden from view. The wildebeests show some nervousness but cannot detect an obvious threat.

A pregnant wildebeest can postpone delivery for at least an hour if she senses danger nearby, but at a certain point she must give in to nature. After a long time, a cow begins her contractions and a calf is duly born. The hyena gets up and moves in for the kill, certain of its outcome. The mother stands guard as all the other wildebeests move hastily away. The hyena tries to snatch the newborn while the mother attempts to head-butt the predator. She defends successfully for a few minutes, armed only with horns and a belligerent spirit, but the hyena's persistence pays off. Never losing focus, it spots an opening to grab the calf and makes off with it.

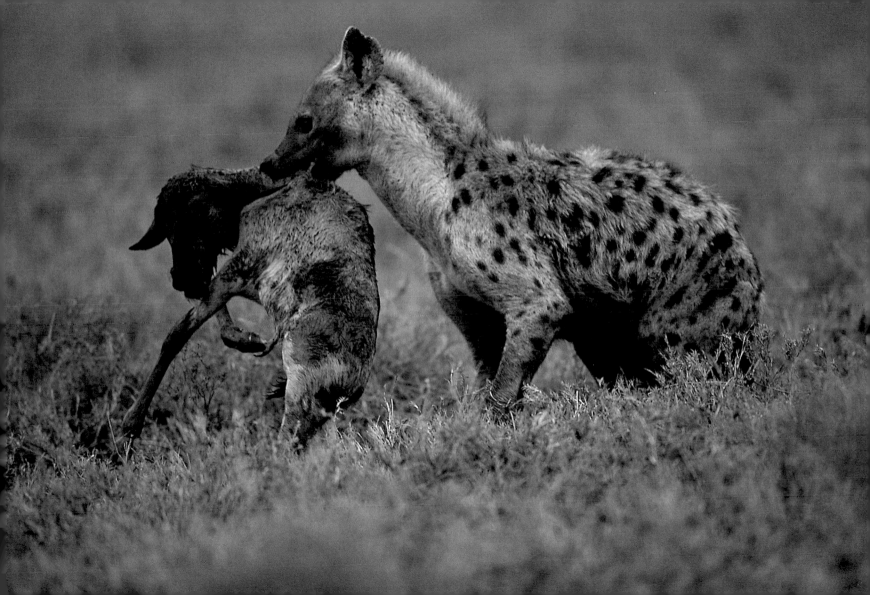

On this gloomy morning a feeding hierarchy takes place before us on a wildebeest carcass. First, two lionesses have their fill of the carcass. When they saunter away, a hyena, who has been hovering in the wings, takes possession. There is no hyena den in the vicinity, so it is likely this one picked up the scent of the carcass during its solo wanderings; it is thought that a hyena's sense of smell is hundreds of times more powerful than a human's. Following the hyena's feeding, a pair of jackals takes over, and when they are satiated, the vultures move in.

A week-old calf can run at 20 mph (35 kph) and at two weeks can gallop almost as fast as its mother. It's evening near Ndutu, and a spooked herd is on the run. The adults jostle one another, not in panic but strategically. Each calf runs alongside its mother, almost touching her side, and each mother places herself between her calf and the source of danger. This makes it very difficult for a predator to pick out the calves.

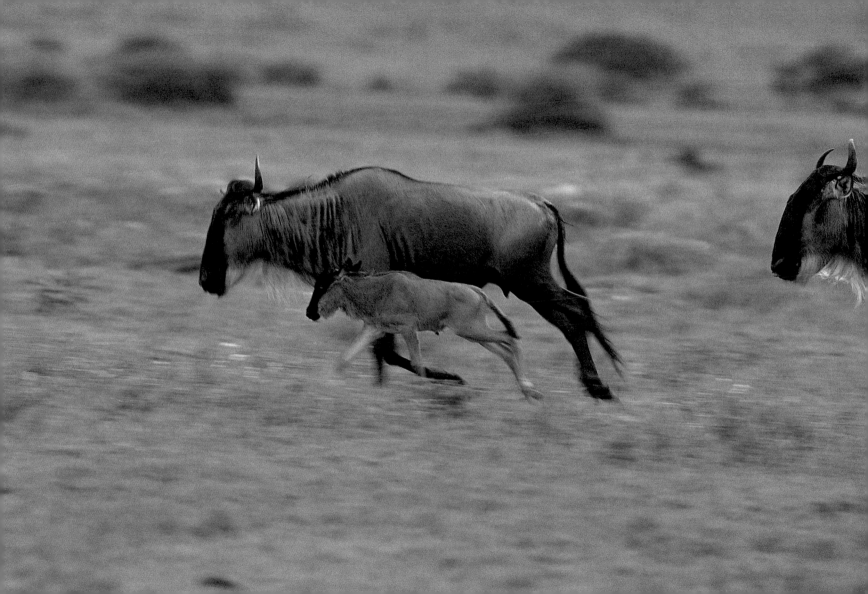

Whether resting, feeding, walking, or running, a calf stays close to its mother. But separation often occurs when there is bedlam in the herd, as when a predator attacks. Once separated, a lone calf is a pitiful sight, all by itself on the plains with the herd and its mother gone. The calf will run back and forth, searching for the familiar odor, the familiar tongue, but the plains are so vast that the chances of a reunion are next to none. Cut off from its lifeline of milk, the calf will quickly become dehydrated and weak and likely to fall prey to a predator after all.

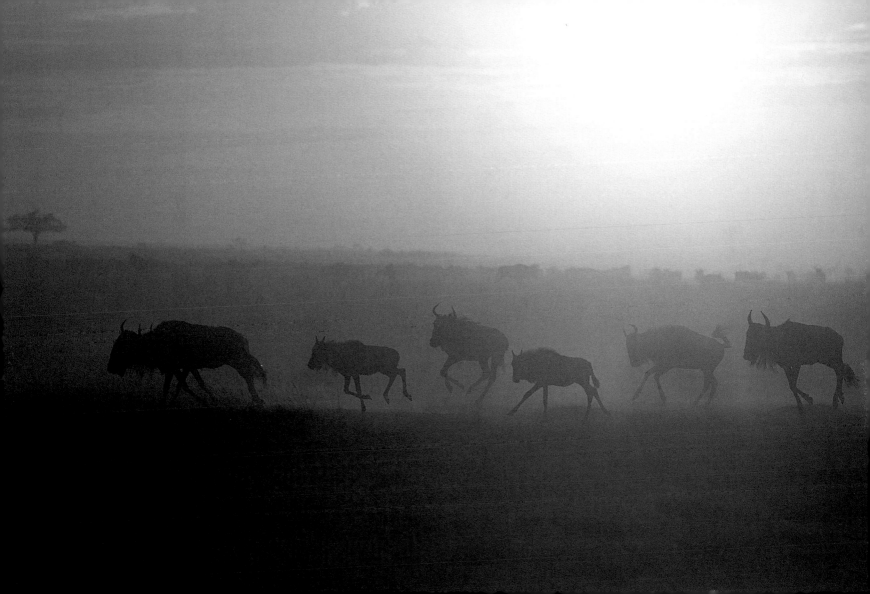

It is another crisp morning with a cloudless sky and the herds are spread out on the plains. The plains rise and fall almost imperceptibly. The air is so clear that one can see far and wide for miles. The waves of this vast grassland invoke the immensity of time and space, mocking the trivial concerns of human existence. There is an extraordinary sense of freedom as well. Ostriches appear on the crest of the undulating plains, in perfect silhouette, like three pendants on a necklace, strung along the break between land and sky.

The previous three days have been sunny and hot. Today starts out the same. It stays bright and clear until early afternoon, when clouds start to gather and the wind picks up strength. A large herd starts trekking eastward toward the ominous clouds. Soon the light starts to diminish and, in the distance, you can see rain filling the horizon like smoke. Lightning flashes in the distance followed by deep rumbles of thunder. The grazers vanish over the crest moving inexorably into the storm. By evening a blanket of clouds covers the Serengeti, stretching from horizon to horizon. The boom of thunder and sudden vivid explosions of lightning make the air crackle. Maybe the herds should have stayed here after all.

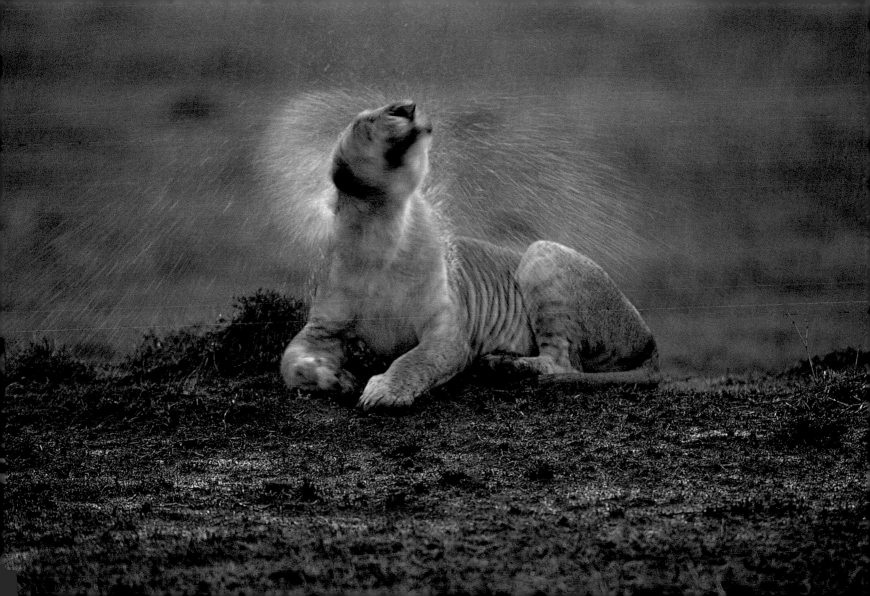

The wildebeest birthing season continues, right alongside that of the gazelle's. Mother gazelles leave their newborns hidden in the grass. It is a behavioral adaptation to escape notice by predators.

Driving slowly, and with the help of binoculars, we search in the longer clumps of grass near a female gazelle herd. We spot a fawn lying absolutely motionless, gripped by orders passed down through its evolutionary past. As we drive away, a female gazelle looks up from grazing, as if to make sure we go. A gazelle fawn's reliance on camouflage and hiding is a behavioral pattern that seems to have been inherited from its forest ancestors. Fawns are tiny and do not move much in the first few days of life so it's possible for them to remain quite well hidden, even in the open plains. A fawn develops quickly, however, and can run fast by the time it is a week old. Thus the danger period is short.

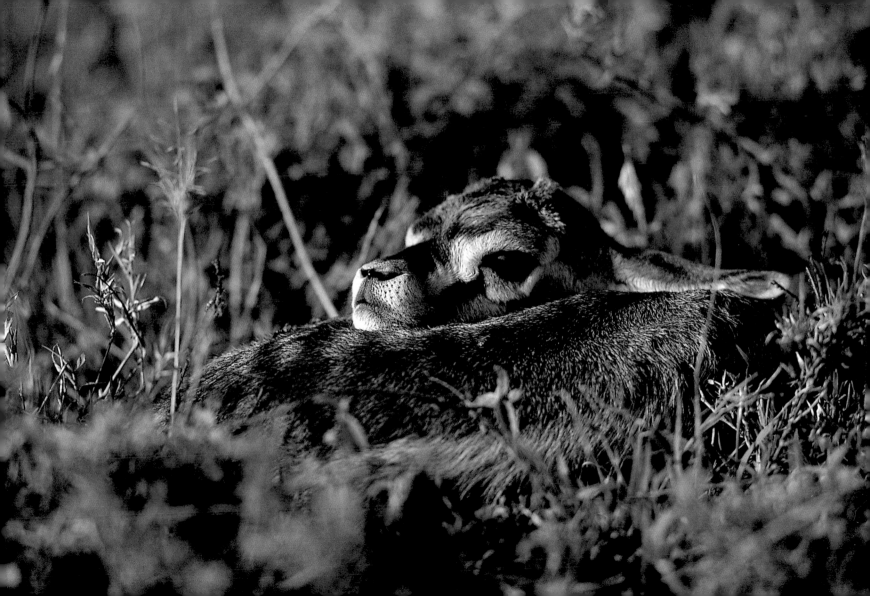

It is a somber start to the day once again. The Cub Valley pride is returning to the kopje, sauntering along with tight, heavy bellies. With about two million grazers at their doorstep, hunting has become a cinch. The lions become a little playful as they reach their destination. In the exuberance of play, a young lioness flushes out a hidden gazelle fawn that manages to run no more than a dozen yards before the bounding lioness knocks it down and seizes it by the throat. She carries it jauntily, swinging it in an arc and tossing it into the air. She is not at all interested in eating her catch; this is the season of abundance, and famine is a distant memory.

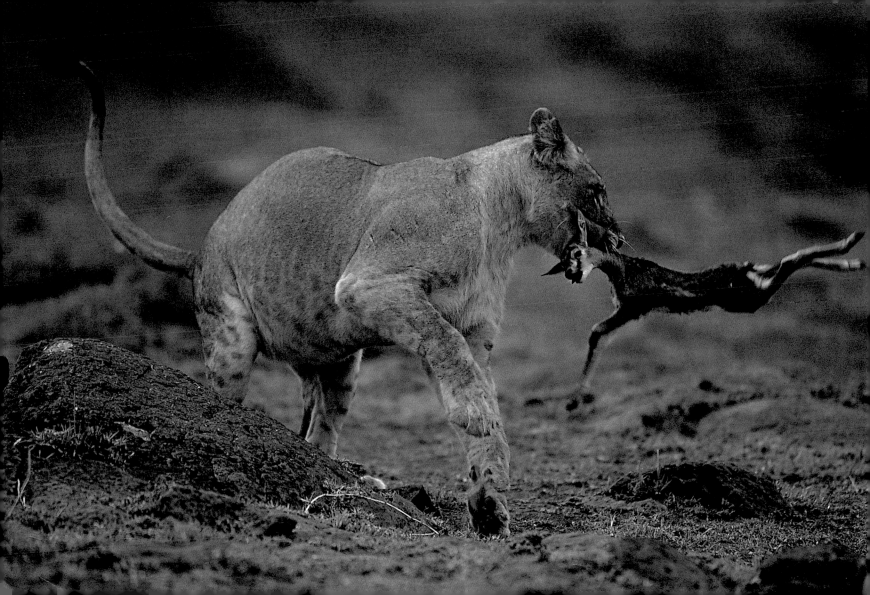

This morning, after a lazy duel with the clouds, the sunlight finally reaches the plains. A Cub Valley pride lioness that had temporarily gone solo is heading toward the watching pride. She roars as she walks toward them purposefully, never wavering. The pride does not return her calls. Instead, they watch her attentively as she approachs. Are they trying to decide if she is a friend or a foe? When she is almost upon them, three adolescents get up to greet her. A young male rubs his cheek against her head. The other two encircle her as well. With a heavy sigh she flops down and closes her eyes. She has been reintegrated into the pride.

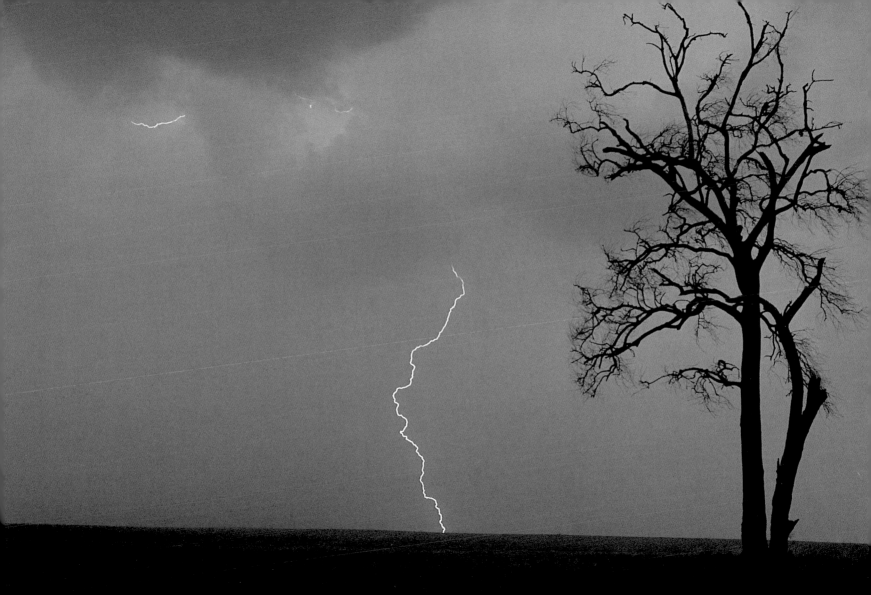

Unlike yesterday's dawn, today's is dismal: The cloud cover has remained firmly in place. From the vantage point of a kopje, we can see the herds in many loose agglomerations, grazing and resting. Kopjes are perhaps the best lookouts on the plains, and they come in all shapes and sizes. These three-billion-year-old rocks were covered by ash when nearby volcanoes erupted over a million years ago. Where ash deposits were thinner, and the forces of erosion greater, the ancient rocks became exposed and now form what we call kopjes.

The Cub Valley lion pride we spy from the kopje is on the plains now, for once not seeking shade. At mid-morning, the lions move to the kopje and drape themselves on the open spaces. They relax in the manner of cats that are content and confident. But not for long. Thunder mutters along distant horizons, and the rain clouds advance surprisingly fast and are soon upon us. In the pouring rain the lions seek cover without much haste.

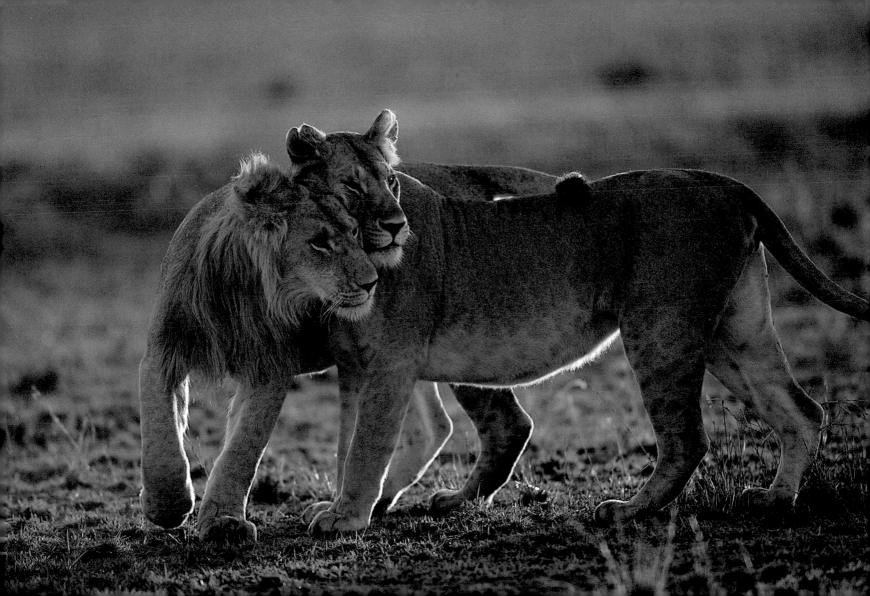

Today the sun is back in business, rising in a cloudless sky, bathing the plains with its warm light. To the south of Cub Valley about 12 miles (20 kilometers), an ostrich is picking its way across the plains, two chicks in tow, avoiding areas where the grazing herds have congregated.

Ostrich nests might contain the eggs of a single ostrich or a dozen. The egg laying process might be leisurely, spread out over days, or it might be quick, completed in a few hours, as female after female adds her share to the communal nest. It is impossible to predict how many chicks will hatch in an egg-filled nest; a sixty-egg nest might produce only two chicks, but, conversely, a ten-egg nest might produce a full hatching.

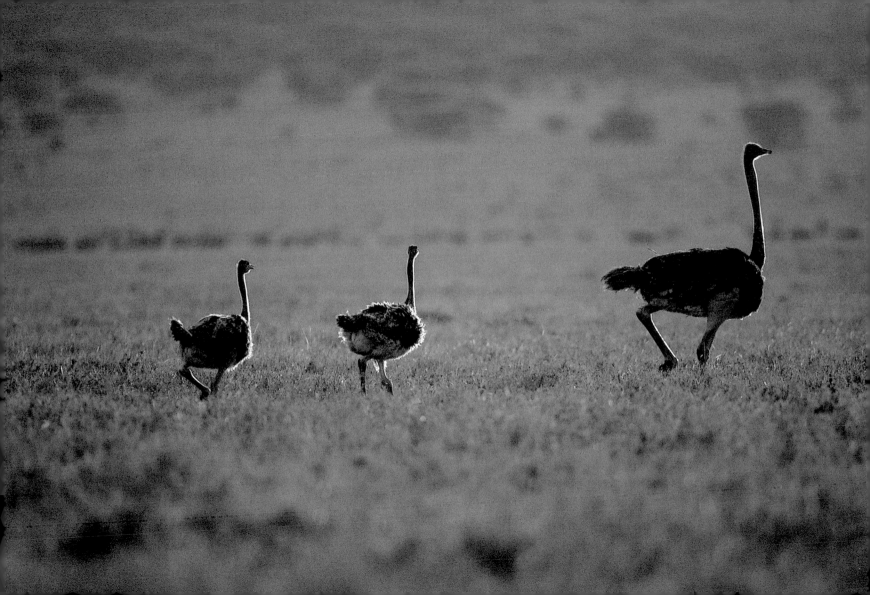

Large groups of Thomson's gazelles congregate on the eastern edge of Serengeti National Park. A male gazelle that is grazing next to a herd of females becomes conscious of danger but is not yet able to pinpoint the source of it. He resumes grazing but some sixth sense whispers to him to look up again. A cheetah is sprinting, on collision with the herd. The gazelle watches, frozen in place, not sure whether he is the target. The females scatter in panic, but the cheetah, with her advantage of surprise won by stalking behind a rise on the plains, is closing in on her target. She signals the successful kill with a puff of dust way beyond the gazelle herd.

Driving over closer to the cheetah, we notice that the cat is lactating. After a few minutes, she calls, chirrups rather, to her hidden cubs. She actually sounds like a bird! Eventually two cubs come running. The family sees the day out, contentedly feeding, grooming, and resting. The gazelles have resumed grazing.

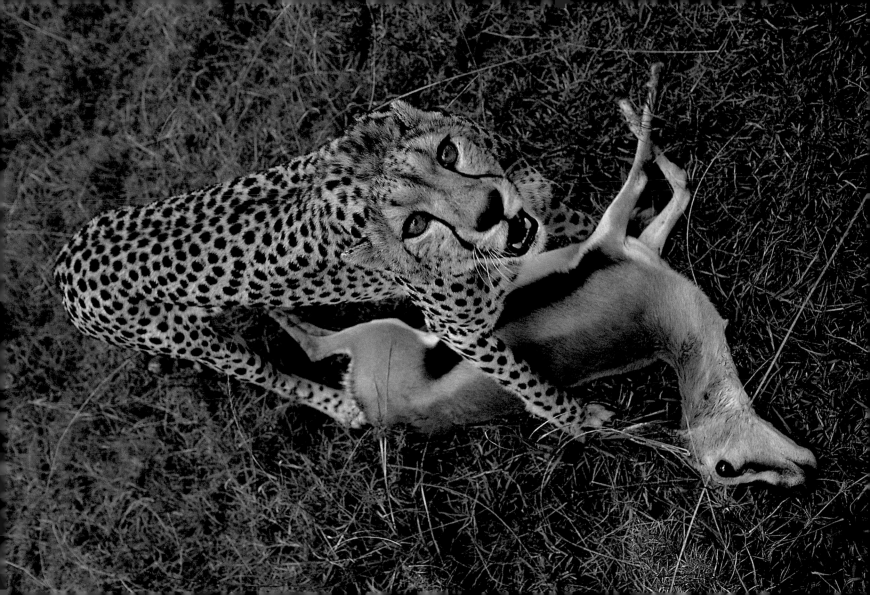

After an hour's search, we find yesterday's cheetahs near one of the easterly Gol Kopjes. The family is all alone, except for a few vultures in a tree. The cubs are having fun, playing with youthful energy. In sharp contrast to their boisterous games, the mother is all caution and circumspect. She scans, a worried frown on her face, lies down, gets up to scan again, and repeats the process until she is satisfied that they are cut off from disturbance. She chooses a tiny bush with enough shade for herself and two tired cubs. We spend the day watching them change position with the moving shade.

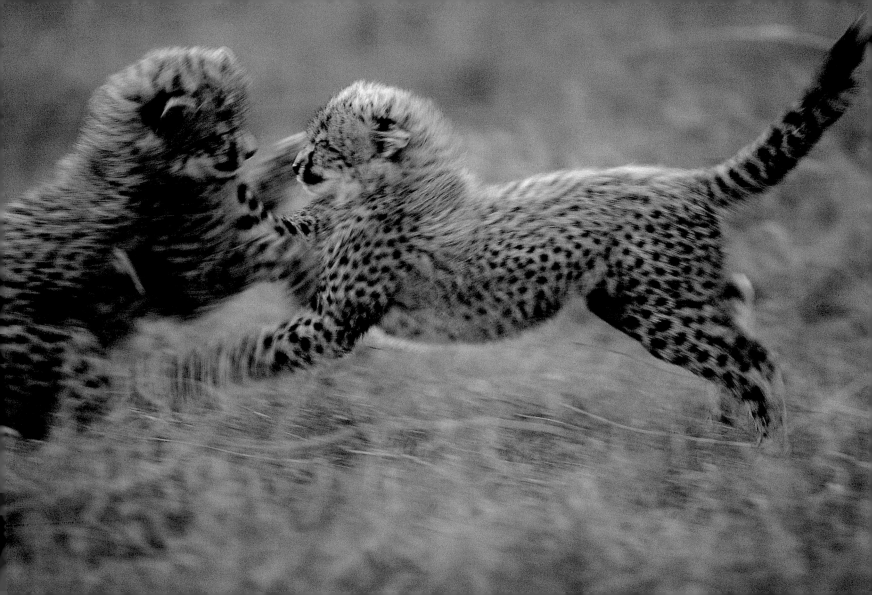

A loping hyena at daybreak leads us to its clan's den near the Gol Kopje. On its way, it encounters another hyena. It is clear by their body language that they recognize each other long before they are close enough to greet. They go through an elaborate greeting ritual, which includes sniffing each other's genitals. It is likely that greeting serves to reinforce knowledge of the other's scent. Like all social animals, the spotted hyena is married to the group. Its physical makeup and its adaptation to territory, seasons, and emotions are shaped by the evolution of group living.

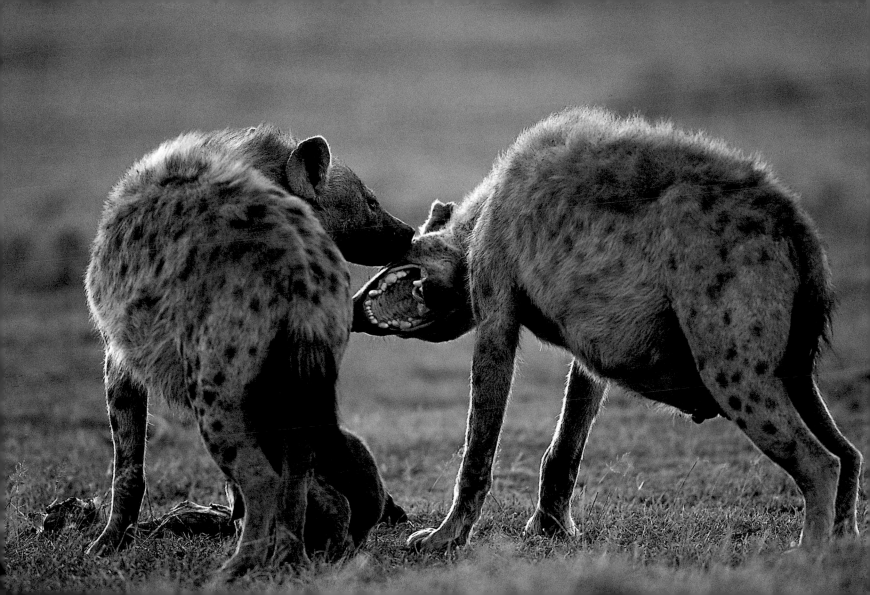

Yesterday, the hyenas slept a lot. Today, we are at their den before dawn and there is a lot of activity. At the center of the site, young and old pups are romping on, biting, and chewing wildebeest skin. A lone adult hyena arrives, carrying a wildebeest leg, and settles down at the periphery to gnaw at it. A few adults are lazing. At the edge there is a subordinate female suckling her twins. After their liquid meal, the pups get on with the business of play. There is chasing, tug-of-war, and play fighting. Such play may determine which pup will dominate, but in fact, they are in a race for dominance from birth. Once rank is established, and a truce is enacted, everyone can relax into play for play's sake.

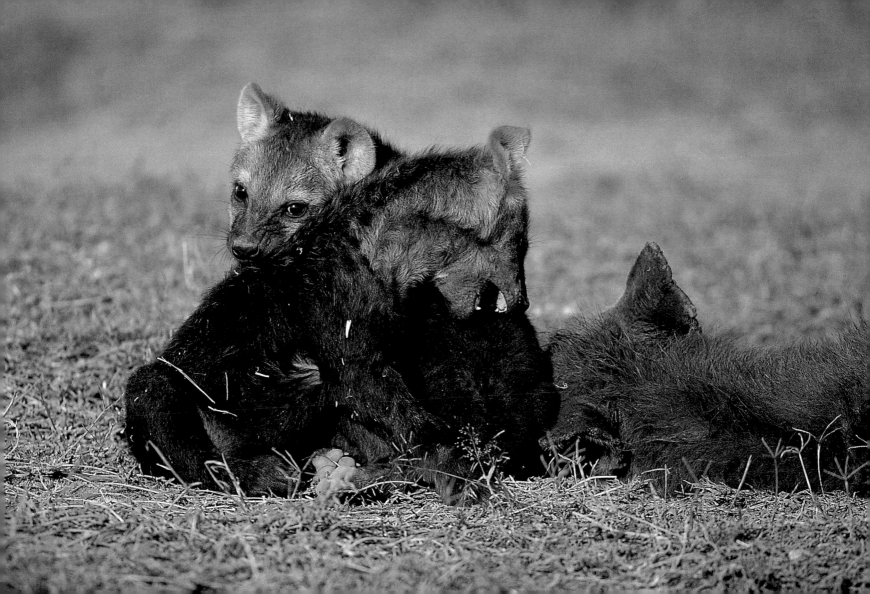

In the absence of other playmates, zebra foals often try to play with their mothers, but mares tend to be rather unhelpful. Not to be discouraged, a foal will play by itself, running in circles around its mother, burning up energy.

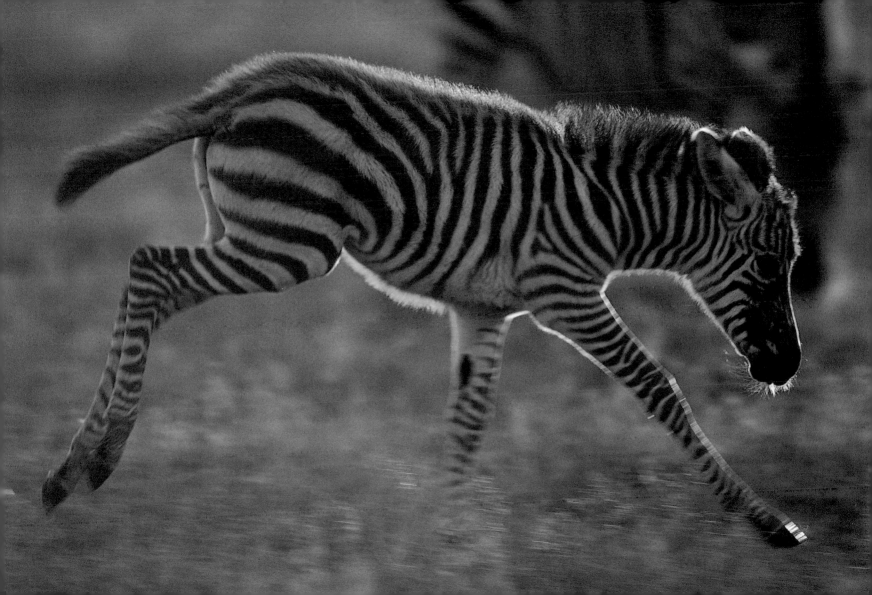

A wildebeest calf plays solo, discovering the bounce and spring in its legs. During the course of such cavorting it strays further from its mother. It stops, calls to re-establish contact, and comes running back to its mother's side. The whole point of migration is to protect an investment in life, the investment of using wildebeest DNA to make more wildebeest DNA. In the migration that DNA makes every season from gonads to egg, the most vulnerable couriers are the young.

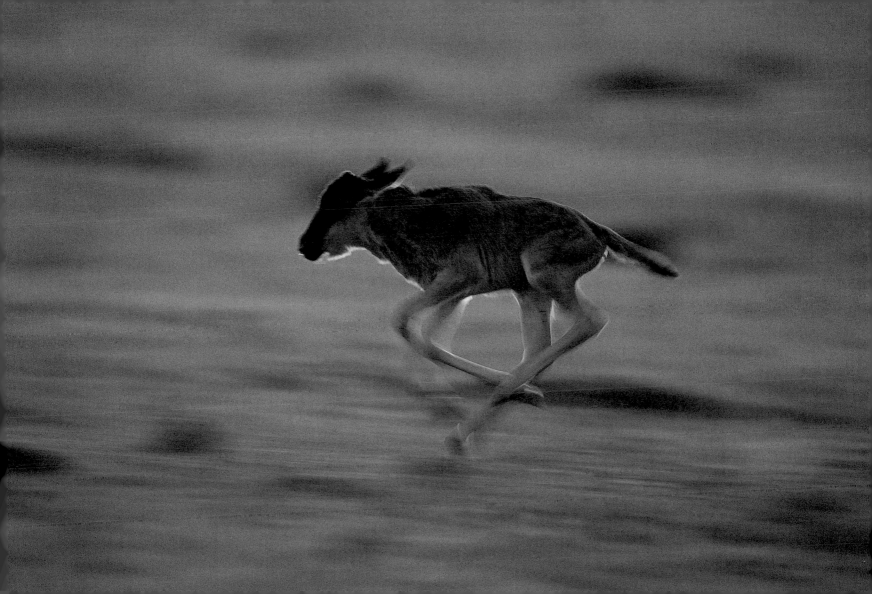

A group of wildebeest mothers with their young is easy to spot—the group stays apart from the main herd and the brown-buff color of the babies stands out clearly. With enough food and play, young wildebeests grow fast, twenty times faster than human babies in terms of body mass.

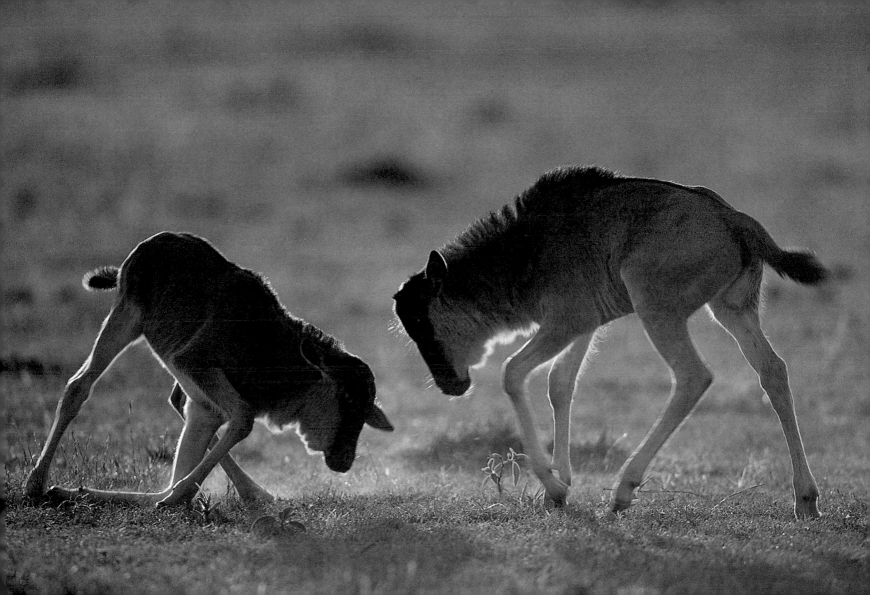

It has not rained for ten to twelve days and the herds are edging toward water sources where lions lie in wait. A lone wildebeest calf is running without destination, while a Ndutu pride lioness slips into the tall grass and crouches. As the youngster passes by, she launches into a short burst and slaps it down with her paw. Before the calf can recover and get up, she has it by its throat. But it seems that the mood for play has spread to the adults, for there follows a macabre game of cat and mouse. Every time the calf tries to escape, it is playfully bowled over. Eventually the lioness tires of the sport and closes her muzzle over the calf's windpipe.

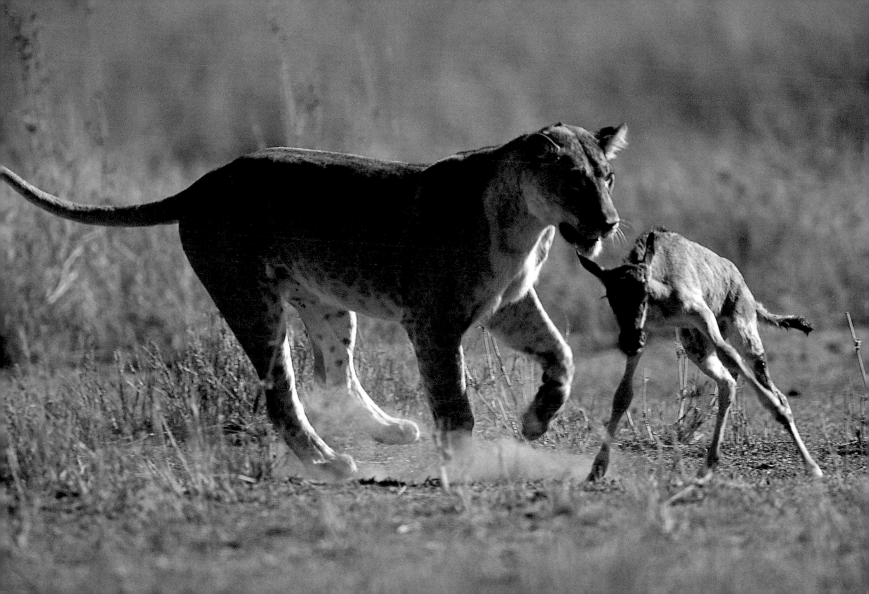

Despite the fact that the newly born calves are on their feet within a few minutes of being dropped, they are still vulnerable to predators at large. Ambushed at a pool, the face of this young male lion is the last thing this calf sees as the lion's jaws grip it by the throat. The lion will not let this calf live. This fact is as pitiless as the killing. Nature has no favorites—wildebeests die today, lions die tomorrow. Yet there is selection at work here. The calves that are the slowest to follow their mothers, the last to react to danger, are the most vulnerable. Their death is part of the natural mechanism by which quality is constantly monitored.

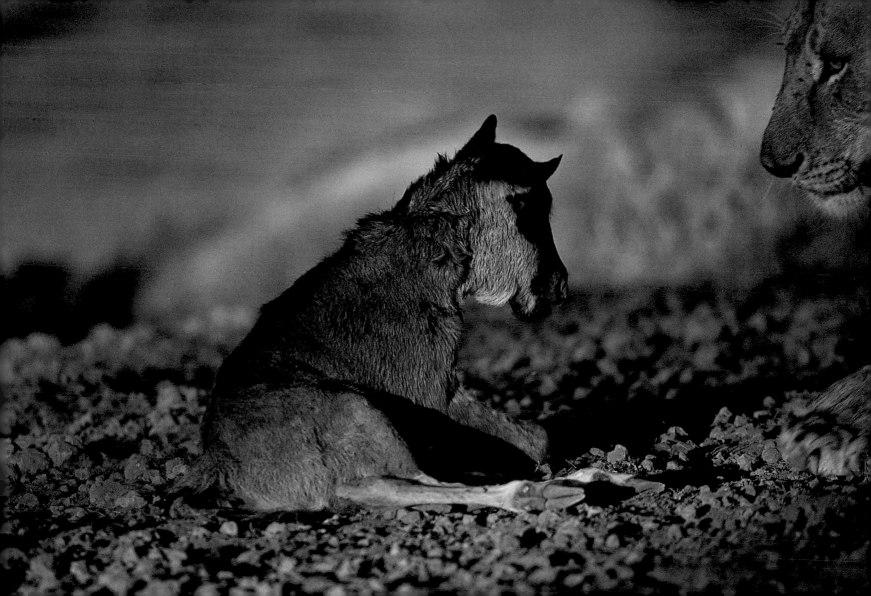

Today, like yesterday, started with a reddening of the morning horizon, with all the clouds scattering after a feeble attempt to contain the sun. At a water hole next to a small kopje, golden jackal pups are at play, their parents having left on a mission to catch gazelle fawns. True of all young, especially of carnivores, once their curiosity is aroused, they must investigate. These pups drink at the pool and notice a terrapin on land. Without hesitation, they follow it, led by the nose, sniffing it and pawing at it. Once the terrapin goes into water, the nonplussed pups give up and resume their terrestrial explorations.

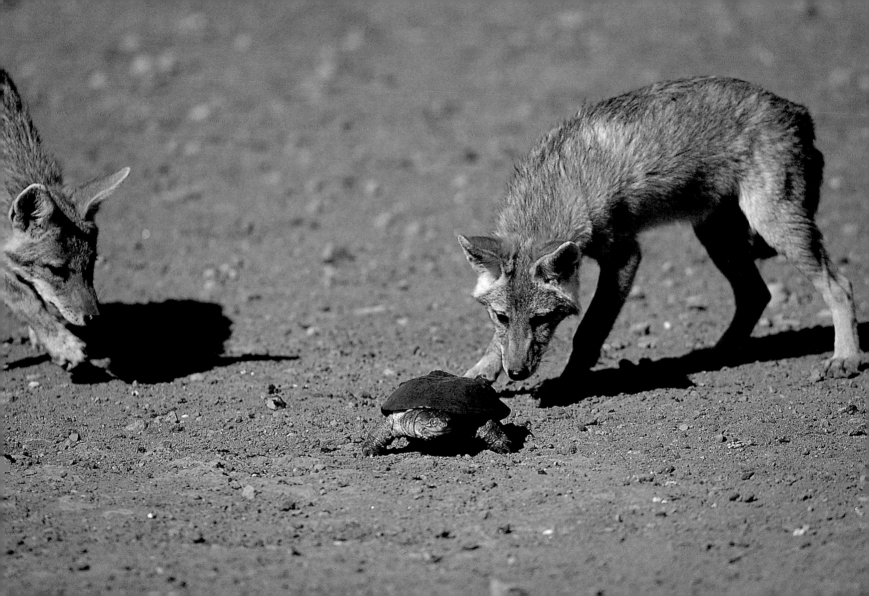

The weather changed last night. It rained heavily for most of the night. Now, before sunup, a chilly wind blows, only to fade with the warm glow of the rising sun. The Ndutu lion pride has had a productive night and is strolling back to its woodland hangout. The cubs linger to play, explore, and generally raise a raucous. The migration is a moving feast that promises full bellies until the herds depart. But the Ndutu pride is better placed than many of the plains prides. Its territory encompasses both woodland and grassland. It might experience feast but famine is not as common for this pride.

OVERLEAF

Nomadic migrants respond in a highly opportunistic manner to the vagaries of rainfall. Indeed, this is what motivates them to be migratory creatures. This afternoon, clouds gathered in the east, some 12 miles (20 kilometers) away. The wildebeests around Lake Lagera have started moving in response, taking a shortcut through the lake. What strange compulsion urges them to cross the lake when they can simply walk around it? On one occasion in the past, they crossed and recrossed it in the tens of thousands, leaving hundreds of drowned calves in their wake.

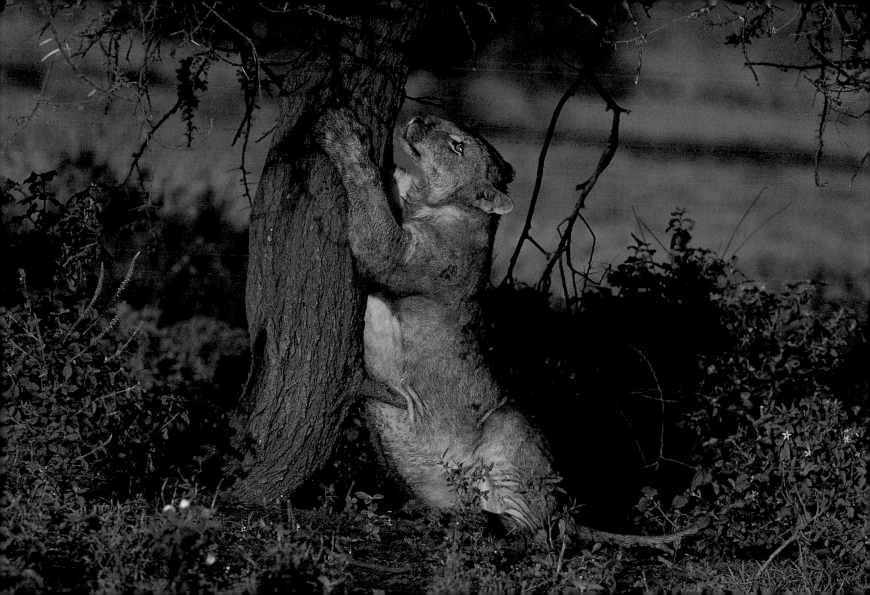

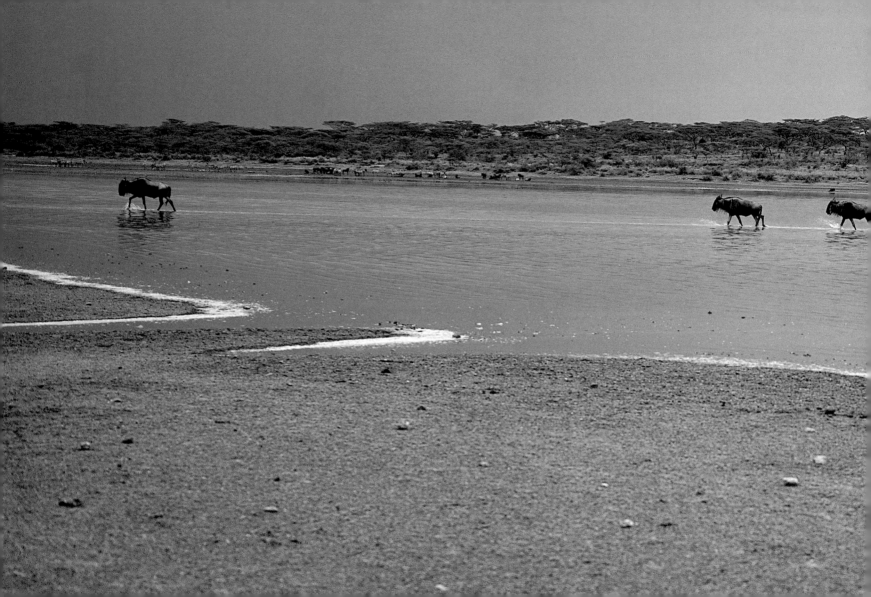

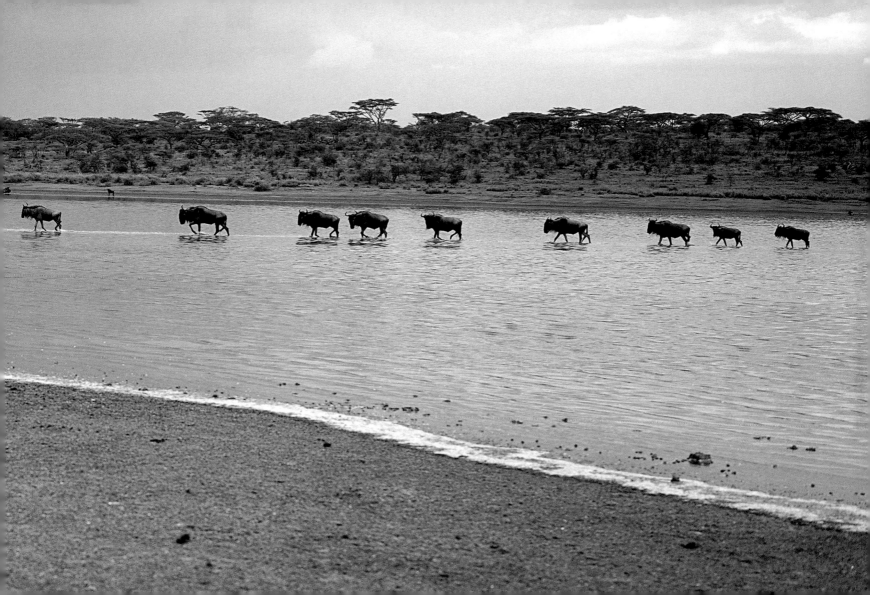

The herds are on the move in the direction of Lemuta, an area of great scenic beauty inside the Ngorongoro Conservation Area, which borders the eastern edge of Serengeti National Park. To the east you can see the crest of Lemuta Hill jutting up from the horizon. Faint blue hills crouched beneath mountains of clouds lie further south. The short-grass plains here are unmarked for miles by tree or shrub. They are also diminishing. For more than a million years, no major volcanic eruption has struck, and the soil on the plains, no longer enriched by volcanic ash, is being carried away by the wind, particle by particle.

OVERLEAF

It is a beautiful morning in Lemuta with a kopje behind us and a pool in front. At eight o'clock, a noisy party of yellow-throated sandgrouse arrives, swinging toward the pool, landing with their unearthly, throaty chuckles. They wait at some distance from the pool, allowing some jackals to finish their business of exploring it. The jackals move on, following their noses. The bolder sandgrouse strut forward to drink; slowly, others follow suit.

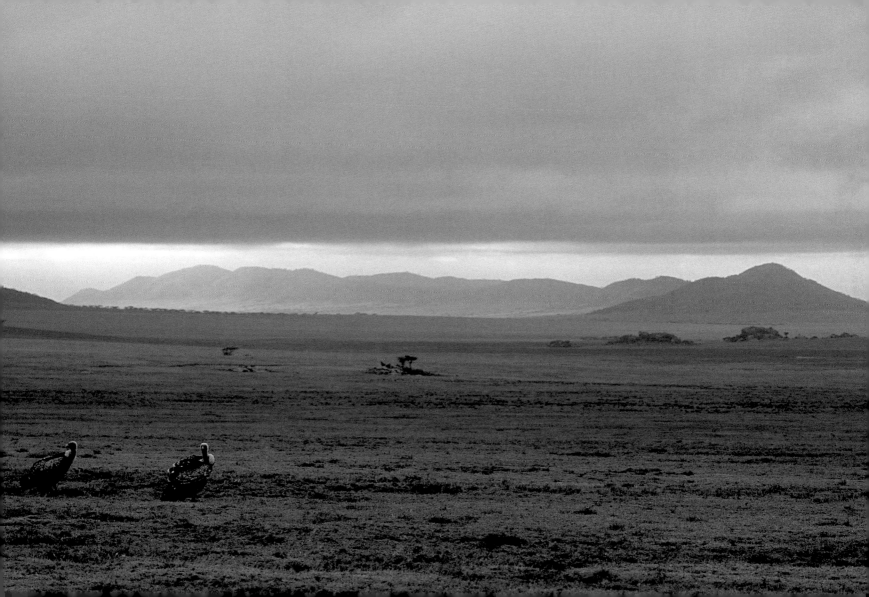

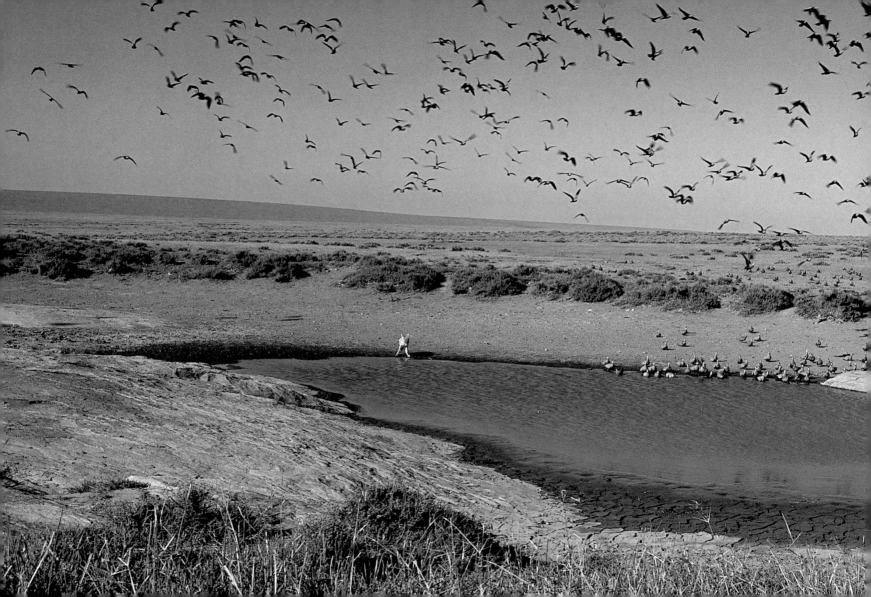

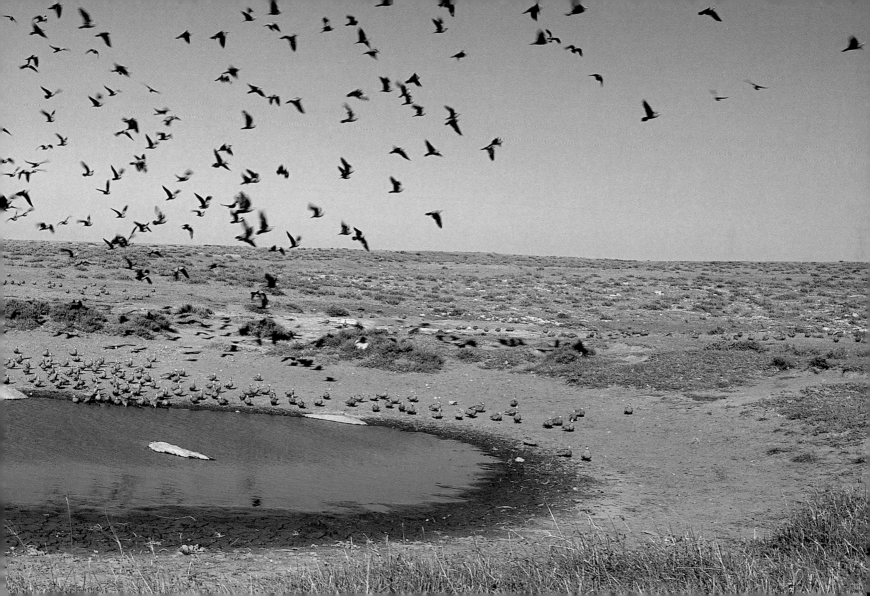

The plains of Lemuta are a mosaic of golden jackal territories, each one, on average, only a few square miles. Each morning the adults venture forth to patrol their territories. We follow a male-female pair, whose territory encompasses the kopje with the pool. After half an hour of trotting, marking, and investigating, the male accelerates. He has spotted another jackal, an intruder, on his turf. Instinct kicks in as the intruder turns tail and takes off, pursued by the determined male who quickly catches up. The intruder, a male, signals submission. He is unmolested but chased out of the territory. Jackals treat territorial incursions with hostility. And there is a division of labor here: An intruding female would be chased by the resident female, the intruding male by the resident male.

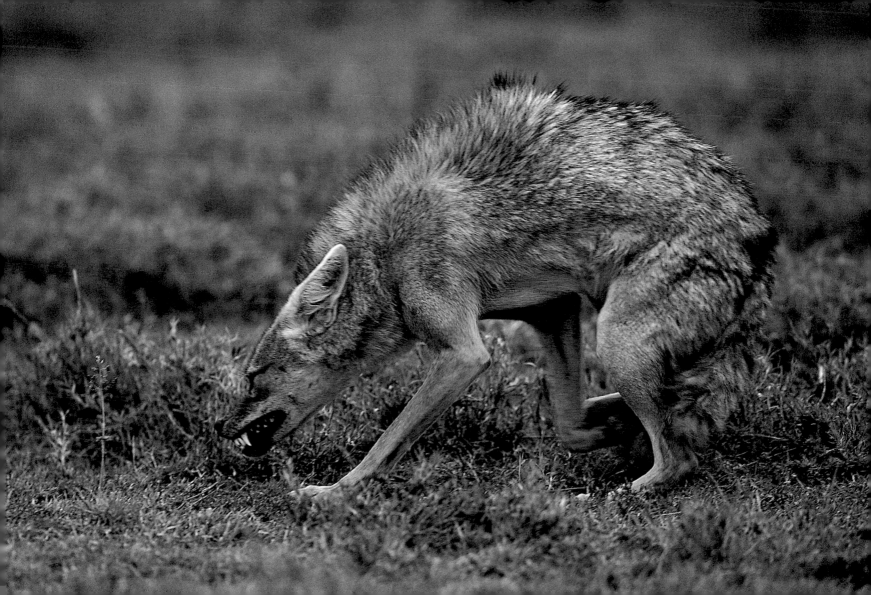

The jackal pair has set out on a territorial patrol-cum-hunting foray before daybreak. Before long, it stumbles upon a grazing herd of gazelles. The male gazelles watch them, unconcerned—jackals are not powerful enough to tackle adult gazelles. The jackals continue to seek out fawns, however. But in searching for fawns, the jackal cannot employ its powerful sense of smell since fawns are odorless. So the jackal searches by sight and by checking out patches of longer grass where the fawns might be hidden. At one such patch a fawn is spotted, and a chase begins. The fawn runs at speed and erratically changes direction but the jackals keep up. True to form, the fawn is soon exhausted and easily overtaken. There is no wrong or right here, only the strong versus the weak.

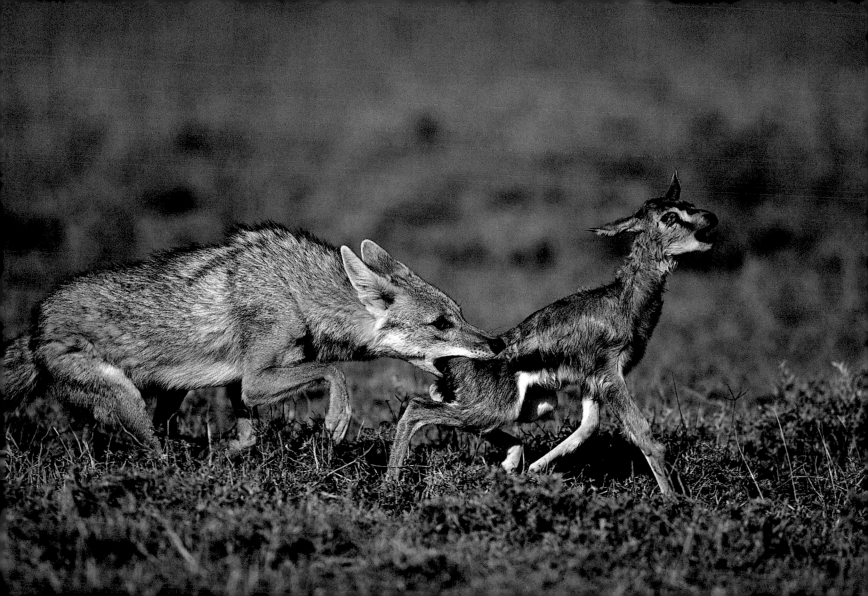

The jackal pair repeats yesterday's routine and catches another fawn at the end of a long chase. Alerted by the commotion, a few hyenas arrive to investigate. The lead hyena grabs the fawn as the jackals stand aside — some instinct, or the body language of the hyena, informs them to relinquish the kill without a fight. But the lead hyena's troubles have only just begun as another hyena moves in to steal the fawn. They race at high speed in huge circles, but persistence pays off for the chaser as the first hyena drops the fawn and runs away.

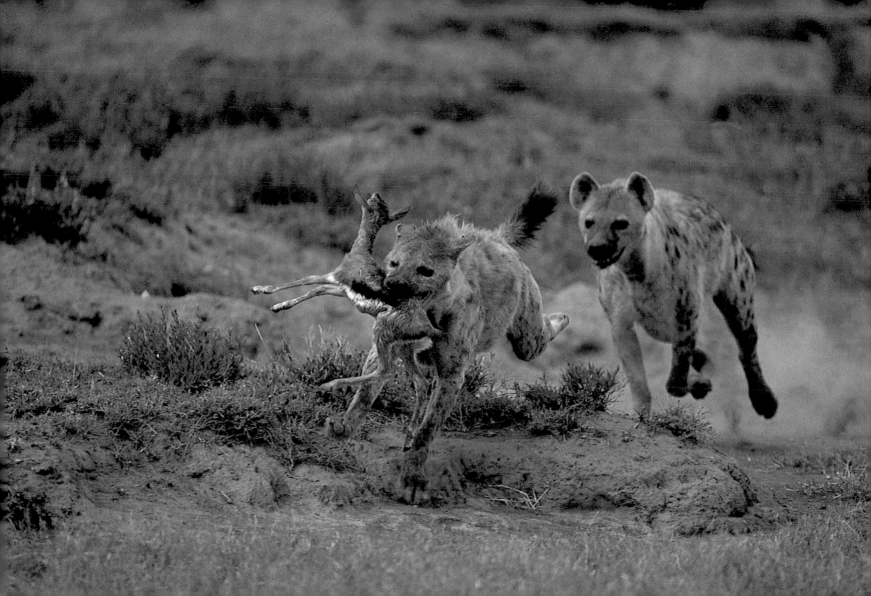

Today we witness an unusual event. Like yesterday, the jackal pair trots along the gazelle fawning grounds. Once again, the male jackal in the lead spots a victim and accelerates toward it. However, this time the fawn's mother, who has been watching nervously with tail wagging furiously, races in and charges at the jackal to deflect him from the fleeing fawn. Undeterred, the jackal resumes the chase, closely followed by the fawn's mother who is followed by the female jackal. But it can only end one way as the fawn tires from running half a mile at 30 mph (800 meters at 50 kph). And so the jackals have a nice breakfast despite the efforts of the mother.

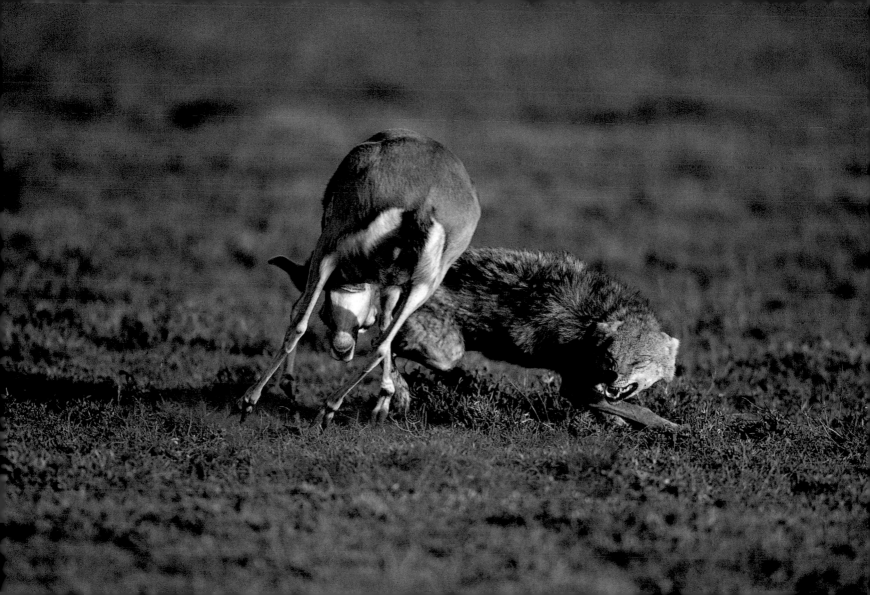

The same jackal pair of the last two days is trotting through the gazelle herds in their territory. In due course, an unlucky fawn is spotted and chased. The fawn is followed by the male jackal, then the female, with the fawn's mother bringing up the rear. The fawn tires, collapses in a heap, and the male tries to maim it as the female keeps the gazelle mother at bay. It is all over for the fawn, and the mother can do nothing except watch helplessly. The jackal pair immediately pulls the fawn apart into two pieces. In this way, should a hyena come to poach, it would, at most, get away with only one piece. The jackals feed separately without acrimony. The gazelle mother resumes grazing nearby as if nothing has happened. That is the way of life after death on the plains.

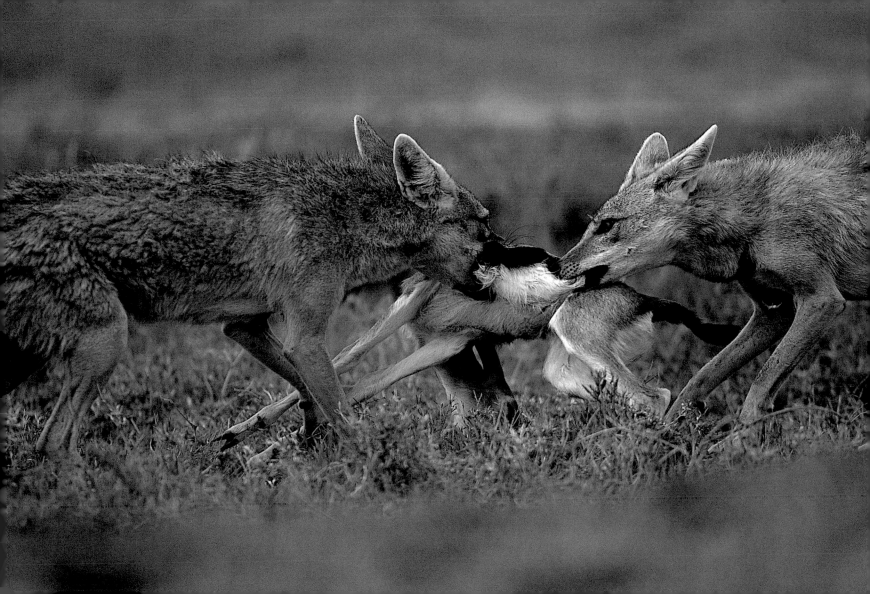

Arriving at the jackals' territory once again, we find the pair gulping down meat chunks with a few vultures in attendance. It seems that the jackals are in control of the situation for now. Another vulture arrives, this one a lappet-faced vulture.

Of the three species of jackals—golden, black-backed, and striped—the golden is the boldest, with an aggressive streak and teeth like needles. But the lappet-faced vulture is bold and aggressive, too. Now there is a subtle shift in the balance of power. As more vultures arrive, the jackals are put on the defensive. The male jackal bares his teeth and lunges. The vultures retreat temporarily. The jackals finish their hurried meal and abandon the leftovers to the noisy birds.

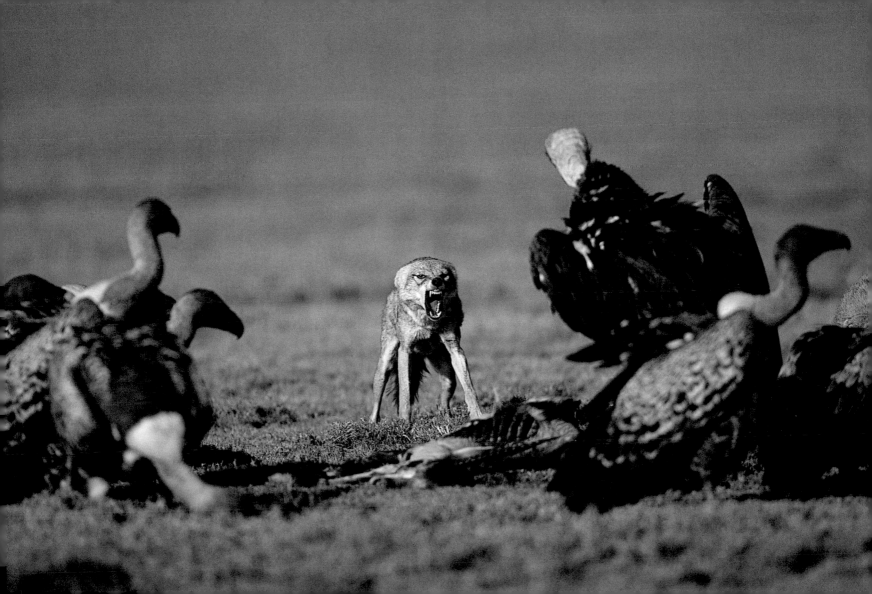

At dawn, our jackal family wakes up. Their pups start playing and the adults join in. The games are simple but energetic. The adults seem to be aware that the pups are not as powerful as they are and so hold back force. As the play winds down, the adults distance themselves from the pups and then leave for their usual territorial and hunting forays. The pups continue playing and then retire to their underground den to escape the heat of the featureless plains and to await the return of their parents. Jackals pair-bond for life, and each pair stakes out its own territory in which to live and raise their pups.

OVERLEAF

An icy northeast wind sweeps down across the plains day and night from the Loliondo Hills. It is particularly acute in Angatakiti, along a narrow corridor beyond Lemuta and leading to the Gol Mountains. The Angatakiti Valley is wild and desolate, with only the wind sweeping down and rearing up on each side. A big herd of wildebeests is in the valley, grazing contentedly. It may be endless plains of grass to us, but to them the plains are a veritable smorgasbord. The grazing will cause new grass seeds to fall to the ground. Watching daily life unfold in this valley you get the feeling that its rhythms have not changed for hundreds of millennia.

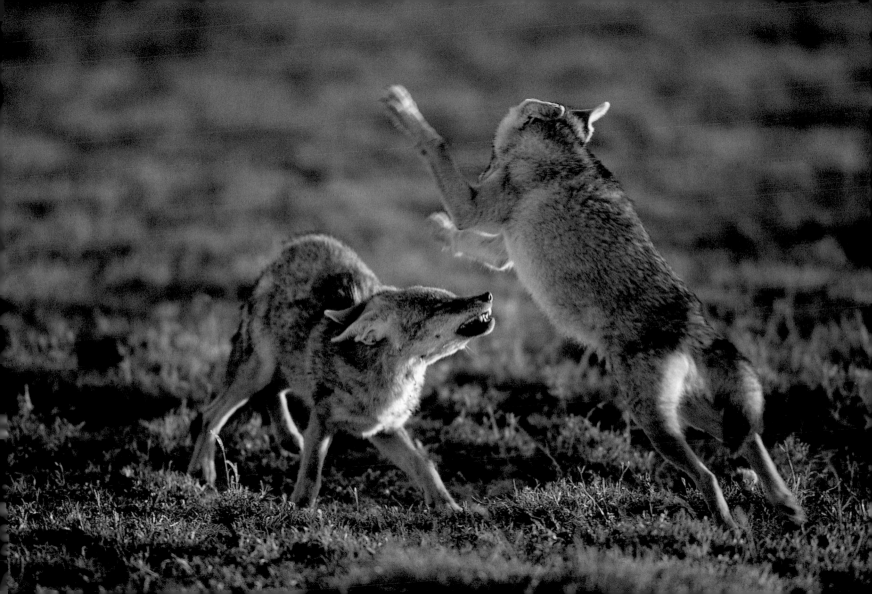

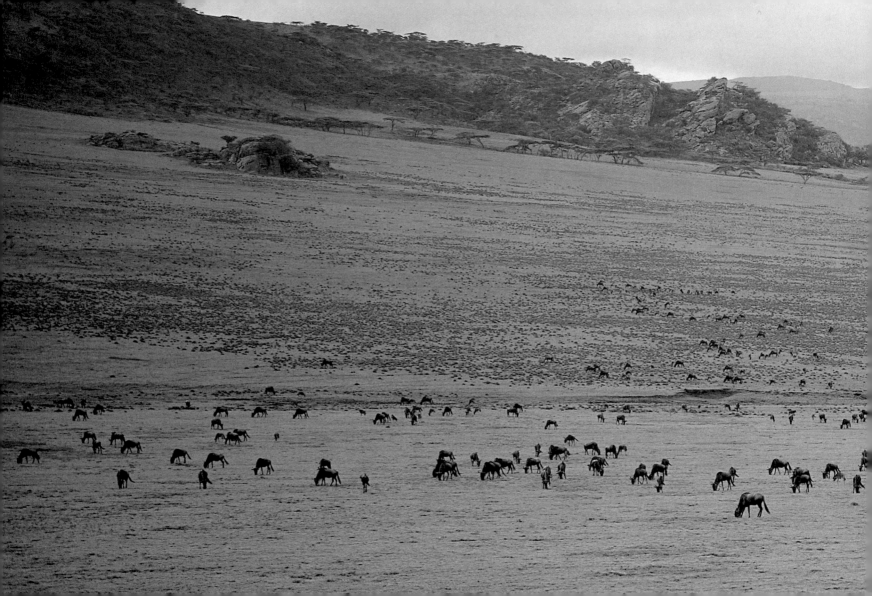

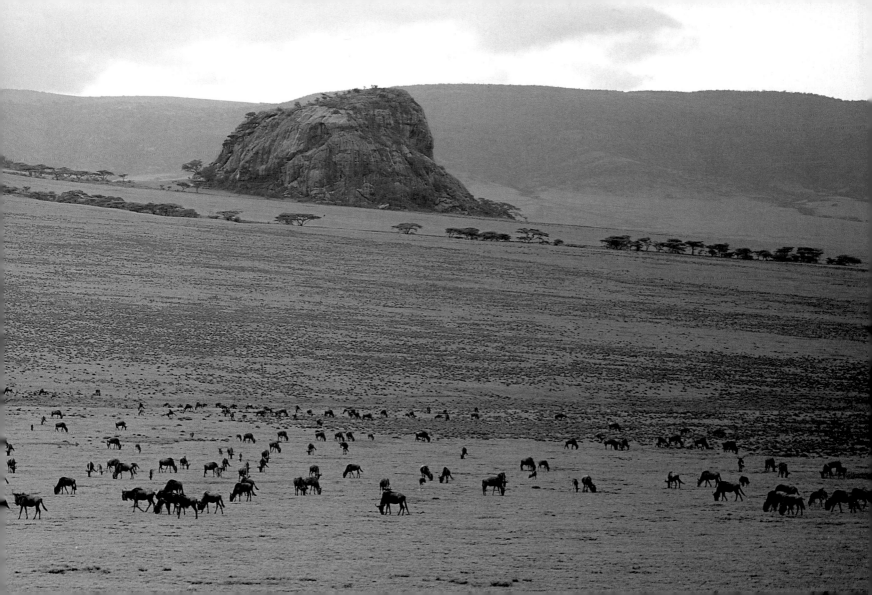

The soft whooping cries of the hyenas slide eastward. They are set on a course that will take them to the unsuspecting herds a few miles away. The impending appearance of the sun washes the sky in scarlet and catches the silhouetted forms of a few gazelles watching the receding hyenas, delicate figurines set in this immense landscape. Here, beyond Lemuta, the land undulates gracefully. The land also seems bereft of all human influence, an illusion since the Maasai come here occasionally. Nevertheless, only the rules of the wild—and there are very few of them—hold sway here.

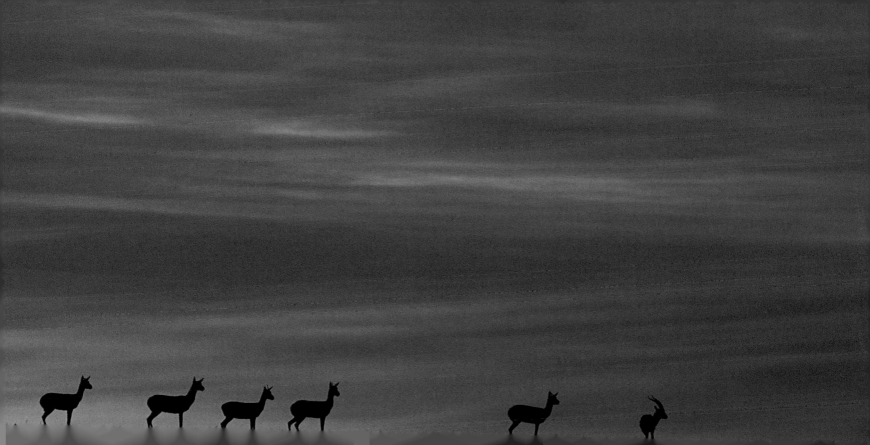

Similar in appearance to the spotted hyena, the striped hyena is not attractive to human eyes, even when it erects its splendid mane. Books will inform you that the striped hyena is a nocturnal loner, living in bush country where its stripes are a superb camouflage, more so since it has the ability to stand absolutely still. So what is a striped hyena doing here on the plains and in broad daylight? Perhaps this enigmatic creature is not yet fully understood.

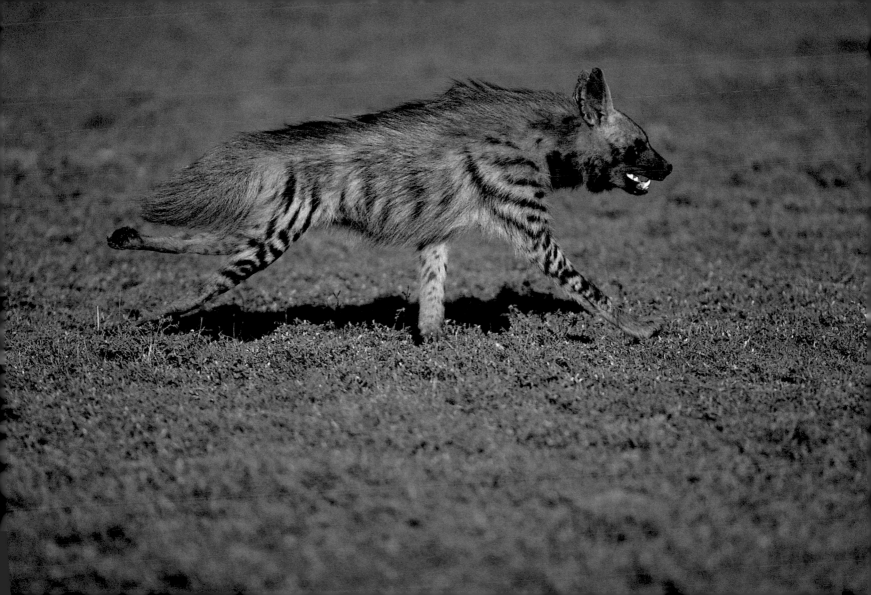

More and more herds are moving into Angatakiti, the narrow corridor linking Lemuta to the Gol Mountains. In the background is Nasera Rock, a huge boulder standing on its own. From its crevices, fig trees dangle long roots toward the ground. The rock is revered by the Maasai, and anthropologists have carried out excavations here to probe into the origins of humankind. Surprisingly perhaps, the presence of so many grazers does not damage the plains environment. The herds never stay long enough to inflict damage. They fertilize the soil with their waste, and their saliva acts as a growth stimulant to the grass when they feed.

OVERLEAF

Last night we camped in Angatakiti. Most of our needs became irrelevant in the night under the stars—essentials such as food, water, and shelter from the wind were all that mattered. One bonus is clean air outside, peace of mind within. The Maasai have lived thus for centuries. Occasionally they appear on the plains in the wet season with their flocks and herds, but since there is no permanent water here, they go elsewhere in the dry season—just like the wild herds.

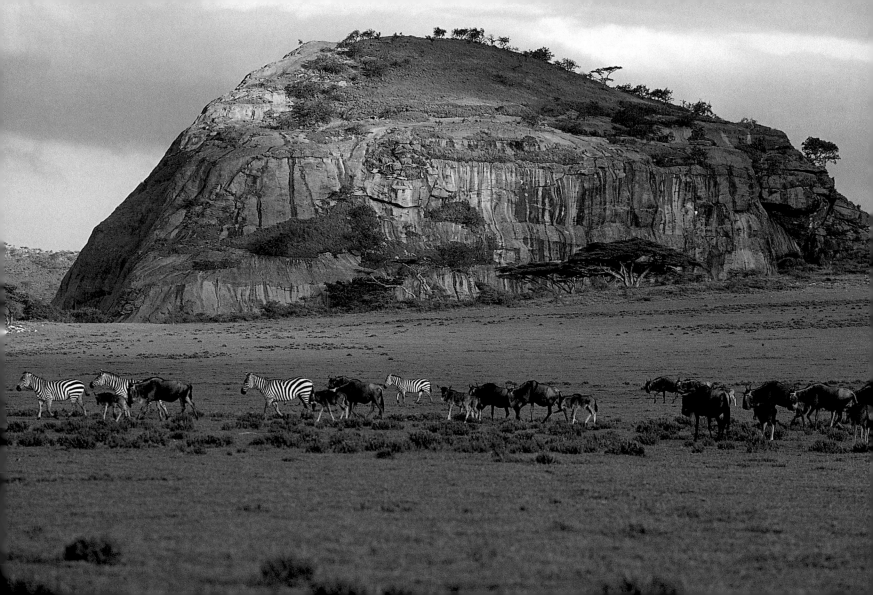

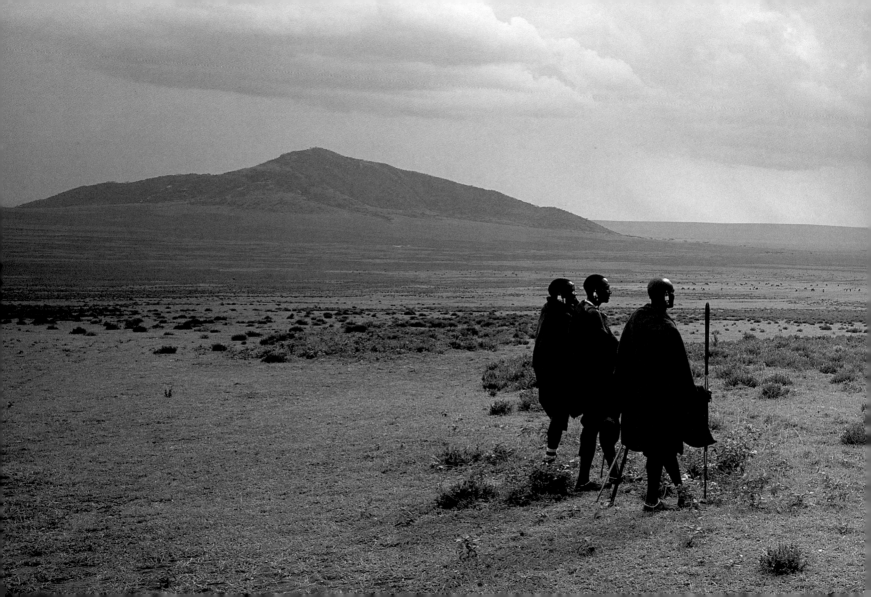

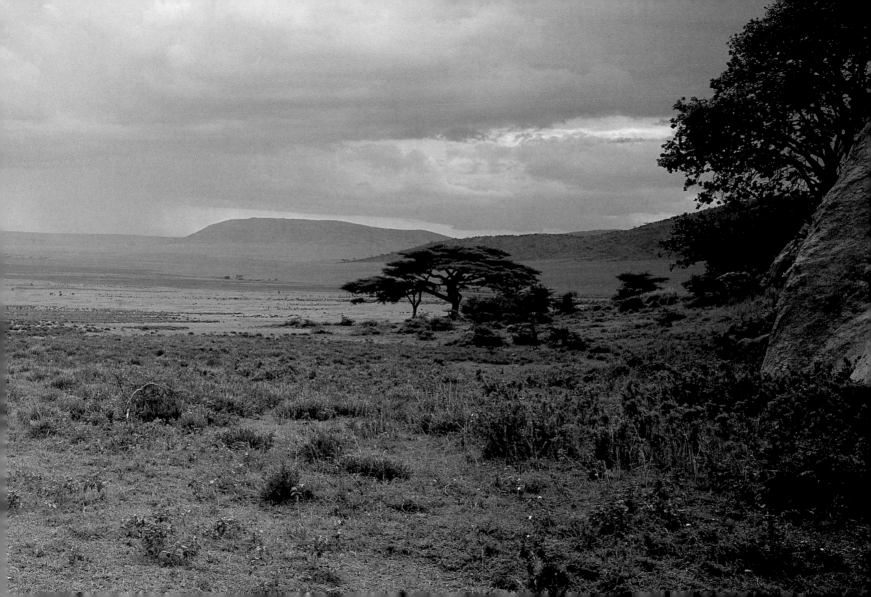

North of the Ngorongoro Crater, the Gol Mountains rise up, creating a distant backdrop to the short-grass plains. They are not so much mountains as one long, broken line of hills that rise and fall in folds. Many of the migrants are here today, tempting us to pitch our tent for the night. Camping out on the plains at the foot of the Gol Mountains with the herds all around is like entering another world. At night the constant grunting of the wildebeests is like the sound of a million bullfrogs. Then suddenly there is silence as they sense a hunting predator, followed by the thunder of hooves as panic spreads. This world belongs solely to the hunted and their hunters.

Olrarien is a deep weathered gorge, which plays host to one of the largest colonies of Ruppell's griffon vultures. Over a thousand nests have been counted here. The rising sun warms the rugged flanks of the gorge and by nine a.m., the cool night air has given way to warm morning air. From clefts high up, a vulture uses its broad wings to capture the updrafts that the endless winds drive against the gorge. By launching itself outward, a vulture can balloon up 2,000 feet (600 meters) in a matter of seconds, where it will be in the company of other vultures, all with the same intent—to find a carcass. The energy-saving thermals carry them, without any effort on their part, to their sky-watching stations. From there they can see the direction, size, and speed of the migration, as well as a host of other lives. And death, of course.

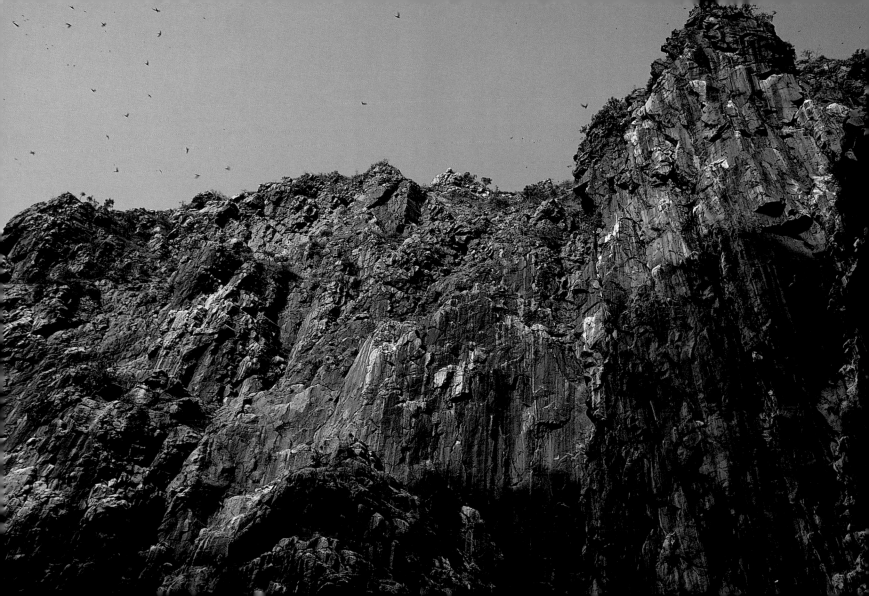

As the movement of the rains across the landscape continues, the herds thread their way through passes in the Gol Mountains to the Salei plains, which lie east of Olrarien Gorge.

It is said that a vulture, from a height of 12,000 feet (3,500 meters), can distinguish blobs of gazelles in an ocean of green. A couple of lappet-faced vultures descend near a female gazelle they have discovered on her own for some unknown reason. There is a commotion as the lead vulture grips something on the ground and the frightened gazelle mother bounds away. Because of its great size and its powerful beak, the lappet-faced vulture can kill rats, hares, and even newborn gazelles. And now there is one less gazelle fawn on the plains.

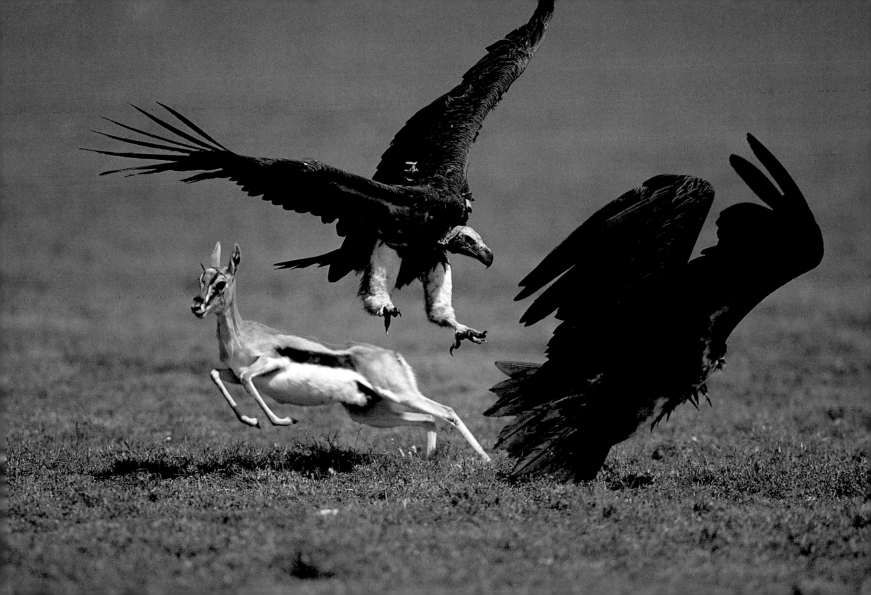

Information is everywhere, every second, but available only to those, like the vultures, who can read it correctly. Out on the plains, scarcely any kill is possible without the knowledge of vultures. Their falling bodies speak a universal language, well understood by all other animals. The lappet-faced vulture is the largest and most powerful of the six species of vultures found in the ecosystem. Often, other smaller species of vultures reach a kill first, but this intimidating bird uses swagger and bravado to drive these early arrivals off the kill. It uses its strong body and leg muscles, in conjunction with powerful twisting motions of its head, to tear large chunks of flesh, sometimes too big for it to swallow.

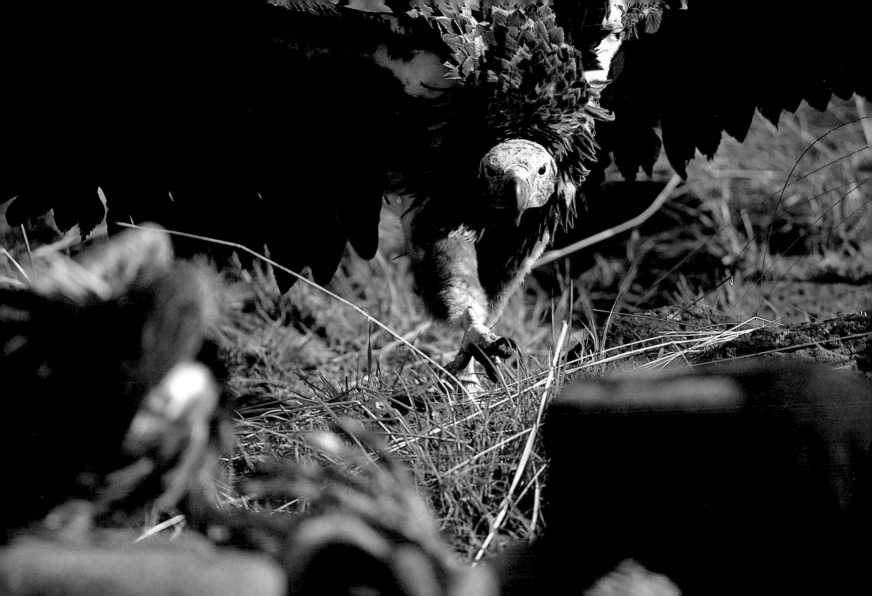

Cliff-nesting Rupell's griffon vultures travel daily from Olrarien Gorge to feed on the carcasses of the migrants. This daily round-trip can take up to eight hours and cover 60 miles (100 kilometers). When a particularly large carcass is found, the Rupell's and the white-backed vultures will open it to get inside. Often Rupell's vultures dominate a carcass through sheer force of numbers. They are noisy birds when they jostle for access to flesh. Yet the ferocious competition for meat unites them in crackling tension.

The breakdown of a dead body can also occur in other ways. Columns of ants sense the meat and masses of wriggling fly larvae can easily consume an entire corpse. The plains would be one huge rotting rubbish dump without its many scavengers and decomposers.

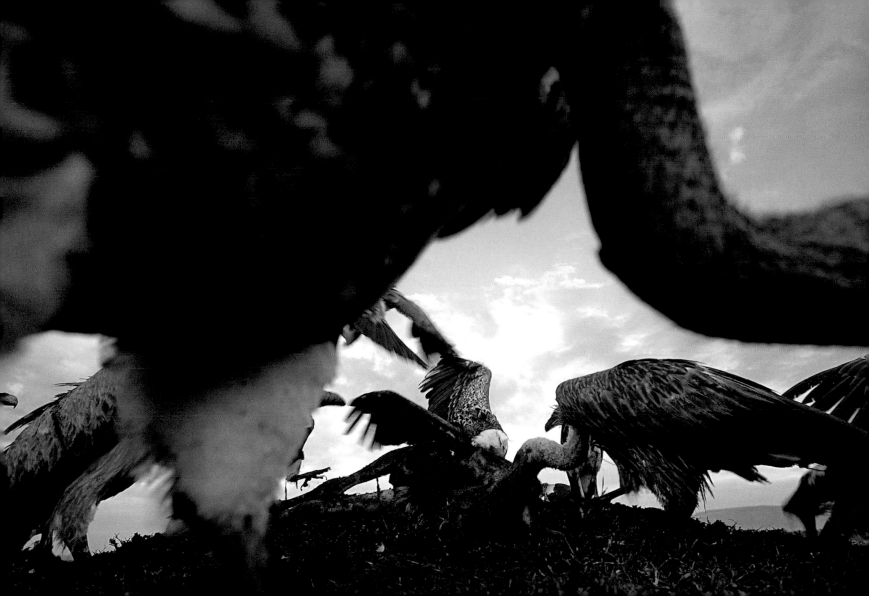

Angatikiti Valley under Lemuta Hill sweeps down to Salei Plains. Today, the herds are grazing on the plains under the shadow of Ol Doinyo Lengai, the slumbering gray volcano with steeply gullied sides. It stands on the edge of the Great Rift Valley, overlooking Lake Natron and the dry wilderness around it.

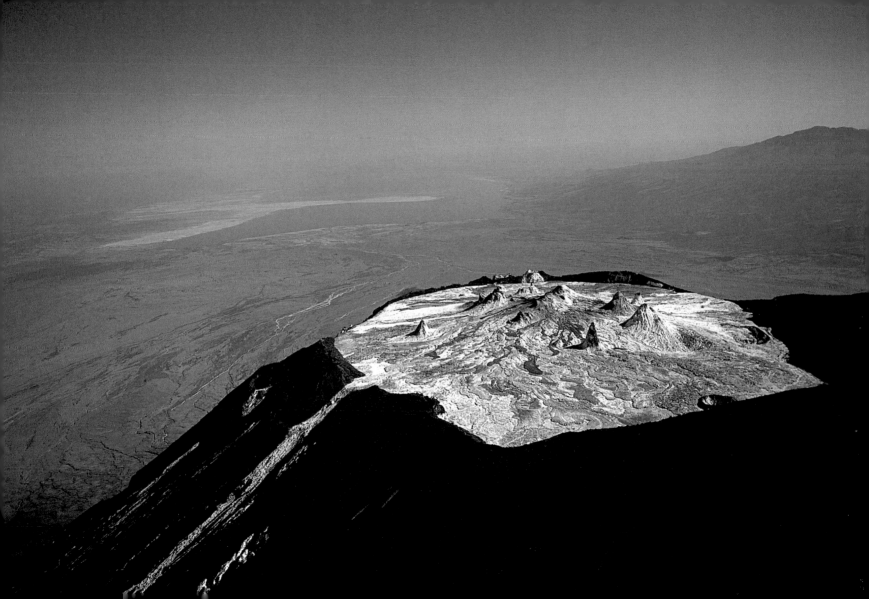

At present, the migration moves through a region that is approximately 11,500 square miles (30,000 square kilometers) in area, half of which is Serengeti National Park. Lake Natron is at the easternmost boundary of the migration. Today, we fly over Natron, a shallow alkaline lake in the Rift Valley. It is an important breeding ground for flamingos. In some years, when it is wet around the lake, some of the herds graze within sight of it; however, not this year. We continue our flight over the crater highlands, which form the eastern boundary of the ecosystem and the great migration. We land at the Ngorongoro Crater airstrip and camp on the crater rim.

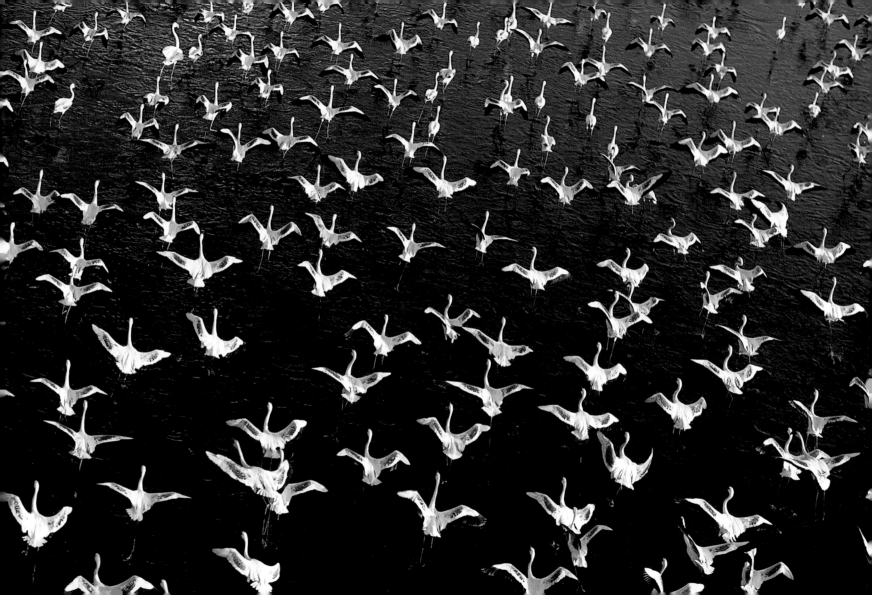

There is a small forest in the Ngorongoro Crater called Lerai Forest where vervet monkeys are found. Agile climbers, vervets ascend and descend vertical tree trunks headfirst, using their tails for balance. They rarely freefall more than three feet.

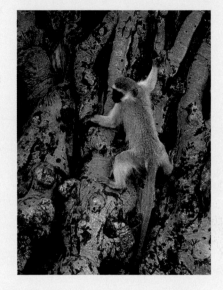

The Ngorongoro Crater floor, although only about 125 square miles (325 square kilometers), is a microcosm of East Africa, with its plains, streams, swamps, a forest, and a soda lake. The lake attracts flamingoes whenever there is an algae bloom, and it is fed by the Munge River, which is fringed by tall grass in areas, providing plenty of cover for lions waiting to ambush wildebeests and zebras come to drink. To avoid them, thirsty animals walk through the shallow water along the lake's shore to get at the river where it meets the lake in open terrain.

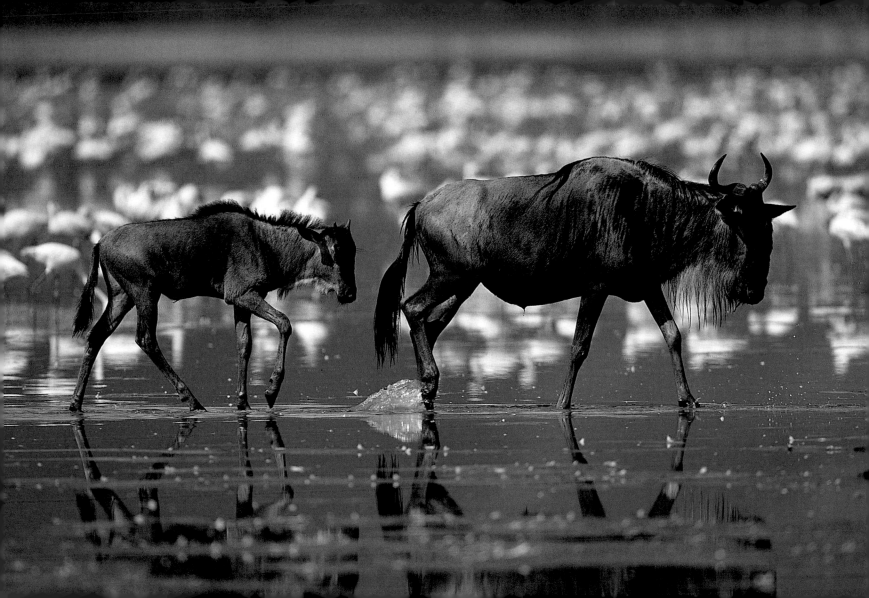

A zebra stallion in the Ngorongoro Crater charges at a challenger, and there ensues a running battle of bites and kicks. The challenger's resolve weakens and he gives up, but the other stallion continues to chase him far away from his mares.

There is a resident population of zebras and wildebeests in the crater. These animals can leave this area if they'd like, but they choose to remain year-round, for there is enough water and grazing available, even in the dry season, that there is no need to migrate.

OVERLEAF

There are five populations of wildebeests in and around the Serengeti ecosystem. The largest is part of the herds that together take part in the Great Migration each year. There is a much smaller population that roams from Loita Hills to Maasai Mara National Reserve; another small resident population occurs in the Western Corridor of Serengeti National Park; a small population moves around Loliondo Hills to the east of Serengeti National Park; and finally, there is the resident population in the Ngorongoro Crater.

In addition to the resident zebra and wildebeest population of the crater, there is a resident buffalo population that has no need to migrate for food or water. Munge River, which flows into Lake Makat, is a good source of water in the dry season.

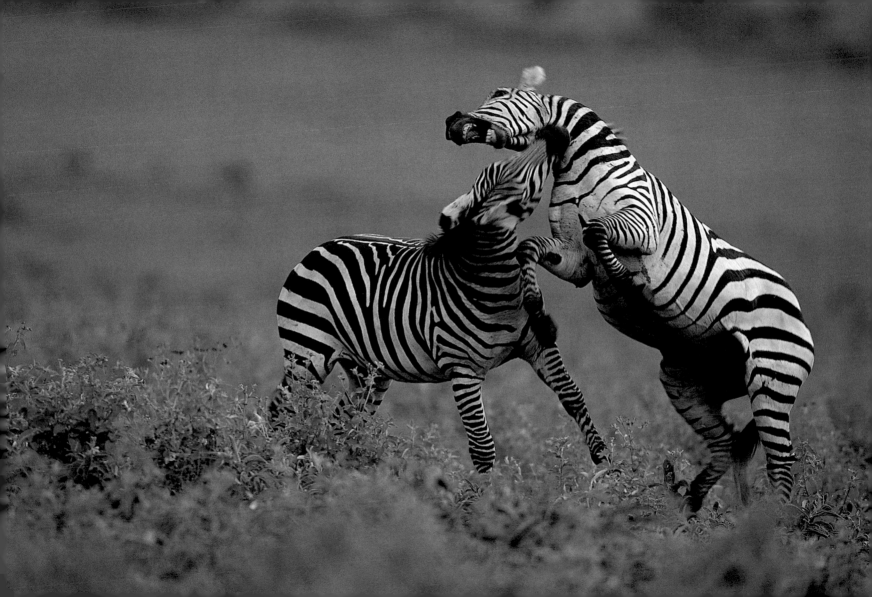

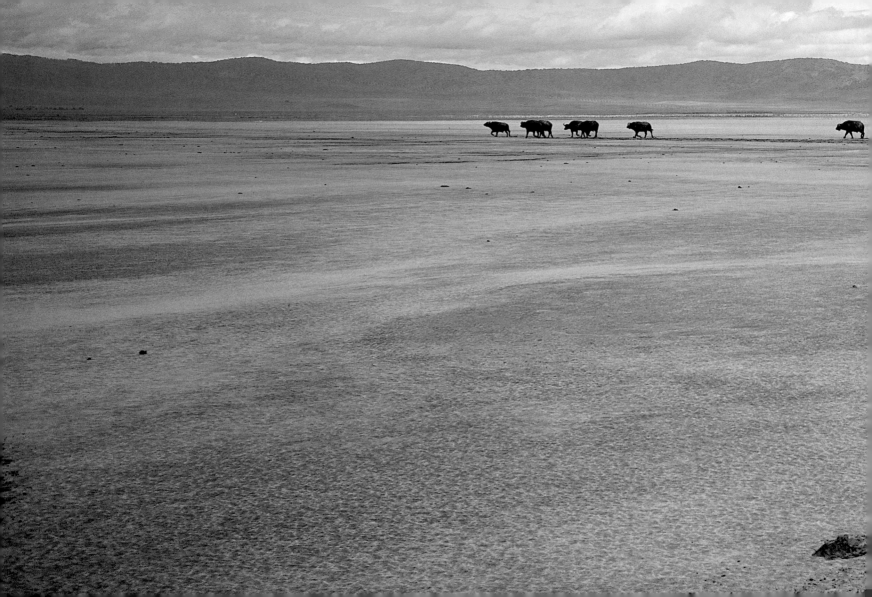

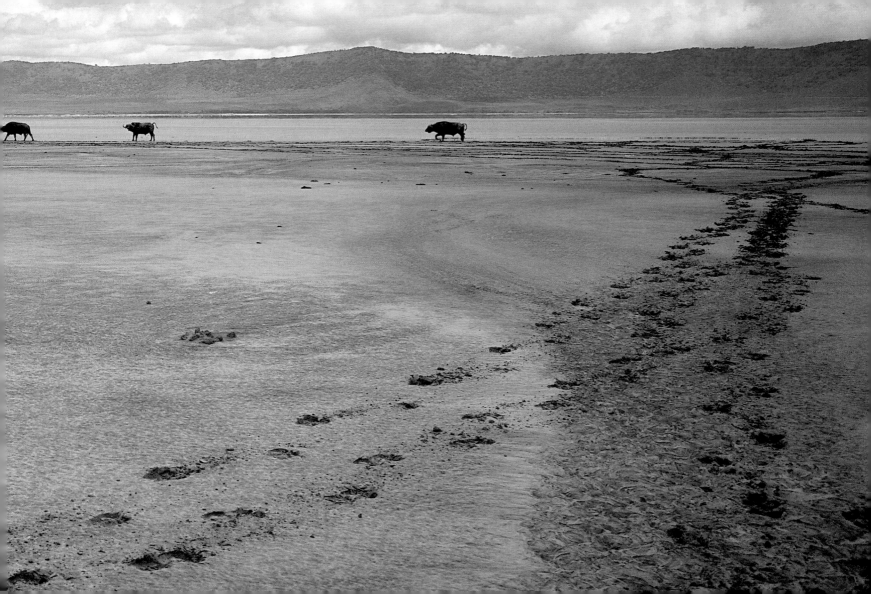

The flamingos crowd into the mouth of Munge River, bathing and drinking. A resting golden jackal studies the birds for a little while. It gets up and wanders toward them, giving the appearance of being more interested in smells on the ground. Casually, it enters the shallows. At first the birds take no notice, but when the jackal gets closer some start to drift away. As if this is a signal, the jackal begins to sprint, eyes fixed on a target. The birds flee, skinny legs pumping hard to get up to speed before taking to the air. The jackal continues sprinting. In the panicky jumble that occurs, some birds have difficulty taking off. However, just in time, the targeted bird takes to the air and avoids the jaws of the hurtling predator.

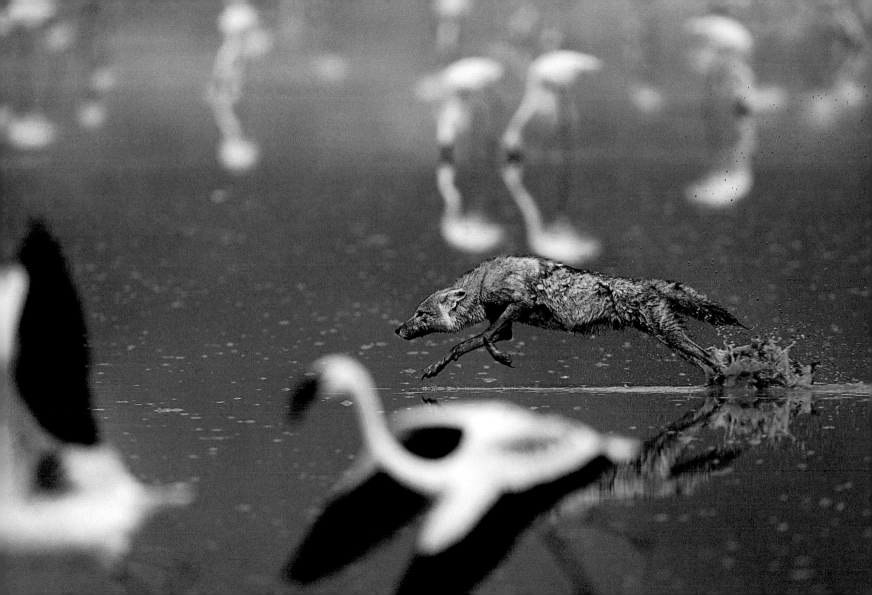

Quite near the crater is Lake Manyara National Park, famous for its tree-climbing lions, elephants, and giraffes. On the shore of the lake we come across a large herd of giraffes. The migration is now turning back from its boundary in the southeastern Serengeti and beginning its return to the short-grass plains.

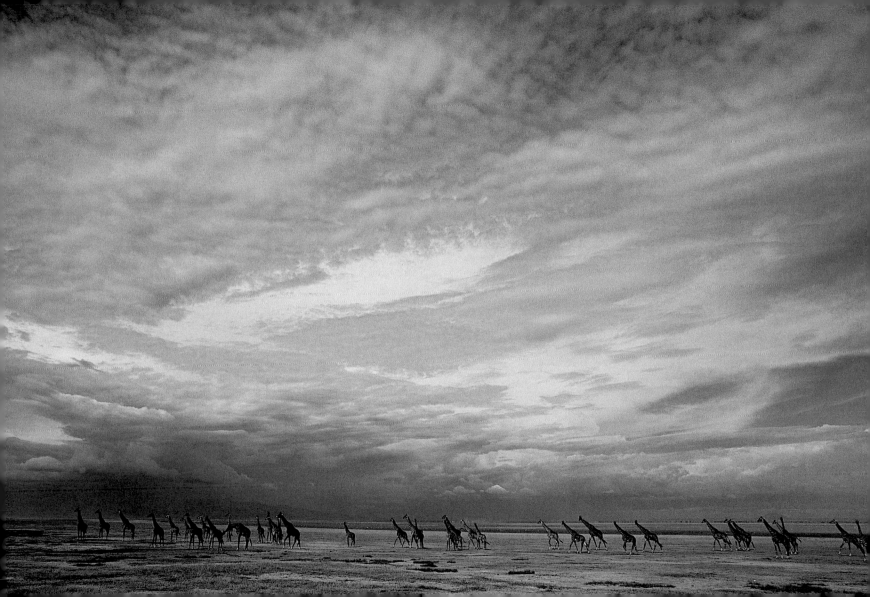

When we were camping at Lemuta on the short-grass plains two weeks ago, we could look down over 60 miles (100 kilometers) of low, undulating country packed with herds sweeping away, up to the remote, dark-blue shapes of the crater highlands. Today, as we fly over the highlands, they look green, and we notice folds indicative of lava flows.

The crater highlands are part of the ancient Great Rift Valley whose formation was accompanied by much volcanic activity a million years ago. The ash from the volcanic emissions settled on the ground to give rise to the fertile short-grass plains. The herds are now heading back to the heart of these plains.

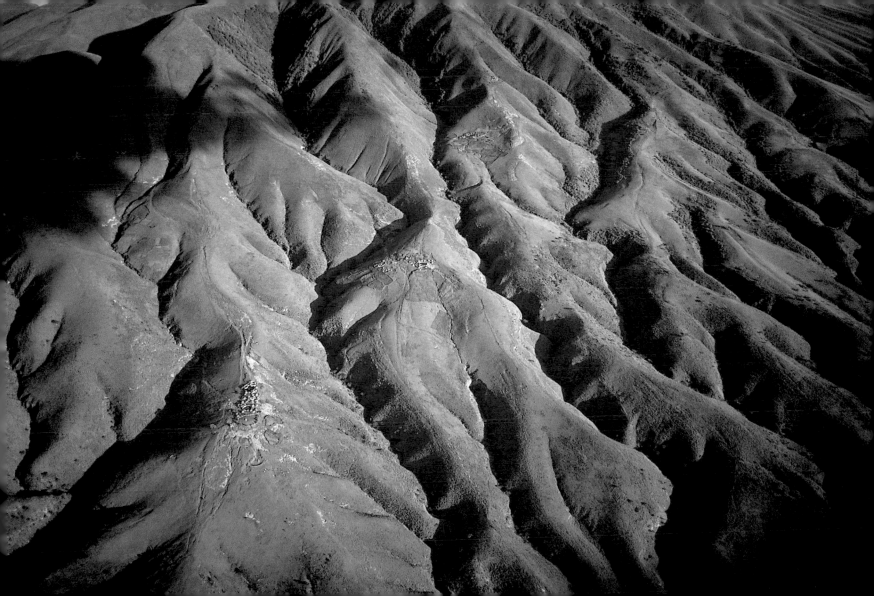

In pre-dawn darkness, the lions at the center of the plains wait on a kopje for the herds to return. Gradually, the eastern sky changes color from light black to shades of gray and when the sun is about to break over the horizon, it changes to crimson. Then the tip of the sun shines like a star and glides over the horizon to usher in a new day.

The migrants have been making decisions throughout their wanderings: where to give birth, whether to move or stay, which way to go. How do the migrating animals know which way to go? Is it encoded in their genes? Did the animals that went the wrong way, i.e., where there was no green grass and water, die before leaving their genes behind? Do they thus follow the implicit command: Whenever you see distant thunderstorms and lightning, hear thunder, and smell newly wetted soil wafting on the freshening wind, go?

Today, on the plains between Naabi Hill and Gol Kopjes, it stays cloudy throughout the day. In the evening the first returning zebras appear, moving across the plains in loose aggregations, accompanied by a few wildebeests. It is a convergence of zebra family groups in response to a new growth of grass. They graze in an open group of a few thousand animals, joined in an easy mutuality of grazing.

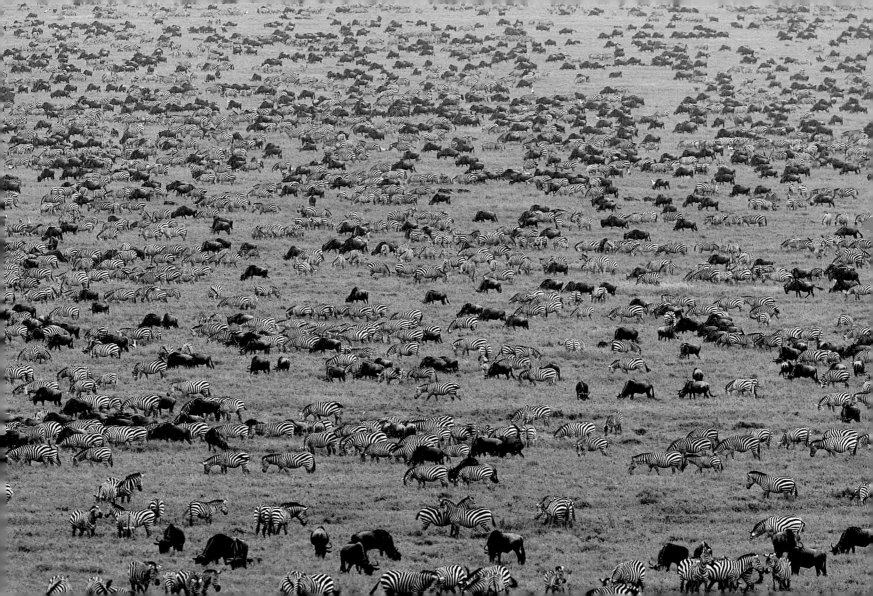

A jackal has picked up the aroma of an African hare, but the scent passes on abruptly as a wind whisks it away, giving no hint of the hare's location to the jackal, which resumes trotting. With the habits of millennia ingrained, this hare had crouched motionless while the jackal paused. The hare waited for a few minutes more and then lowered itself still further into the grass to make itself invisible.

OPPOSITE

A male ostrich raises its head to scan. With just a small movement of its head it can cover a 360-degree view. It is incubating the eggs laid by its hens in a nest that is not much more than a hollow in the ground. Male ostriches are polygamous and one may have as many as five hens in its harem. The eggs are laid by all the hens in a single nest. Incubation, which takes about forty days, is carried out mainly by the cock, but the dominant hen will take over for some of the daylight hours.

On the western side of Naabi Hill, the plains stretch up to Maswa Game Reserve. The evening warmth of the sun is on an ostrich crèche that is under the stewardship of a few adults. In ostrich society, the young of different parents form a crèche under a kind of community guardianship.

Hyenas favor ostrich chicks but often find it difficult to get past a towering adult. Like the giraffe, the ostrich is not easy to attack. Its neck and head are too high to grab. If a hyena was able to seize a leg, it risks getting kicked by the other, and a well-aimed kick can propel a hyena high into the air, crushing its rib cage or shattering its back. Even if the hyena manages to get past the kicking legs, the ostrich's mass of feathers prevents the predator from getting a good grip in that vital moment of the killer bite.

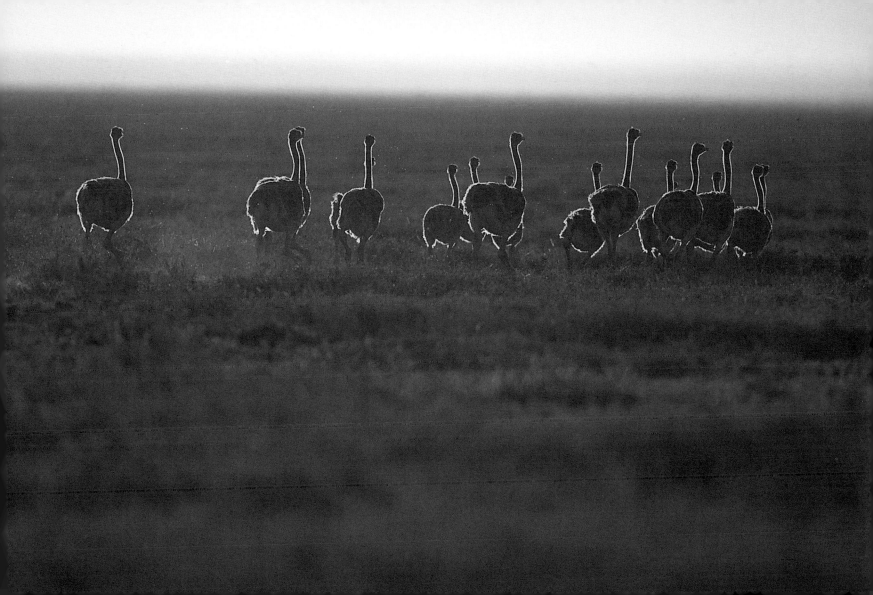

Returning to our camp at Naabi Hill at dusk, we come across a large herd of wildebeests on the plains east of Naabi, exactly where the zebras were grazing a few days ago. Something spooks them. Black shapes stumble through the haze. The panicked animals pass among lapwings at their nests studded across the plains. The birds, their night senses poor, remain at their nests while the ground trembles under the heavy feet of thundering dark shapes. How many lapwings are crushed in a world over which they have no control? Such musings prevail in our silent ascent of Naabi Hill.

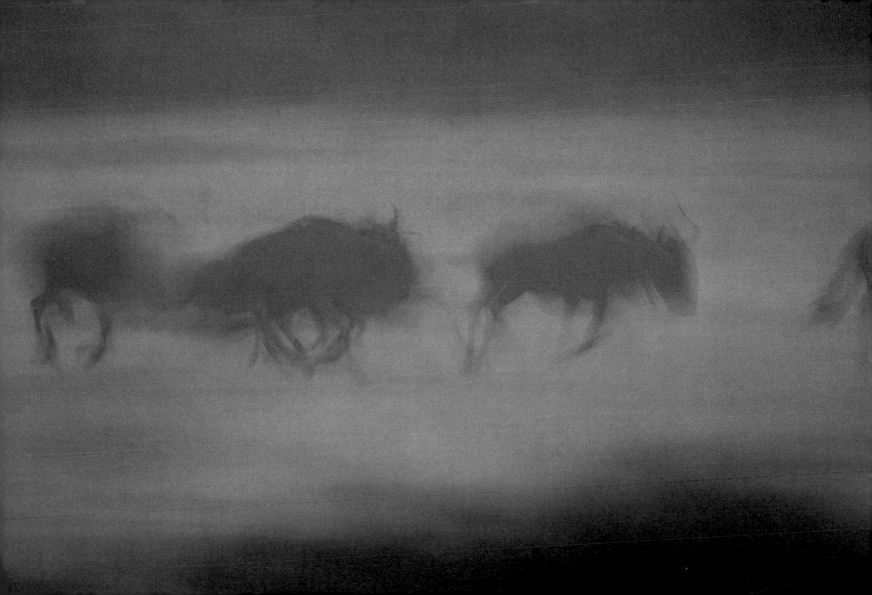

Overnight, the herds of wildebeests have amassed between Naabi Hill and Gol Kopjes. There is a sizable gap in their midst this cool and sunny morning. Within view of the wildebeests, a deceased member of the herd is being feasted upon by two males of the Naabi lion pride. Another male from the pride arrives, and a fight almost erupts between the two males. But it seems this is superficial conflict, for just as suddenly as they rise up on their hind legs with raised, threatening paws, they split apart and glower at each other. The tension eases but a hint of menace hangs in the air. As much as they've been studied, the social and sexual affairs of a lion pride remain some-what inscrutable.

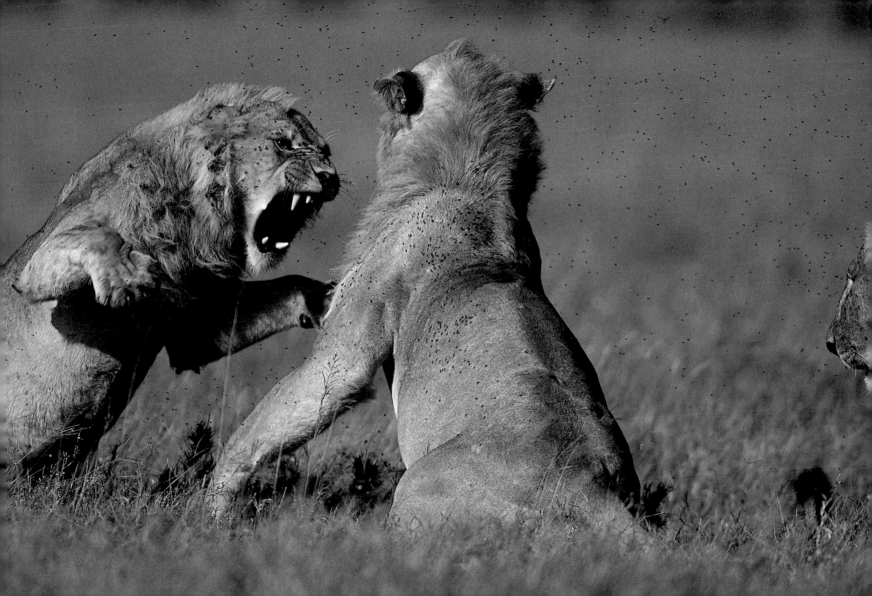

The herds have drifted back toward Gol Kopjes. In the evening, near the central Gol Kopjes, the herds part. Two males of the Gol lion pride move slowly, heavy heads lolling, padding forward imperiously. Inexplicably, they flop down and have no difficulty falling asleep. The wildebeests are in no danger, but, just to be on the safe side, they quietly, one by one, vacate the area. Within half an hour, the meadow is without a single mammal except for the two males sleeping blissfully, unaware of the respect they command.

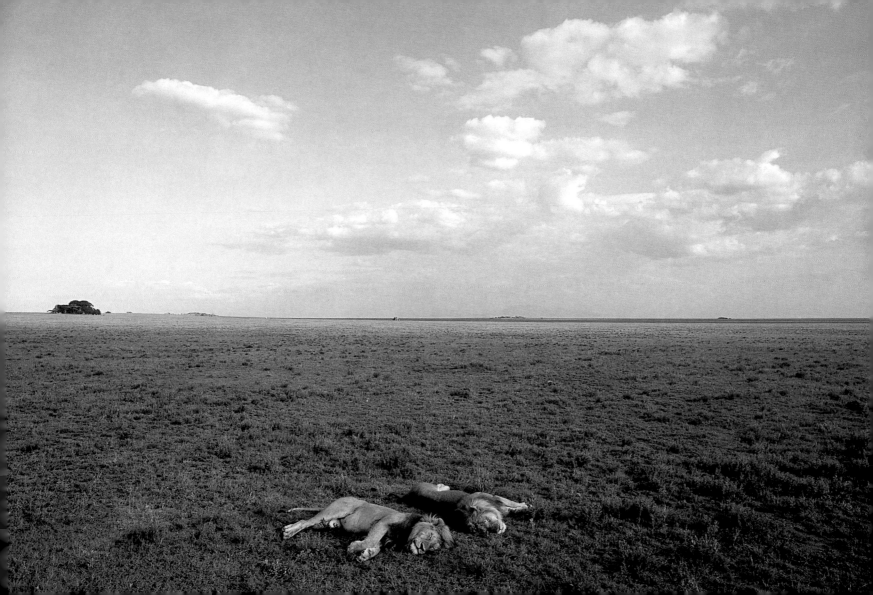

We drive into the gray gloom of dawn. At first, the sun is a dull orange disk on the horizon, but it quickly catches fire as it climbs up out of the thin morning haze. An African marsh owl is crouching in a small hollow in the grass. Its black eyes are wide and its two small ear tufts erect. This species of owl is terrestrial, nesting and roosting on the ground. And there it goes, flying over its territory. With green grass everywhere, the movement of the herds is not directional. If anything, they are spreading out, scattering across the plains.

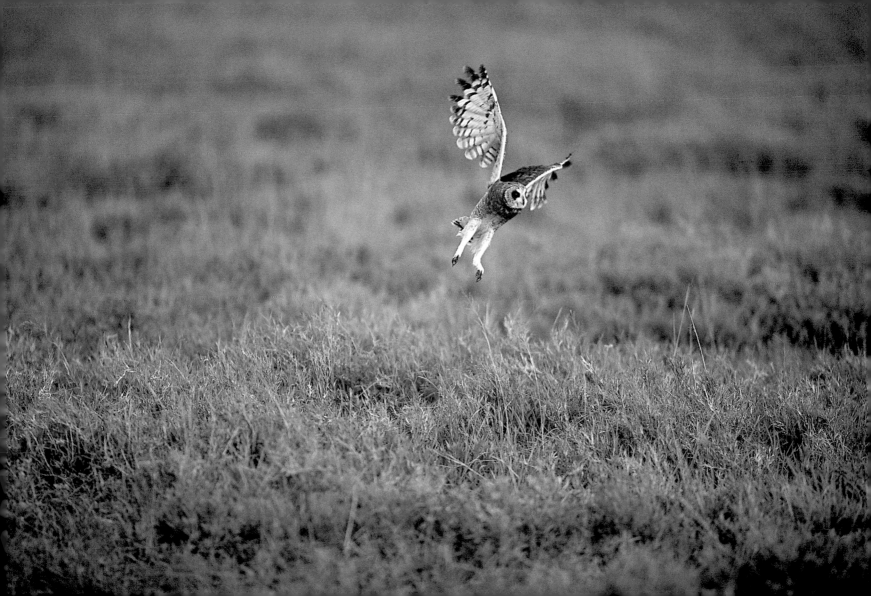

Mornings are usually quite busy on the plains, but the evenings tend to be tranquil. Dusk is the transition time between the winding down of daytime activities of diurnal animals and the start of nighttime activities of nocturnal animals. Birds, such as these storks, arrive one by one to roost on a tree near our camp on Naabi Hill. They have a clear view of both the plains and our camp and, no doubt, they watch our transition from the four-wheel cage to camp life with curiosity.

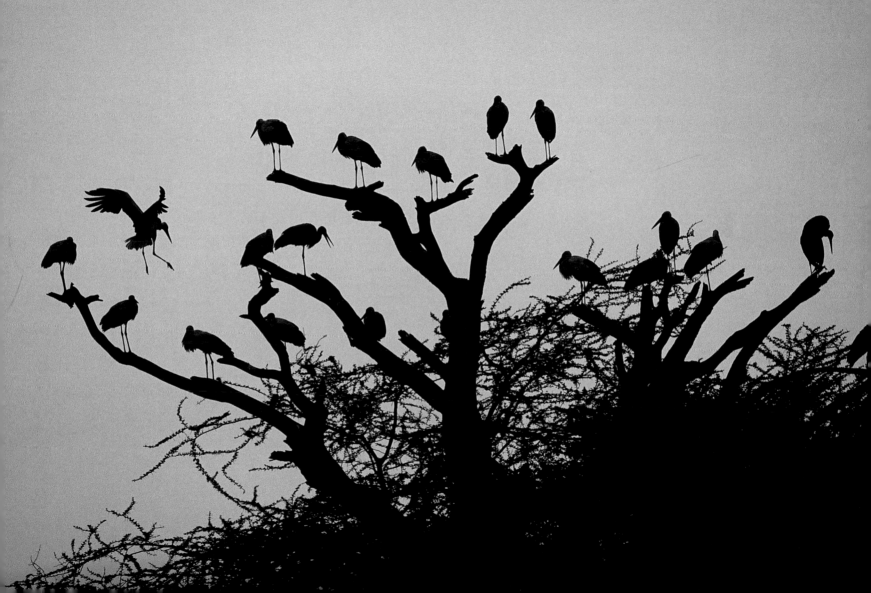

The European white stork is a common Palearctic winter migrant to Africa. Every year great flocks arrive in the Serengeti, stay awhile, and then move further south. But their short tenure on the plains is not without hazards. The serval cat of Naabi Hill sneaks up on a stork and catches it expertly with a short rush. It kills with a throat-bite and carries the kill to a thicket. The serval cat is twice the size of a domestic cat and it is spotted like a leopard. The mainstay of its diet is rodents, which it locates with antenna-sharp ears that allow it to pounce upon its prey with great accuracy.

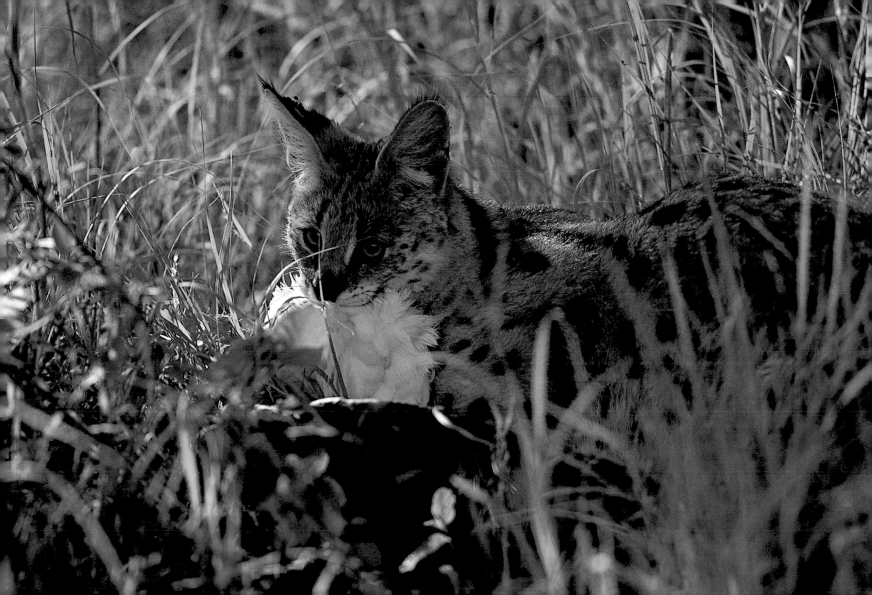

The wildebeest is an inquisitive creature and will stare with incredulity at newborn gazelles, caracals, and even cheetah cubs. This herd has overcome its instinctive fear of large cats to doggedly follow, at a prudent distance, a cheetah with three cubs. The cubs play, run, and engage in all sorts of antics as they follow their mother, and it is this activity that seems to fascinate the wildebeests. The cheetah mother does not relish her large following and tries to shake the herd off.

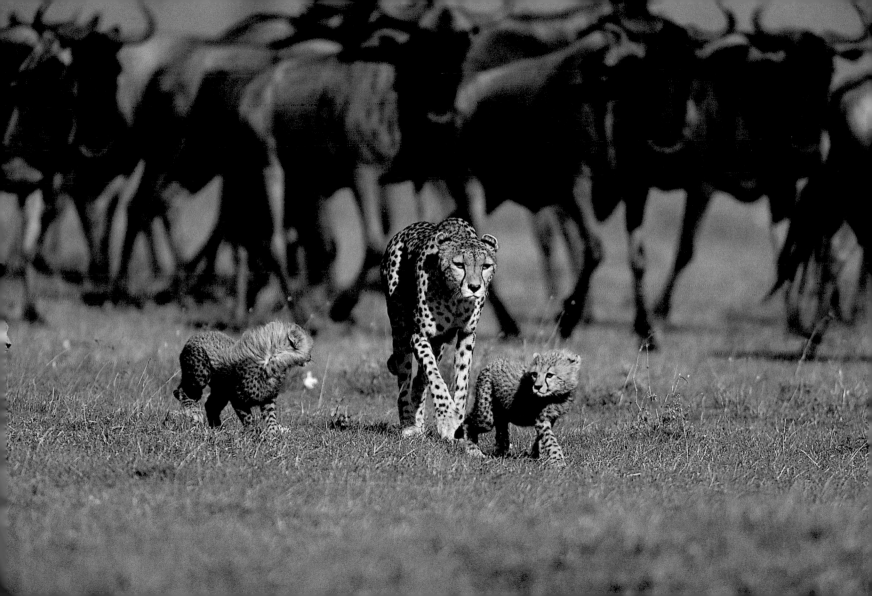

The peace and tranquility around a wildebeest herd is disturbed when a lone hyena appears on the scene. It bears down on an adult wildebeest, loping at 30 mph (50 kph). The herd parts and the chase is on. The hyena chases with its head up, rocking on the plains with an easy pace, snapping at the prey's hocks. The tenacious hyena closes in and manages to grip the antelope's flank. Does the wildebeest feel the sharp sting of a bite, the dragging weight of a body hanging onto it? A tug-of-war ensues: the hunted pulling to escape death, the hunter pulling for a meal. A hyena's jaws are among the most ferocious hunting tools on the savannah. They can crunch the thick bone of a buffalo in half, crack skulls, and possess great gripping power. No wonder its terrible bites at the tender wildebeest kills, even though it is one-fifth the weight of its victim.

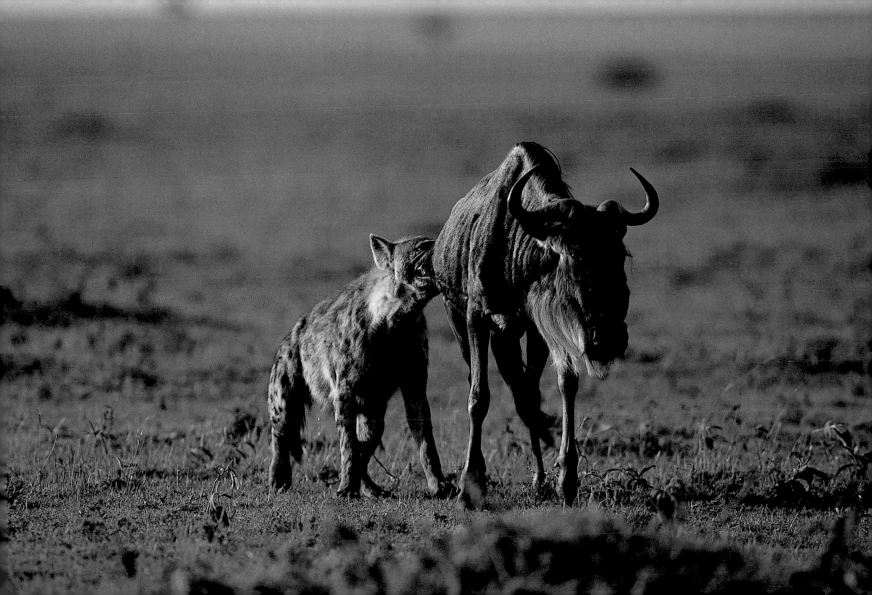

A female cheetah is following the migration around the short-grass plains. Quite unexpectedly, she has six adolescent cubs in tow, an extremely rare accomplishment in the cheetah world. Now she has chanced upon a lone male gazelle with his head down and only 50 yards (45 meters) away. She quickly prepares to sprint—years of hunting experience has told her that the time to attack is now. Caught unawares, the gazelle has no choice but to run away from the cat closing in. Programmed by natural selection, she now reaches that supremely coordinated moment when her paw deftly swipes and trips the frantic, running victim. Then she puts her four feet down and brakes in a dusty skid, seizing the tumbling victim and eventually killing him. Immediately the cubs arrive on the scene and commence feeding while she takes a moment to get her breath back.

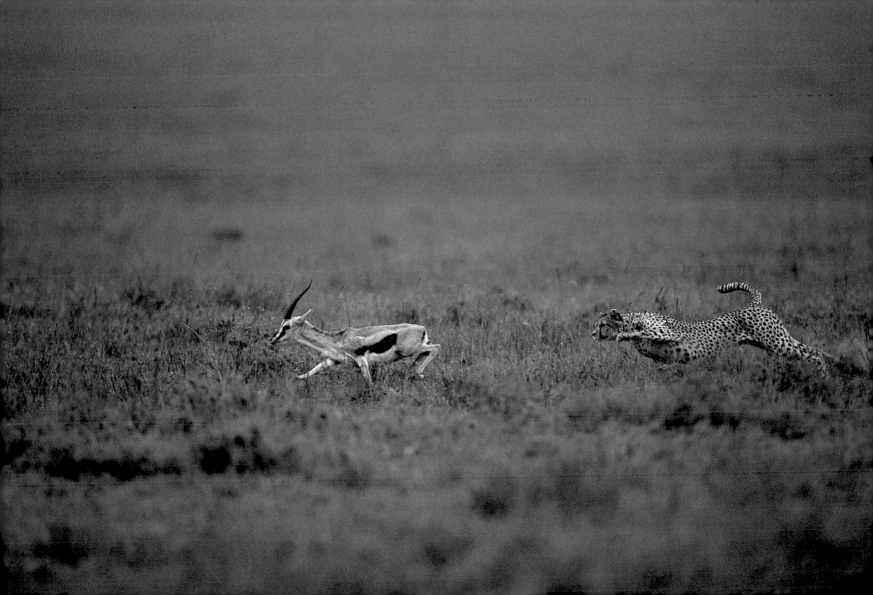

As the sun rises, a red glow floods the plains with lambent light and reveals the grazers already at work. Near a herd of gazelles we find a confusion of footmarks and smears of blood on the ground. The gazelles are busy grazing as if a cheetah attack had never transpired. Nearby, the cheetah family from yesterday is feeding in a star formation. One of the adolescent cheetahs lifts its red muzzle to scan the plains for any sign of scavengers. There are none for the moment so the cheetahs feed in peace alongside the grazing gazelles.

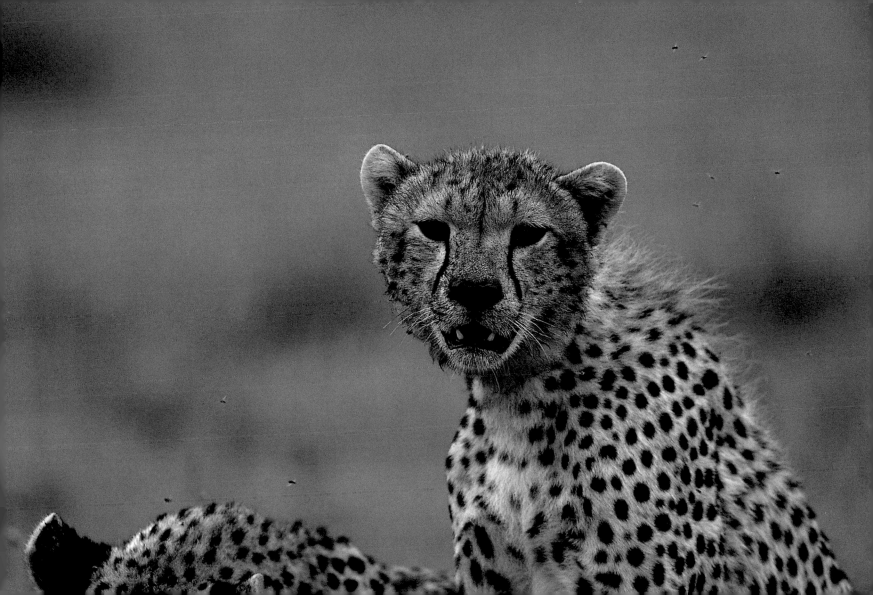

The gazelles are in the same location as yesterday, and there seem to be more cheetahs in the area. The conditions are in place for a cheetah hot spot. This temporary phenomenon occurs when the congregation of gazelles on the short-grass plains draws in female cheetahs, which attract male cheetahs.

A cheetah mother with a small cub has brought down a gazelle. After feeding, mutual grooming begins and the cub purrs with contentment. The grooming serves to lick the gore off their muzzles and thereby reduces the number of flies buzzing around their faces. This activity also serves to strengthen the bond between mother and cub.

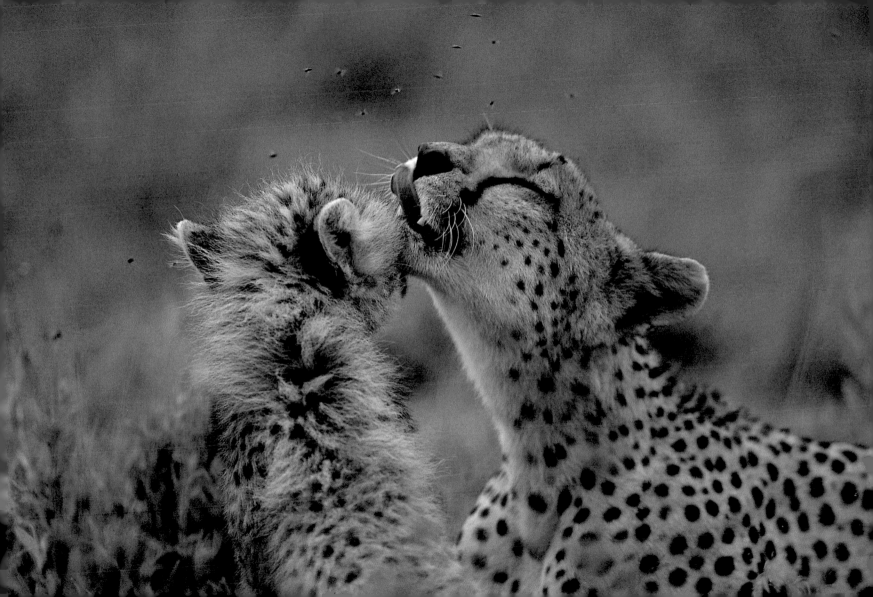

A gazelle spots the mother cheetah with her six cubs just as her fawn stands up. She prances off, hoping to divert the attention of the cats while the fawn instinctively falls back into the grass, freezing into its chin-to-ground posture. But it's too late. As the cheetahs run to the hiding spot, the hapless fawn jumps to save itself from converging cheetah jaws. But its efforts are useless, of course. In the wild, there is no fair play.

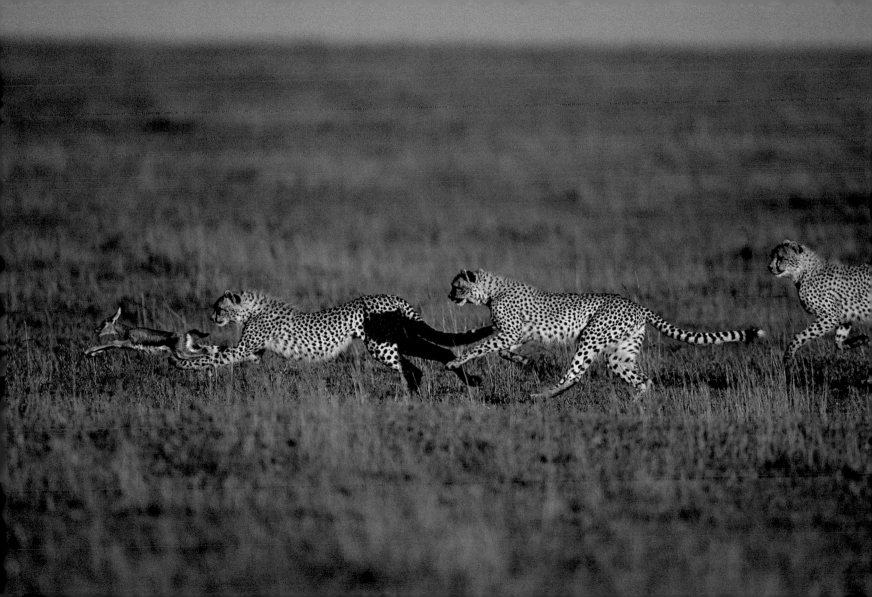

There is a small, isolated kopje with an adjacent pool between the Gol and Barafu Kopjes. Because of the undulating nature of the plains here, it is concealed from view from most angles, although thirsty animals have no trouble finding it. Lions also haunt this scenic spot, taking advantage of the tall grass around the kopje to lie in ambush. However, when satiated, lions cannot resist lounging on the kopje itself in full view of other animals on the plains. The pool attracts zebras, wildebeests, gazelles, jackals, hyenas, and many other species. A small group of zebras arrives and drinks at the pool, quiet and orderly. Somehow they have correctly sensed that there is no danger from concealed lions today. Nevertheless, while they drink, one zebra's head is always up, scanning for trouble.

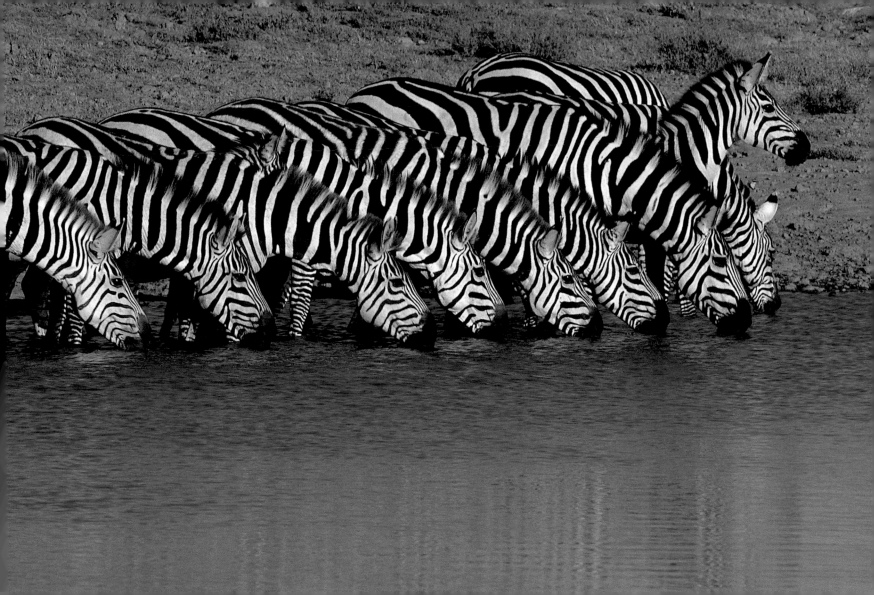

Waiting by the pool in semidarkness, surrounded by the sonorous grunting of wildebeests and yelping of zebras, we keep an eye on a lioness that has slipped into the tall grass at the base of the kopje. Unlike zebras, wildebeests will move quickly to a water source to drink, throwing caution to the wind, and making plenty of noise and commotion along the way. They arrive at the pool without ceremony, lower their heads, and drink against the glare of the rising sun, watching all the while. Just then, a pair of plovers flies in circles over the hidden lioness and calls out a warning. The drinking wildebeests flee, looking back only from a safe distance. The lioness shows herself, stretches, yawns, and climbs the kopje. Slowly the grazers drift away from this otherwise beautiful spot.

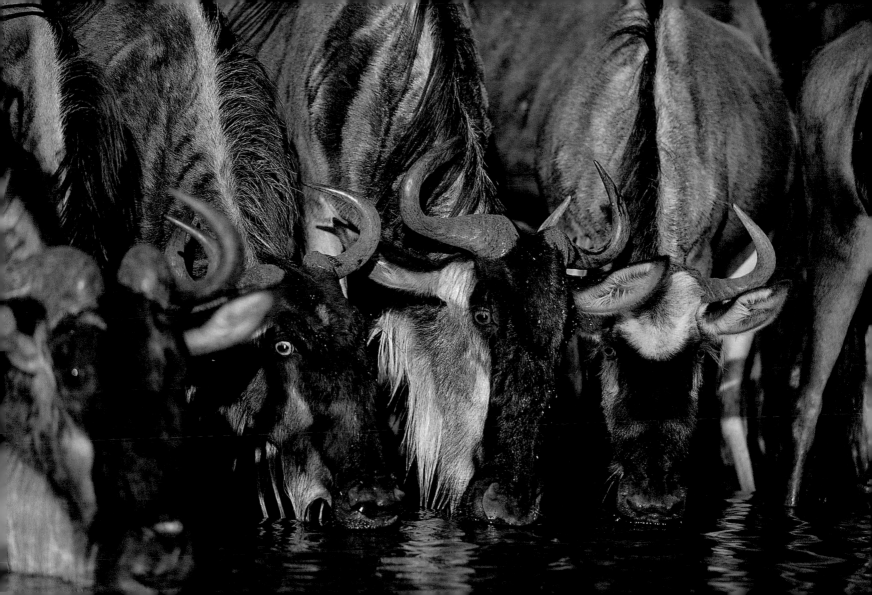

All too late, the last wildebeest in a single-file line realizes it has walked into an ambush. Cut off from the line of wildebeests, the intended victim turns around and runs back the way it had come. The lioness is bounding after it, sometimes with all four legs in the air. Both the prey and the predator have to negotiate some slippery terrain. The lioness slips—unlike the cheetah, the lion does not have anti-skid ridges on the pads of its paws—but quickly regains her balance, still moving at top speed. She grabs the hindquarters of the victim and then leans to the right to topple the animal over with the force of her body weight. As the animal hits the ground, she moves to grip the neck and bite the throat, well clear of the kicking hooves. Sudden death is no stranger on the plains.

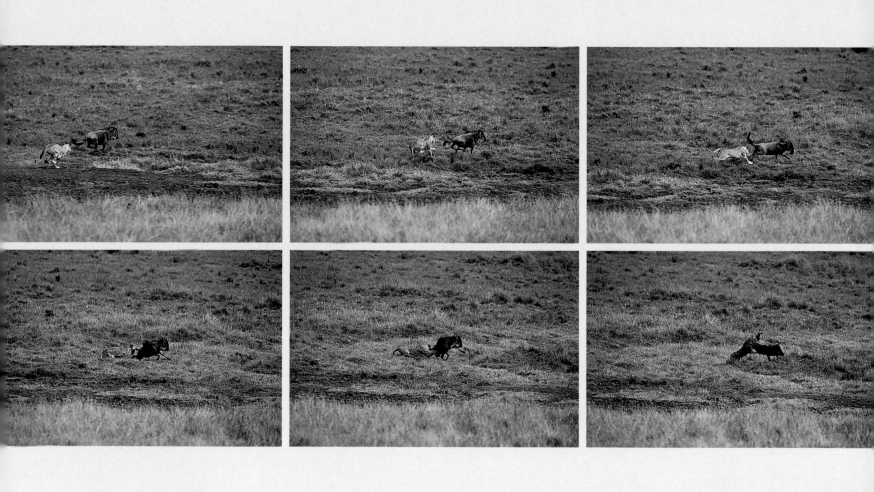

Marabou storks are the great sentinels of the plains and woodlands. After arriving at this kill, they wait while lions gnaw at the scattered bones of an unlucky migrant. When the lions retire, the birds use their long, spearlike bills to pick morsels of flesh from inside the vertebrae and joints, from the skull and the pelvic bones. They also pick up scraps near the bones. Nothing misses their probing beaks. Like vultures, they are scavengers and have sharp eyes, but unlike vultures, they are omnivorous.

OVERLEAF

Nowhere on the plains do the rains fall evenly or predictably, so the great herds of the migrants rotate around the pastures, frequently on the move, following the rains. Today, they are busy grazing around Gol Kopjes where it rained last night. Wildebeests are noisy animals. Even when feeding, they mutter and grunt, and the rumble of their voices carries far across the plains in a resonant drone, like a giant hive.

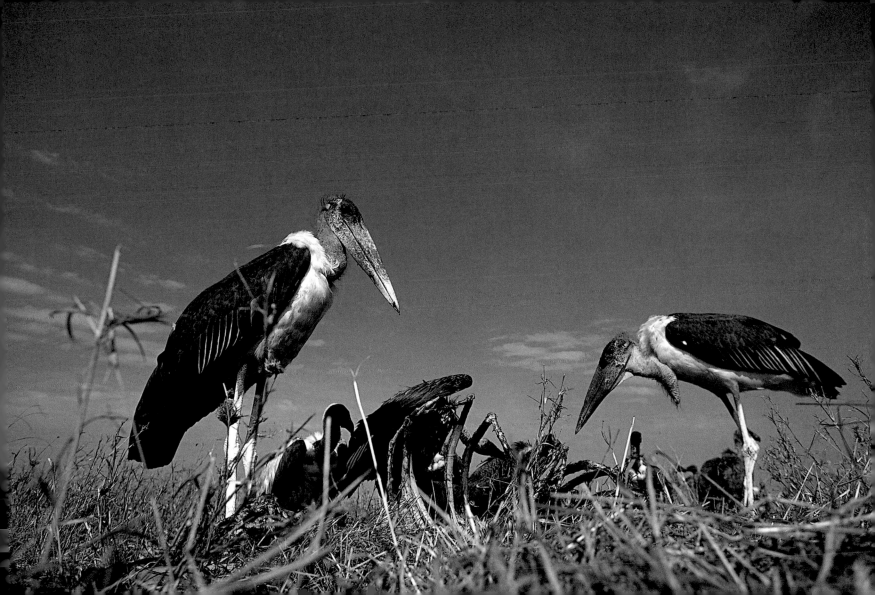

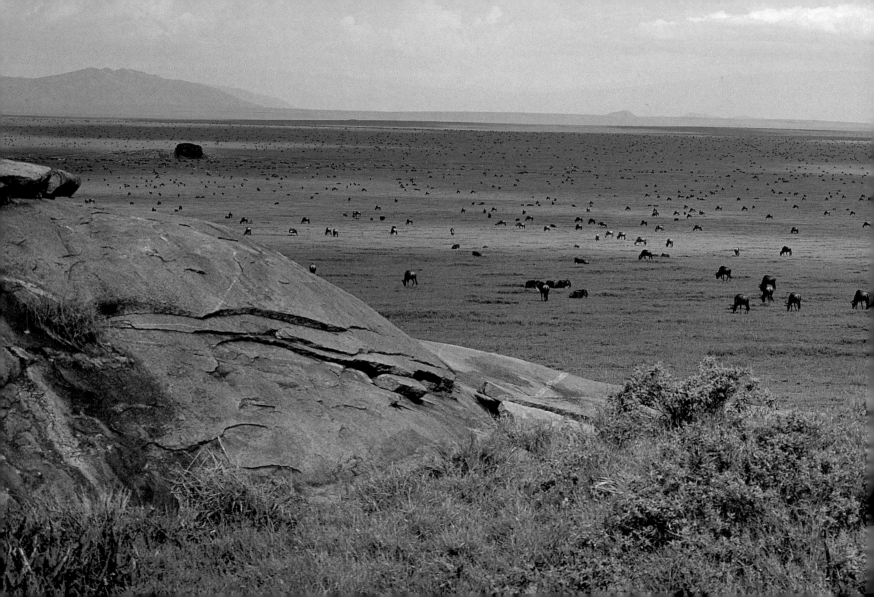

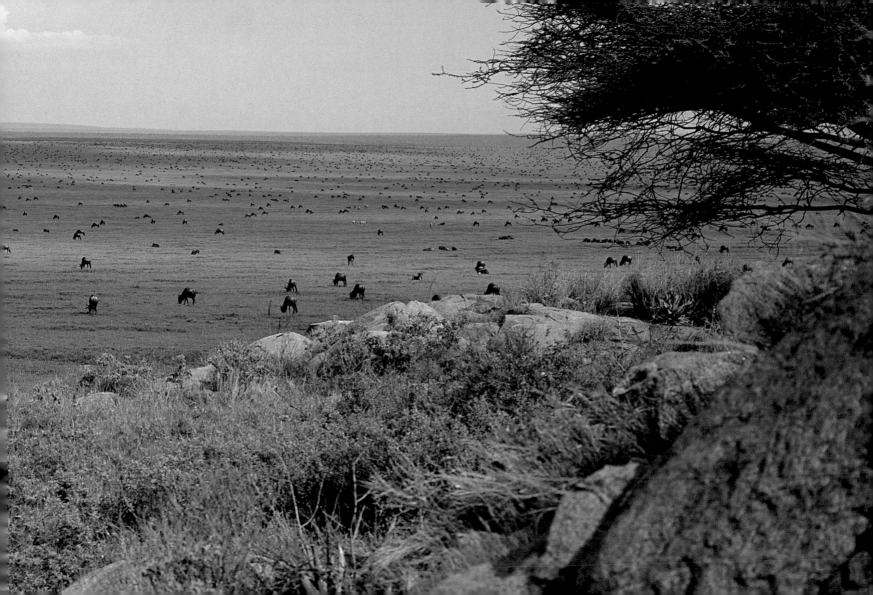

If you were to take a walk on the short-grass plains, the chances of encountering a snake are miniscule unless you seek one out. The vast majority of snakes on the plains are very small and well camouflaged. Snakes also tend to avoid danger, which includes people walking. Most of the plains snakes, like this one on a dirt track, are not poisonous. Deadly snakes, such as the cobra and adder, are usually found in the caves and crevices of kopjes.

Snakes are abundant in and around the woodlands, where it is not wise to take a walk without being alert for venomous snakes such as Egyptian and spitting cobras, black and green mambas, puff adders, and boomslangs.

The wildebeest population is never static. It shrinks in the face of disease and drought, then expands again in years of good rainfall. In 1961, there were only two hundred thousand. Since then, they have increased nearly eightfold. Such numbers place a huge burden on the dung beetle. As it is, dung beetles roll the dung of millions of herbivores into neat round balls, which they bury and in which they also lay eggs. It is estimated that they process over 8 million pounds (3.5 million kilograms) of manure daily, cleaning up and fertilizing the plains. In fact, dung beetles could be called the saviors of the short-grass plains—without them, large parts of this semiarid region, with its light, friable soil, would turn into a dustbowl.

A kopje stands like an island in a sea of grass. The early sun is warming it up. Hyraxes appear on the exposed rocks to sunbathe with the purpose of raising their body temperatures. They are draped over rocks in comradely groups, letting the life-giving heat sink into them. Hyraxes resemble rodents in movement but are almost rabbitlike in appearance, except for their short ears. Some say they share many physiological traits with elephants, such as their elongated incisor teeth and, oddly enough, the bones in their feet.

The seven huge boulders constituting Barafu Kopjes stand out like small fortresses on the open plains. To the east rise the Gol Mountains and Lemuta Hill 15 miles (24 kilometers) away, and beyond them, the remote crater highlands. To the west, Nyaraswiga stands up over the horizon 30 miles (48 kilometers) away.

The kopjes are ancient. Long before the first wildebeest appeared on Earth, their granite domes had been smoothed and wind-worn into strange elephantine shapes. Gray and weather-stained, marooned in the vast plains, each rocky outcrop is a self-contained and secret world of its own, a watchtower, a food source, a sanctuary for many different creatures, such as this lizard, that could never survive out on the open plains.

The last rains have fallen on the plains, but the temporary pools thus formed anchor the herds here for the time being. From the air, the wildebeests look like slow-moving clots as they spread out to feed. But there is a change in the air—the dry season is on its way. The life-giving pools will begin to dry up quickly, signaling the movement of the herds to more permanent water sources.

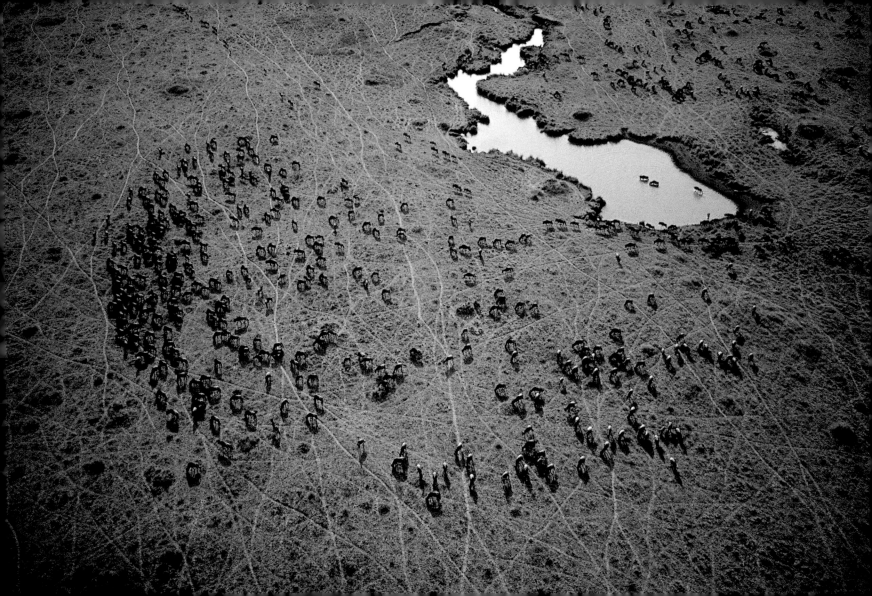

This morning the suspicion of a change is confirmed. Literally, the wind has turned hot and dry, blowing from the northeast. At mid-morning, it tempers the heat that is now rising. There are a few pools left on the plains surrounding Gol Kopjes. For now, some hyenas are luxuriating in wallows at a favorite pool. Although hyenas can last for days without water, they delight in it, frequenting pools where they can sprawl on their briskets in the muddy shallows and escape the constant irritation of biting flies.

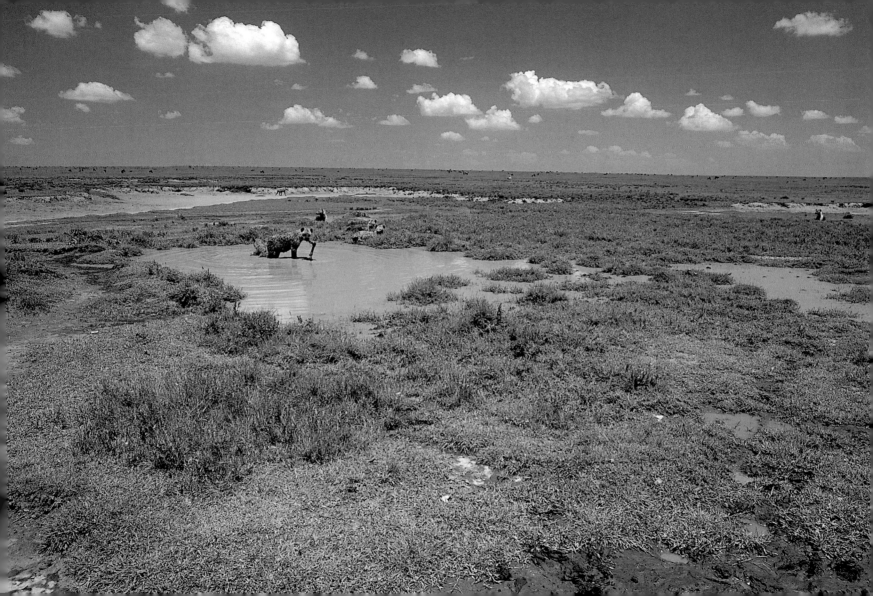

Heat and dust encroach on the landscape. A dry-wind whisper makes a different sound from the moist breezes of a few weeks ago. Some of the more common tricks to resist heat and dehydration are to seek shade wherever available, to limit activities to mornings and evenings, to become nocturnal, or to bury oneself in the cooler ground. The herds are no longer scattered. Instead, they are clustered around the last remaining water sources.

OVERLEAF

The Sametu lion pride is spending a lot of time near its pool. It is the largest stretch of water for miles around and now attracts animals day and night. When satiated, the lions show themselves, frightening the would-be drinkers. But even this pool will dry up soon, such is the intensity of the heat. Then the lions will have to adjust their lifestyle.

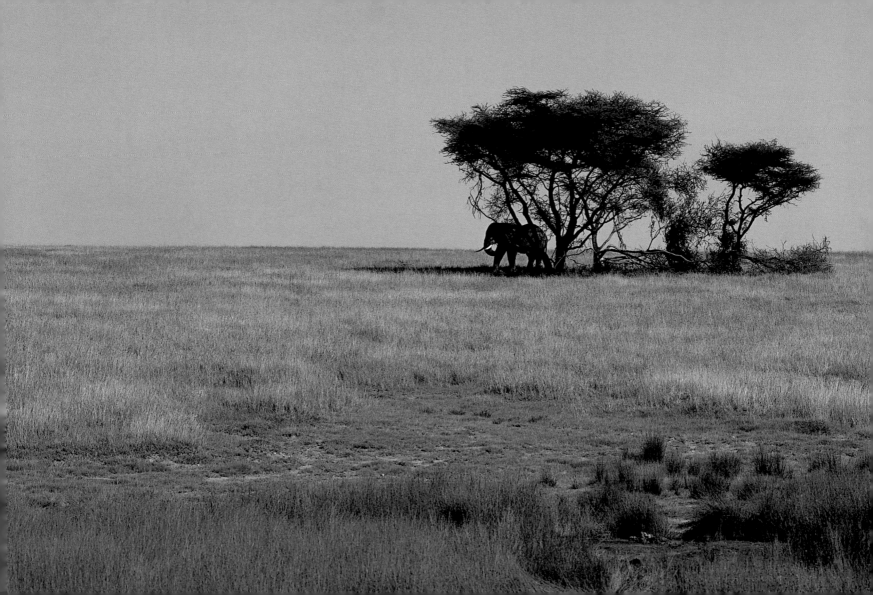

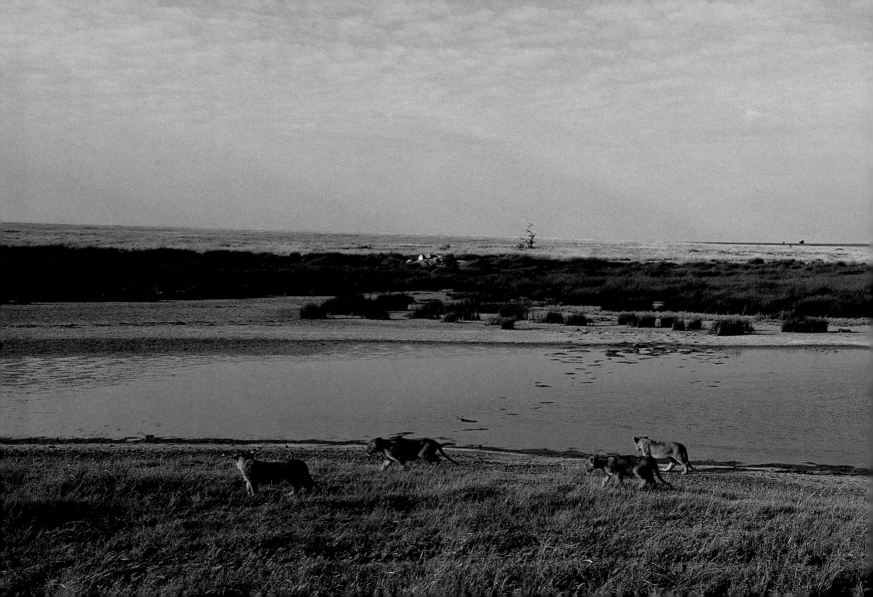

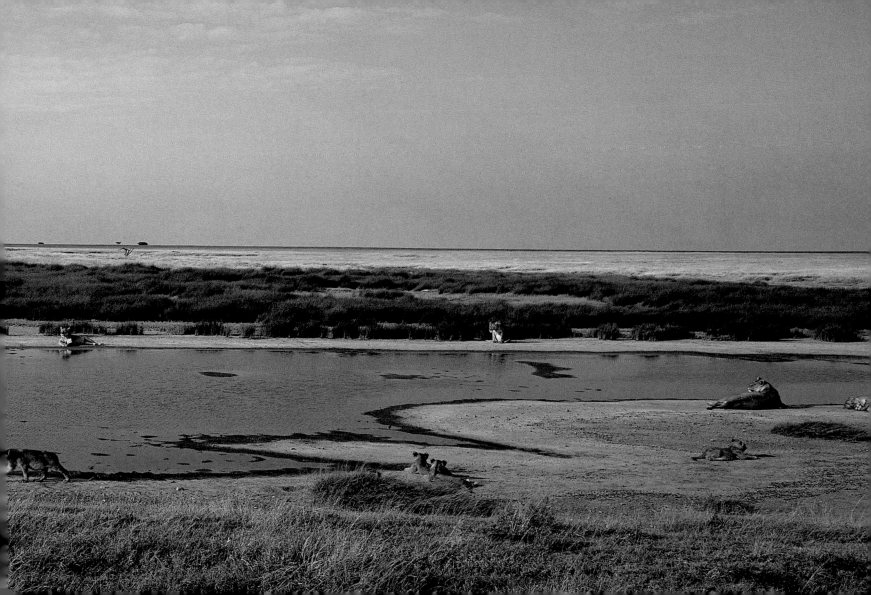

Heat rises from the plains as the dry winds blow with increasing strength. With the progress of the dry season, the seasonal streams begin to dry up and pools recede such that within two weeks there will be only one small waterhole in every hundred square miles (260 square kilometers) of plains. Within a month, these too will disappear. Some dry-country animals such as ostriches, jackals, mongooses, lizards, birds of prey, and Grant's gazelles can live on the plains throughout the year, by making the most of the moisture in their food. Thus raptors draw moisture from the blood and tissues of their prey.

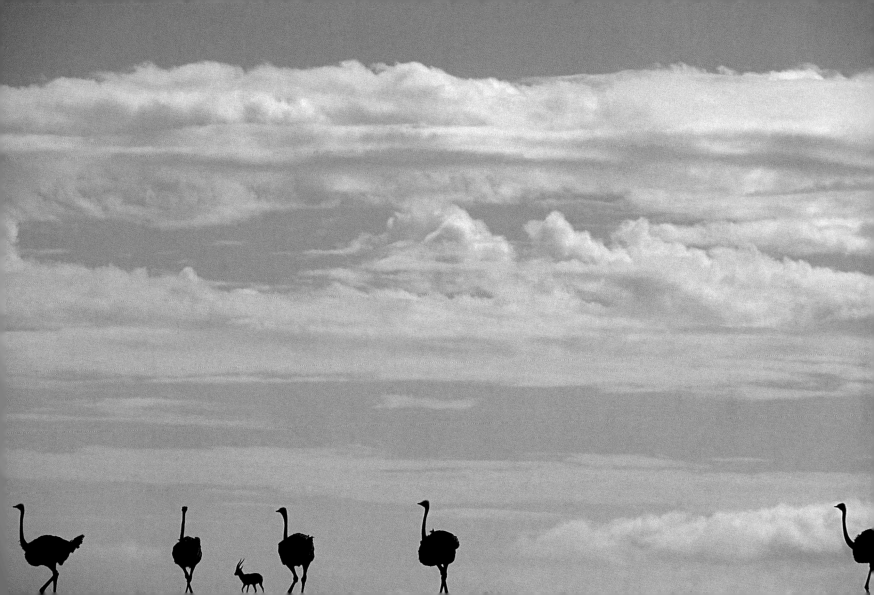

Evening on the plains: There is nothing around us, it seems, apart from three crowned cranes—a male-female pair and their nearly grown offspring—busy foraging. They are wandering, head to ground, in no particular direction. Their foraging leads them within 10 yards (9 meters) of our stationary vehicle, which they ignore. They continue their feeding until the sky turns yellow-orange, at which point the trio flies to a bare tree and begins their evening ritual, primarily preening, before turning in for the night. We take the cue and slip away.

Dry winds sigh in the lifeless grass and whip the loose soil into tall dust devils. The wildebeests have descended to a pool of water but failed to see a lioness in ambush. But the lioness breaks cover too early and the herd erupts in a panic, whipping up thick clouds of dust in their wake. The calves are larger now and less easily separated from their mothers. Now is the time that the lactating females start to feel the pinch, as the short-grass plains deliver less and less nutrition and the water holes become increasingly foul before drying up.

OVERLEAF

As the land shrivels without moisture, the zebras and wildebeests start leaving the open plains, bequeathing them to the gazelles. Generally, Thomson's gazelles avoid wildebeest herds; they will tarry awhile then bring up the rear of the march toward the long-grass plains. At this pool, sandgrouse seem to hang on the wind before settling to drink. The males wet their wings with water, which their chicks will drink. They take off and swing toward their nests on the plains, uttering their haunting guttural cries.

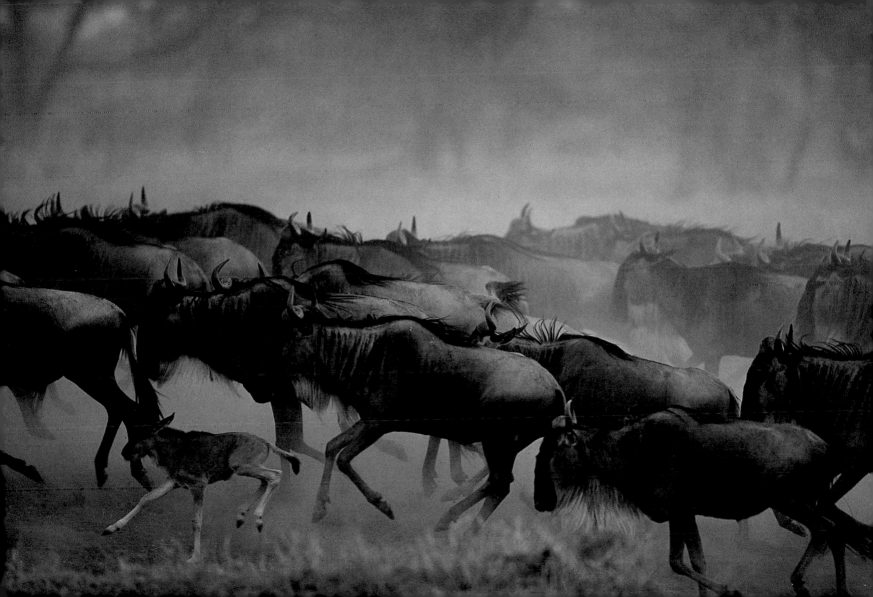

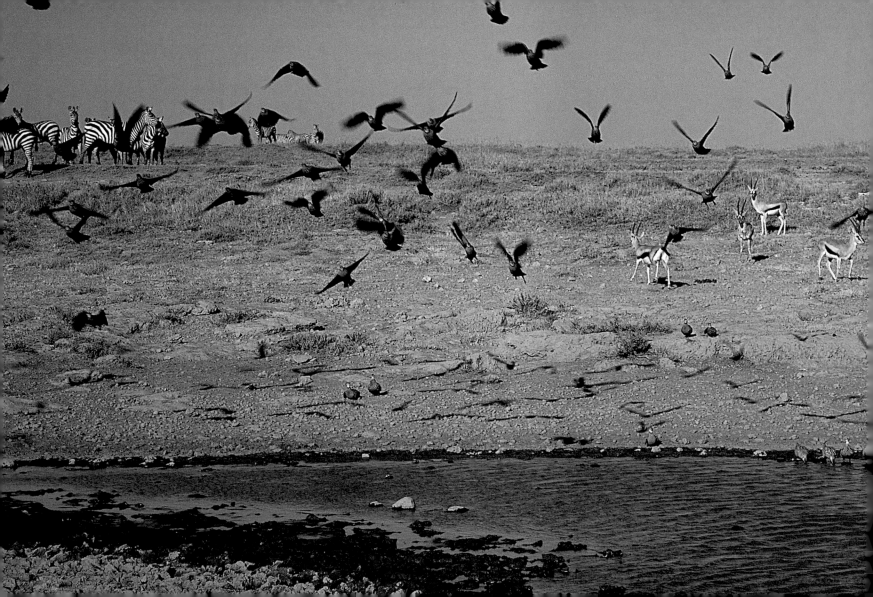

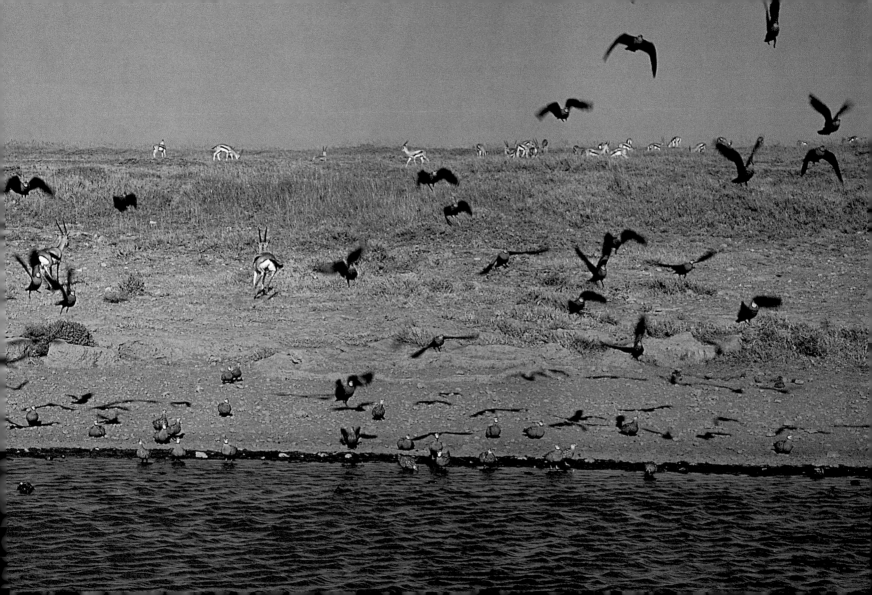

This bull elephant, feeding and walking on his own, has come across the unfamiliar—a honey badger that disappears down a disused burrow upon the elephant's approach. He extends his ears and raises his trunk—a classic alert posture. Satisfied that there is no threat, he lowers his trunk and changes direction. The honey badger does not reappear; most likely it has exited from one of the several openings radiating from the burrow.

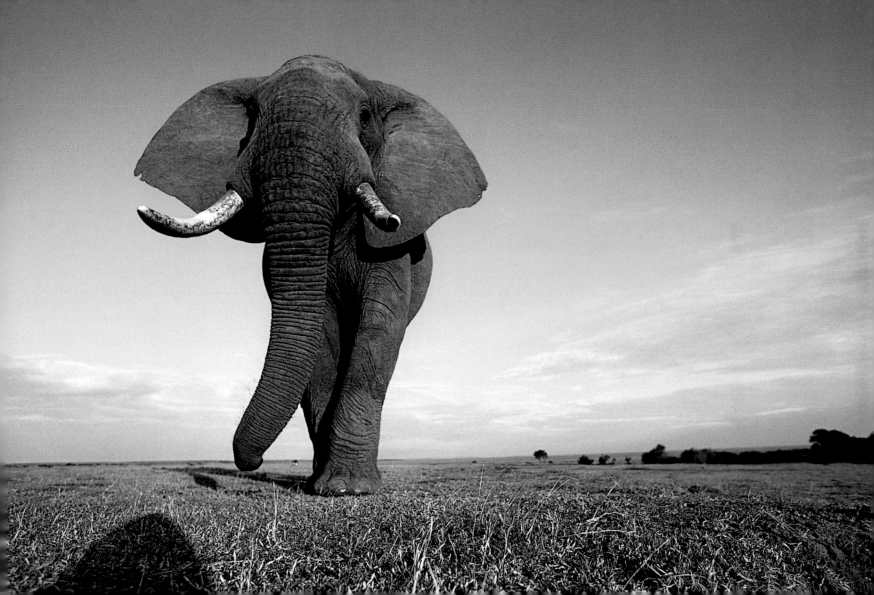

With the herds migrating north and northwest, the vultures patrolling the plains are facing a scarcity of food. No wonder there is a squawking scrum of vultures at a carcass near Barafu Kopjes! It's a chaotic free-for-all until a lappet-faced vulture lands, swaggers up, then charges in, monopolizing the carcass. But not for long—white-backed and Ruppell's vultures dash in and out, gulping down whatever they can snatch.

In general, fresh meat is hard to come by for vultures. Hyenas kill and eat at night and do not leave much food for daylight consumption. Possessive lions won't tolerate thieves. Only timid cheetahs provide opportunities for meat scavenging. That said, vultures eat more meat than any other carnivore on the Serengeti, yet, wind riders that they are, they need only 5 percent of the energy to cover the same distance as a land-based animal.

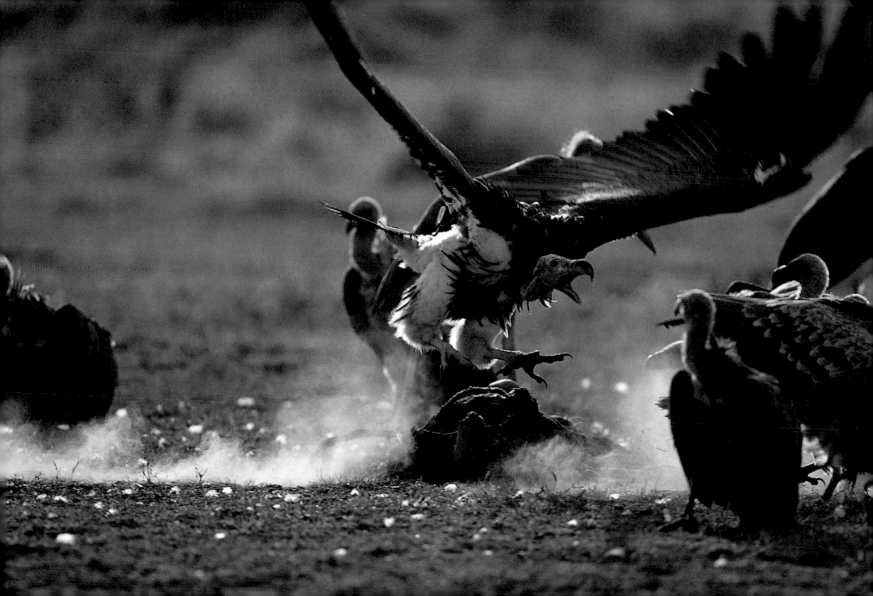

A frenzy erupts as a hyena chases vultures from a wildebeest carcass. Single-handedly she is both feeding and keeping the mob at bay. Time and again, fur bristling, tail raised tensely, she lunges, baring her teeth in a threatening grimace. And what extraordinary teeth they are! A hyena can shear through hide and sinew with its sharp carnassial teeth and crack bones with its powerful cone-shaped premolars to get at the marrow. Parting this hyena from her kill is a teasing, deadly game for the vultures. But it is a rare chance for fresh meat, and they are willing to play the stakes.

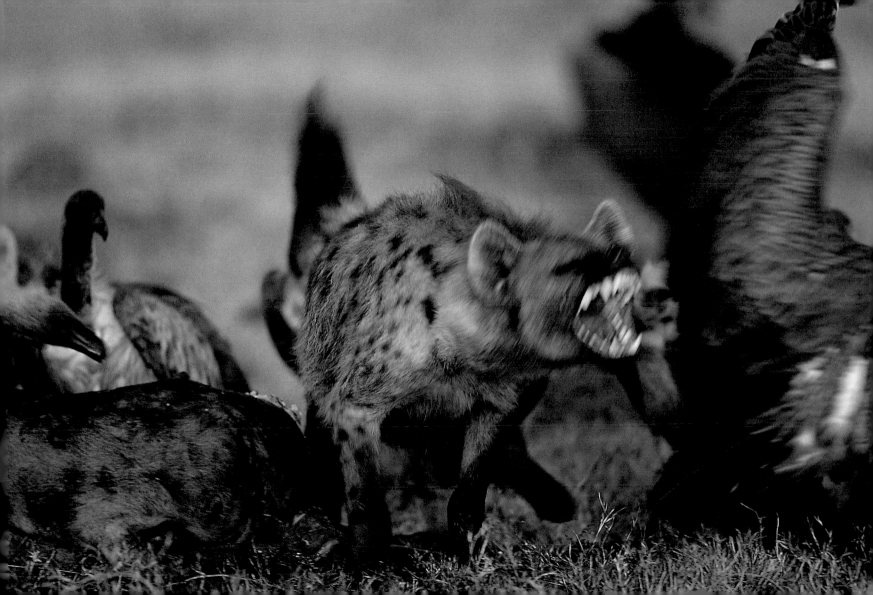

A vulture circles a lone acacia tree and drops swiftly to it, settling at the top. The sun dips into the horizon as the sky slowly explodes into strong reds, oranges, and yellows. This vulture has tarried too long to fly back to its roosting ledge in Olrarien Gorge. It needs the warm, rising air to lift it into the sky, so it will roost here until the morning, when the sun will warm up the air once again.

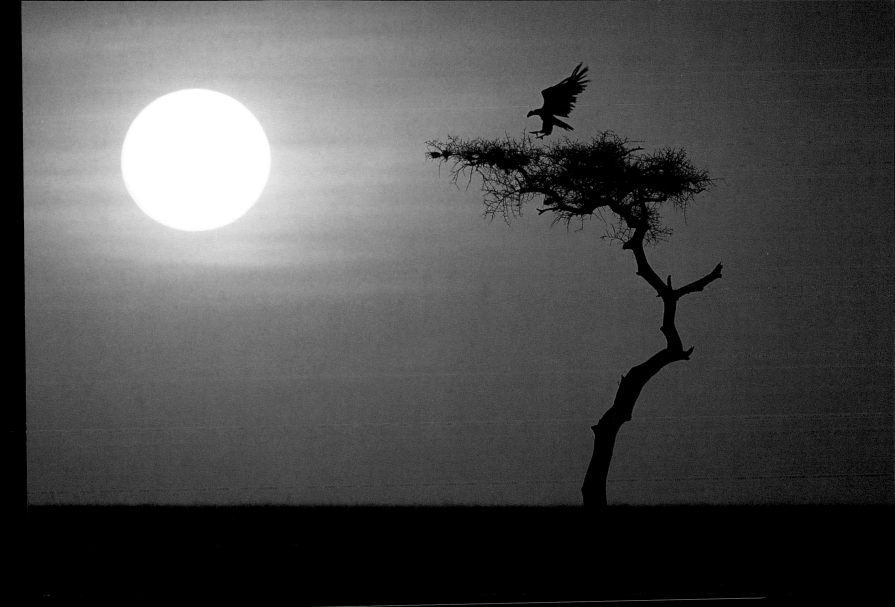

Already the short-grass plains are turning brownish yellow with the onset of the dry season and eddying with the dust of departing animals. There is better grazing and water in the north and west. By migrating there, the herds can bridge the seasonal variation in their food supply. In following the herd you follow the rains. Thus, as you drive from Naabi Hill, you begin to detect subtle changes in the vegetation, such as longer grass, the more frequent appearance of trees, and the occasional permanent stream.

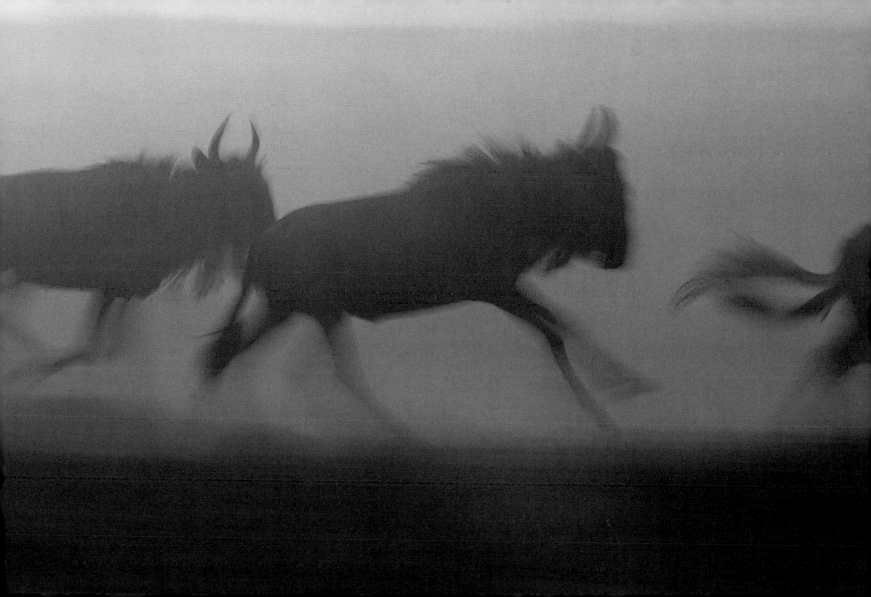

A banded mongoose pack leaves its burrow shortly after dawn. Pups remain in the den, too small to run with the adults, and an adult babysitter stays behind to watch over them. The pack forages, working methodically. An acute sense of smell and hearing guides the mongooses to the insects, reptiles, rodents, frogs, and small birds (and their eggs) they eat.

The plain is dying for want of water, turning into a mere ghost of its former self. The zebras lead the retreat and wait at a water hole that is still a quarter full. As they wait, the mongooses cross in front of them, busy in their foraging. They pass safely across, which encourages the cautious zebras to trek down to the pool.

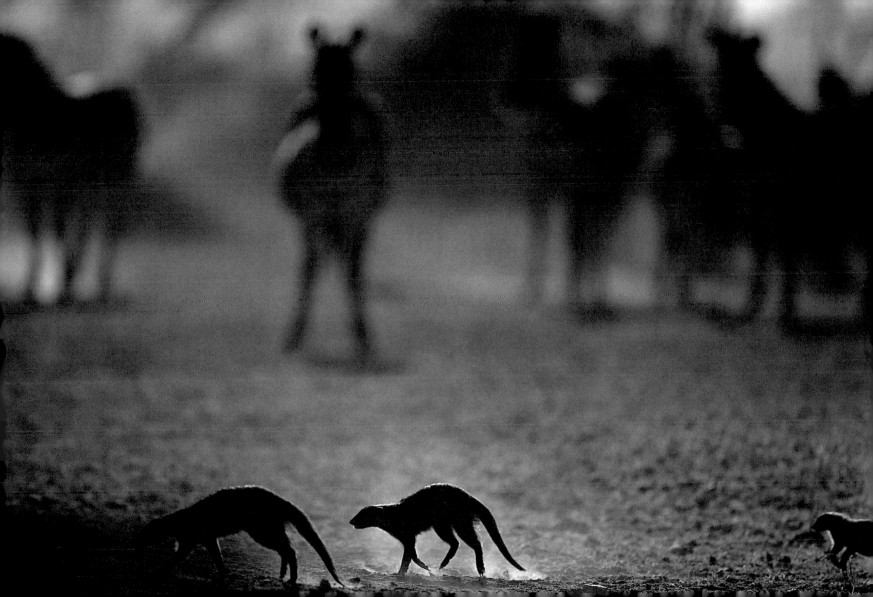

Not a single drop of rain has fallen on the plains for two weeks. The grasses stopped growing a week ago. The dry winds have taken over the airspace, confirming that the rains are truly over. The tropic sun beats down unrelentingly. It bakes the earth and turns the fertile soil to dust, transforming a Garden of Eden into a desolate landscape, a salad bowl into a dust bowl. This helmeted guineafowl happened to wander into the scene at the same moment that the zebra foal was dashing away.

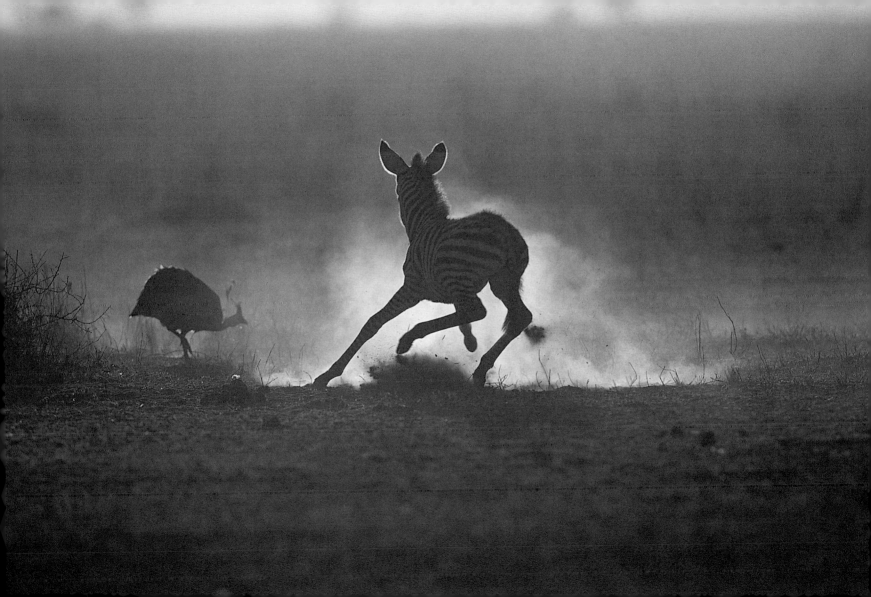

One by one the dwindling pools choke and die. The pool near Cub Valley was once large with clear water, drawing life to it. The little water that now remains is undrinkable. The plains around the pool have been grazed bare. With the herds gone, hunting is tough. Yet the lioness and her cubs, who have taken a temporary lease of the pool, seem in no hurry to leave the heart of their territory. They will, in due course, but like all animals here, they take their time, banishing haste out of their psyche.

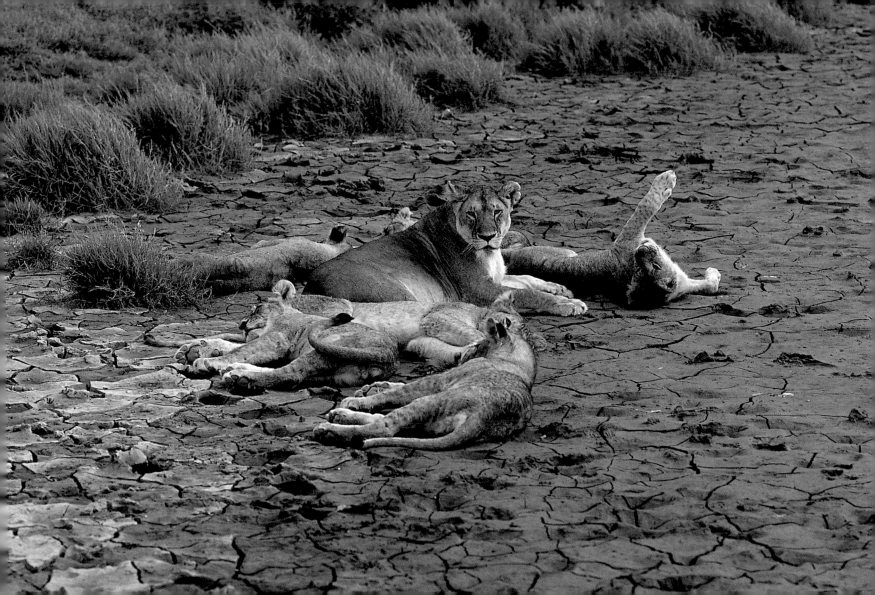

Another pool on the plains that has run dry. Many animals drank, slobbered, bathed, and wallowed in it. They all drank from the same soup.

Once, this was a large pool with good cover available to one side of it, convenient for lions with murder on their minds. They set up frequent ambushes and got away with a number of kills. Now their prints have been exposed along the shoreline. White crystals of alkali encrust the cracked, dried mud around the edges, and the sun has baked the mud in the center with impressions of tension-filled times.

A lioness climbs an enormous kopje where the plains meet the woodlands and scans out over the plains, where one plain merges with another and another into a multitude of plains. They are empty.

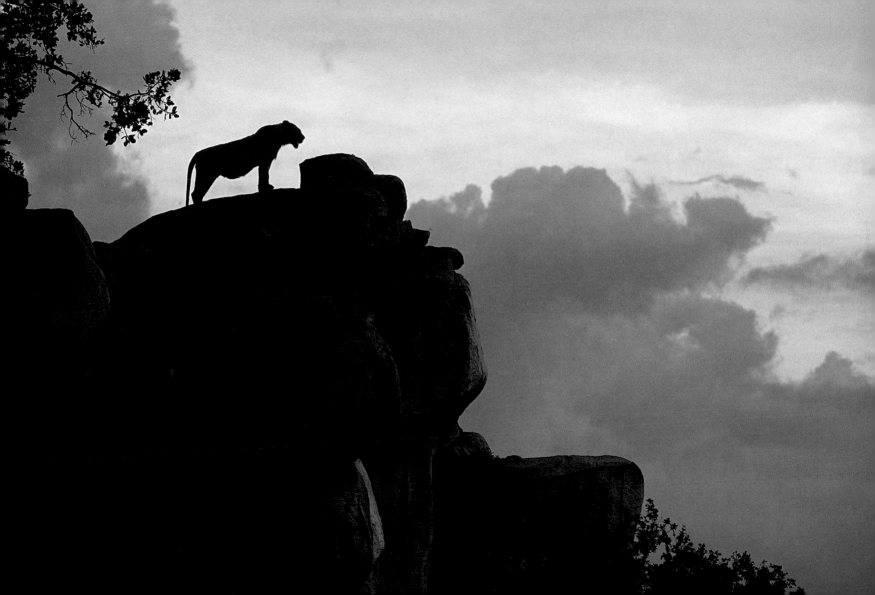

The pool next to yesterday's kopje has plenty of drinkable water. The few remaining herds are bound to come here on their exodus to the long-grass plains, first, then onward to the woodlands. Two motionless Egyptian geese, a male-female pair, stand at its edge, where sandpipers patrol. As the day wears on, a few gazelles silently drink. The pool is open to visitors for a limited period.

It is mid-morning at a last remaining pool. A zebra family approaches the water noiselessly. A mare steps forward, the stallion hanging back at the rear of his family. She hesitates at first but after a few minutes continues forward. At the water's edge, she scans, but seeing no danger, smelling no threat, hearing no strange sound, she drinks. At once the family joins her, and this act pulls in a few more families. A few zebras even venture further out into the pool. A lioness, hidden in the grass at the side of the pool, rushes at the zebras. It is a half-hearted probe, but all the zebras flee at once. Was the lioness looking for some weakness among them? No animal was hurt this time, but a stampede like this sometimes leaves injured animals in its wake.

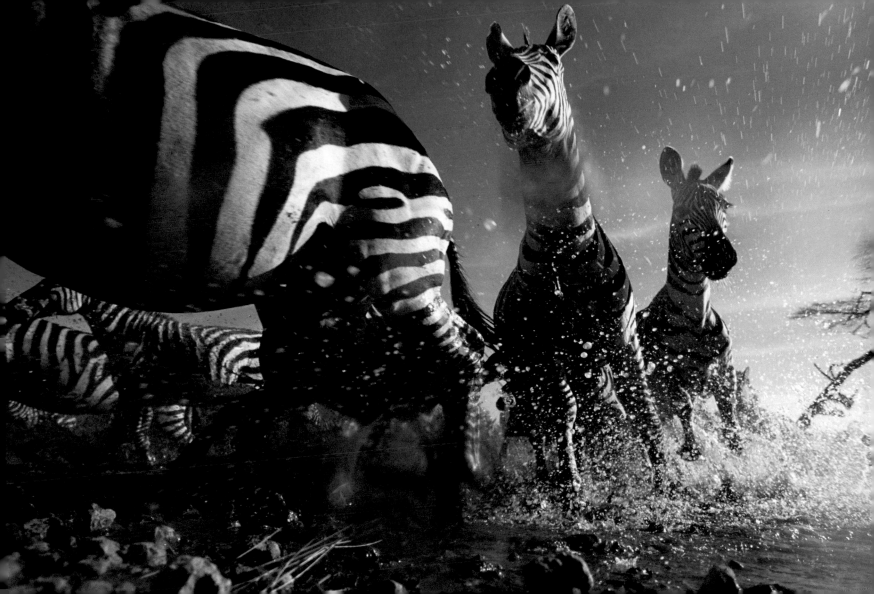

With the moisture depleted from the grass, the zebras need to drink daily. The migrating zebras know the locations of the remaining pools on the edge of the plains. Daily, new families arrive to drink at these last pools before continuing the march to the woodlands.

At one such pool, these zebras gathered, poured into the water, stomped it into mud as they drank, but then rushed out in alarm. They now look back to assess the situation, but it was a false alarm.

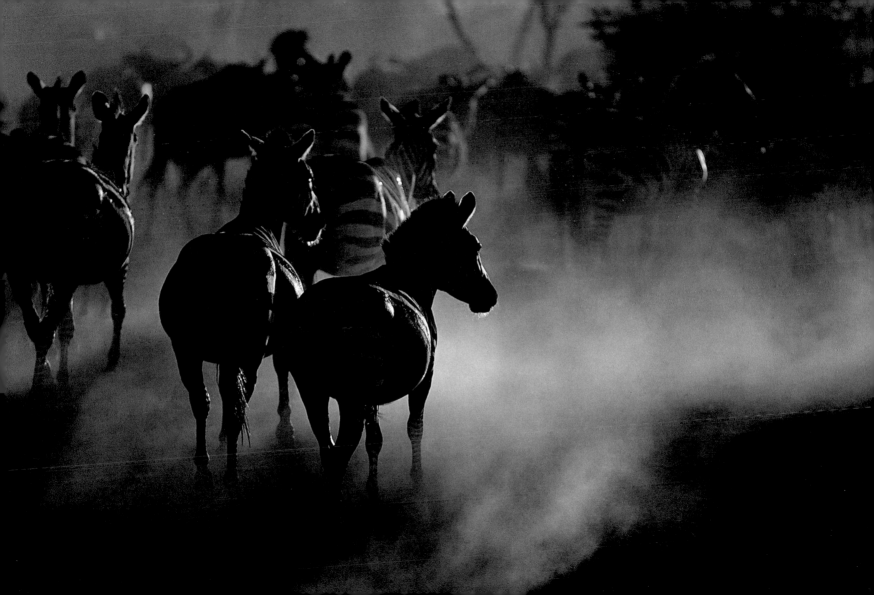

The first grass fires started this morning and died out by evening. A secretary bird strolls slowly but purposefully through a patch of partially burned grass, peering intently downward for cater-pillars, beetles, grasshoppers, centipedes, lizards, and snakes fleeing from the fires. If the bird finds either of the latter two, it will stamp it to death with its powerful feet before swallowing the broken body head-first.

Secretary birds are odd inhabitants of the grasslands. They strut with stalking dignity and assurance, their long stork-like legs sporting black knickers underneath, their long crest feathers protruding backward from their heads. The bird's eyesight is as keen as an eagle's and its fleetness of foot is almost equal to that of a bolting gazelle. Everything about this lean bird suggests an evolutionary midpoint between the harmless and the dangerous.

OVERLEAF

In their customary fashion, the gazelles are following the zebras and the wildebeests, who have reduced the grasses of the long-grass plains to a convenient eating height for them. They, in turn, are attracting the cheetahs, who have been roaming the short-grass plains over the last few months.

From a distance, this cheetah spots a gazelle mother with a fawn. The fawn is only a few weeks old but bound to be fast. The cheetah first assesses the situation by stalking. At about 30 yards (25 meters), it hurtles over the grass, eyes fixed on the target. Both mother and baby realize too late that a feline missile is bearing down on them. The cat knocks the fawn off balance in a cloud of dust and finishes the execution with a firm throat-bite. It is a clinical execution, absent of all emotion.

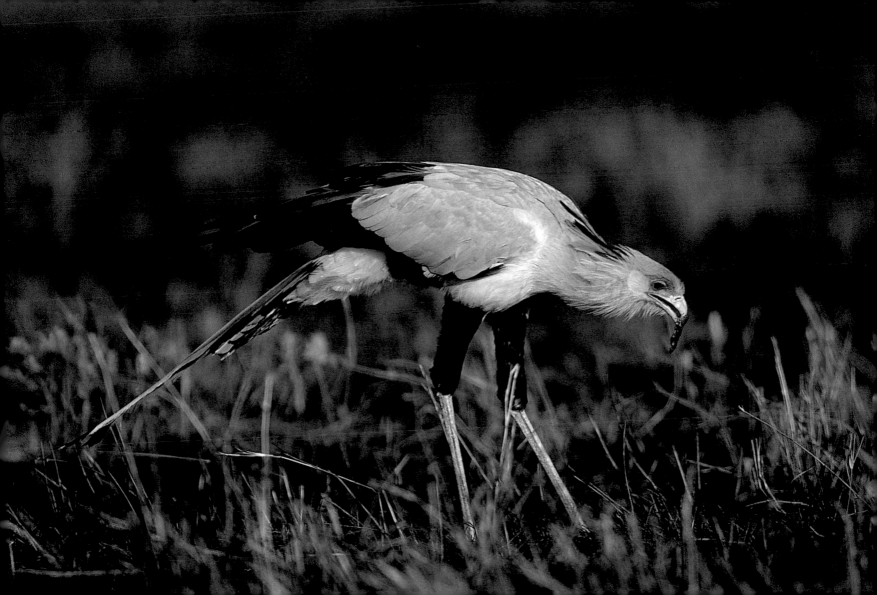

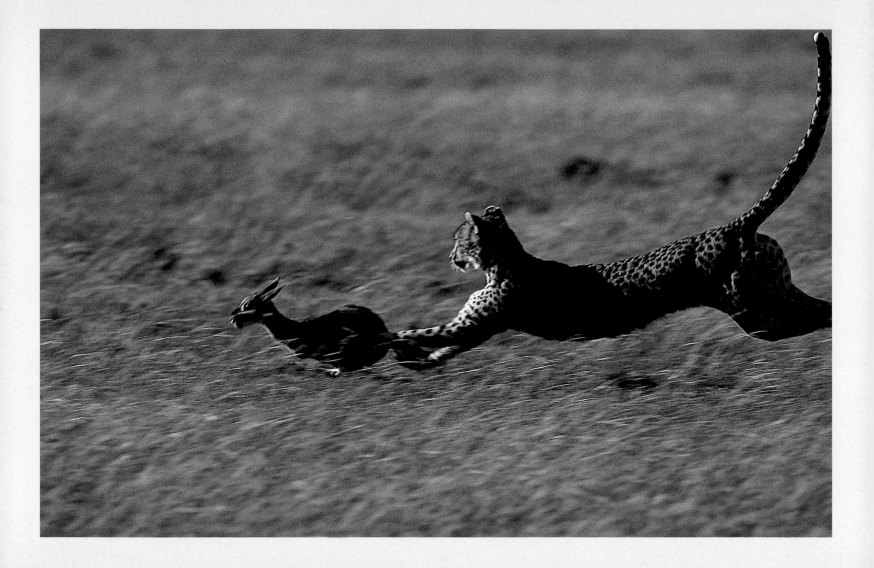

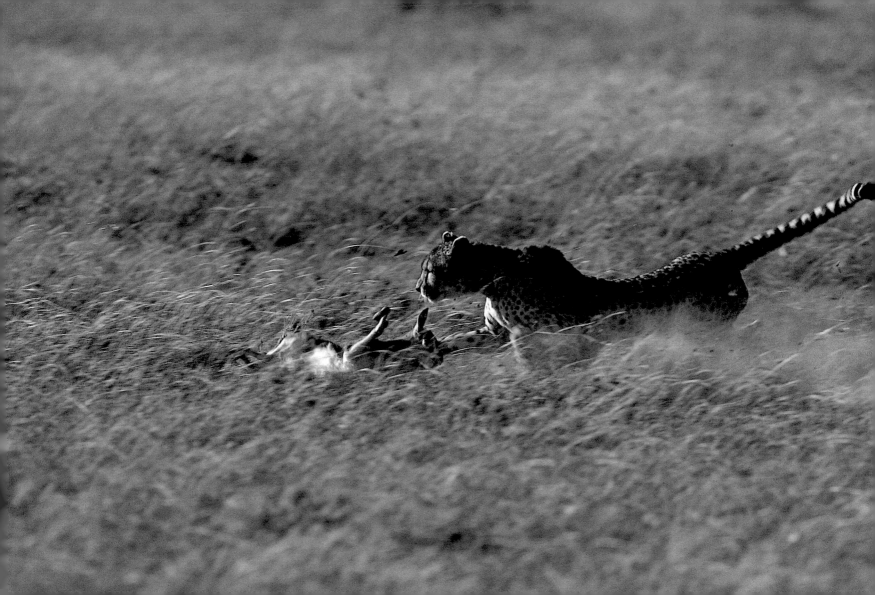

The herds move inexorably toward the life-saving grasses. Today they have traveled for 10 miles (16 kilometers), heading for a corner of the Serengeti where soils are deep, trees are plenty, and tall grass obscures features—and predators—in the landscape. The wildebeests are superbly adapted to move quickly and economically over long distances. It takes no more energy for a wildebeest to run a given distance than it does to walk it. They take full advantage of grass wherever it is found and remain within reach of water. During the dry season, it is a march for life.

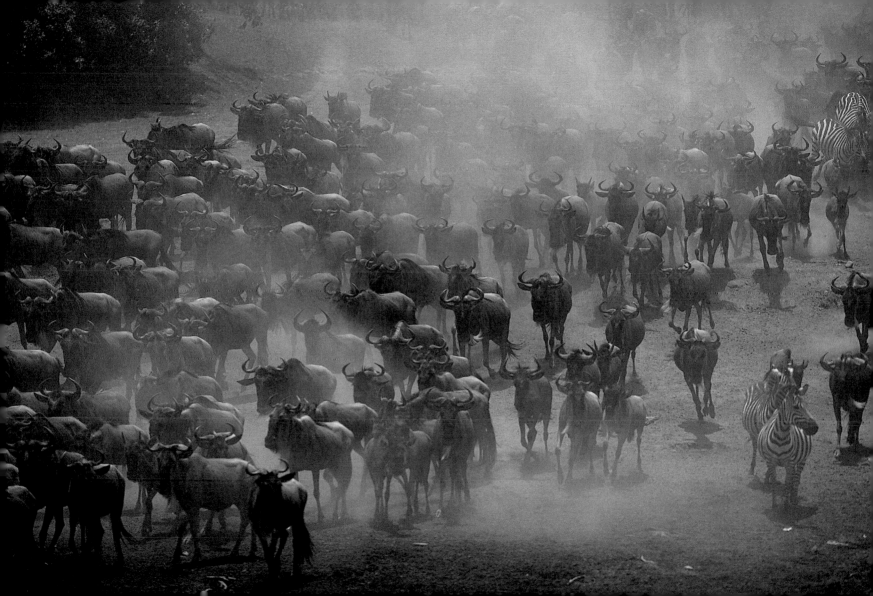

Where there are trees to browse, there are giraffes; and where there are giraffes, there are oxpeckers or tickbirds that rummage through giraffes' skin, looking for parasites to devour. The oxpecker's bill is flat on either side and is used in a scissoring action to pick parasites off the host animal. Its legs are short, its claws are very sharp, and its tail is stiff, a combination that enables it to climb all over the fantastically shaped giraffe rather like a woodpecker climbing a tree. Although oxpeckers keep the pelage of the giraffe free of blood-sucking parasites, they also feed on dead skin and scar tissues, keeping wounds open and vulnerable.

The granite islands known as Maasai Kopjes are near the center of the park, in the middle of the long-grass plains. Some of the migrants are within striking distance of these kopjes.

Before dawn, there is a ribbon of pink growing above the horizon. The sun rises and for a moment is cut in two by the horizon. Two adolescent lions, who have been resting on the kopje, make a move. They descend and enter the plains, vanishing in the grass.

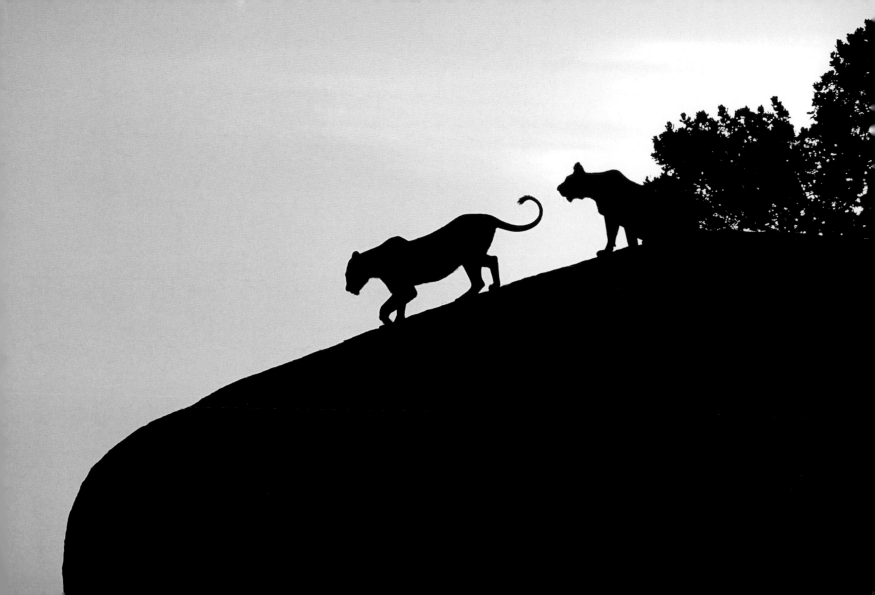

Boma Kopjes is a cluster of kopjes near Maasai Kopjes. There is a lioness sleeping at its base. The first zebras have arrived here, and they graze quietly at a distance. But when the lioness wakes up, stirs, stretches, and climbs the kopje, the stallion squeals to his mares, and they all canter away in the deepening light of the late afternoon. The lioness listens to her distant companions who have started to roar. She stands stock-still, ears cocked, looking in the direction of the roaring. Having pinpointed it, she climbs down and walks purposefully toward it.

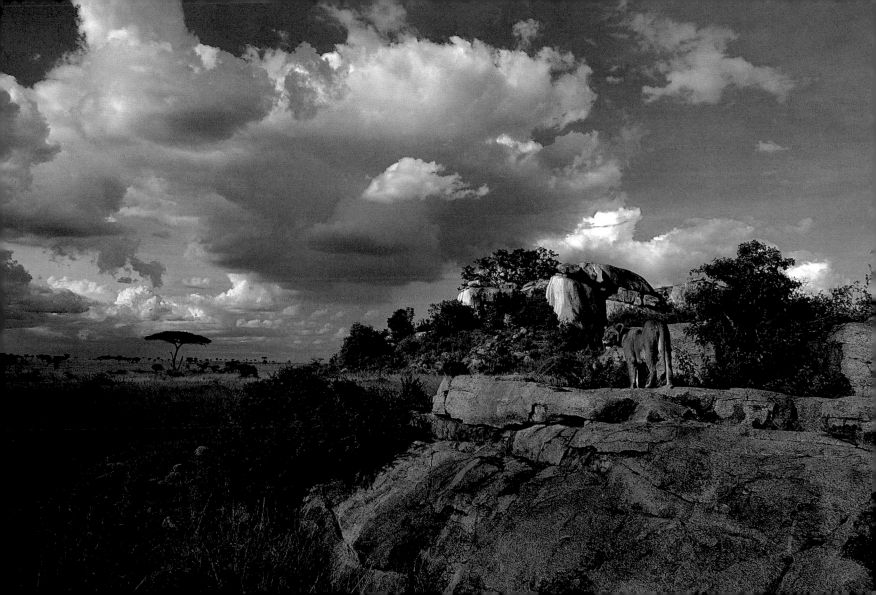

Driving on a track through the long-grass plains around Maasai Kopjes and Boma Kopjes, we pass 10- to 12-foot-tall (4 meters) trees every 400 yards (365 meters) or so. They serve as hunting perches for medium-sized birds of prey such as this kestrel, which are on the lookout for small prey, such as rodents and hares.

He is magnificent, nearly ten feet (three meters) long from nose to tail-tip. Broad-muzzled, deep-chested, immensely powerful with a magisterial, almost insolent swagger in his stride, he pads on the plains. He is patrolling in the early morning, renewing his scrapes and scent-marking his boundaries. Wildebeests watch him saunter past. They sense that the lion is not hunting and do not flee, but every head turns to face him. They are drawn to his wake, trailing after him as if they cannot bear to let him disappear from sight.

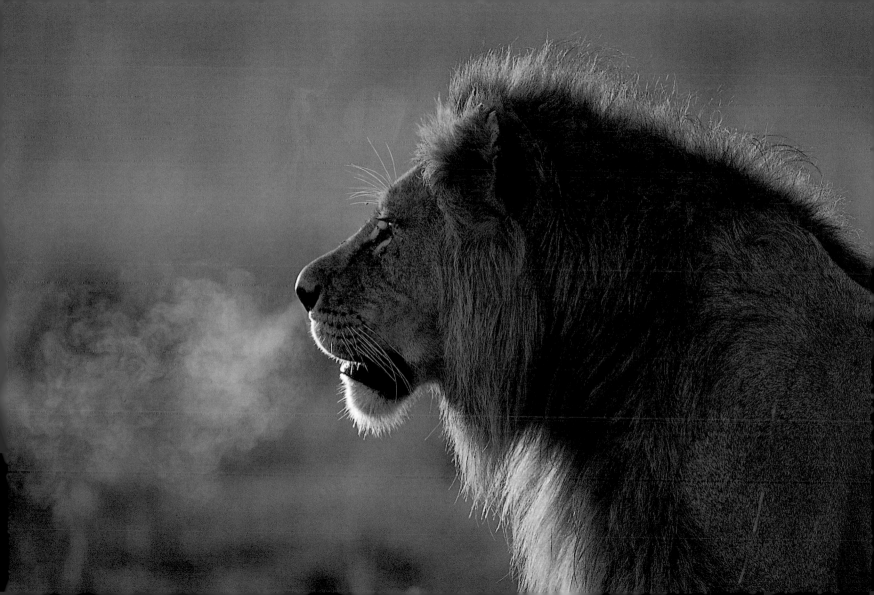

Over the shoulder of a hill, Sametu Kopjes rise in view. The largest kopje bulges organically out of the ground, a bastion of permanence in a landscape of restless change. Atop the boulders rests a fig tree. A shallow streambed drains a triangular green marsh beside a rapidly drying brackish pond. Shore birds pace around the edge of the water. We are at the very center of the range of the Sametu lion pride. The lions come up here for the shade under the fig tree, the view, and the shelter. The nooks and crannies between the boulders are good places to hide tiny cubs. During the wet season, the pride clings to the kopjes, but as the dry season unravels, it will wander far and wide.

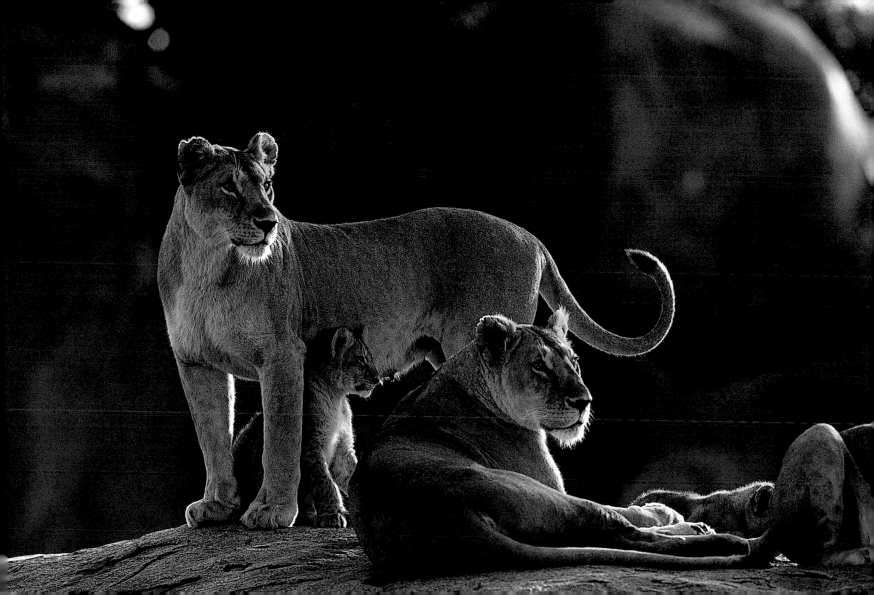

Blood-stained from feeding, an adult female is greeted on her return to the den by two pups that may or may not be her own. To help ease the reintegration process into the clan after an absence, hyenas engage in ceremonial one-to-one greetings. Hierarchical in all things, hyena etiquette requires the submissive animal to initiate the greeting. Several hyena clans live in the light woodland country surrounding Loliondo Kopjes, which are near Maasai Kopjes and Boma Kopjes. Now that the herds have entered the woodlands, the hyenas are spared commuting long distances for food.

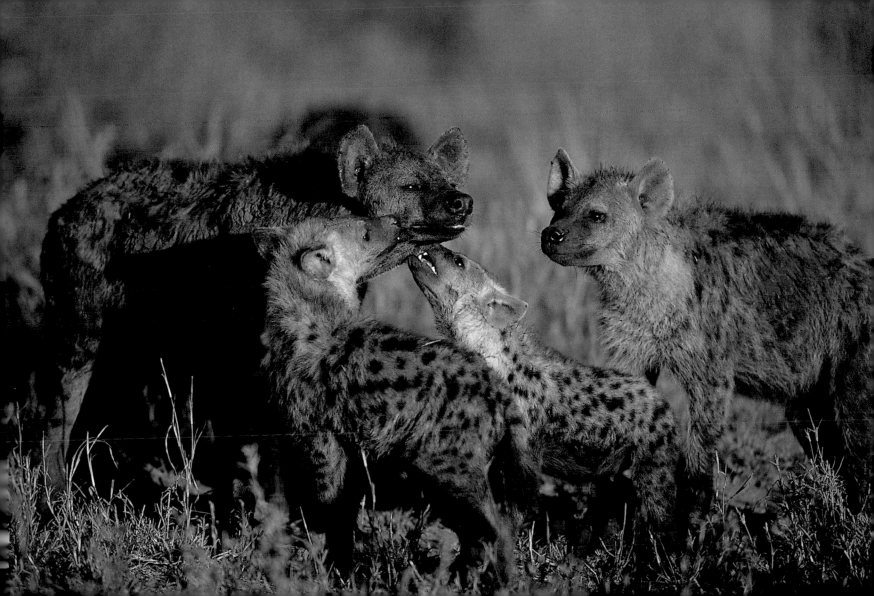

Having greeted each other and confirmed their hierarchical status, these two hyenas seem to be engaged in a painful fight, but they are only playing a friendly game. One seems to be saying, "I trust you. You can do whatever you want with those teeth. I know you won't harm me." Scientists believe that, as in human society, a hyena's position in the hierarchy determines its well-being.

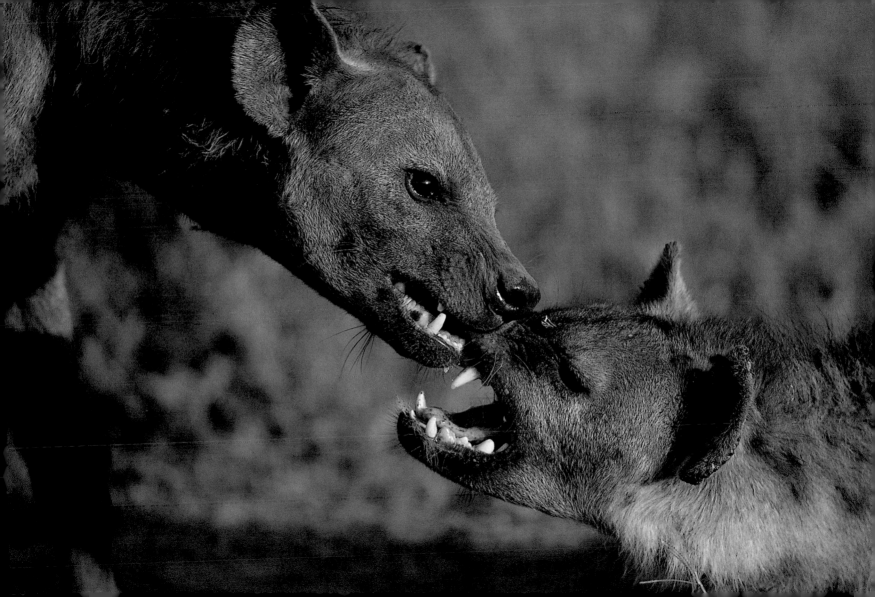

We come across a bull elephant on its own, feeding with dignity. We watch it for half an hour parked under a tree and notice that he is never quite still. He glides toward our tree silently and browses. After a while, he turns his great head in our direction. His mouth is enormous. Then, backing up gently, he makes a graceful three-point turn and moves away without a whisper.

The migration is on the move again, taking in several miles per day. When the grazing is done, they set off, marching nose-to-tail, all at the same pace, obedient to some hidden command. While marching single file, they try to keep the line intact. Where predators lurk, it is safer to follow in the footsteps of others than to wander at random and risk an ambush. Natural selection has favored wildebeests that follow dumbly rather than those that stray. This habit has become embedded in the wildebeests.

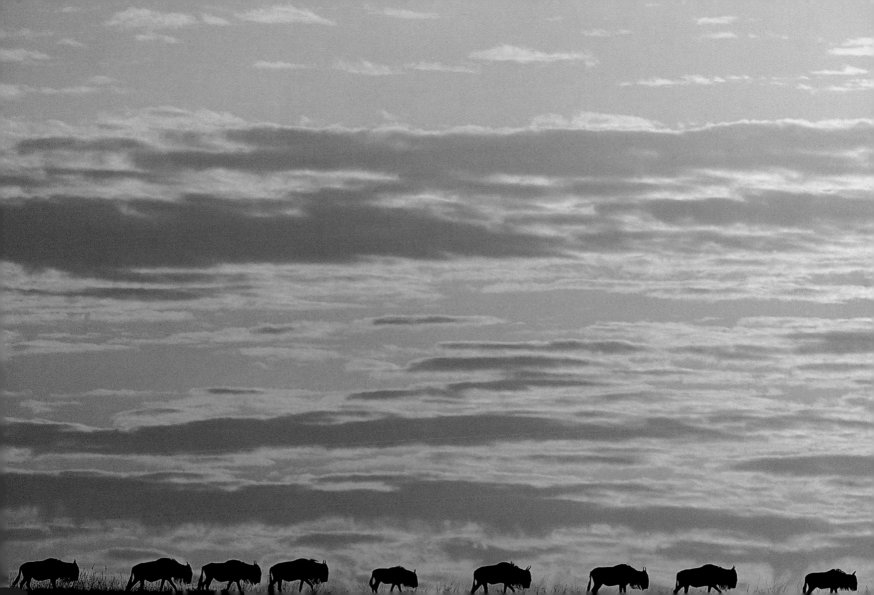

As usual, the zebras are ahead of the wildebeests. Silently, family by family, they have started arriving in Moru Kopjes, a sprawling complex of ancient rocks shrouded by denser vegetation where plains and woodland merge. A family led by an adult mare drinks at a pool just after dusk. The stallion lingers and scans after the rest of the family has moved on. This is dangerous country, especially at night, the time that belongs to hyenas and lions.

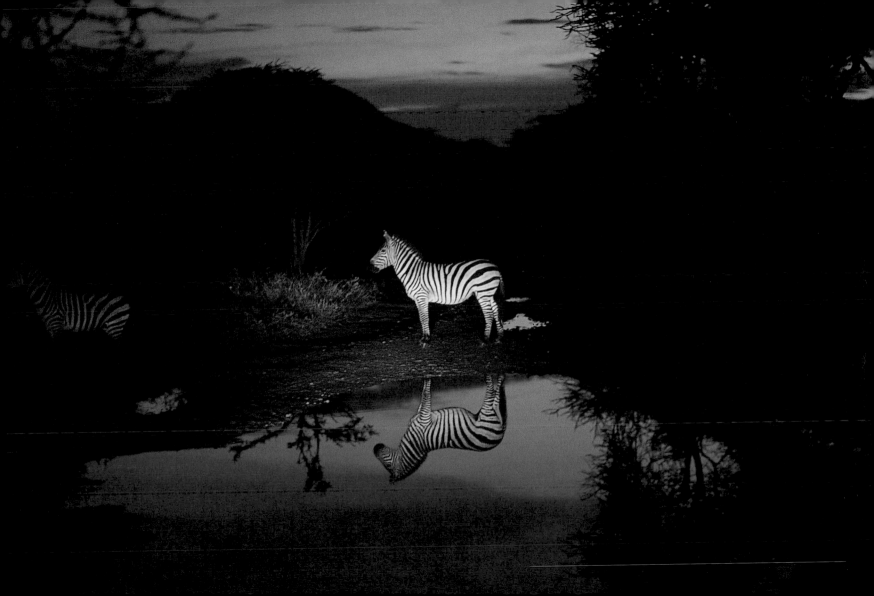

Moru woodlands are well supplied with pools of water, and terrapins, at roughly 12 inches (30 centimeters) in diameter, are the largest residents. They patrol their pools, on the lookout for thirsty birds. They submerge themselves completely in water only a few inches deep and wait with their eyes positioned just above the surface. When they spot a sandgrouse drinking on the far bank, they'll swim toward it without a ripple. If the sandgrouse moves into the water to bathe, the terrapin will strike.

The rugged Moru Kopjes in early May. To the northwest of the kopjes, the Nyaraboro Plateau stands defiant. There is permanent water here so the westerly movement of the migration will pause here. The herds have trekked for miles in long, wavering lines, and now they are fanning out to graze. From the air, the country looks covered with ants.

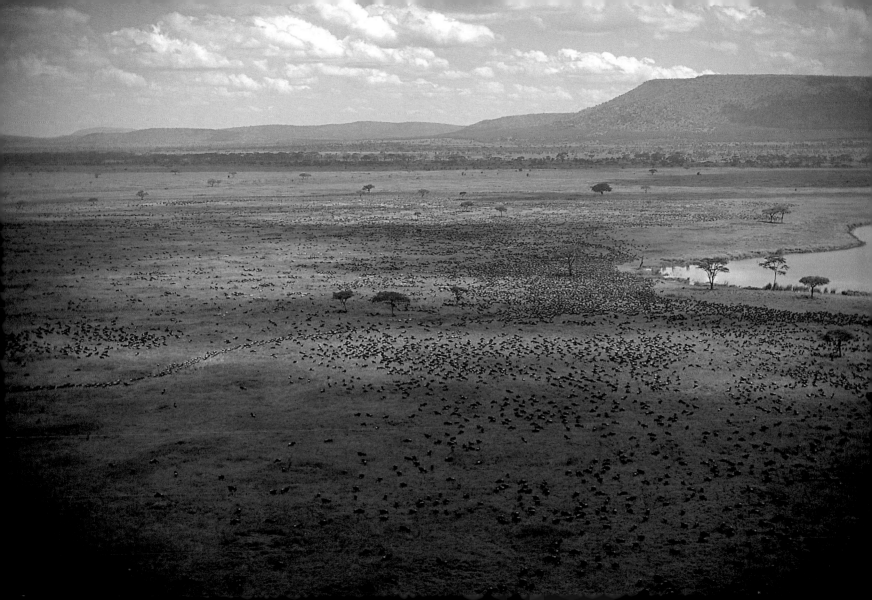

The "Moru crush" has begun. The herds have massed together in a very small space, almost touching each other. The sounds of the migration—the honking and grunting of wildebeests, the yelping and barking of zebras—are the loudest. The animals give the impression of an organized yet noisy army as they line up to trek to water; they will leave in single files once drinking is done.

On this, the second day of the "Moru crush," a family of zebras picks its way through the throng of wildebeests. It walks in a line, senior mare in front, stallion bringing up the rear, all staying close together.

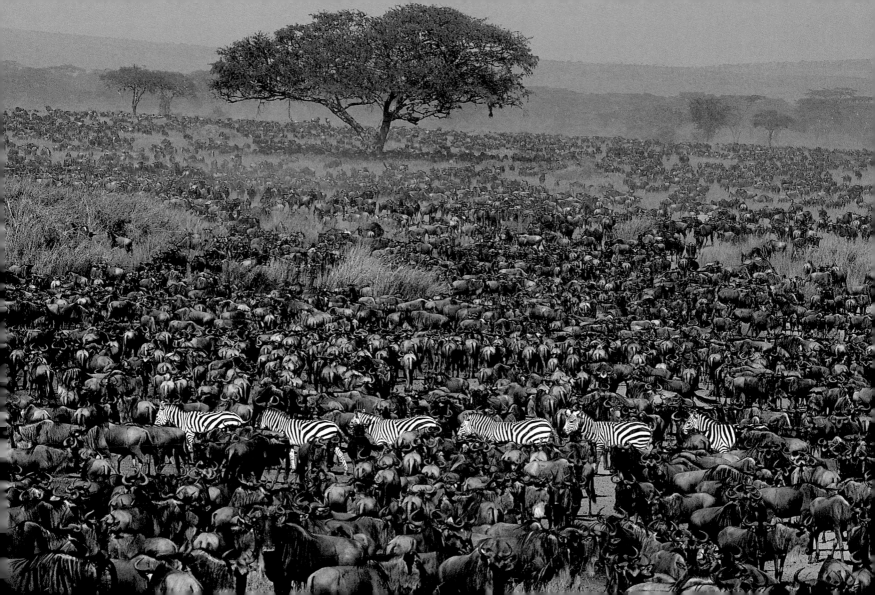

The best of the grazing at Moru has been cropped. Water that was clear a few days ago has turned opaque. This evening the animals give the impression of being restless. A few strike out west and a few thousand follow. It appears that after a short pause at Moru, the long march is under way again.

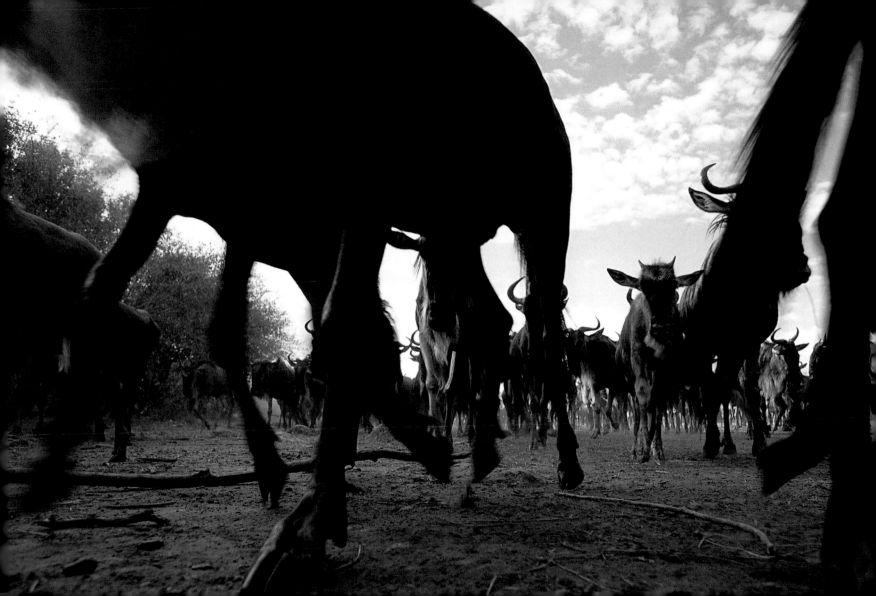

The "Moru crush" disintegrates. The herds are leaving Moru in the form of two giant organisms: Roughly two-thirds move toward Seronera woodlands; the rest head down the Mbalageti River and will follow it into the Western Corridor of Serengeti National Park. We watch them being swallowed by a sea of bush and turn to the others who are raising dust as they head toward Seronera.

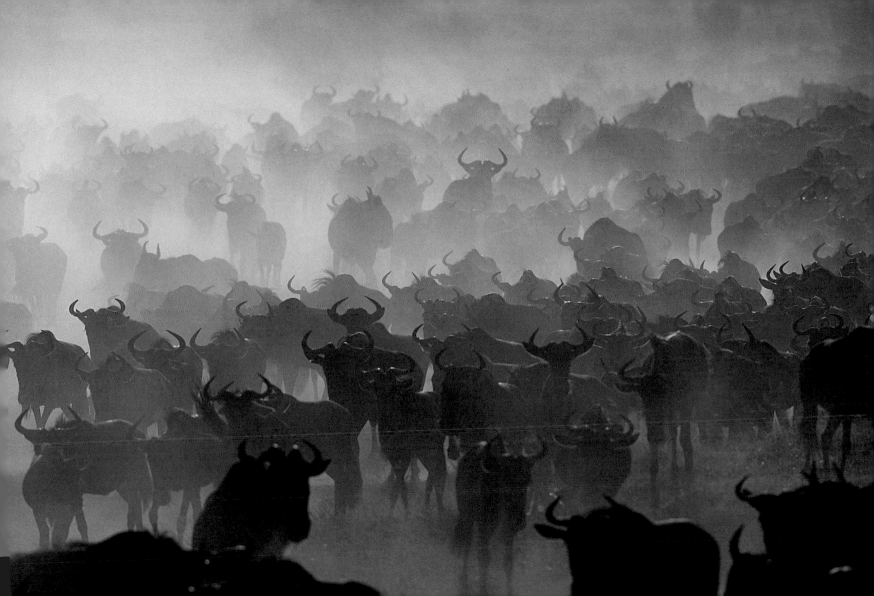

The herds are departing, so lean times lie ahead for the Moru lion pride, although they were busy in the night, successfully reducing the wildebeest population by one. This lioness is still feeding this morning, aware of the waiting vultures. She is almost full, but she is reluctant to leave the remains of the kill to the birds. As she walks to shade, she looks back, sees the vultures advancing to the kill, and charges to drive the scavengers away. Soon, however, the lioness abandons the kill for the cool shade, where her companions are resting.

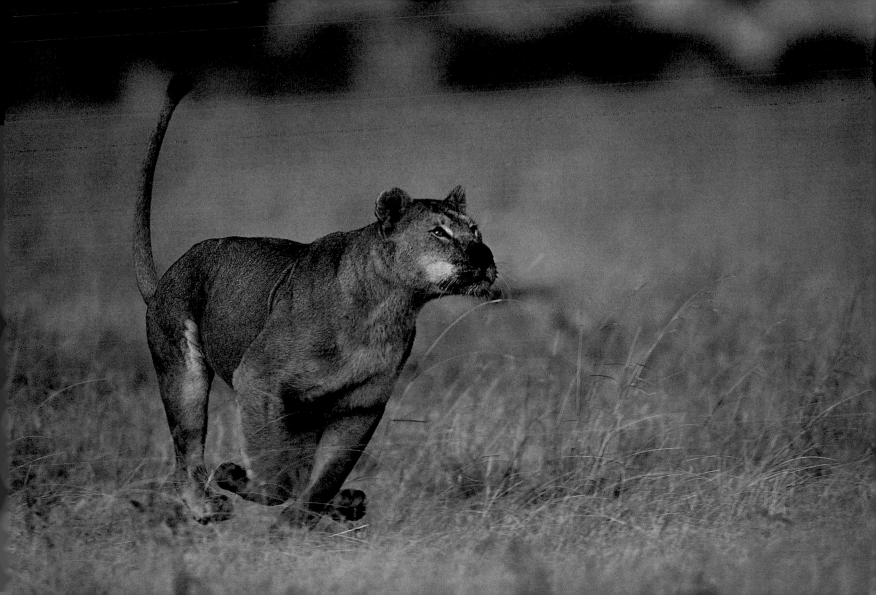

In the predawn semidarkness, something scares the herds heading toward Seronera. In panic-stricken flight, their hooves stomp the faintly lit earth. There are burrows and hollows, dens and refuges lying in wait to snap a wildebeest leg, but in their blind terror, they seem to ignore all such risks. We are following the herds heading to Seronera. The herds that went along the Mbalageti River will be negotiating terrain that no truck can navigate.

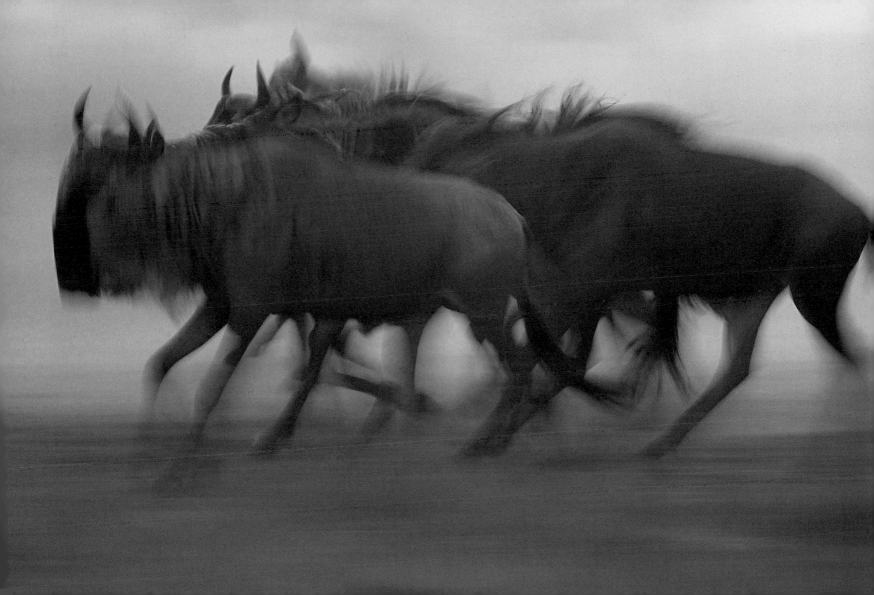

Wildebeests pour down Mukoma Hill, trampling the grass beneath their hooves. Once in Seronera Valley they disperse to graze on the red-oat grass plains. The open woodland of Seronera Valley is broken in places by granite kopjes and winding *luggas* (seasonal riverbeds), whose overgrown banks provide deep cover beneath beautiful stands of yellow-barked acacia trees, palm trees, and shady sausage trees with their strange pendulous fruit. The herds will stay here for some days, for there is both water and grazing.

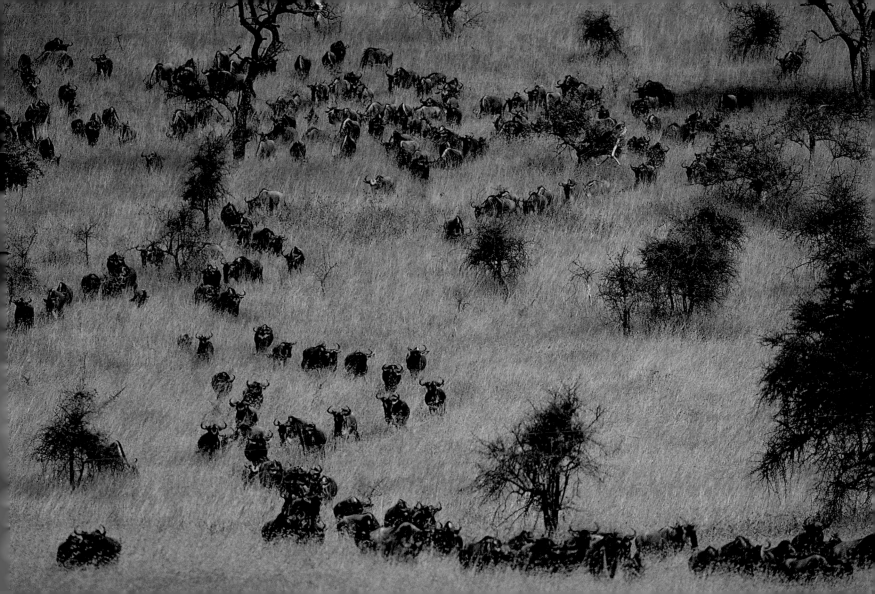

The springs around Seronera hold water throughout the year, which is why the area is partially wooded and always holds a larger diversity of game than the plains. The migrants avoid the pleasant coolness of the glades: The trees are a favorite haunt of leopards, and lions lurk in the cover. So the herds keep to the treeless plains as much as possible. However, when thirst pulls them in off the plains, they warily approach places where they can drink. Wildebeests fear sudden silences, which often signal a predator is approaching. But these two marabou storks fighting for a tree-perch are indifferent to the hush.

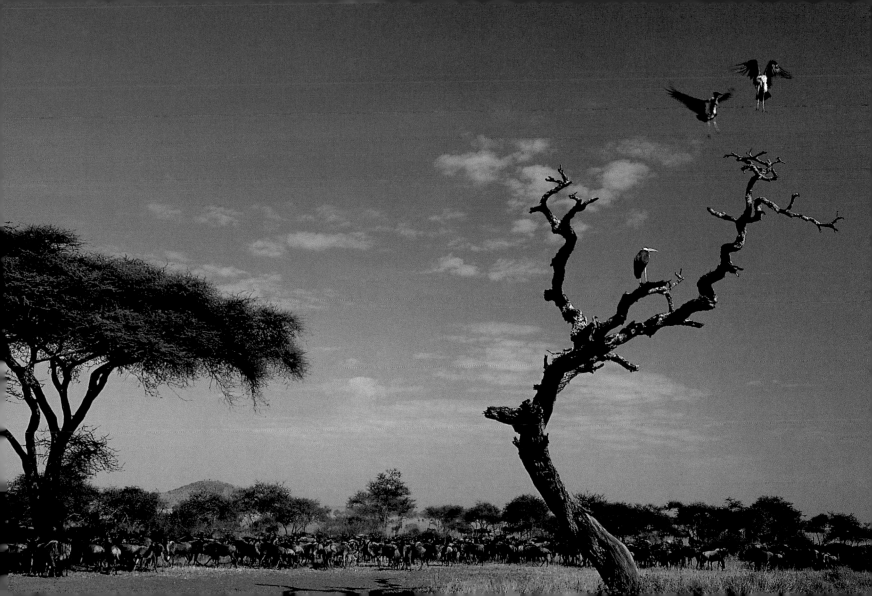

Three male buffalo are grazing, and another one is horning vegetation, a dominance display. The plains and the woodlands are two different worlds, inhabited by different species. Among the wooded grasslands there are many more topi, Coke's hartebeests, giraffes, impalas, dik-diks, and buffalo. When these wooded grasslands are invaded by the migrants, grazers such as hippos and buffalo may experience a shortage of grass.

A leopard hides in the grass, its spotted hide making it almost invisible, except for its tail. Without cover, the leopard cannot hunt successfully. While it does not have much stamina, it is an extremely powerful animal with an explosive, short sprint and weapons of death, its teeth and claws. The leopard has no need to migrate. Wandering up and down its territory, which extends along the swampy watercourses, it catches reedbucks, impalas, dik-diks, warthogs, guinea fowl, and, on occasion, a jackal or an African wildcat. However, the migration brings opportunities to ambush wildebeest calves and zebra foals, most of which have never seen a leopard and know nothing of its guile. When it finally locates its prey, the leopard will lower its tail.

RIGHT

There is good browsing for elephants at Seronera, which leaves them with time to socialize and play.

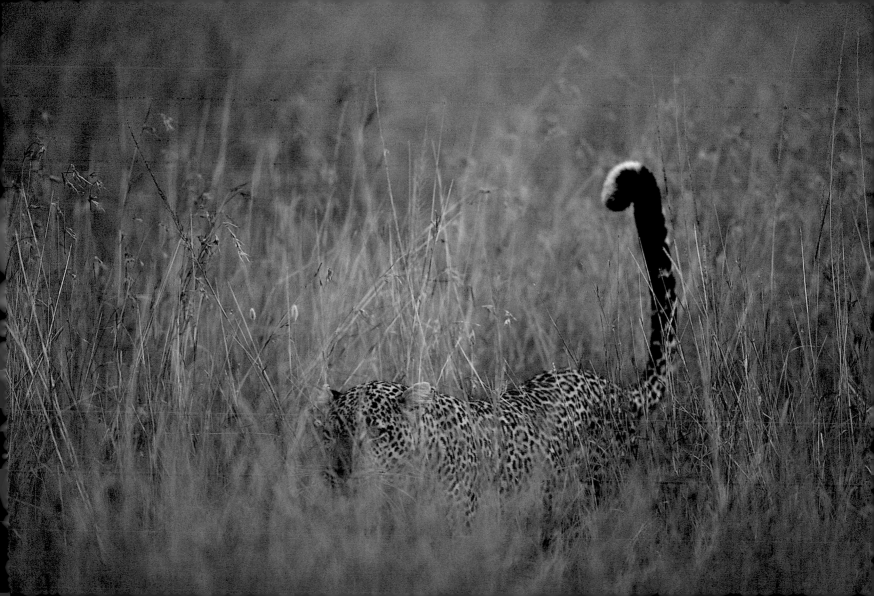

The sentinel baboon up a tree with its great vision is, unwittingly, the finest warning system on the savannah. For the baboon, the tree is a refuge from the torment of flies. The tsetse flies suck the blood out of wildebeests, but they will target warthogs, giraffes, buffalo, duikers, hippos, and other residents when the herds are not around. They drink less frequently from the active impalas and the secretive waterbucks, and they have great difficulty reaching vervet monkeys and baboons when they are high up in a tree.

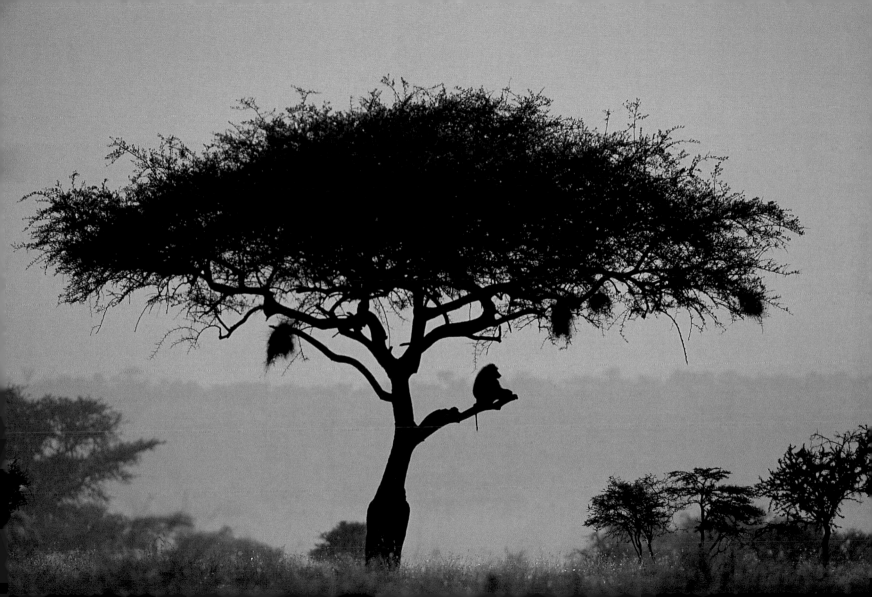

Evening at a Seronera pool. This lone zebra foal's movements are sluggish, its reactions slow. It stays standing in the pool for quite a while, listless and spiritless. Perhaps it is tired or perhaps it is sick. Or perhaps it has nowhere to go, having lost its family — there are no other zebras in the vicinity. Its being here by itself is a mystery. It is safe for now, but soon darkness will crowd out the evening and lions and hyenas will be on the prowl.

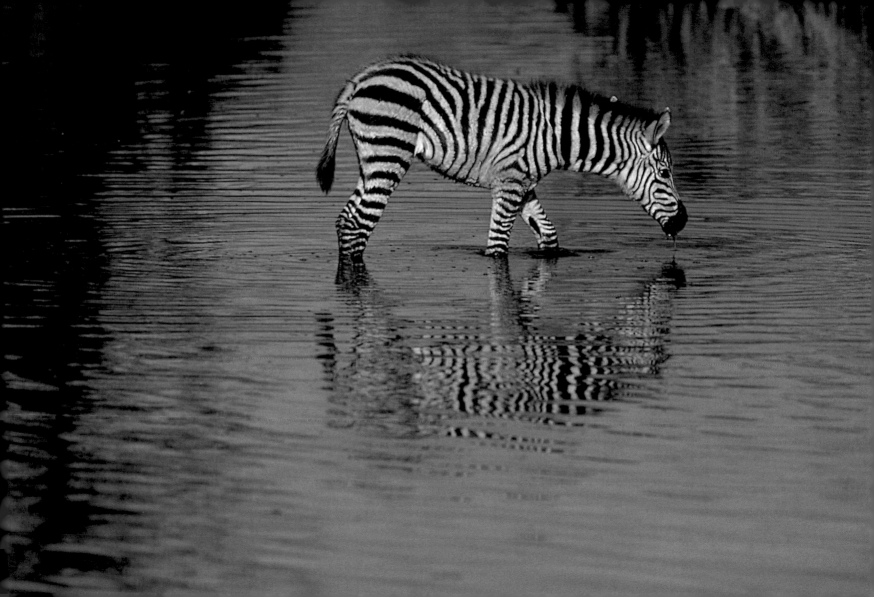

Seronera Valley has a great deal of tree cover, with ample scatterings of flat-topped acacias on which giraffes feed. Giraffes host nematodes in their livers, parasites in their bloodstreams, and swarms of parasites on their skin, which send hungry oxpeckers exploring all over their bodies in search of ticks, eggs, and larvae. But despite the efforts of these birds, the most common cause of death among giraffes is likely parasites.

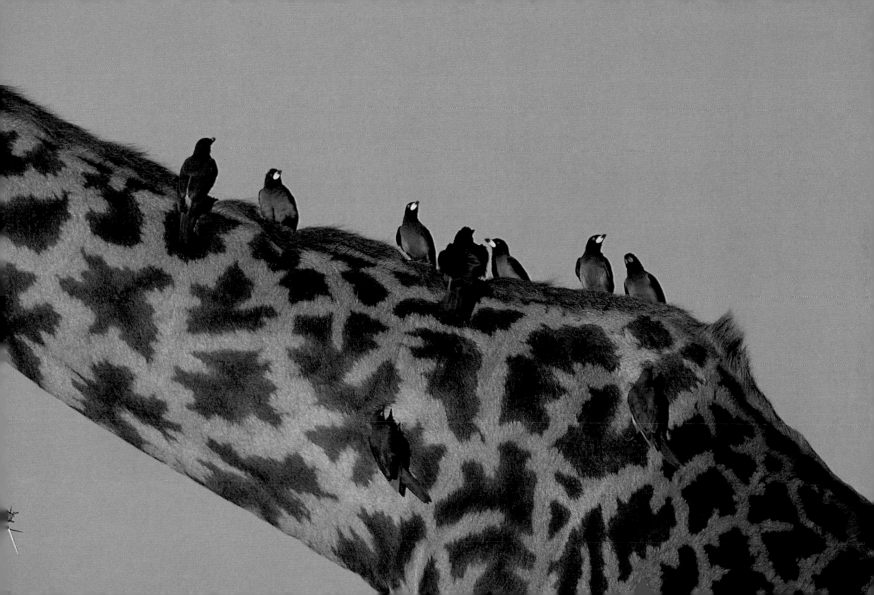

A Verreaux's eagle owl sits on a perch by the river in mid-morning light. Its eyelids, which show from time to time, are a startling pink. A creature of both night and day, it is the largest of all African owls as well as an accomplished hunter. Its flat facial discs conceal ears so sharply attuned to their surroundings that they can locate and identify sounds as faint as the patter of a mongoose in the grass, or the dry, papery rustle of the blue-and-red agama lizard as it scuttles over a fallen tree trunk. Its varied diet includes hares, hyraxes, hedgehogs, bush babies, frogs, snakes, guinea fowl, francolins, and even unfledged birds of prey.

Sunbirds are indifferent to heat. They head for flowers to suck nectar, revealing the exotic details of their iridescent feathers. They are similar to North American hummingbirds, except that they cannot hover in the air.

A male red-headed agama lizard emerges from a crack in the rock on a kopje. With its garish combination of bright orange-red head and deep-blue body, it is sometimes identified as a rainbow lizard. These rich colors are ritually used by males to advertise territory to rivals and consorts. Taking station on a prominent rock, males carry out a series of jerky push-ups, bobbing their bright heads in semaphored challenges. Other males take note and steer clear. Like chameleons, agamas can change color in seconds. If chased by a rival, an aggressive male in full coloring turns drab olive.

A band of dwarf mongooses has spent the night on a kopje in the heart of Seronera Valley. A troop of vervet monkeys has passed the night in a stand of nearby trees. Half an hour after sunrise, the mongooses emerge onto the open rocks. Just then, the vervets arrive. One young monkey sees a lone mongoose and decides to play with it. The mongoose is rather taken aback by the monkey's antics and becomes defensive, at which point the monkey gives up the game and continues on its way.

Across an acacia-dotted plain at Seronera, a nursing hyena mother lopes along in hunt of prey. Even in moonlight, it is not safe to run at top speed over a landscape littered with termite mounds, holes of bat-eared foxes, jackals, honey badgers, and warthogs; one misstep into a mongoose burrow could cause serious injury to a leg. For the present, the herds are in Seronera so she will not have to run far. Nevertheless, her powerful muscles are capable of sending her more than 25 miles (40 kilometers) from her den in search of the red meat that will fill her udders with rich milk for her pups.

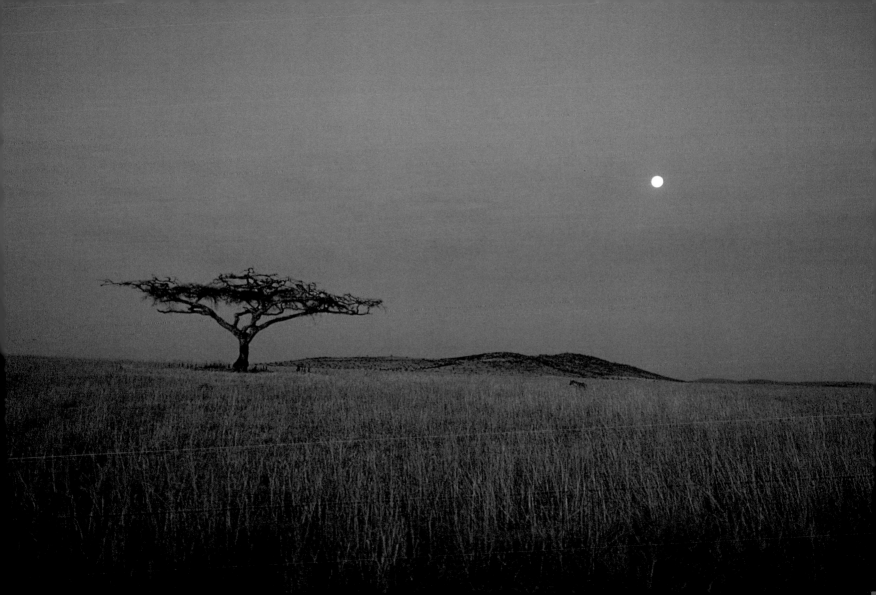

About a third of all migrants have poured into Seronera, filling up the sunlit grasses. These zebras and wildebeests normally stay in and around Seronera for about a couple of weeks and then move west. There, they meet up with the herds they parted with at Moru. Another third of the migration is moving directly north.

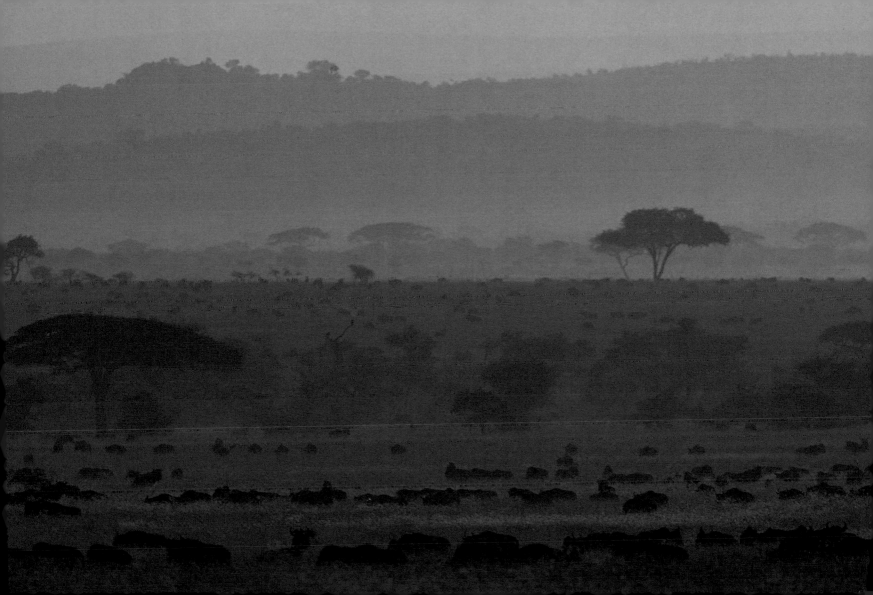

A Seronera lioness sleeping in tall grass is aroused by the noise of the herds close by. As she watches the grazers, every muscle in her body is taut, her muzzle is thrust forward, and her gaze is locked on the noisy cavalcade. Crouching, she slides forward, snakelike. She stops and uncoils her tense body to charge. In that moment, a pair of giraffes ambles by and spots the big cat, and a zebra notices the giraffes staring fixedly into the grass. Others catch on, one by one. Caught in the act, the lioness understands the game is over, at least for the time being. Soon she will be on the prowl again.

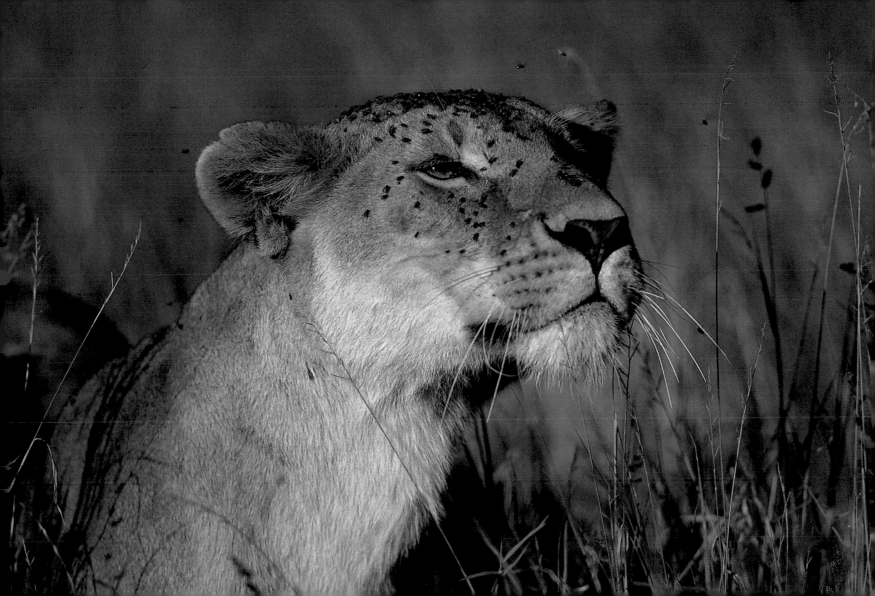

Dangers always lurk near rivers and pools. These advancing zebras are more cautious now that they are close to the river. At their head is a female, most likely a veteran who knows that such places are dangerous. Keen to drink, she advances, followed by other zebras and wildebeests. Then something moves in the bushes and the animals beat a hasty retreat. They turn and wait. In due course, a dik-dik emerges, looks surprised at being at the center of attention, then continues on its way, bemused.

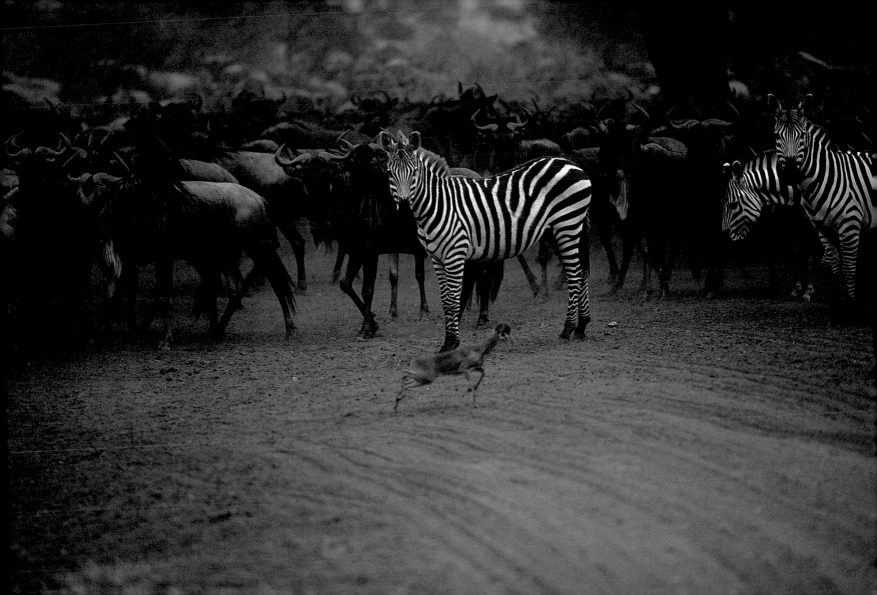

Leading a migratory life means that the herds are always entering new territory, where the lay of the land is unfamiliar and possibly dangerous. Seronera River is just such a place. Of all the animals in the migrating herds, zebras are the thirstiest followed by the wildebeests. Unlike wildebeests, who congregate noisily at the river in large herds, zebras arrive in small family groups. Zebras are also more cautious and more easily spooked. Any hint of danger and the suspicious zebras are the first to dart away, with the wildebeests not far behind.

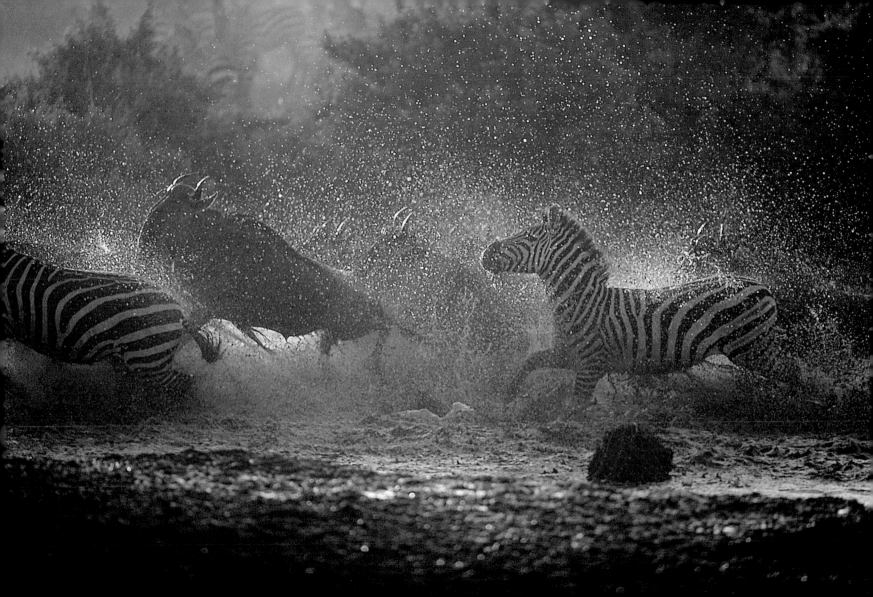

Along the routes of the migration, much disorder prevails. An old zebra mare leads her family to the river. She stops, checks and rechecks for danger, and, apparently satisfied, goes down the bank. As her mouth hits water, the rest of the family joins her. While the zebras are obliged to watch and drink at the same time, a lion waiting in ambush has only to watch. On the other hand, with a fair start, a zebra can outrun a lion, which is what happens this time. When a zebra spots the lioness early on, she lunges away, the others close behind, their hooves beating the earth like a drumroll.

The plains surrounding Seronera have been stripped of their cloak of long grass by the migrants. They look parched, the soil is ash-gray, and whatever grass is left is rustling dry and lifeless. The migrants have begun the exodus to new lands.

Nyaraswiga Hill is a prominent landmark overlooking Seronera. To the west of Nyaraswiga, the landscape is wild and beautiful, and rocky cliffs tumble down into Musabi Plains and Datwa Plains. This is wild, unspoiled country—this is where the Seronera herds are heading.

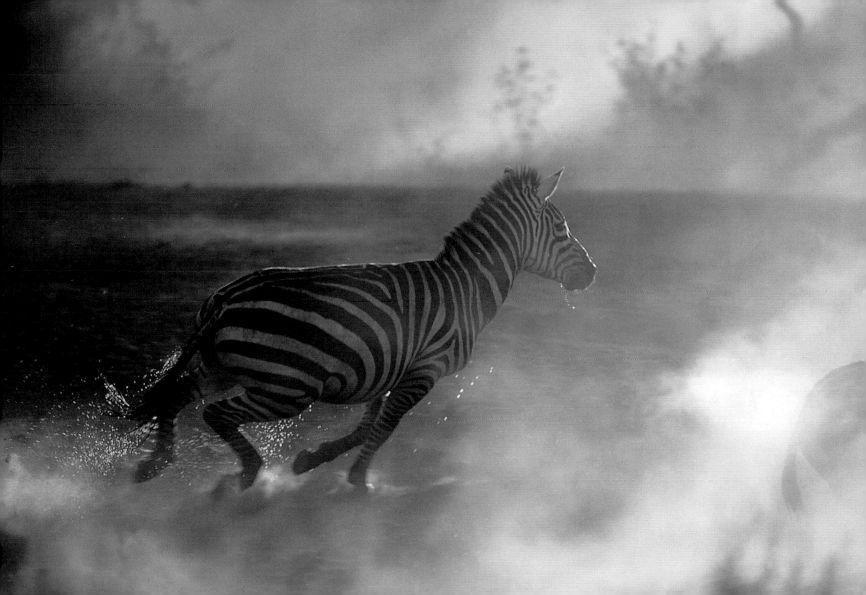

Early morning, Seronera. A freshly burned area appears blackened and desolate. Somewhere, there are charred crisps of insects overtaken by last night's flames. Its only a matter of time before birds that feed on insects discover this banquet. The migrants pay no heed, skirting the area on their way west.

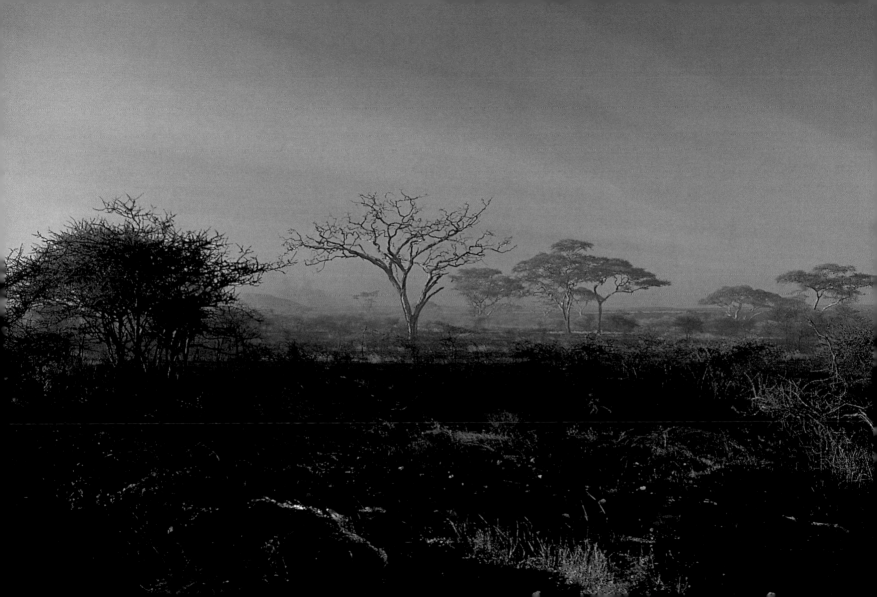

By now the majority of migrants have left Seronera behind and entered the Western Corridor. This herd is spearheading the migration across the Musabi Plains in the corridor.

In terms of vegetation, much of the Western Corridor is whistling thorn country: Those stunted-looking little trees bear black galls, which are full of ants. Here, under stony hills, there are also acacia woodlands and open plains dotted with spiky thickets of wild sisal.

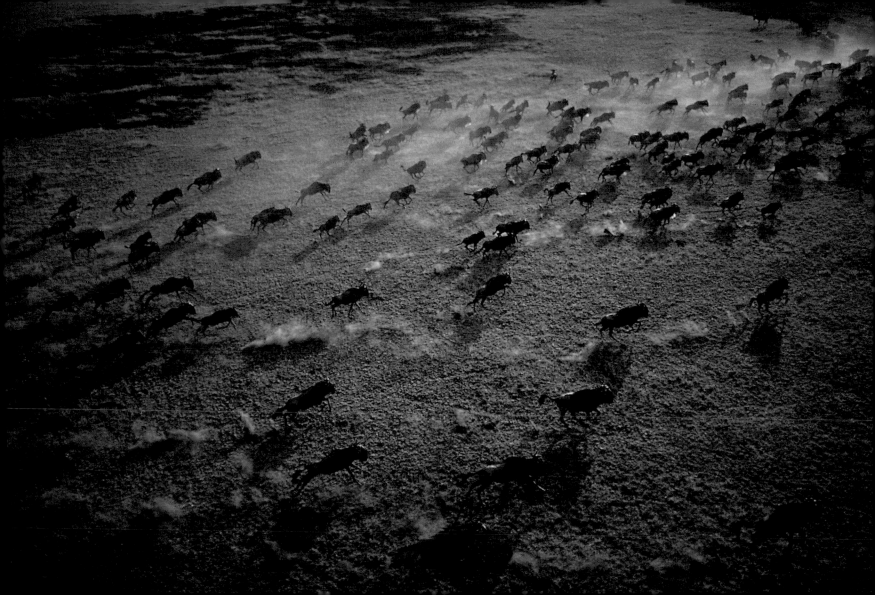

A herd on Musabi Plains in the Western Corridor has broken up into smaller groups of ten to fifty females and calves that are feeding and resting. A bull oversees each herd, patrolling continuously with his head held high. This is the time of the rut, and there are many brief clashes between bulls jealously guarding their females. Most clashes are "challenge rituals" intended merely to warn off other bulls. Thus, when two bulls draw near, they accelerate and drop to their knees, head to head. They may or may not make contact. Then they run off, heads held high, moving away with their characteristic rocking gait.

All around there is repeated tossing of horns, pawing of ground, and a great deal of grunting and roaring. The mature bulls are having a hectic time, simultaneously chasing off intruding males and trying to keep the females within tiny, temporary territories.

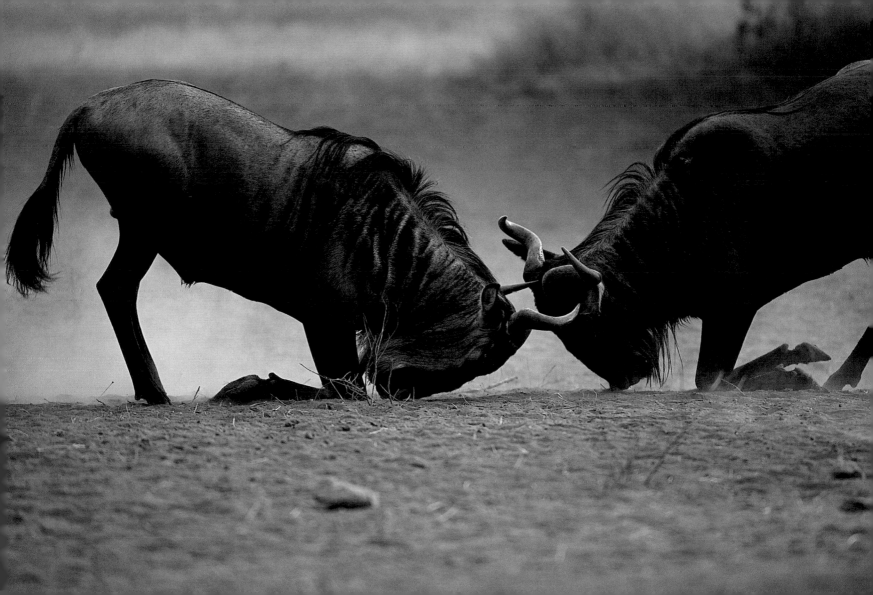

The basso profundo mating chorus, which sounds like a cross between a cow moo and a giant bullfrog croak, fills the air. Thousands of wildebeest cows have come into estrus within a very short period of three weeks. This concentrated rutting season is timed to coincide with the season of nutritious grass on the short-grass plains, where the wildebeests will be months from now, at the time of birth. Wildebeest mating and conceiving takes place on the road as the migration moves through the wooded grasslands. Since gestation is eight-and-a-half months, most births will take place next February.

A fire feeds hungrily on large quantities of dried vegetation. Large mammals such as these giraffes are not disturbed by fires, which they can avoid with ease. The combination of grasses found in the Western Corridor reflects the impact of seasonal fires, which for centuries have swept through these areas during the dry season, thinning out the woodlands and enabling particular fire-adapted grass species to evolve and thrive.

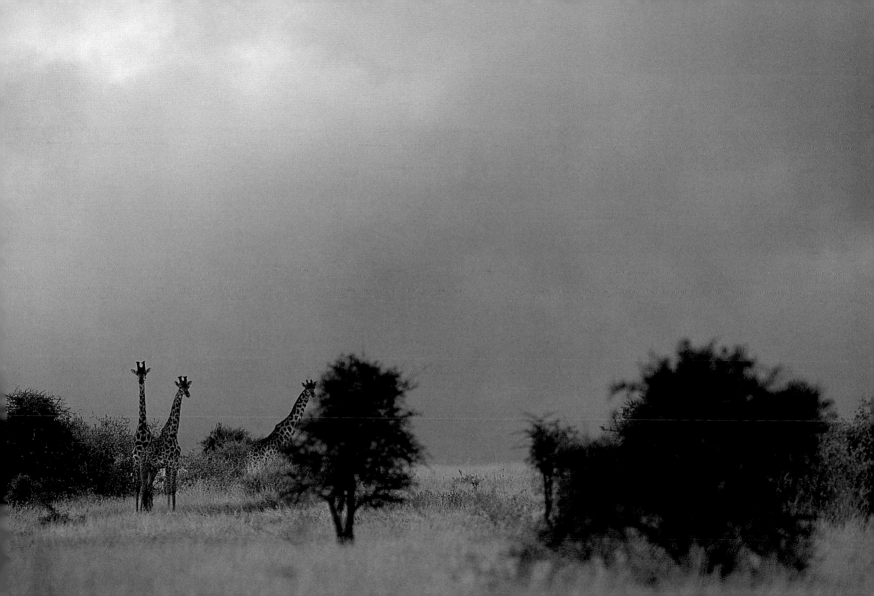

Guinea fowl flee from a raging fire. Guinea fowl are found throughout the plains and shaded acacia country, and they are a constant resource, available to any determined hunter. They are caught along the edges of pools and watercourses, in the trees by leopards and baboons, and in long-grass country by serval cats and caracals. When attacked, they cackle their outrage uproariously. Theirs is a special kind of survival, one that is difficult to comprehend.

At a different fire, a few miles west of yesterday's fire, the air is filled with fleeing winged insects, and storks are busy feeding on them. The storks are unperturbed by the heat as they traverse the edge of the fire, snapping up small life. Occasionally, a marabou stork stabs at a snake, picks it up in its beak, batters it on the ground, and swallows it whole. The migrants graze nearby, seemingly unaware of the fire.

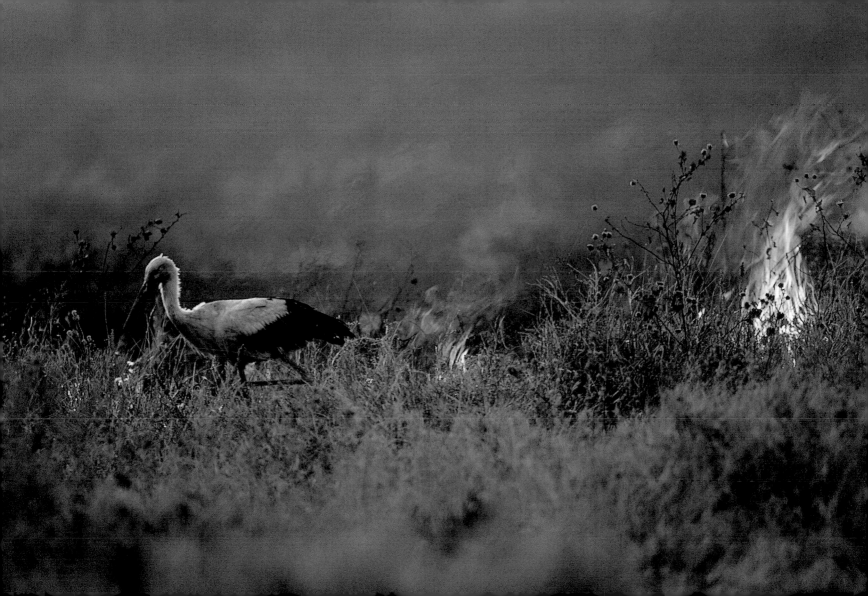

A lilac-breasted roller, one of Africa's loveliest birds, swoops down and expertly catches an insect fleeing from the fire. Fire sweeps the woodlands and tests the mettle of trees and grasses, shrubs and herbs, all of which have to resist it or die. The bark of some trees is corky, receiving the heat, absorbing it, and blackening but not actually burning. Some grass burns above the soil, but the roots live on. Others produce seeds that are fire-resistant enough to survive the scorching. The fires suggest death but the devastation presages the distant season of green when trees will sprout new leaves and grass will grow again.

The sky is empty. Everywhere there is quiet. But the peace of the moment is lost on this nomadic cheetah, for it is preoccupied with tracking the movement of the herds. It moves because its victims are moving. For resident cheetahs of the Western Corridor, the influx of migrating gazelles is a mixed blessing; the supply of gazelles increases, but along with that, the influx of nomadic cheetahs increases demand.

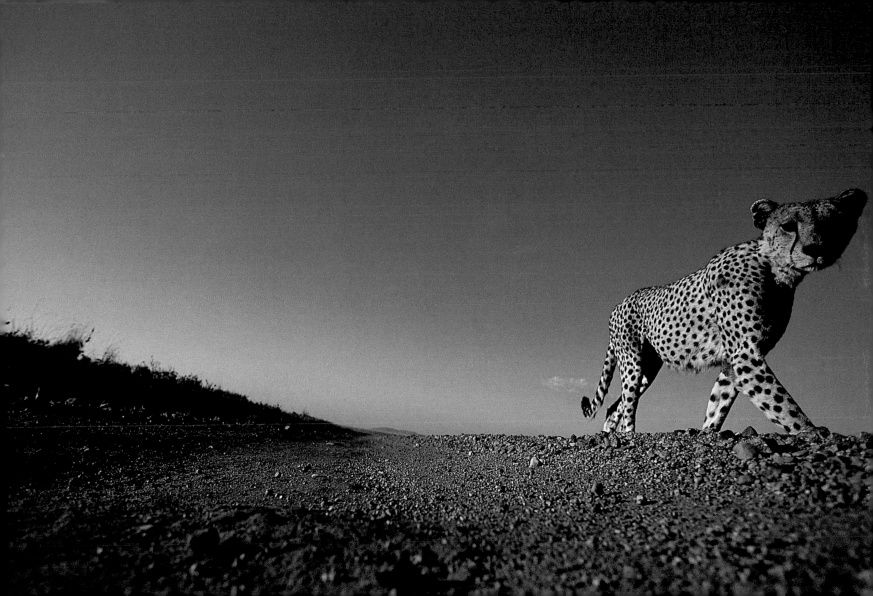

Skittish zebras are slow and hesitant on the approach to water but quick to exit at the slightest hint of danger. Permanent woodlands demarcate the position of the Grumeti River, which flows through the Western Corridor. The hills on either side of the corridor are also covered with open woodland partly reflecting the increased amount of rain received here and partly reflecting the replacement of the thin volcanic soils with the more ancient and deeper granite soils.

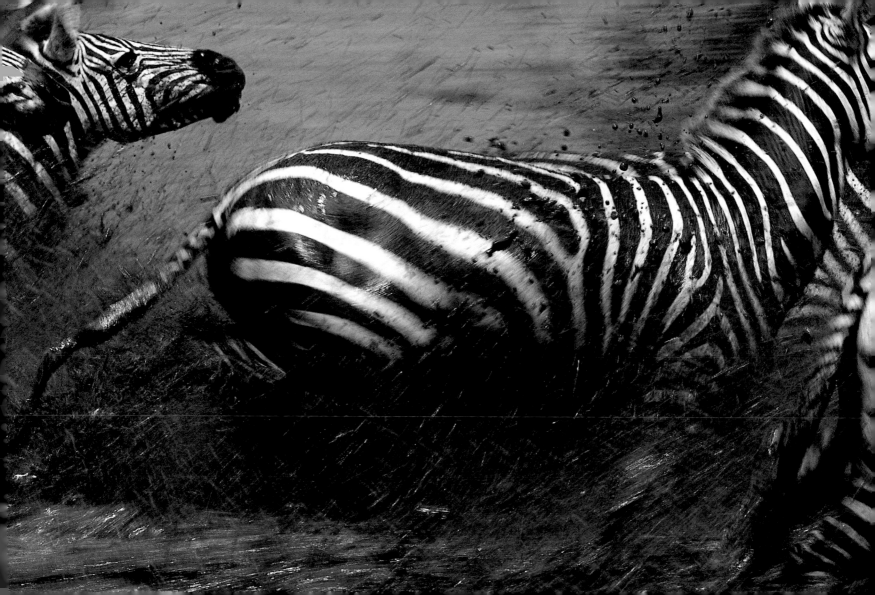

In this drying land, the Grumeti flows. Wild figs, podo, and borassus palms grow at the river's edge. The flow of water is narrowing, and pools are beginning to form where the riverbed is wide. The river starts in the northeastern corner of Serengeti National Park, in the beautiful granite hill country, not far from Lobo Safari Lodge, and flows into Lake Victoria, 100 miles (160 kilometers) away. It is a year-round source of water upon which the migrating animals depend. The herds are bound to come here and perhaps stay for up to two weeks before resuming their march. We pitch our tent in anticipation.

The migrants are in the woodlands on the hills, inaccessible even to those in a four-wheel drive vehicle. They are about a week's march from a stretch of the river called Kirawira. Today, we have an avian visitor, a hadada ibis. A wading bird with thin legs, and a long neck and bill, it is looking for small edibles such as frogs and fish. For a second, its plumage is caught in the light, showing off its metallic sheen of purple, green, and bronze.

There is a growing human population outside the park, adjacent to the Western Corridor, and poachers sneak in to trap animals. The anti-poaching patrols manage to gather most snares but not all. Those unlucky enough to get caught in one will struggle to break free and may even lose a limb in the bid for freedom. This was probably the fate of this three-legged lion. While his spirit to live is remarkable, and he actually looks healthy, how he manages to survive is a mystery. All we know is that he lived alone and scavanged for his food.

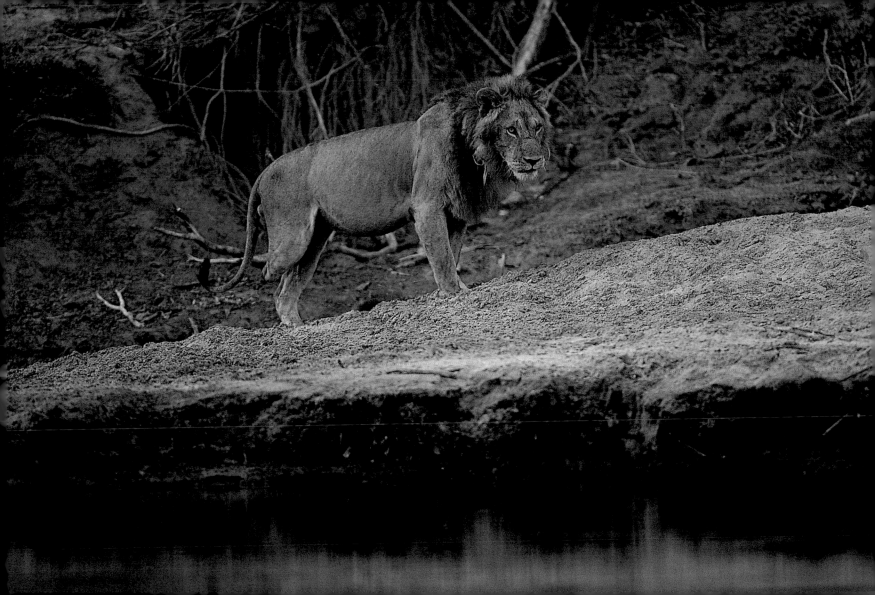

As the dry season lengthens and resting spots shrink in number, crocodiles and hippos are forced to share the diminishing space, but they have adapted to the point where they will actually rest relatively peacefully side by side on the wide, dry banks. Occasionally, curiosity will compel a young hippo to examine his neighbor, which, in this case, happens to be a crocodile, by nibbling at it, much to the reptile's displeasure. Each species is fully capable of inflicting serious damage on the other, but generally, under these circumstances, they refrain.

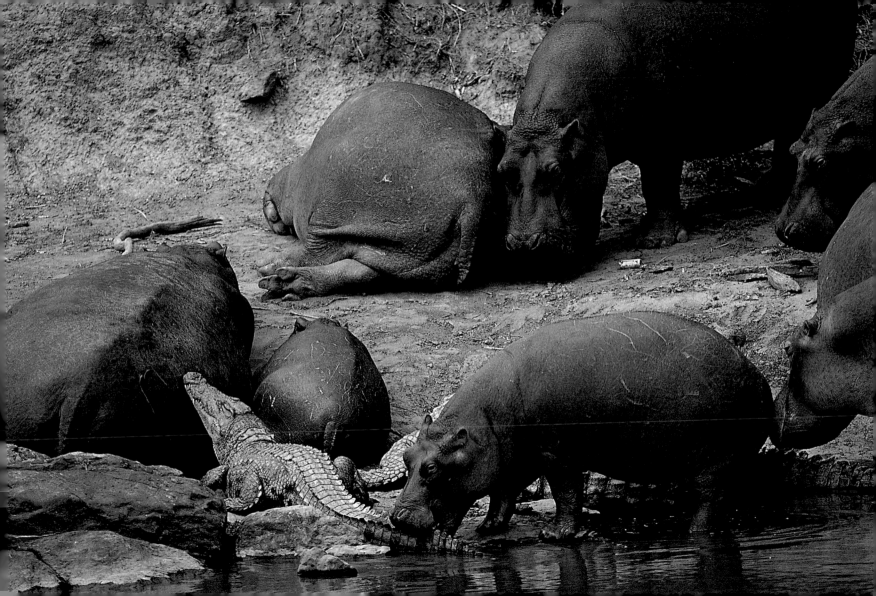

A bull hippo in a shrinking pool displays his strong territorial tendencies. As a small group of elephants arrives, he lifts his huge bulk and turns to face them. A fierce whoosh of breath is expelled through flared nostrils as he shakes his head with rage, but the elephants ignore him. Resigned, he sinks back into the water, although two tiny eyes remain above water to keep watch.

With its short legs and massive barrel body, there is nothing equine about the hippo except its Latin name, which means "river horse." It is essentially a gigantic pig that has adapted to an aquatic life. Its two essential requirements are water deep enough in which to submerge, and access to grazing on land.

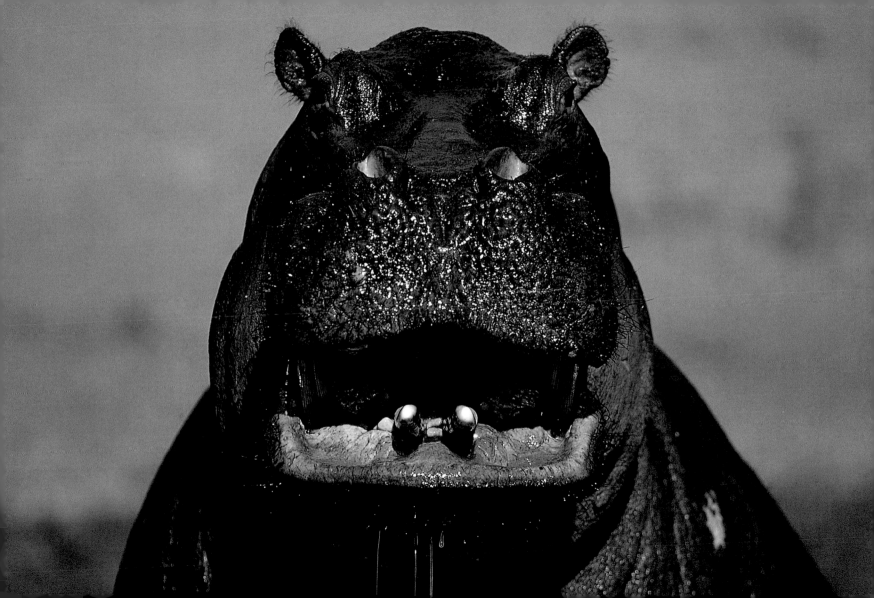

The river is shared by many species, from tiny dragonflies to a giant crocodile whose tail provides a convenient perch. Hundreds of large, menacing Nile crocodiles live along this deceptively tranquil stretch of the river. This is, in fact, home to the biggest crocodiles in Africa. The metabolism of these giants is such that they need to eat only half their body weight each year. Fish provide them with some calories and, once a year, wildebeests provide them with the rest.

The crocodiles are in the path of the migrants. They can probably sense the herds coming, if not today, then tomorrow, or the next day. In the meantime, they are content to sleep, living off their fat.

This is our fourth day at the languid pool. Very early in the morning, the territorial male crocodile floats like a half-submerged log. Then he heaves himself up on a sandy flat inside the pool and basks with jaws agape, alert to the signs of any intruding male crocodile entering his turf. We call him Bwana Kuba ("big boss"). He is twenty feet long and probably weighs almost a ton (900 kilograms). He may live for more than a hundred years if records can be trusted.

This ancient denizen of Kirawira is the stuff of nightmares. Even if he were to see me daily for twenty years, I suspect his killer instinct would get the better of his familiarity were I to approach him.

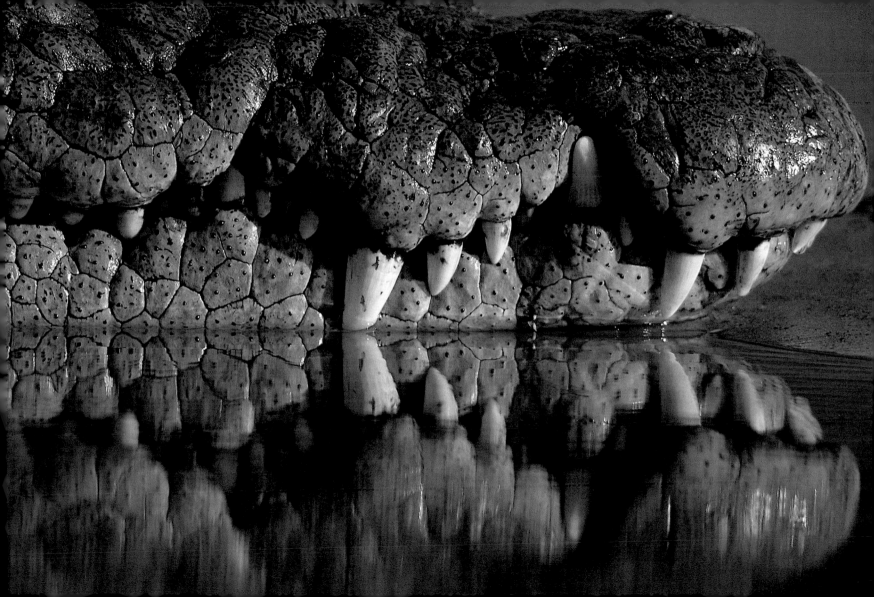

The two sets of herds—one arriving from Moru following the Mbalageti River and the other from via Seronera—are drifting toward the Grumeti River. Bwana Kuba's territory—a stretch of the river—is in a location that male crocodiles have to pass through in order to gain access to the females on the other side, so he must deal with quite a lot of "intruders." Just now, he chances upon a male entering his range; he cuts him off and attacks him with the intent to harm only if the intruder does not show submissiveness. This intruder arches his body and opens his mouth in a gesture of submission. Bwana Kuba lets him go, following closely behind to see him out.

At the pool this morning, we discovered Bwana Kuba in hot pursuit of an intruder. He is closing in fast, but just as he is about to catch up, the intruder makes a spectacular leap into the air, clears Bwana Kuba, and makes good his escape.

In the evening, we drive across the bushy plain bordering the river and climb a hill. Presently, we can hear the cacophony of the herds. They should be at the river in a day or two.

Morning: Bwana Kuba, always on guard, spots an intruder trying to swim past and is quick to try and cut him off. He manages to catch the intruder by his tail, which he grips in his jaws for about ten minutes before releasing it. The intruder wastes no time scuttling away.

Evening: We can see the first herds on the bushy plains between the stretch of the river, Kirawira, and the hills. There are many more behind the leaders. The grazing is good here so they will probably stay for a week or two.

The herds have most likely gone without water for close to two days. Now, thirst drives them to the river. Although the flow of the river is weakening in the relentless heat, there is still plenty to drink at the pools of Kirawira.

The wildebeest herd waits at the bank, assessing danger. Gradually the throng edges closer, faltering, jostling, and pushing until those at the front have no alternative but to move forward to the water's edge. Order is restored once they line up at the bank and start to drink. But a crocodile in the river chases another crocodile that has entered his territory, attracted by the proximity of meat. The herd panics and charges up the bank and onto the plains. They do not return to drink today.

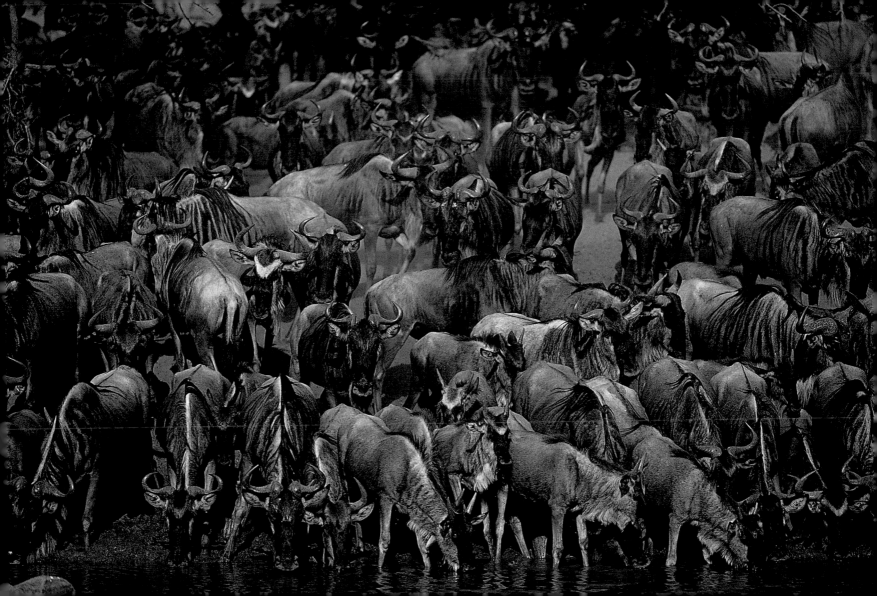

Lurking with eyes barely breaking the water's surface, a crocodile patiently waits and calculates as a herd drinks. It targets a calf, then swims underwater and erupts vertically in an attempt to catch it. The calf reacts in the nick of time and the crocodile falls back into the river. The herds are not terribly familiar with crocodiles, which are terrors almost beyond comprehension. There is no chase, just a sudden explosion as a nightmare of yellow gin-trap jaws and bristling teeth launches with no warning out of the pool.

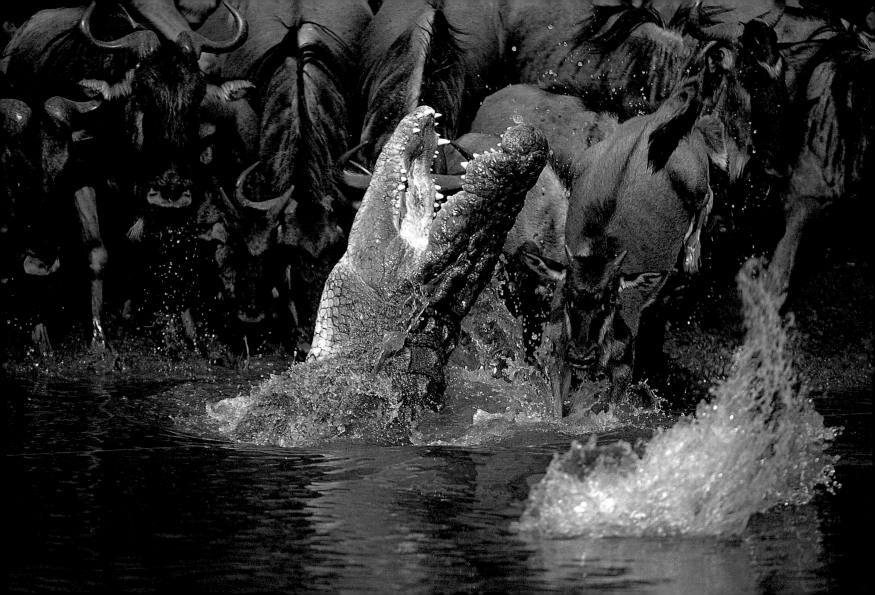

A long line of animals drinks, their horned heads reflected in the water this early morning. None seem to notice the armor-plated monster nosing soundlessly toward them (see lower left of image). Almost imperceptibly it drifts nearer, with only its eyes and the body ridges on its broad back breaking the surface. Since crocodiles do not stalk wildebeests on land, the young and inexperienced of the wildebeests do not recognize them as predators. But the older ones do. One adult notices the eyes of the crocodile, stops drinking, and stares. Other drinking animals pick up on the direction of the gaze and bring their heads up sharply. The wildebeests are now on their guard, so the crocodile must wait another day.

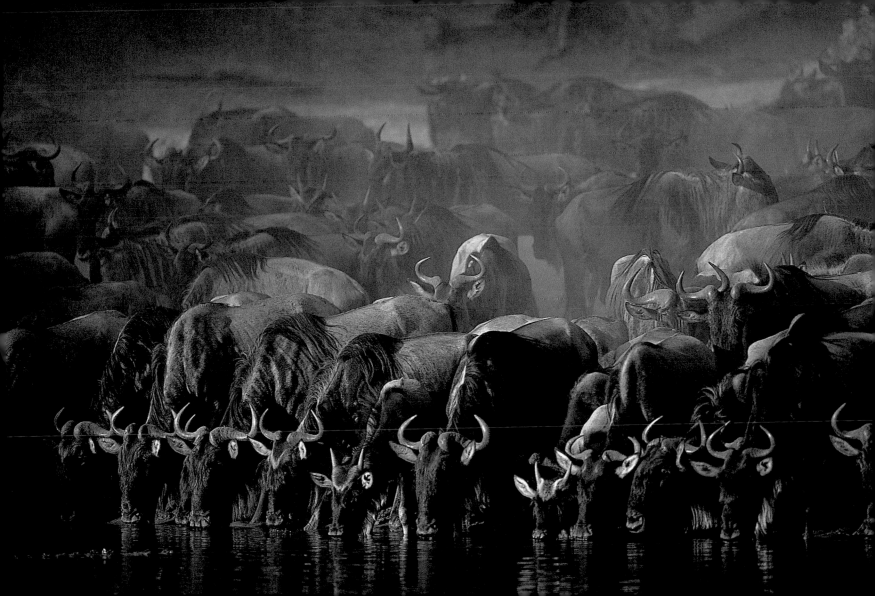

In the usual flow of things, a herd approaches from upriver, drinks, moves downriver, and does not return. This morning, a tightly packed herd arrives at the river to drink where a crocodile is waiting, having already slipped into position. As the beasts bow down their heads to drink, the crocodile approaches underwater, having estimated where the drinking is taking place. There is a great splash as the reptile lunges up and out, but the remarkably fast reflexes of the targeted wildebeest save it. Nimbleness and luck are united in a wildebeest's run for survival.

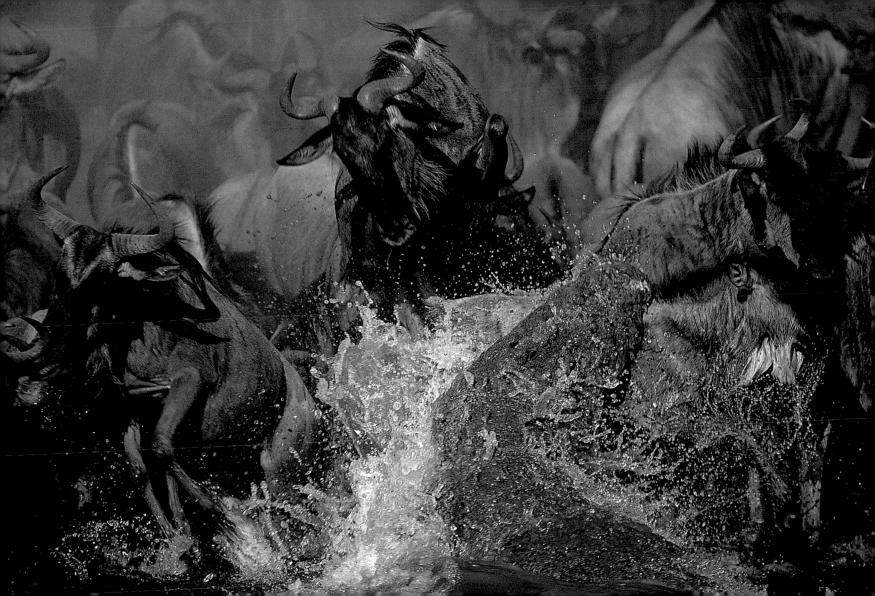

This morning, the wildebeests are at the river before sunrise. They rush in madly, not checking for signs of danger. In their haste to drink, they have not noticed the huge crocodile lying in wait nearby. As more and more wildebeests pour in, the drinking line extends toward the silent crocodile, who lunges but just misses.

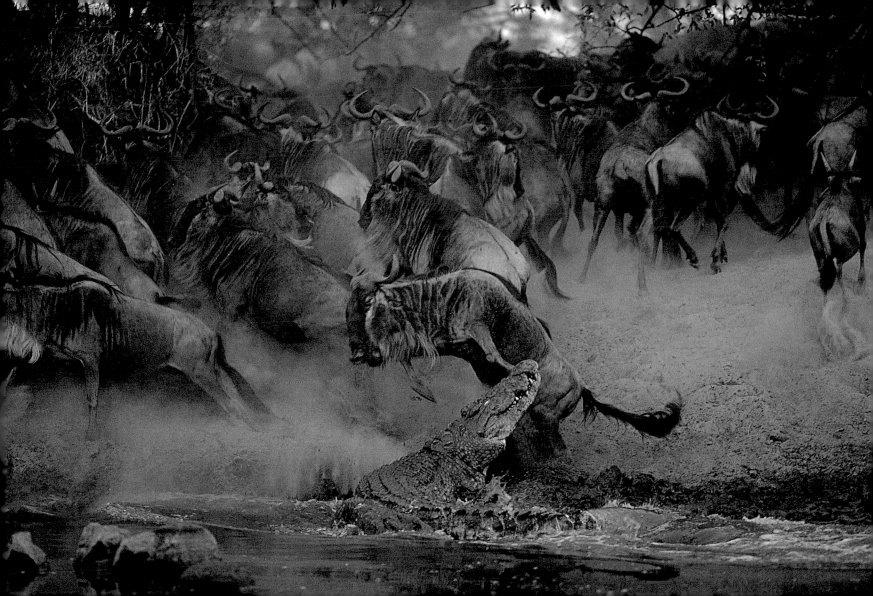

Late this morning, a new wildebeest herd arrives in haste at the river, throwing all caution to the wind. As the animals drink, a crocodile watches, hardly a yard away from a wildebeest calf entirely engaged in quenching its thirst. The strike of the crocodile is swift and shocking, as it grabs the calf and drags it casually back into mid-river, where it will drown and devour it. If any of the young wildebeests saw the crocodile, it was probably their first glimpse; for this youngster, it was the last.

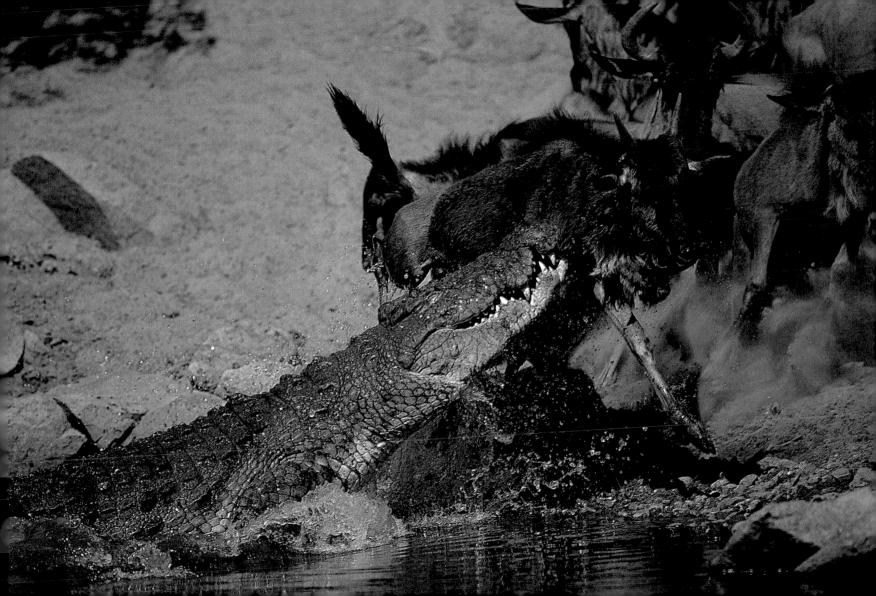

Another morning, the same spot, another killing. This time a crocodile has grabbed an adult wildebeest who is not going to give in without a fight. The wildebeest's feet are touching the river-bed so it can gain some traction to resist. While a crocodile does not have the stamina to match that of a wildebeest, it has far more power. Within a few minutes, the balance of life and death tilts in the reptile's favor, as the crocodile manages to pull the victim into deeper water. Now the struggle ceases, and the crocodile dives, taking its prey with it. The wildebeest, with mouth agape and eyes uncomprehending, disappears from view.

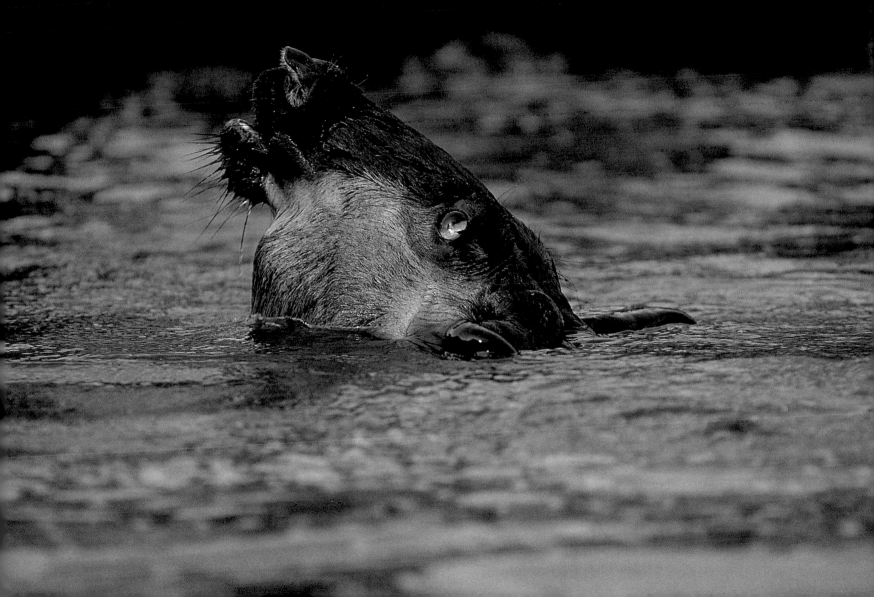

Bwana Kuba swims with a wildebeest carcass but doesn't eat it. Clearly, he is not hungry, but he is certainly possessive.

 We check all the Kirawira drinking spots and work out that most of the herds have either moved downriver or crossed the river. The march has resumed; only a few small herds remain.

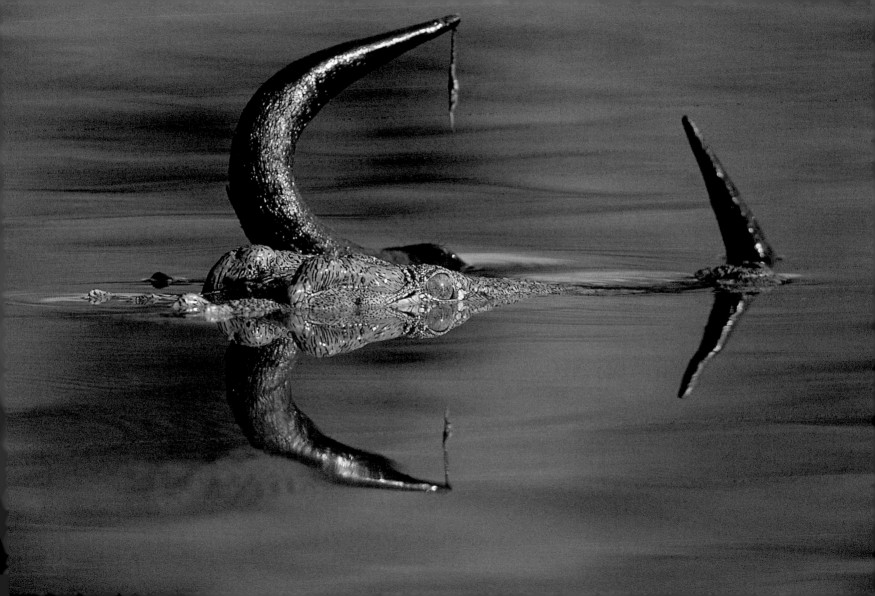

The advance herds are swinging northeast, outside the park. They are entering a spooky place with a danger of a different kind: Here, they will encounter snares laid by humans, which deliver a slow death, and poisoned arrows, which are quicker to kill. The herds will also have to contend with biting hordes of tsetse flies and the scorching heat.

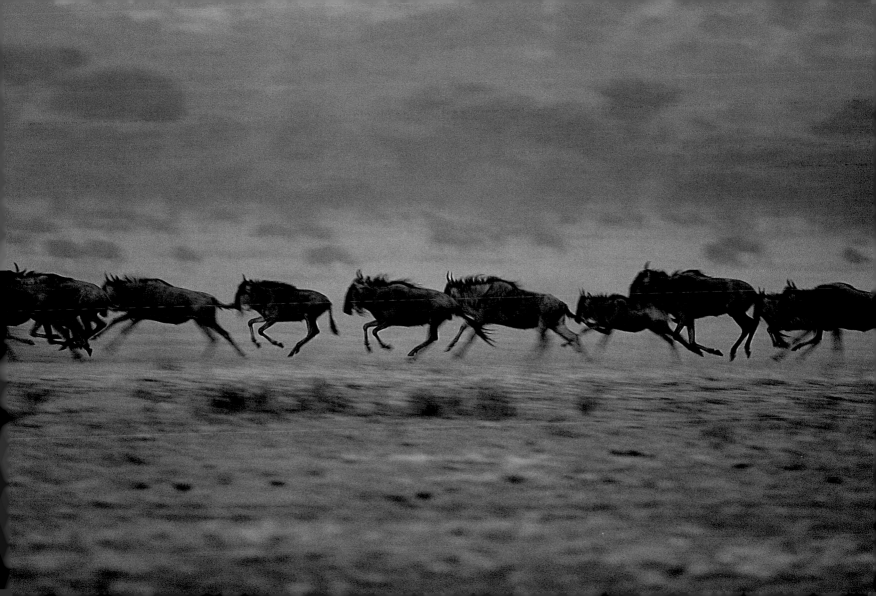

The herds have moved on from Kirawira, leaving the crocodiles to sink back into torpor once more. As hot, dry weather encroaches, the river has stopped flowing and now consists of a series of pools. As the dry season progresses, many of the remaining pools will turn to mud. Then the Grumeti River will become a long, winding, sandy gash in the earth, obscured by the dappled shade of hardy trees. All the herds are now moving outside of the park and should reenter the park 30 miles (50 kilometers) to the northeast in a few days time, if past migrations are an indication of their current behavior.

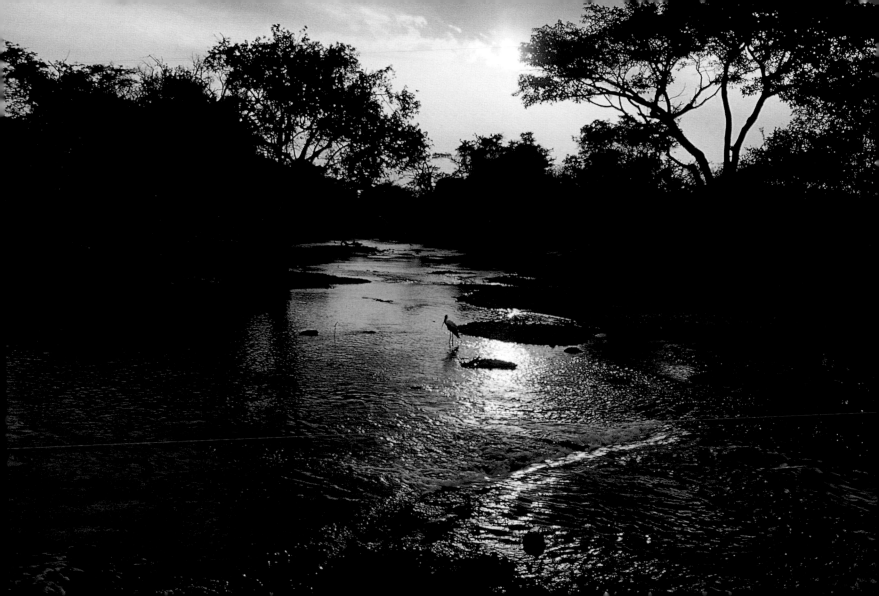

Yesterday's lion pair is now in the throes of copulation. She rolls and lies wriggling for a moment, as if trying to rub an itch on her back. She repeats this kittenish behavior several times as the male follows her, nuzzling her, and grimacing with pleasure at her scent. For half an hour, their courtship grows in this fashion, until she finally trots toward him with her tail held high, turns around, and presents herself to him. At once he covers her, his jaws agape on the nape of her neck. Their mating is fierce and furious. She rumbles open-mouthed, and when he announces his climax with a strange, harsh meow, she turns on him with a grating roar and raises a paw as if to strike at his face, forcing him to dismount and back away. The love-in has begun. At its height, the pair will mate every twenty to thirty minutes for two to four days.

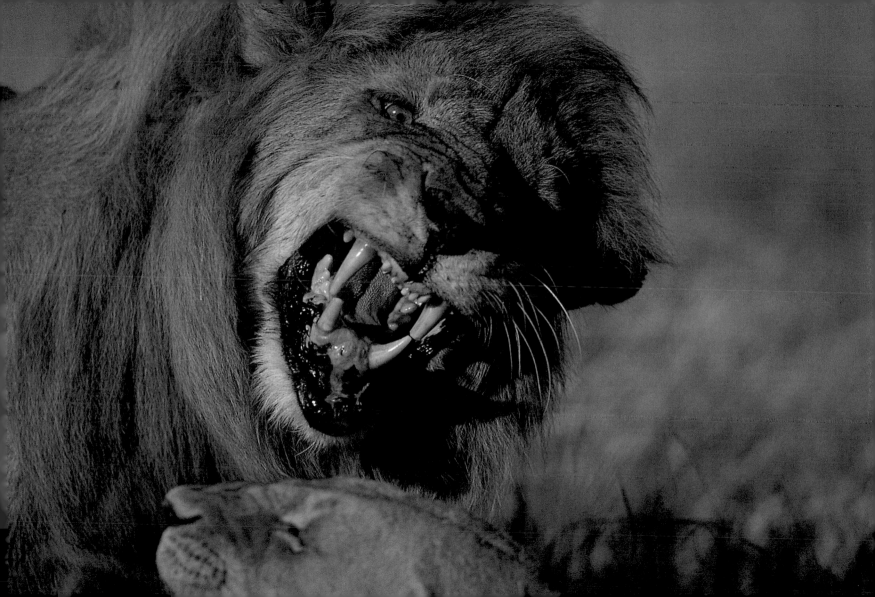

The sun is high and hot, and the flies are bothersome. Marabou storks are standing on the bank of the Grumeti River, waiting for a wildebeest carcass, left uneaten by satiated crocodiles, to break open.

Hunched down, with its neck pulled back into its body, the marabou stork looks decapitated from a distance. Close up, the neck appears scrawny and ill-feathered, while the head is spotted with scabs and houses leering skid-row eyes. It also has a long, pendulous sac of skin on its chest, which it can expand into a startling magenta bulb. The marabou seems to be a creature put together ad hoc, with random pieces in a series of clumsy additions, an evolutionary attempt to emulate the vulture while remaining a stork. You could say it is a stork that has acquired the carrion-eating habits of a vulture.

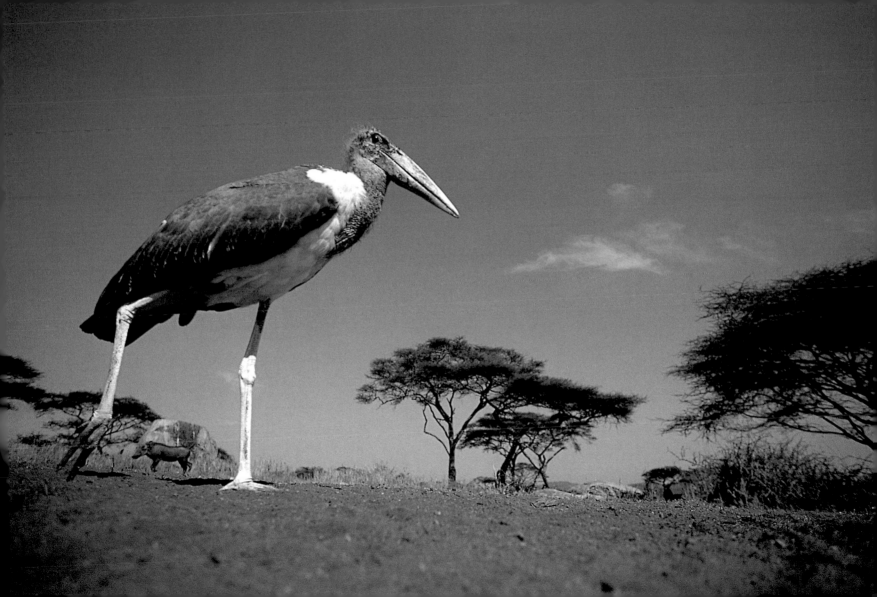

During the long, hot days of the dry season, after the herds have departed, warthogs become an important item on a lion's menu. Lions laze hidden near the remaining pools of water, in position to ambush unsuspecting prey.

A warthog silently approaches one such pool. He is hesitant and circumspect. He spies the water and some inviting mud, but he's aware there could also be concealed lions nearby. Warthogs love to recline in the soothing black ooze, particularly since they are frequently the targets of tsetse flies. These flies are denizens of woodlands and thickets, lying in wait on the shady underside of branches for animals to pass by. They attack flanks and bellies where the skin is thinner, expertly stabbing with their needle-sharp probes to draw blood. I can empathize with the warthog's craving for a mudbath, having been at the receiving end of the bites of these nasty flies a million times.

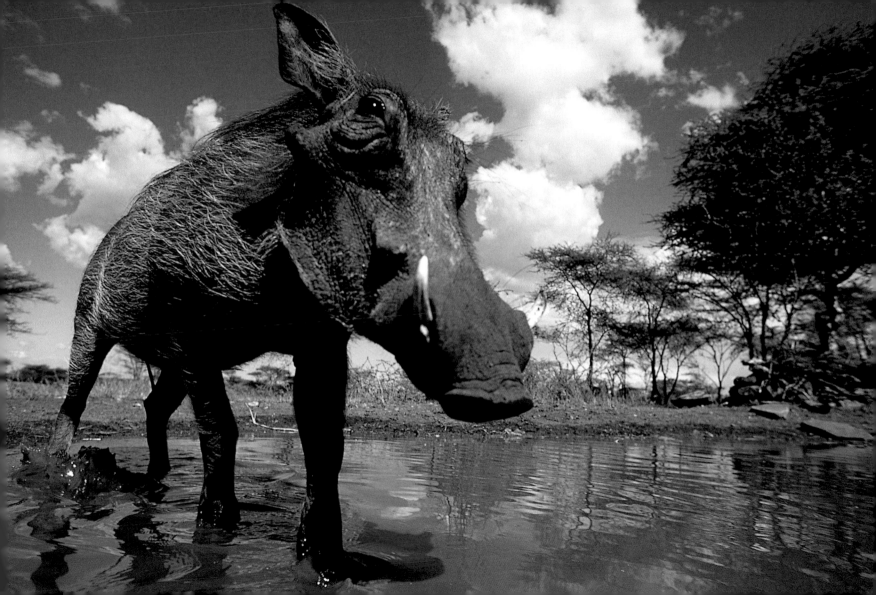

When a lion pride does not migrate to follow its meat supply, its members will go hungry. These cubs of the Kirawira lion pride have not eaten for six days. The younger lions are the first to suffer, as prey suddenly become scarce and the pride no longer hunts together. Increasingly, the youngsters find themselves abandoned for long periods as the rest of the pride spends more and more time hunting prey. Too young to fend for themselves, they become thin and bony-headed; their ribs protrude; their fur loses its sleek and healthy luster. Hunger also causes a sort of depression. The thin cubs become silent and listless. They lie panting through the long hot days, scarcely moving except to feebly shift with the creeping shadows of their tree or to trek to the river in search of moisture for their dehydrating bodies. The extremes of the wet and dry seasons seem to rule the world of young lions.

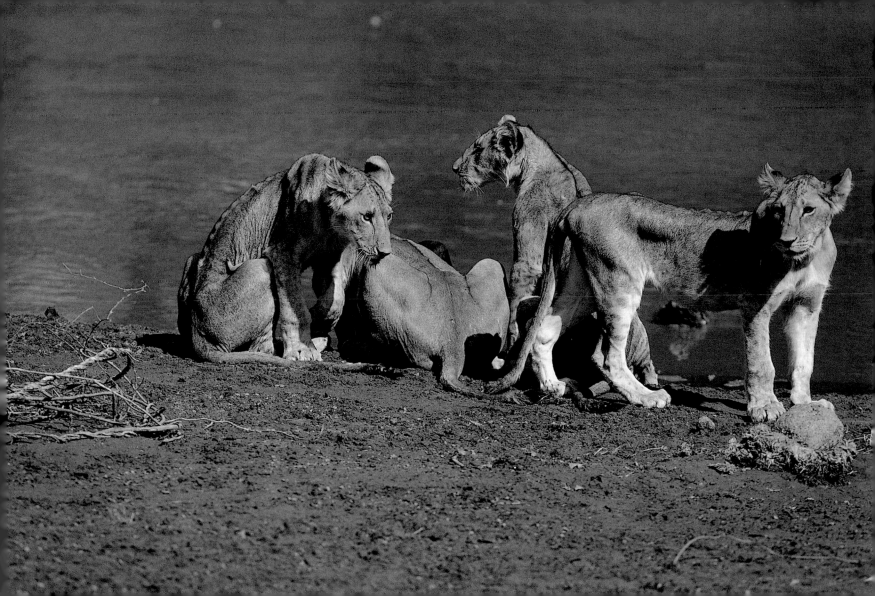

The herds that moved through the Western Corridor carried on northeast across the Sabora Plains located outside the park. Then they marched past Fort Ikoma and reentered the park near Baracharuki Falls, where the Grumeti River tumbles in a series of deep pools and cascades. The herds that moved directly north from Seronera have reached Tagora Plains in the park. Here, they will rest from their journey through a long section of woodlands.

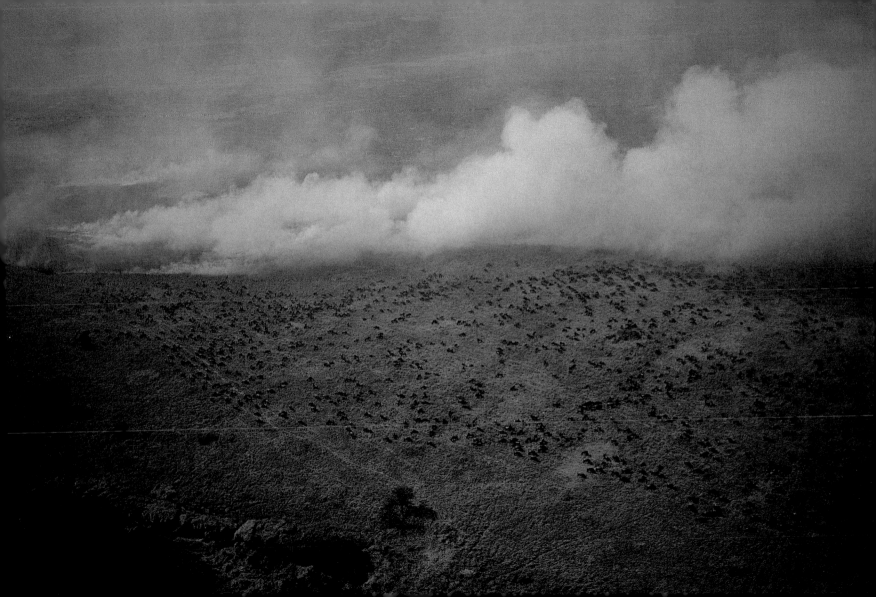

These wildebeests, crossing the tree-lined Orangi River, are part of the herds that continued directly north to the Tagora Plains. Here in northern Serengeti (as well as western Serengeti), soils are deeper than those of the short-grass plains. They hold more water so that grass grows tall and scattered trees abound.

All of the herds will have traversed woodlands to reach this northernmost part of the Serengeti. The woodlands harbor not only parasites, but also woodland diseases, which are stimulated by the dryness of the season. Most animals are able to resist the work of parasites and diseases, but the few that are the most compromised by shortages of grass and water may fall sick and stand by helplessly as the rest continue the march. Since the north supplies most of the dry-season nourishment, the herds have no choice but to traverse the woodlands.

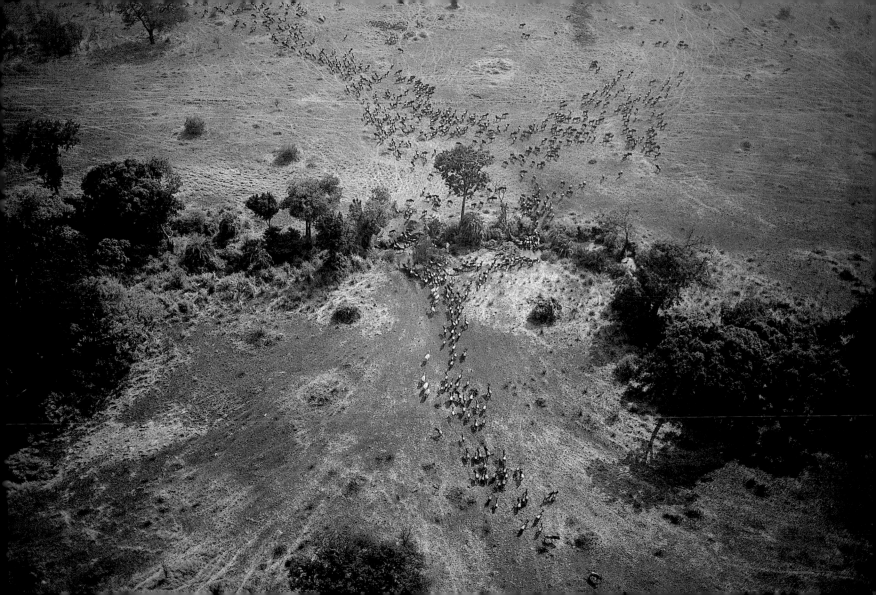

The first herds are near Maasai Mara National Reserve in Kenya, which borders the Serengeti National Park in Tanzania. Maasai Mara holds the most promise for survival of the next few months of the dry season. So they continue the march north, moving in their immense, unbroken columns, heads down, tails twitching to the buzz of flies' wings everywhere. Sometimes they move slowly, heads nodding to the rhythm of their gait. Sometimes they gallop, with manes and tails streaming. Behind them, they leave a maze of narrow trails, where their trampling hooves have cut deep grooves in the skin of the land.

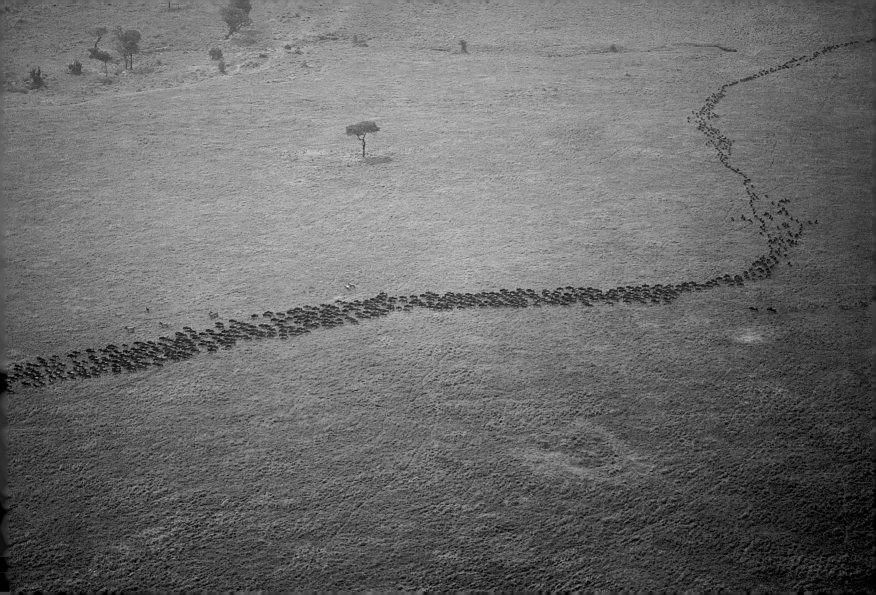

Zebras start arriving in Maasai Mara in family groups, which are usually comprised of several mares, their young, and a group stallion. They move easily in tall meadows to feed on the waving red-oat grass. One-seventh the size of Serengeti National Park, and the wettest region of the ecosystem defined by the dispersion of the migration, Maasai Mara is blessed with rains from November to December and from mid-March to the end of May, with frequent storms in between. The Mara River and its tributaries are like arteries in Mara's skin—no wonder Mara turns into a refuge for the migration during the dry season.

OVERLEAF

The high, pure air of Mara, barely 100 miles (160 kilometers) from the equator, sparkles clear and bright; its peculiar clarity, falling across the far-ranging vistas of the open plains, makes for a heady sense of freedom.

Everywhere in an area called the Mara Triangle, the red-oat grasses are tall (about waist-high on a person) and rank. They stand on their coarse stems, wave upon wave rippling to the horizon in the wind. Mara has been dry since the long rains stopped falling in late May, when the landscape was green. Now it is yellow, and the grass is losing its nutritional value. But the appearance of the migrant zebras breathes new life into the tall grasses.

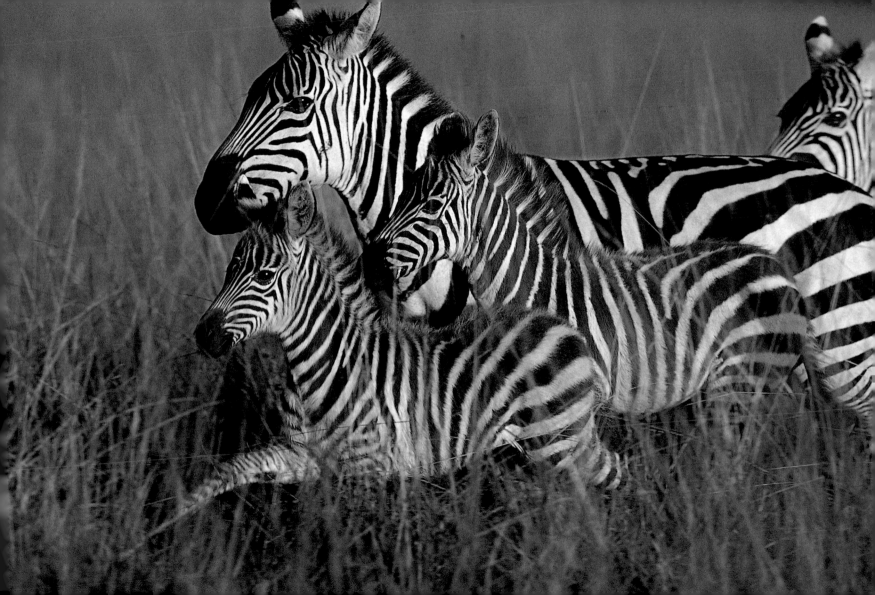

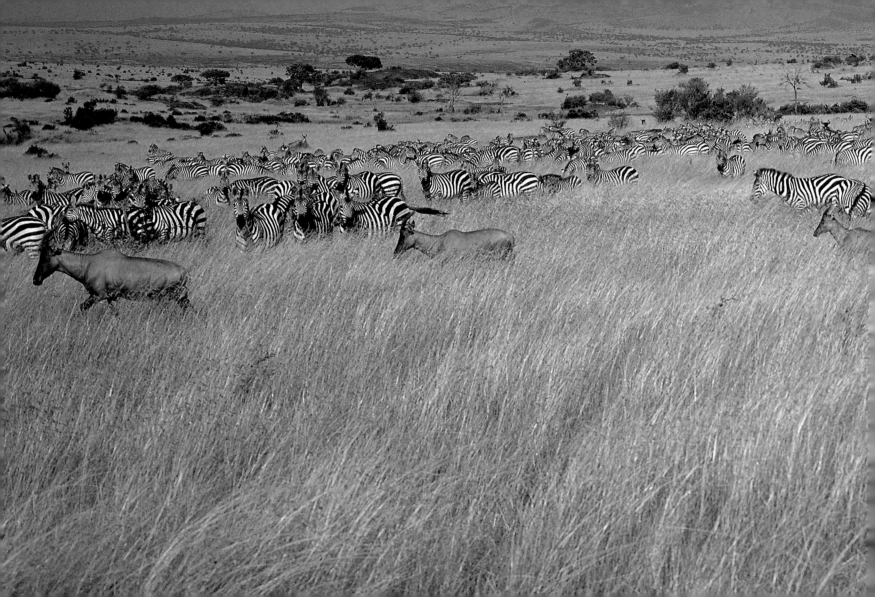

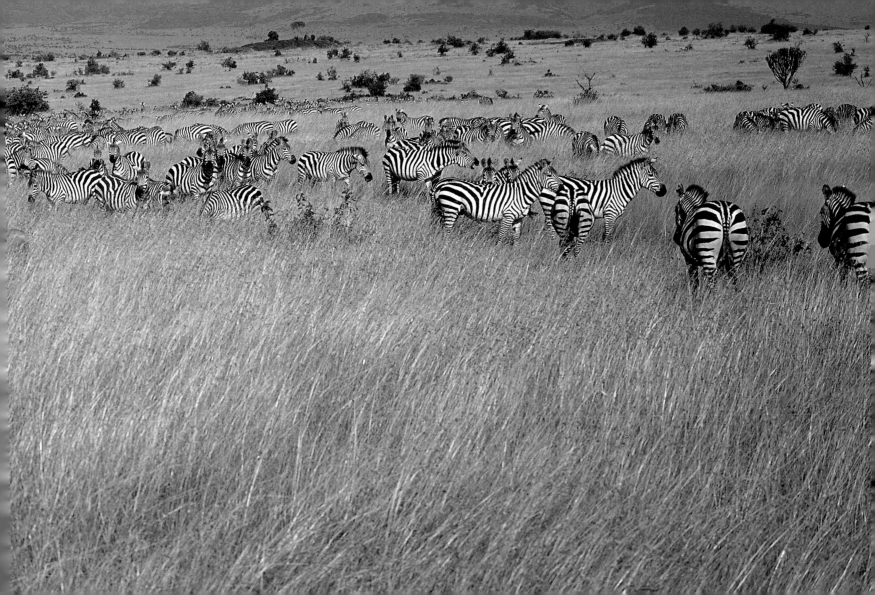

More and more zebras pour into the Mara Triangle. When traveling, zebras walk in a single file; when it's time to graze, they fan out. When the day starts to bake, they rest—loners stand swishing their tails while couples rest with their heads on each other's necks. There is an increase in activity in the cool of the evening, and bare patches of ground invite zebras to partake in dust baths, rolling on their backs with all four legs suspended in the air, which they seem to genuinely enjoy. There is a waiting line at this patch, the order of which probably depends upon family social rank. Zebras also habitually rub their bodies and heads against objects such as trees, rocks, and termite mounds, all of which relieve itching and discourage parasites.

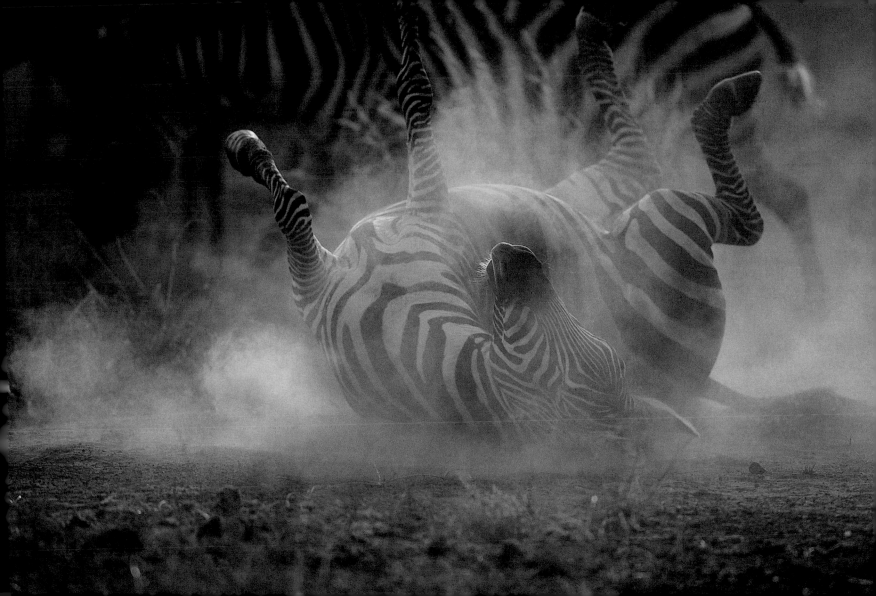

Northern Serengeti, a few miles from the border with Mara. Dawn breaks, a vulture flies, and the advance guard of the wildebeest herds appears over the horizon. One can hear grunts, rather like a crowd of hundreds of humans clearing their throats. Like an infection, the grunting has spread all along the wildebeest line. The herds can smell the damp air of Mara and so the northward surge continues.

Every day, new arrivals swell the numbers of wildebeests in the Mara Triangle, in the southwestern corner of Maasai Mara. They have passed through the commiphora orchards and flat-roofed acacia glades of the Northern Serengeti woodlands. Over the plains they come walking and running, the year's calves bouncing at their mothers' sides, as if glad to be free of the thorny woodlands with their lurking shadows and swarming tsetse flies. The wildebeests' bodies are so finely tuned that they use no more energy when cantering than when walking. Ungainly they may be, even comical with their capering gait, but no animal is better suited to a life on the move than the wildebeest.

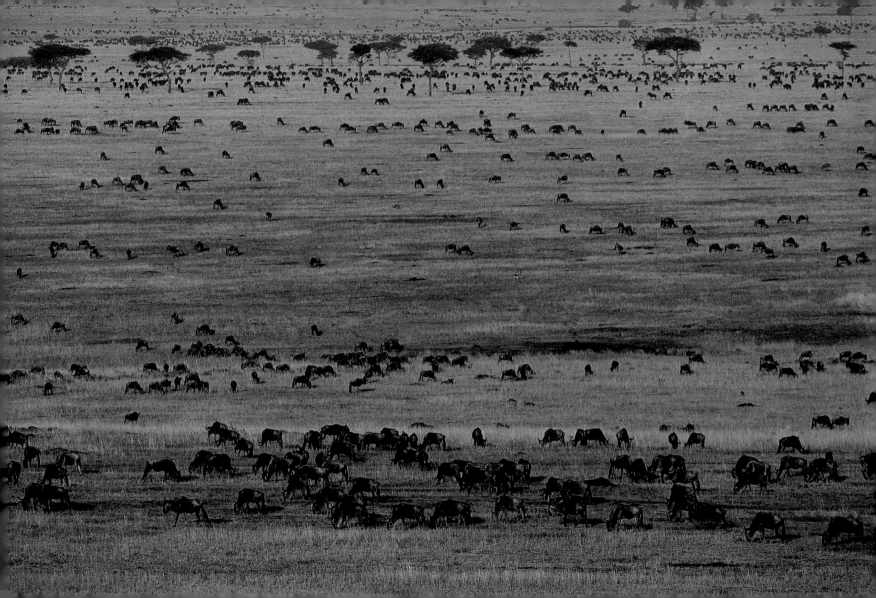

African clouds differ from their European counterparts: Only sometimes do they get between you and the sun. Rather, they seem to part, to let the sunlight through. Their shapes are varied and beautiful—often they look like whipped cream piled in twists and peaks in the sky.

Today the zebras seem to have been feeding nonstop. The wildebeests have taken longer breaks. It seems that although the digestive system of a zebra is less efficient than that of a wilde-beest (which is a ruminant), zebras compensate by eating more, including grass that is too fibrous and low in protein for a wildebeest to digest. Thus a zebra spends 60 percent of its time grazing under the best of conditions and over 80 percent under poor conditions.

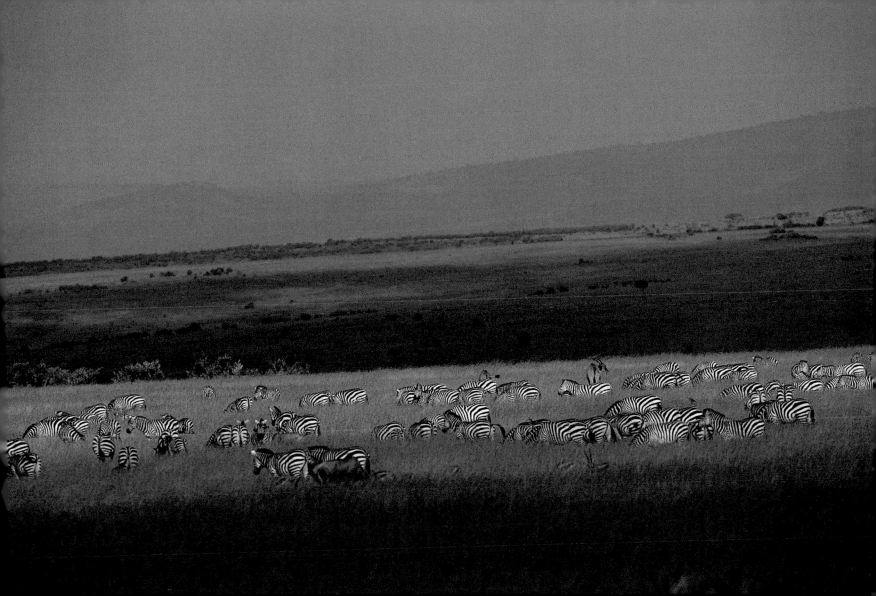

Giraffes amble by, in no particular rush. The grass is tall, the giraffes taller. From a distance, they look like tall ships floating in a sea of grass. Giraffes are browsers, specialists in plucking acacia leaves delicately with their long tongues. They often crisscross the plains, moving from one acacia thicket to another. There is no competition for food between the giraffes and the migrants.

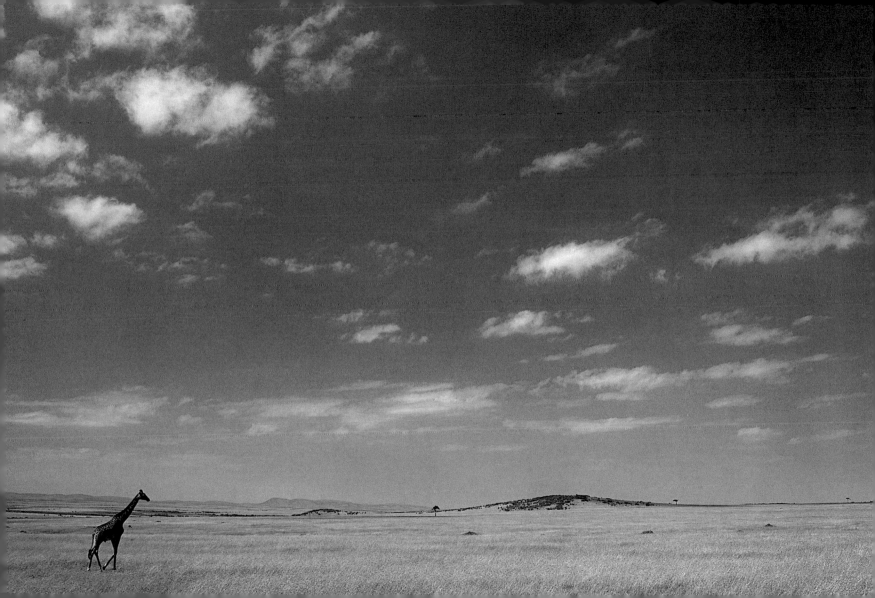

The large and stately kori bustard is spied mostly on foot. It always gives the impression of not being in a hurry. The male, at about 25 pounds (12 kilograms), weighs considerably more than the female. When he preens and flaps his wings, he appears to be a bird of some other species.

OPPOSITE

Morning: Southern Mara is a carpet of tall grass. In some places, a buffalo calf can walk unnoticed. The scene before us is of a buffalo herd grazing quietly on the open plains. The African buffalo is essentially a herd animal, except for the old bulls who wander alone or in the company of only a few other old bulls. This herd is composed of many families—we see adults of both sexes and the young of varying ages. We stay with the herd today and are struck by how peaceful and content they are, grazing and resting.

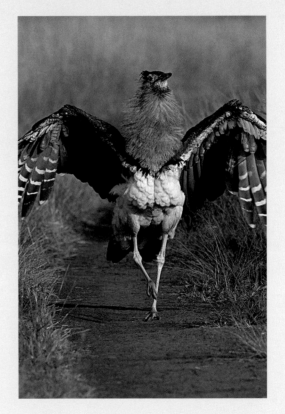

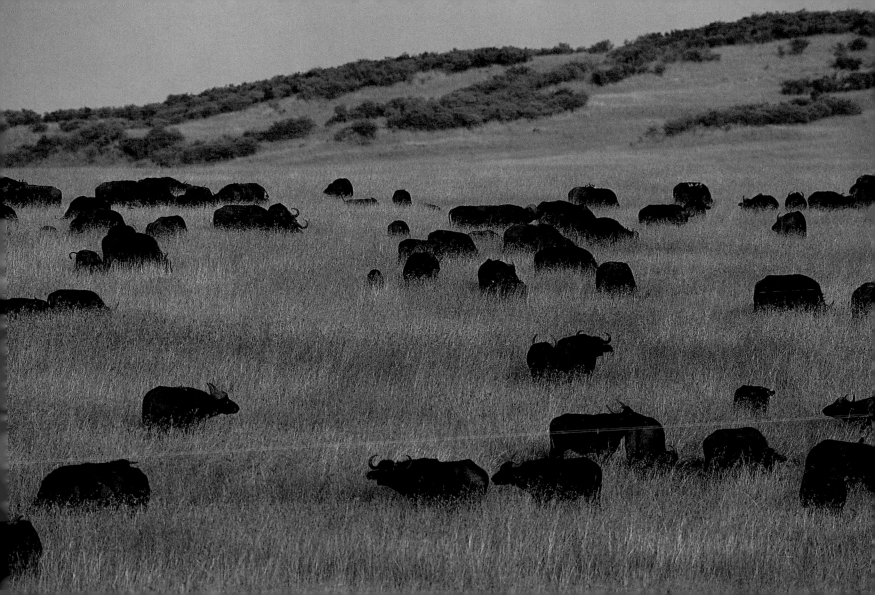

Once the migrants are through with Mara, the grass will have been cropped to the quick. For the present, however, it is tall, making it very difficult to spot cheetahs whose cat color and pattern blends well with the drying grass. Nearly all cheetahs carry fleas that drink their blood and, in the process, inject them with whatever bacteria they may carry. Some cheetahs also succumb to a skin disease called mange, which is thought to be brought on by stress, in particular harassment by lions and hyenas.

The first wave of migrants has crossed the man-made border—that between Serengeti and Mara, which is also the border between Tanzania and Kenya. The migrants have yet to impact the Mara residents. This cheetah cub, engrossed in play with its brother and sister in the Mara Triangle, has probably never seen a wildebeest. When the family of mother and three cubs is on the move, the cubs run ahead of mum, play, and wait. When they are finally spent of energy, they follow her obediently.

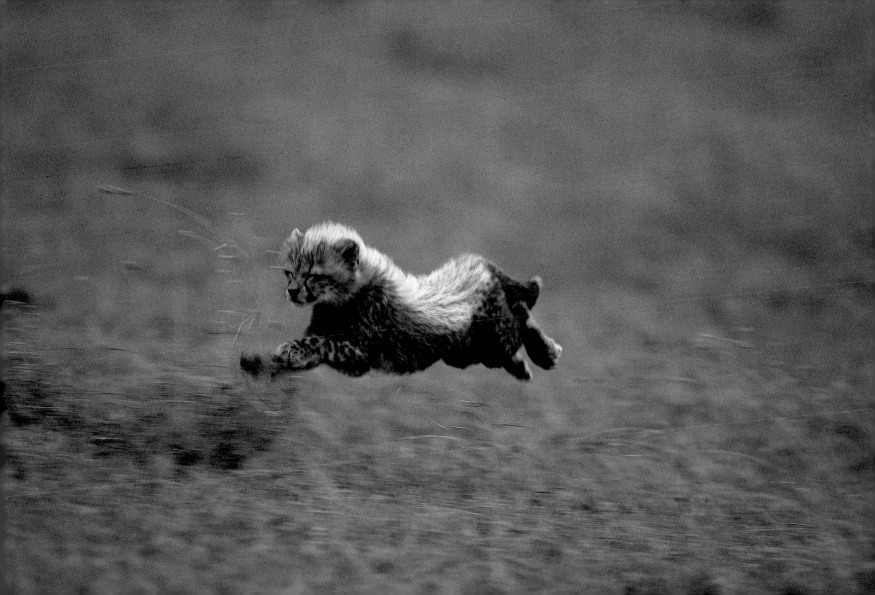

The cheetah with the three cubs spends most mornings preoccupied with hunting. Her method is to walk, scan, and walk again until she comes across a promising situation. Her concern for food is in sharp contrast to that of her cubs, who seem obsessed with play. A cub tries to engage its mother in play, but her maternal duties seem to include looking for prey, avoiding danger, and little else. The relatively fragile cheetah is more careworn, fidgety, and less relaxed than the leopard or the lion.

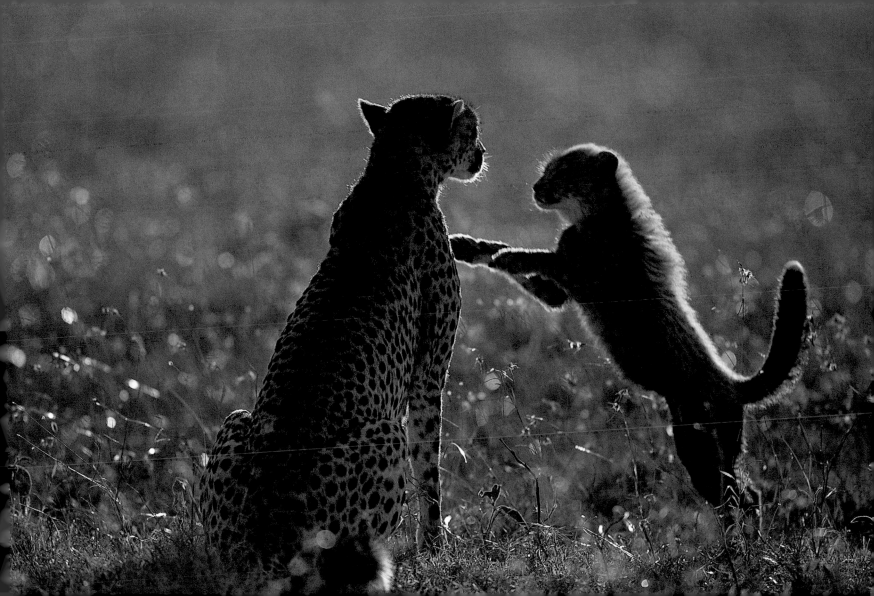

Ignorant of the impending herds, two male Thomson's gazelles engage in a trial of strength. With their little tails wagging frantically, they lock horns and push and shove until one breaks away and trots off. This is early morning activity. As the earth warms up, they will engage in less energetic pursuits, such as feeding and chewing their cud.

When they engage in friendly duels like this, they tend to forget to watch for danger, so statistically, male gazelles are more often targeted and caught by predators than females.

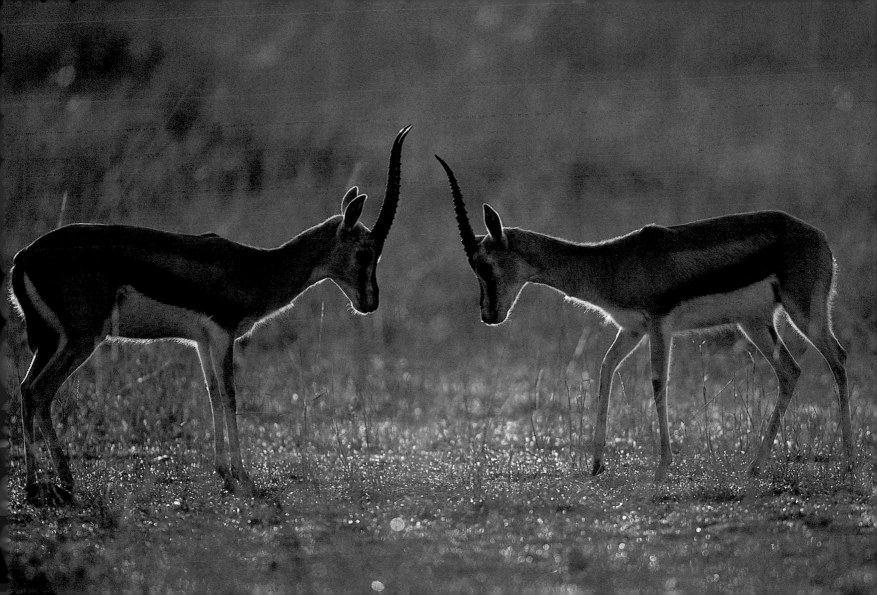

Mid-morning: This mother cheetah has caught a gazelle. Her body temperature must have shot up after the long, splendid chase, and she needs a moment to catch her breath. On the other hand, the chase ended up in the middle of an open plain, so the chances are good that some large predator will soon receive news of the kill and arrive to take it from her. She decides to drag the gazelle to a shady spot, but it is a long haul and the gazelle is heavy. She pauses every ten to twenty yards for a few seconds and eventually manages to deposit the kill under a short, shady bush. She calls her cubs, still rooted to the spot where she left them. The cubs are overjoyed to be reunited with mom and excited to find the kill. They play around the kill, imaginary games of stalking, pouncing, and biting the dead gazelle. Presently, the mother opens the carcass and keeps watch while the cubs feed. Then she joins them, apparently satisfied that they have not been spotted.

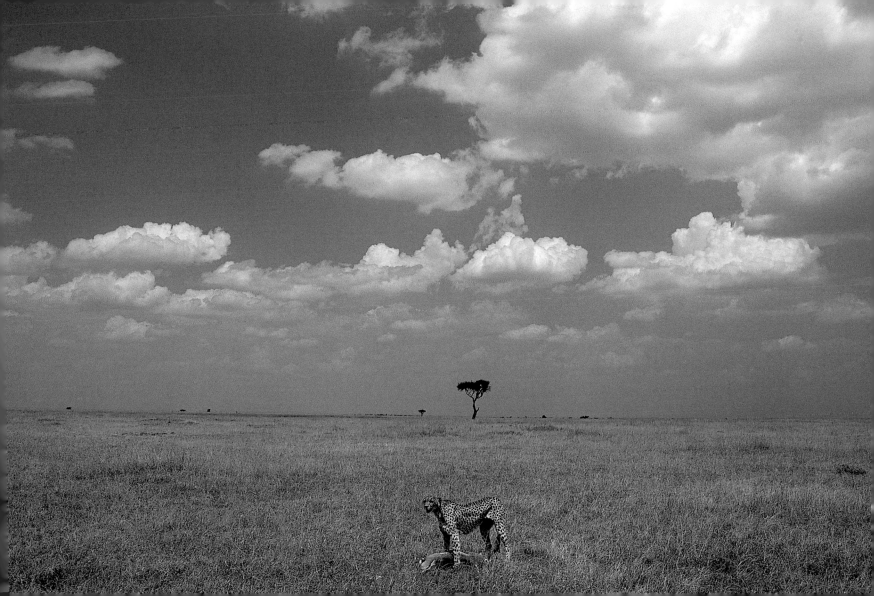

Allowed to feed undisturbed, the cheetah family fed throughout yesterday, and they were still at it at dawn today. Having cleaned the carcass of all flesh, they found a secluded spot, away from the remnant bones and horns of the kill, and relaxed until evening. Then they moved to another cozy place where, before settling down for the night, one cub and mother lavished big, wet kisses on each other's faces. Observing the daily lives of a cheetah family, you come to realize that their needs are simple: food, water, security, shade, and space.

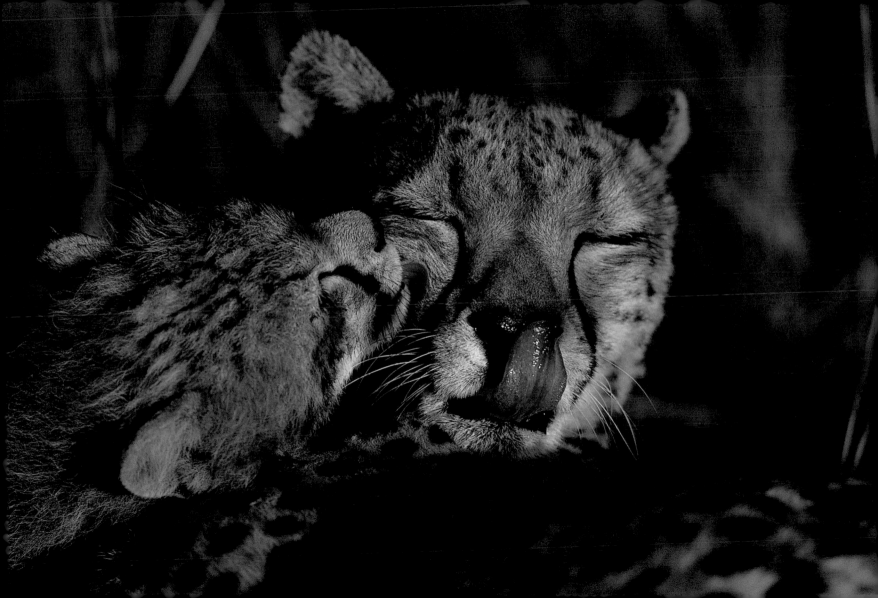

Adjoining Maasai Mara to the north and northeast is Maasailand, into which the migration spills. Here, a lioness of the big pride has come into estrus and is being doggedly followed by a pride male. In fact, he has become her shadow: He rests near where she rests, goes where she goes. However, it is clear that she is not enthusiastic about this sleuthing and vents her frustration when he ventures too close. But he is persistent, and she only gets respite when she climbs a tree. Romeo is too heavy to follow Juliet up the tree, so he settles at its base and promptly falls asleep.

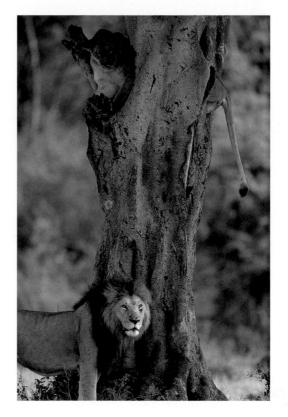

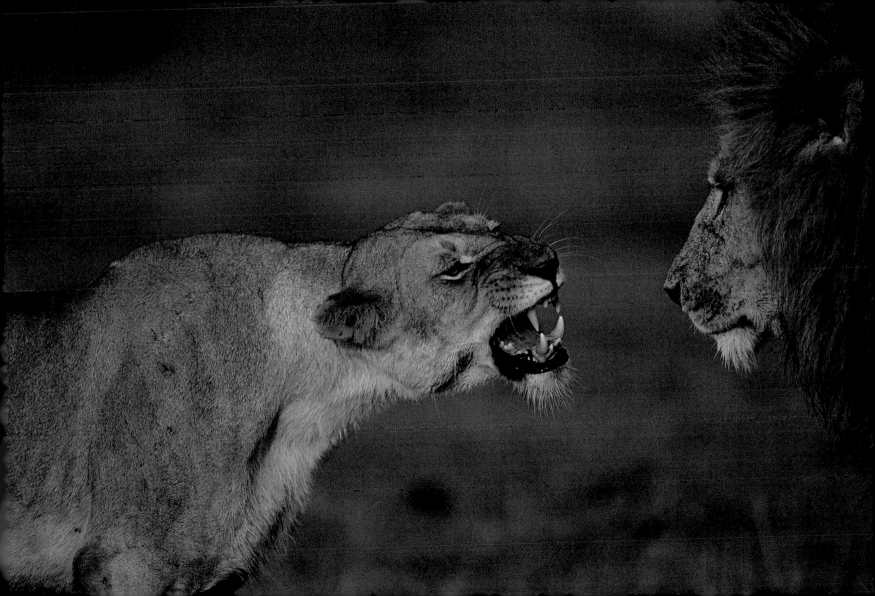

It looks as though the male lion's stubborn courting has paid off. The lioness no longer tries to shake him off, nor does she move away when he sits next to her; she even lets him lick her back. Later we hear the insistent sounds of the lions mating. The insane caterwauling continues through the hours of morning as the pair copulates again and again.

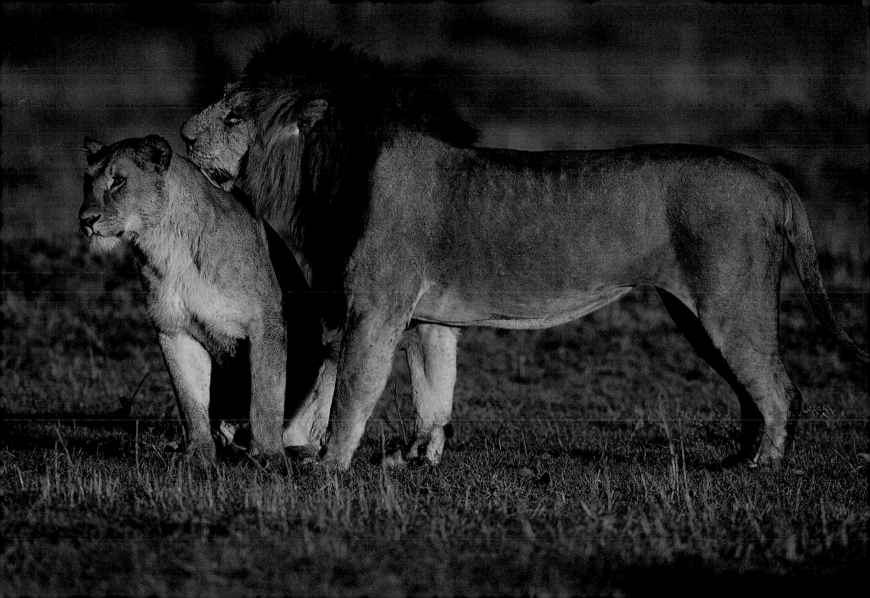

The Mara Triangle is to the south of the Mara River. To the north of the river is Paradise Plain. Here, two young lions of the Paradise pride watch across the river as the first herd of migrants, running as if spooked, enter the region. They instinctively do this when they first enter a new area. The Mara Triangle is taking the brunt of the migration at the moment. The migrants have been grazing here for about two weeks, and some are now close to the river.

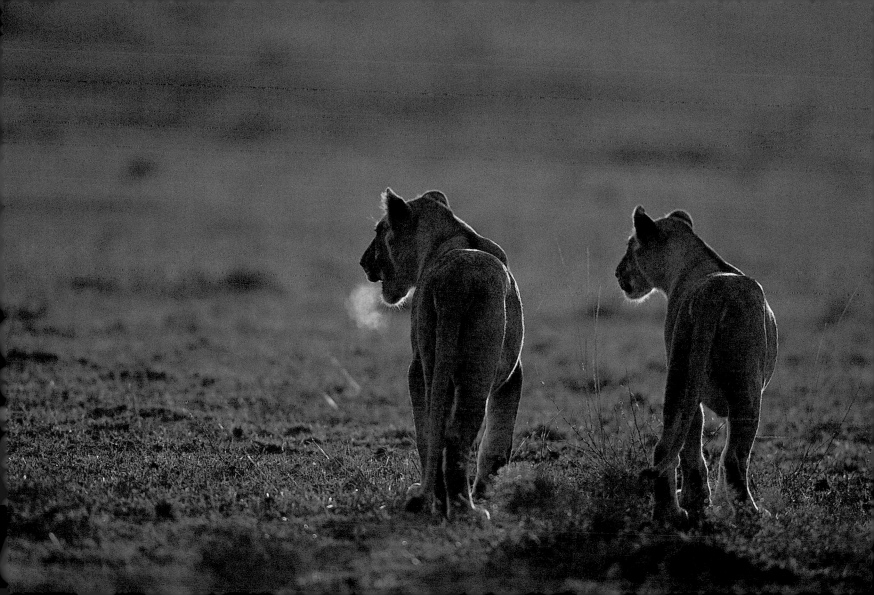

The Mara River starts in a shallow swamp among the forests of Mau Escarpment, the high country that looms over the Great Rift Valley. Fed by the rains that fall at its source, it flows year-round. Entering Maasai Mara, it flows through the reserve in a series of meandering loops and contortions. It then enters Serengeti National Park and empties into Lake Victoria. When they are done with grazing in the Mara Triangle, the herds will move north, crossing the river to do so.

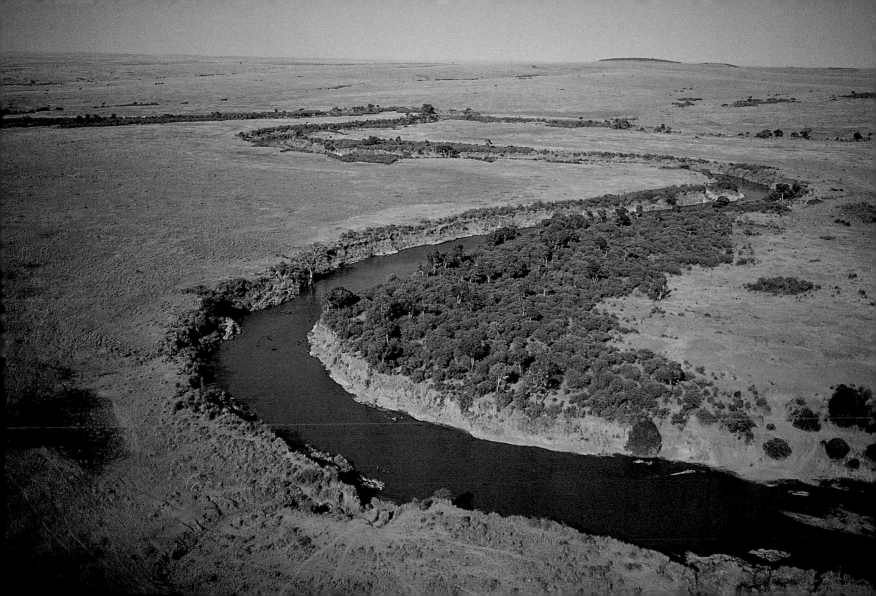

A pair of Egyptian geese bathes and swims in a small stretch of the river. After bathing, one goose flaps its wings vigorously to dry them and then carries out a bit of feather preening. It interrupts its preening when it spots another pair of Egyptian geese that has just landed nearby. Without hesitation, the goose charges at them, and that one act of intimidation is enough to send the newcomers flying. The herds are not far from the river now; and a few small groups come to drink and then turn back to resume grazing on the plains. For the present, the river flows, calm and quiet.

This male hippo is lazing in a lagoon by the river, yawning and snorting. The water is not deep enough for him to submerge completely. Even with his short legs doubled under him and his belly touching the muddy bottom, the sun still shines on his exposed back. He is on his own, without territory, without females, thus his needs are simple. In the evening, he leaves the lagoon to forage in the cool breezes on land and returns under the cover of darkness. Upriver there is a bend where many hippos live. Tomorrow we plan to visit them.

This bend in the river is favored by a group of female hippos: There is a small beach for resting, and the water level and river current are just right. It is here that two male hippos are engaged in a serious dispute over the females. In body size, the two males appear well matched and both seem determined. They slash and parry with gaping mouths, charged with sexual energy. Each has a formidable armory of crooked tusks and powerful jaws. After an hour or so, one hippo is weakening and, during a lull in the sparring, edges away. The victor does not pursue the vanquished far. Instead, he defecates, wagging his tail furiously. His nostrils flare, and a deep, mirthless guffaw of triumph emerges from his throat. He has won the harem. If I didn't know better, I'd think he was rather pleased with himself.

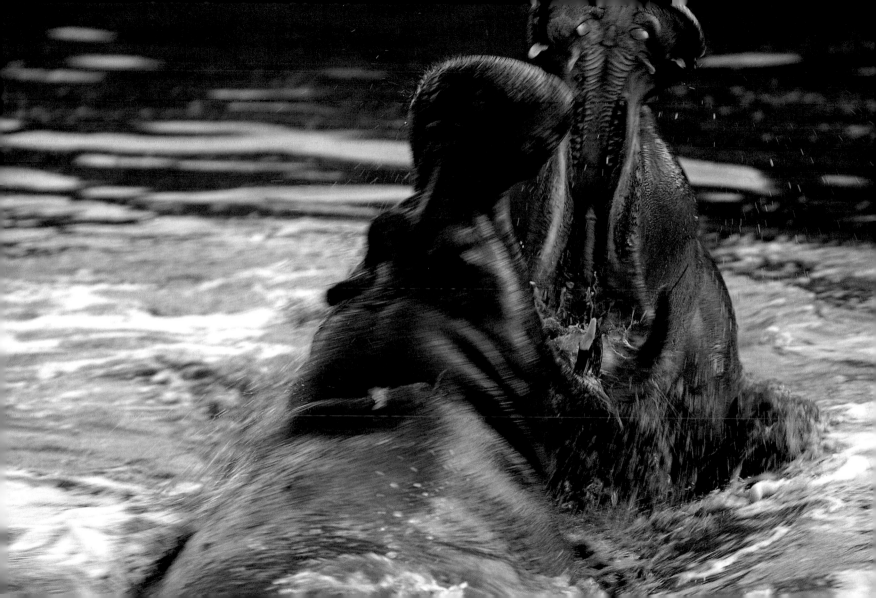

It is a pleasant sunny morning for exploring the river. However, we do not go far before we come across two hippos of unequal size who are detached from the rest of the hippo pod. After a while, we catch onto the fact that a bull is pursuing an estrual cow. Having broken down her resistance with persistent chases, he wastes no time and engages in a courtship display. She responds and clashes jaws with him; they intersperse physical contact with quiet submerged moments several times. Eventually she goes into prostrate submission, whereupon he mounts her in a bid to transmit their genes to another generation.

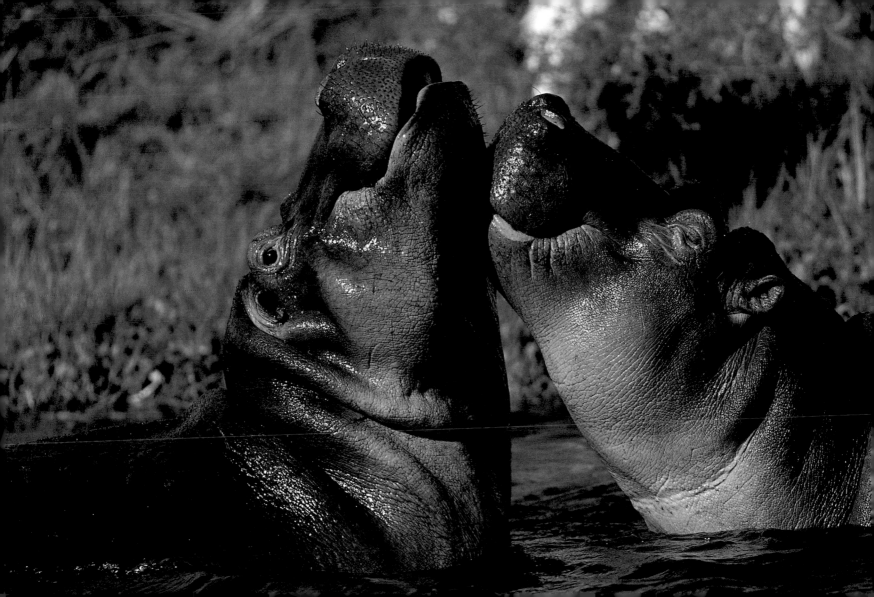

The Great Migration's flow is punctuated with countless obstacles. One such barrier is the Mara River. The river flows from east to west, while the migration moves from south to north, then from north to south on its return journey—at some stage, the herds are bound to meet the river. The smell of water and the sight of the river seem to be pulling a big herd toward it. At the steep banks, the animals hesitate. For the moment, they seem to be content to graze within sight of the river and wait for their numbers and courage to build up.

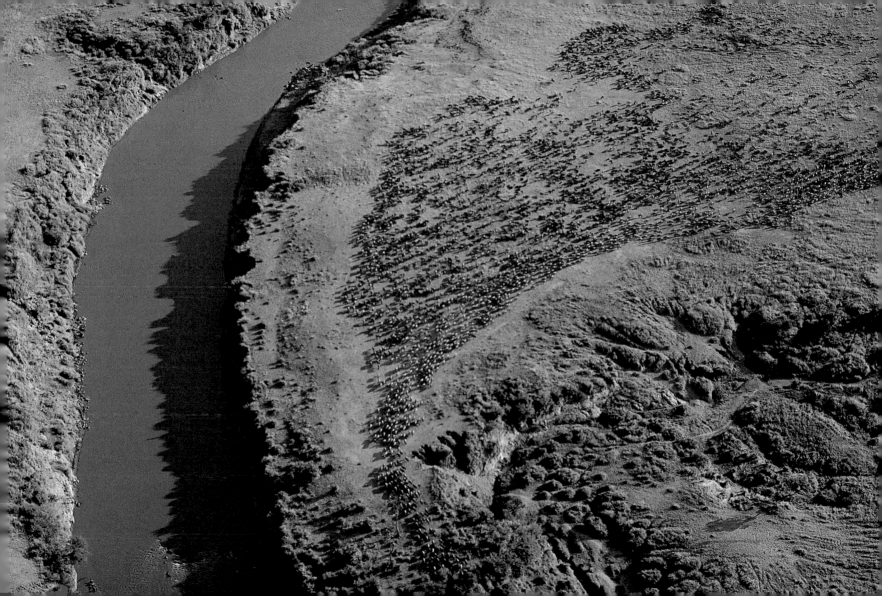

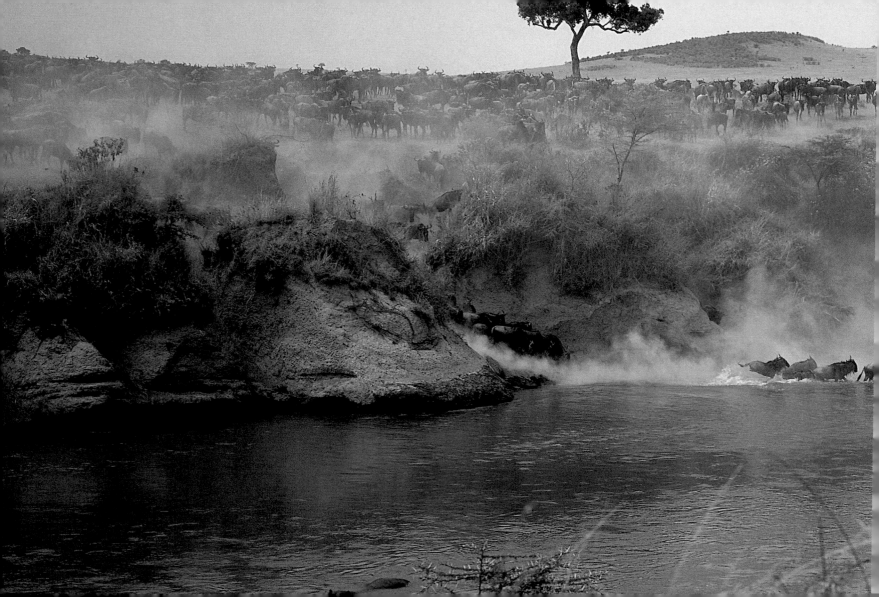

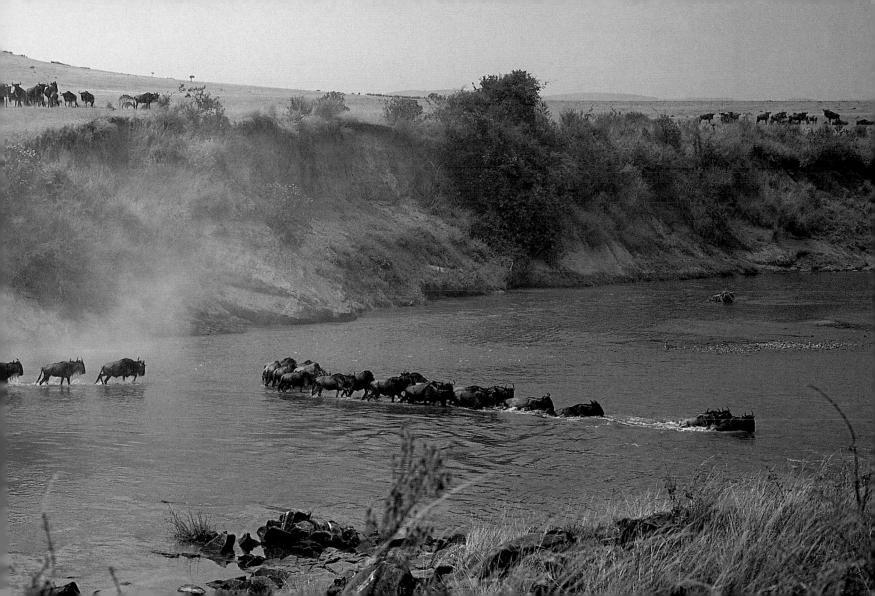

Another herd of wildebeests has massed on the plains beneath Serena Hill. The banks of the river here are low, and it is a gentle walk to the water. The exit on the opposite bank is also benign. Yet the animals are nervous and agitated. It takes a long time before the first wildebeest crosses and the others pile in. Once in the river, the last thing on their minds is to linger. They walk, swim, and rush to get out as quickly as possible. Thus, another crossing ends without any apparent casualties.

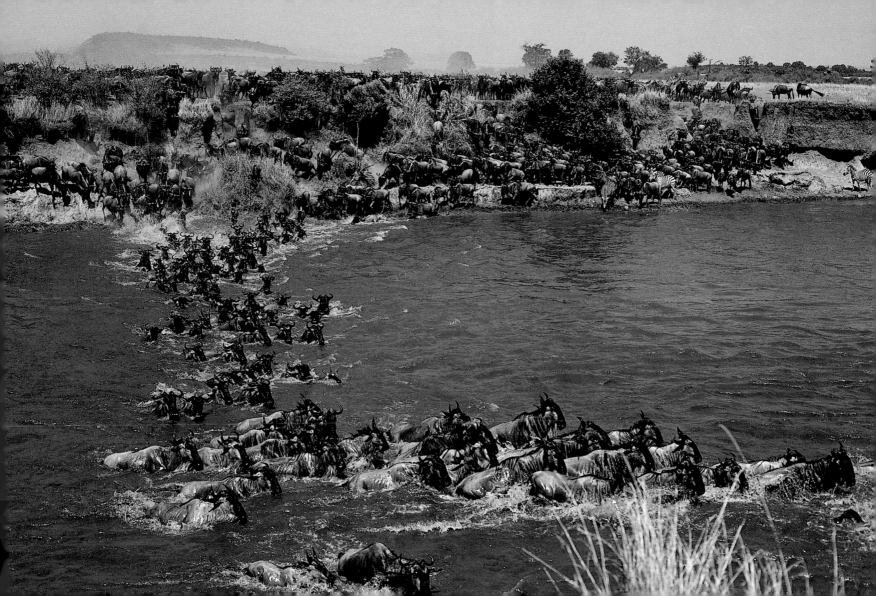

More wildebeests have lined up at yesterday's crossing point. Perhaps it is a land beast's fear of an alien medium that makes them hesitate. Perhaps, the experienced migrants have an image of death lurking beneath the water's surface imprinted on their brains. Whatever the fear that possesses them, they surge forward as though pursued by demons, leaping into the water and scrambling up the opposite bank. The tempo is faster than yesterday's, the uproar louder. But the crossing stops short of being chaotic, and all the animals, as far as one can tell, make it safely to the other side.

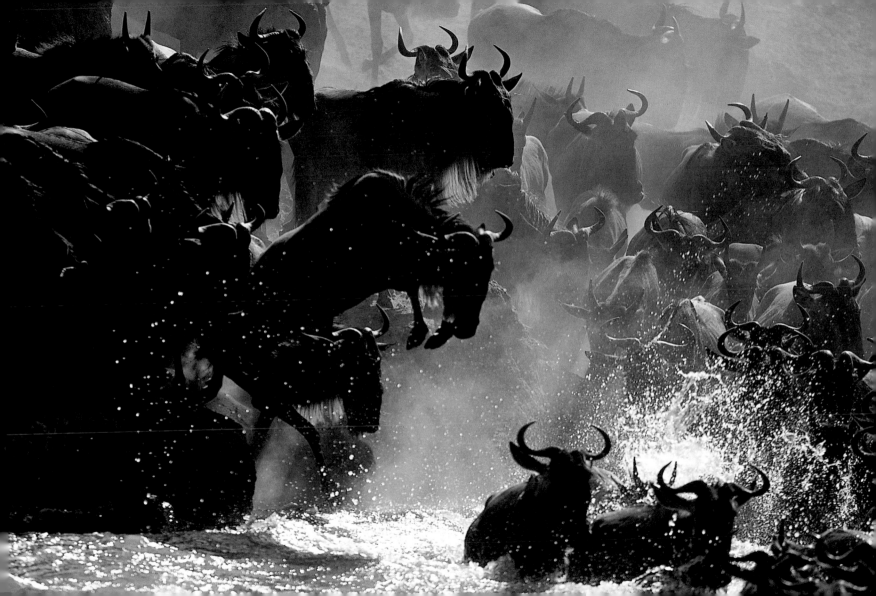

It is strange to note that today there have been no deaths at the jaws of crocodiles. Normally, during these first river crossings of the dry season, the crocodiles are hungry and very active, probing the crossing animals for a manageable kill. But driving upriver, we notice a section in the river of shallow rapids, a spot that would be difficult for crocodiles to swim through. Above the rapids, there sits a solitary yellow-green eye in the water, a chill relic from the age when reptiles dominated the earth. There are more crocodiles here, all waiting patiently for a river crossing to happen at exactly this spot. The crocodile has only two weak spots in its upper body armor—its eyes.

Today, the insistent honking, the grunting chorus from the herd on the riverbank is deafening. It is a doleful choir, thousands strong, giving voice to the rising tension. The herd surges forward and stops at the water's edge. After a long pause, it surges again, crossing the river on a broad front. Billowing dust clouds accompany this huge river crossing. Attracted by the noise and the dust, more animals from the plains join in. The crossing is so swift and furious that the crocodiles are left without a bounty.

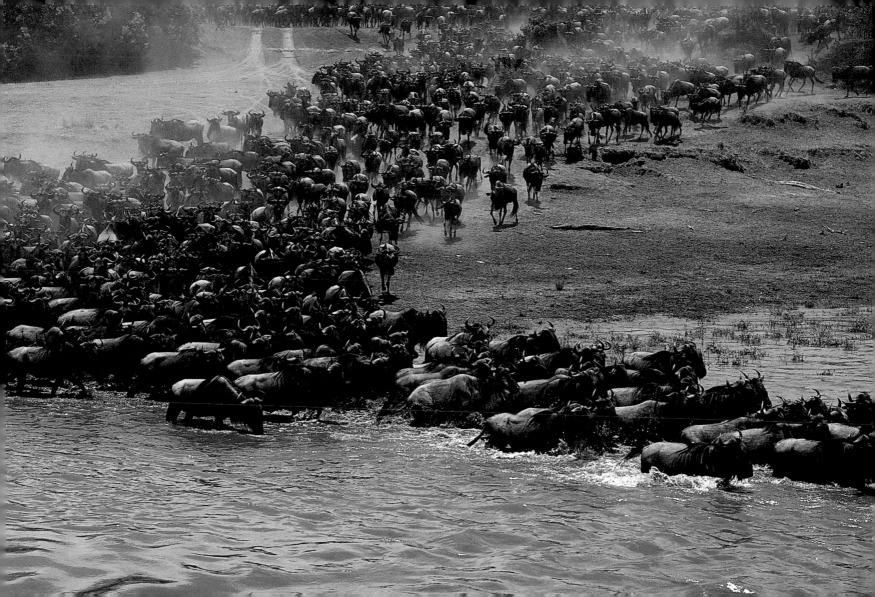

A newly arrived herd has been drawn to a crossing point nearer the crocodiles. The animals are jittery and indecisive, but it is hot and a few loiter to drink. The crocodiles wait. Inexplicably, some wildebeests wade into the river. At once a crocodile sets off to intercept. It lunges at a youngish wildebeest and manages to grip it by its flanks, but it is a clumsy grip. The terrified wildebeest is able to propel itself forward, actually dragging the tenacious reptile with it. The wildebeest manages to find a foothold on the riverbed to boost its movement toward the bank, but in the process, the crocodile gets a better grip on the victim. There is a stalemate for several minutes. The crocodile starts to tire, and the wildebeest can sense it. With a final desperate heave, it is rid of the monster and free to run up the riverbank. It hobbles away, mingles with its own kind, and is lost to human scrutiny.

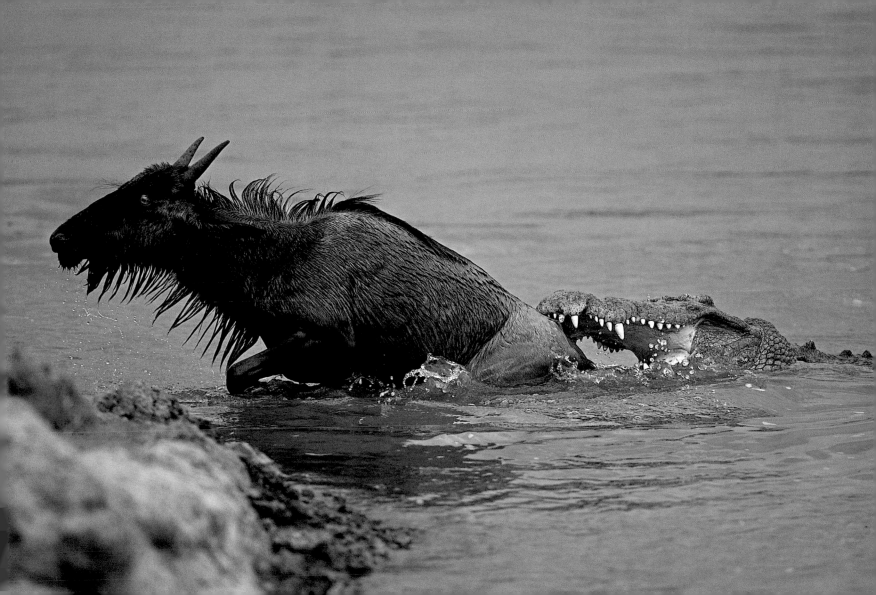

There are a few places—identified by lack of cover, gentle-sloping banks, and grooves carved by the hooves of animals—where the river can be crossed easily. Nonetheless, the nervous herds occasionally choose places where the banks are steep and the exit is problematic. This is one such crossing, where the exit is narrow and steep, but the crossing herd is a small one so the exit remains free of congestion. The animals navigate the banks in small groups and emerge unscathed to canter onto the inviting plains.

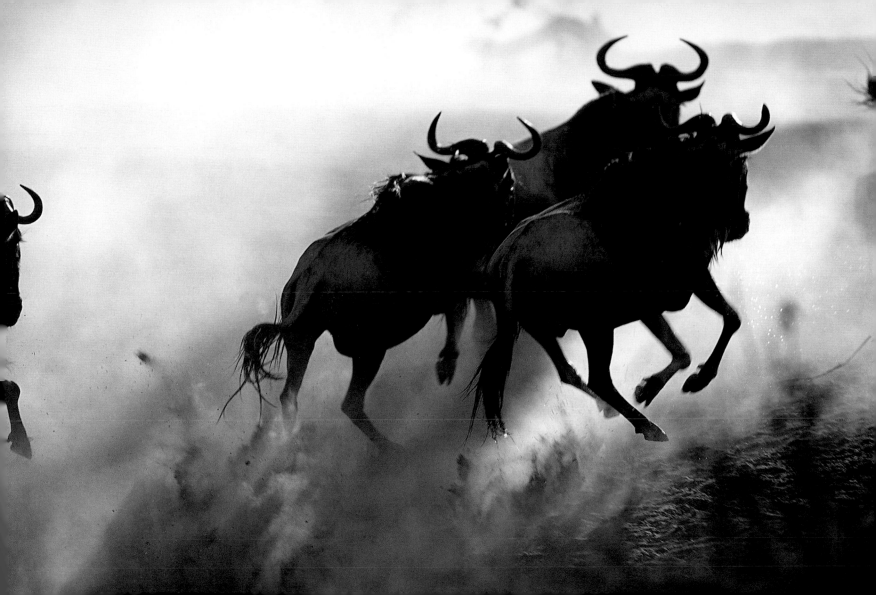

Having surmounted the river hurdle, the wildebeests continue the journey, walking in single file, the best formation for protection against hunters. As they walk deeper into Mara, they emit harsh grunts, sounding much like frogs calling. They walk at a steady pace and in a constant direction. When the time comes to graze, they spread out, like ants speckling the plains.

The grass in the rolling Paradise Plain is not as sweet as that of the short-grass plains, but it is rich in sodium and calcium. It lacks phosphorous and has lower protein content, but it is adequate in terms of calories—choices are limited in the dry season.

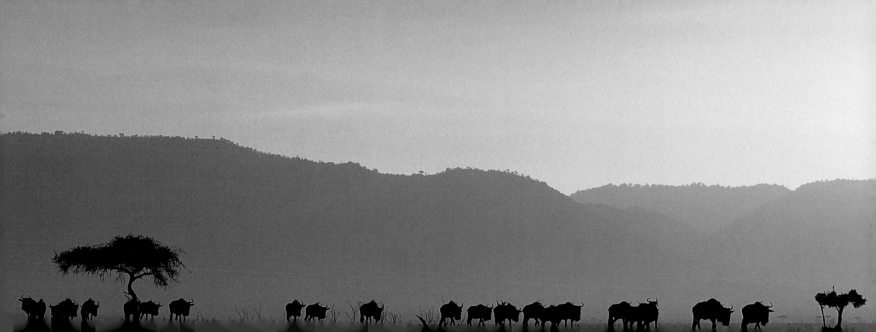

The tranquil landscape of northern Mara. The evening sky is transformed to purple by the silent advance of the night. The presence of trees, bushes, and shrubs indicates that there is adequate water here, unlike the short-grass plains of the Serengeti, which now look like a scene from Mars. In the rain shadow of the crater highlands, they are brown and dull, a devastated landscape.

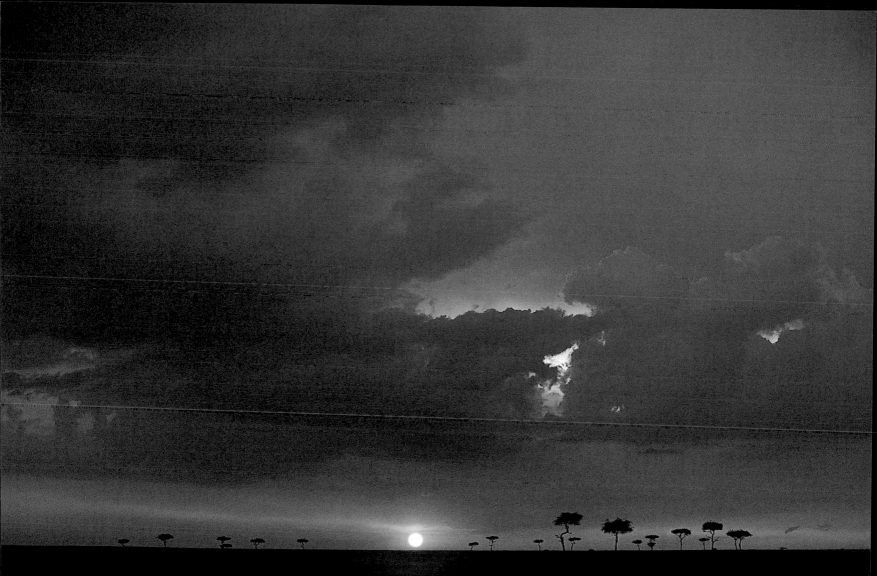

Four miles (six kilometers) to the north of Paradise Plain are the high, grassy contours of Rhino Ridge. Dense stands of green croton bushes are scattered along the ridge. On either side, there are plains of red-oat grass. A pair of kori bustards walks and forages in the tall grass, oblivious to the impending arrival of the herds. Like other bustards, the kori is omnivorous, feeding on a wide variety of insects, seeds, fruit, and flowers. When the pair crosses a track, one of them stops, preens, stretches, and vigorously flaps its wings before continuing its traverse on foot. The kori bustard is Africa's heaviest flying bird, and the male is thought to be close to the maximum weight for a flying bird. So it mostly walks, taking to the air only when it feels threatened or pressed.

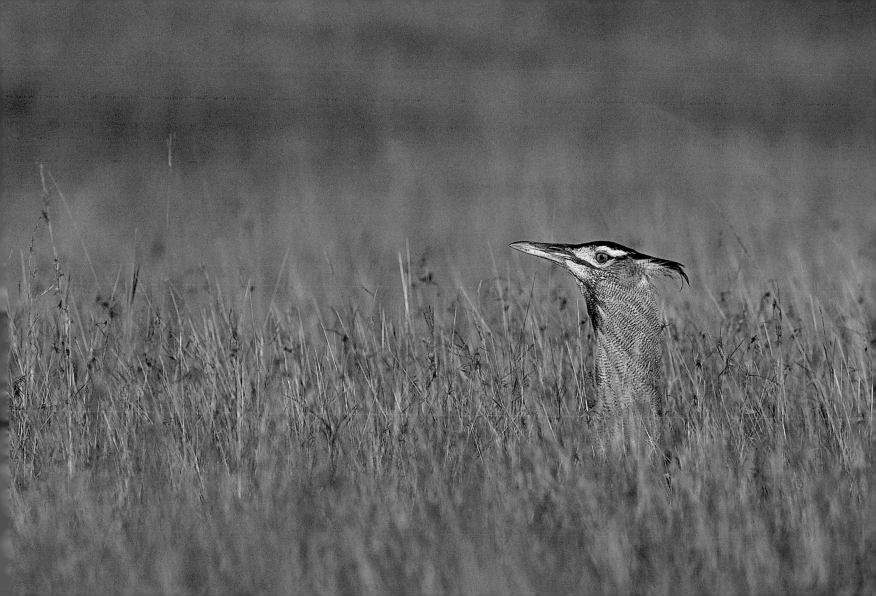

Head up, wet muzzle thrust forward to catch a scent—the somnolent Cape buffalo, which cares for nothing. Violence hangs about a Cape buffalo in the vicious curve of the heavy horns, in the truculent lift of the muzzle, in its stance—foursquare and threatening—a dark, nightmarish shape sifting the air with fierce, flared nostrils. Its horns are a deadly weapon when driven home by 1,750 pounds (800 kilograms) of angry buffalo. Buffalo become much restricted in their foraging habits during the dry spell since they need to be near water at all times.

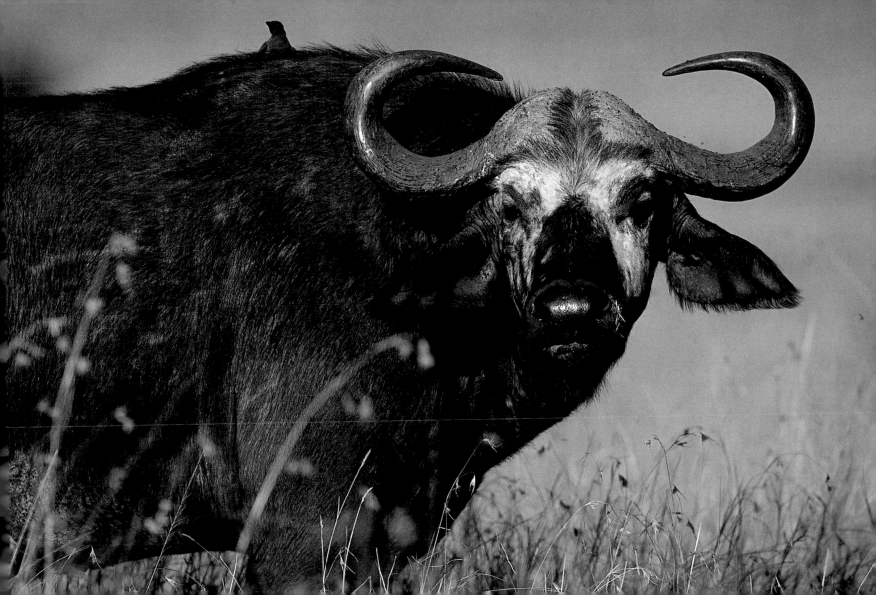

The mysterious, serene landscape looks so pure and stark in its simplicity and grandeur that it suggests innocence. Yet violence lurks there, always. The vast plains on either side of Rhino Ridge are home to several lion prides. For some reason, the migrating herds do not graze here indiscriminately as they do elsewhere so that large areas such as this provide perfect hiding places for lions. Stalking in the long grass, a lion can creep closer to its target, and if unsuccessful, the lion can also promptly fall asleep, and lie undisturbed and hidden by the veil of long grass, to be awakened the moment an unsuspecting animal saunters past. Not surprisingly, zebras, the trailblazers of the migration, proceed extremely cautiously when traveling or grazing in tall grass.

It is mid-morning, and several families of zebras have arrived at Rhino Ridge. In a small clearing, a zebra foal lies down to sleep, assured that the family grazing nearby will keep a lookout for danger. However, a lean, tawny shape steals through the grass toward the sleeping foal. Each time a zebra looks in her direction, the lioness freezes in mid-stride, then glides forward again when the grazer resumes feeding. Soon she is close enough to charge the foal, but at that very moment she is spotted by a zebra who loudly snorts the alarm. The foal looks up for a fraction of a second but wastes no time jumping up and scrambling to safety. The lioness watches the fleeing feet and, perhaps in a philosophical mood, decides to go to sleep.

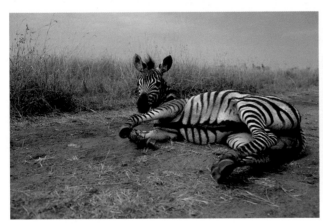 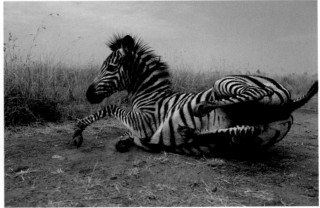

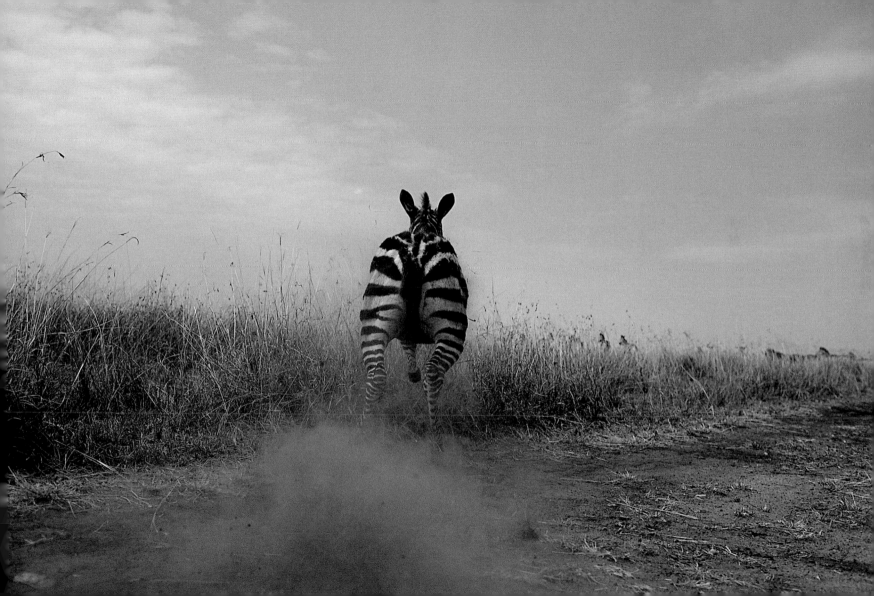

Some zebras have begun the trek out of Maasai Mara National Reserve and into Maasailand, which borders the reserve. Ecologically, there is no difference between the two sides of the arbitrarily drawn reserve boundary, except that the grass in Maasailand has been heavily grazed by Maasai livestock, exposing large patches of bare earth.

Mara's bushland and woodland have yet to be impacted by the migration. There, the rhythm of life continues at its own pace. Although giraffes wander the plains, they spend most of their time in the woodlands, feeding on the leaves of trees. They also give birth there, where secluded areas abound. At near right is an hour-old newborn watched over by a mother who continually nuzzles her precious bundle for reassurance, imprinting, and bonding. Baby giraffes follow their mothers as they forage, thereby learning what to eat and what to leave alone, but at this young age, most of its calories come from mother's milk.

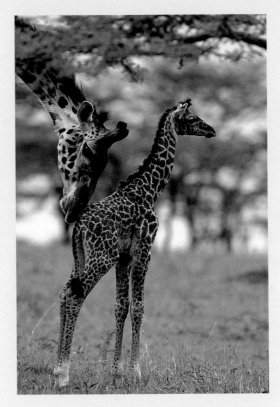

This female leopard's home range is in thorn country, outside the reserve. In a place called Fig Tree Ridge, she has a den with two small cubs. The den is a rocky outcrop with a small opening, one that is impossible for a hyena or a baboon to slip into, so the cubs are safe from them at least. This afternoon, however, she changes dens. If the cubs stay too long in one place, chances are that a marauding hyena or lion will be attracted to the place by the accumulation of its scent and kill any cub playing or resting outside the den. So she transfers the cubs, one at a time, to a new hiding place a quarter of a mile away. She carries a cub by the scruff of its neck and pauses a few times during the transfer. Were she to be spotted by a lion or a hyena with a cub in her jaws, it would be very difficult for her to mount a defense, but the entire operation goes unnoticed save for a few impalas. Work done, she climbs a tree and catches the breeze as she watches life on the horizon.

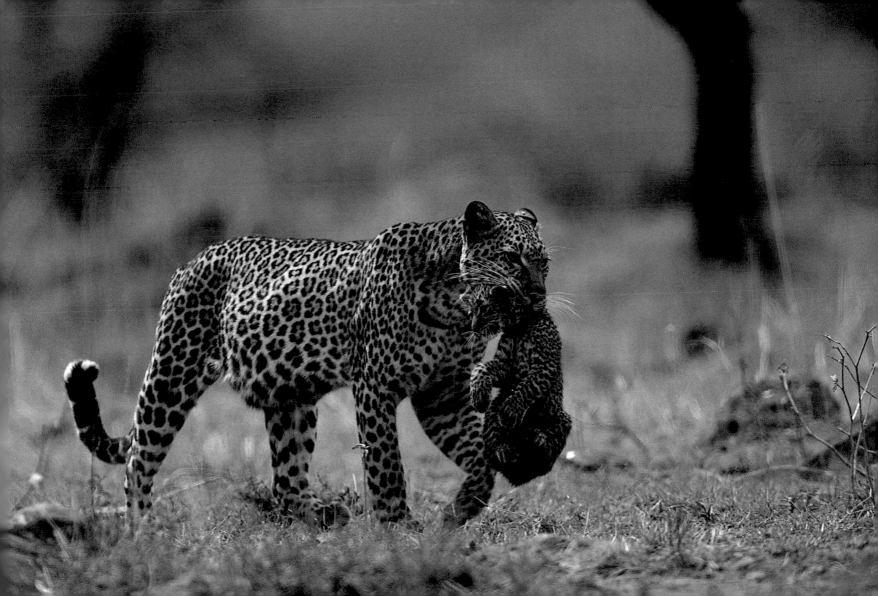

The mother leopard leaves the den very early in the morning and returns in the cool of the evening. From the size of her belly, it seems as if she has had a big meal. She calls to her cubs and lies out in the open. When the cubs come, they start suckling straight away. She lovingly grooms them as they drink. She lies, utterly relaxed, with no visible hint of the power and fury within her, except for her watchful eye. Her stare is chilling, and she seems to possess traits that are dangerous. It is not surprising that she is as removed from group ethics as it is possible to be, such is the power of her personality.

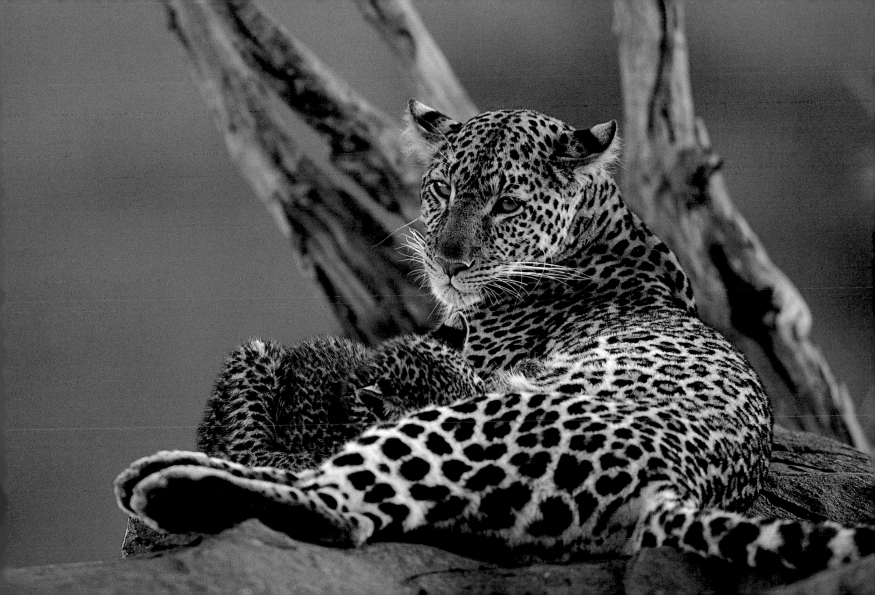

An adult male leopard is the ultimate misanthrope. He lives alone and is rarely seen, and even at that only at dawn or dusk. This male is taking a circuitous route through open ground as he patrols his territory, for a clan of hyenas is feeding near his normal route through thick vegetation. Like all of his kind, he avoids hyenas whenever he can.

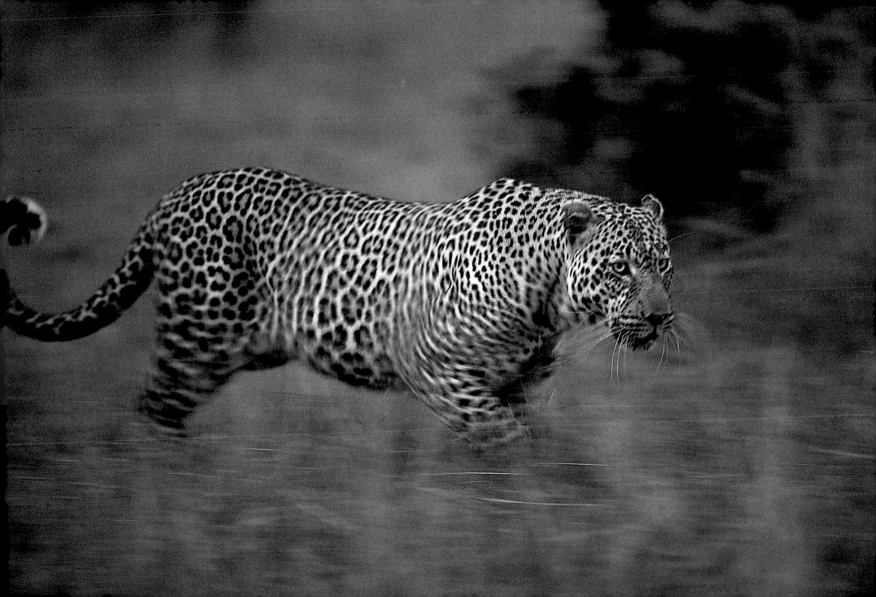

Impalas graze on both Fig Tree Ridge and out here on the plains. Impalas are an ecotone species occupying a niche between grassland and woodland. They are adapted to change their diet according to the season, grazing when the grass is most nutritious in the wet season and browsing on bushes and small trees during the dry season. But they can adapt when other factors come into play, such as times when the arrival of migrants reduces grazing opportunities on the plains, which forces them to switch to the woodlands.

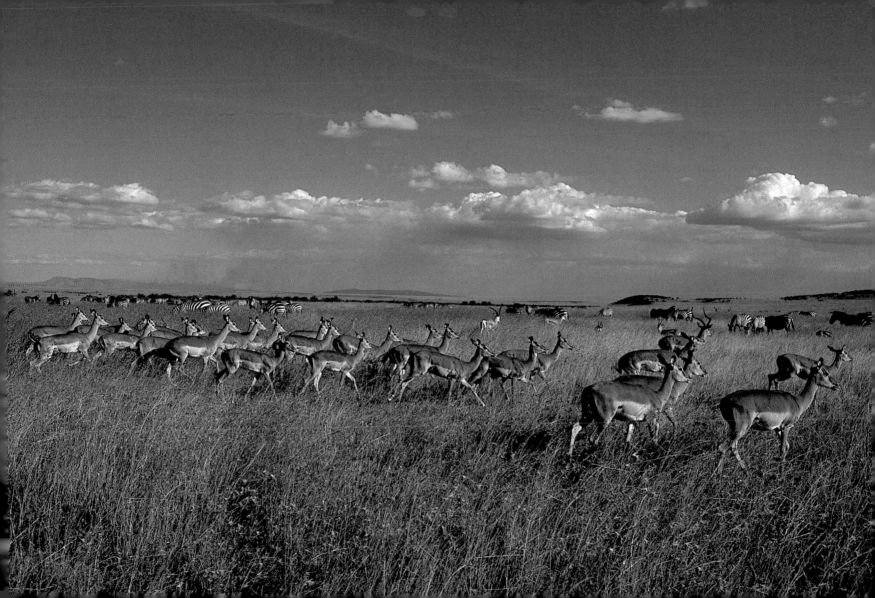

This early morning on the plains is bright and sparkling with a golden light. Two zebras meet and greet with nasal contact and sniffing. After a few seconds, they jerk their heads back and move on. They are from different families whose paths have crossed during the migration. Despite many such brief encounters, zebras tend to remain within their own family units. Any disruption to this social arrangement is due to bachelor stallions trying to steal young mares from a family to start their own harem.

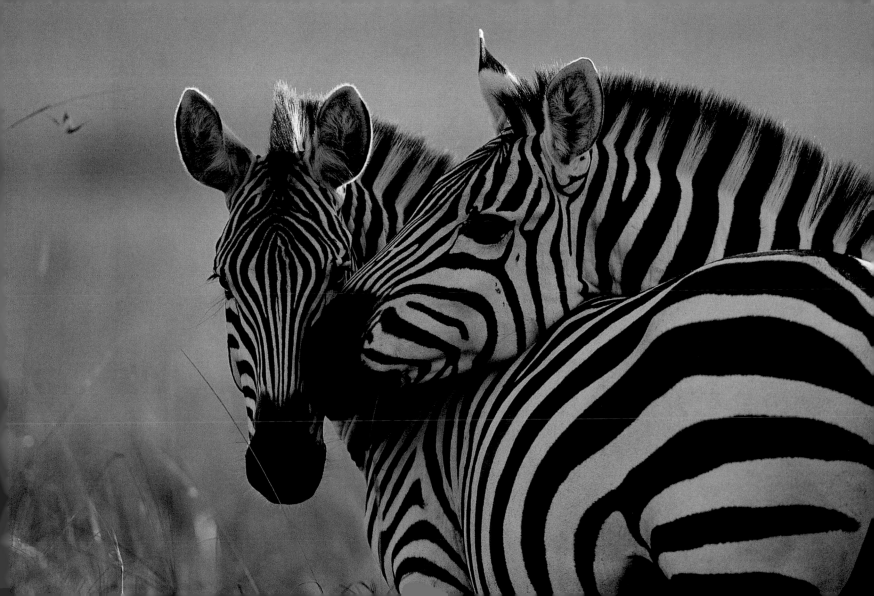

This afternoon, there are signs of an impending heavy rain, which has pulled in more zebras. Coming under a different weather pattern, Mara is typically wetter than Serengeti, and even during the dry season, afternoon storms occur intermittently. Today is one such afternoon. The rainfall is heavy and fades away after half an hour, leaving behind a coolness combined with the fresh smell of soaked soil. The light stays gloomy, and the clouds fill the sky as dusk falls.

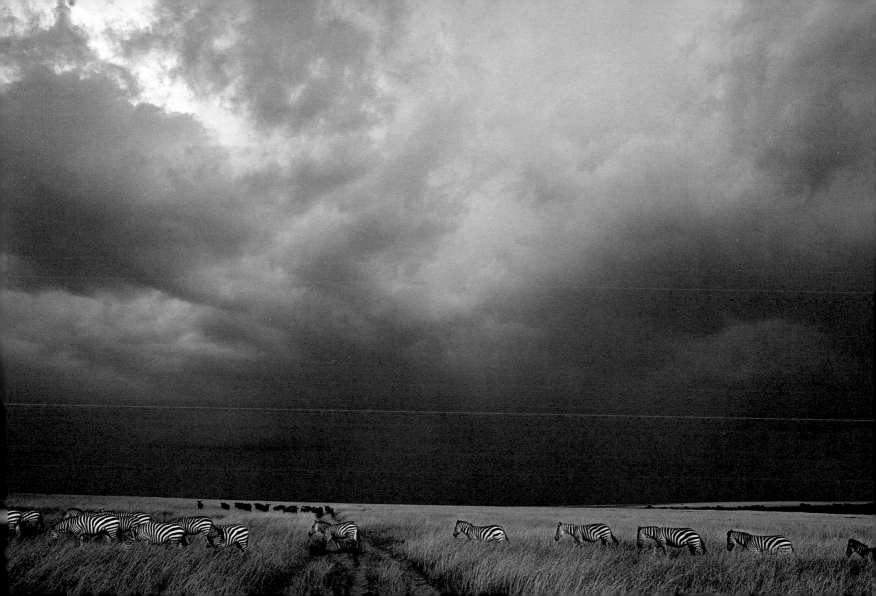

Mara means "the spotted land" in the language of the Maasai. A few decades ago, Mara was indeed spotted with trees and bushes, but thanks to the work of elephants and fire, it is now characterized by large areas of open grassland. The versatile trunk of the mightiest mammal of them all, the elephant, can bring down a tree taller than itself, but it cannot repel parasites. Botflies sneak inside their trunks to lay their maggots, a supreme aggravation for the elephant.

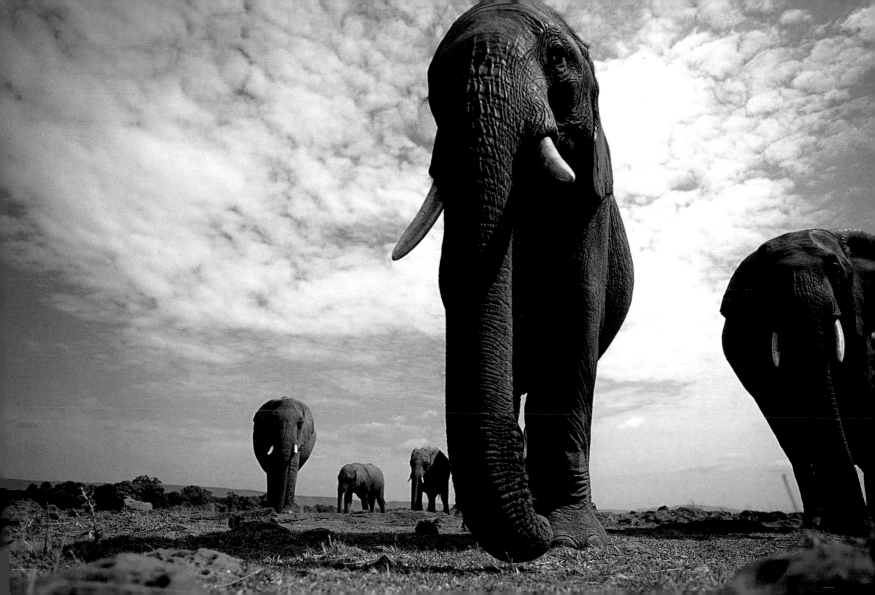

An elephant's hide may look impenetrable, but parasites, particularly the warble fly, can send maggots into the flanks, shoulders, thighs, and backside. There is one parasite that even manages to bore into the iron-hard tissue of the animal's feet.

September is the month of new life in Mara. Hyenas gather at a clan den to give birth to twins; black-backed jackals give birth to four to seven pups; litters of warthogs accompanied by hoglets are seen; topi, too, start giving birth to single fawns. These two beetles are going about the business of starting a family as well.

Something small is moving very slowly and deliberately in the bushes. It is placing its grasping feet very carefully on the stick-like branches, one in front of the other, its tiny eyes revolving independently of its head in turrets. A chameleon is easy to identify, as it does not resemble any other lizard.

In spite of the occasional storm, the dry season continues, insensitive to the needs of a mother and a baby. This seven-month-old wildebeest stays close to its mother through rain or dust. The wildebeest young that have survived the rigors of the migration so far still have five more months to go before becoming independent of mom and a member of the herd.

It is half an hour before dawn, and there is a chilly breeze blowing. By the time the sun appears, flaming red, we have found a cheetah with three adolescent cubs on Paradise Plain. The mother is keeping a vigilant watch from a mound—there are lions in this area—but the cubs, one of which is seen here, are not bothered. In the cool of dawn, they play chase at high speed, running and leaping with gleaming eyes. When mother moves to another mound to continue the vigil, they bound after her. But the day warms up quickly, and they are soon resting in shade.

The sun is near its midday point. The cheetah with the three cubs has been actively on the hunt since dawn. Crisscrossing an area of six-inch-tall grass, she finally flushes out a gazelle fawn, catches it, maims it, and then stands aside as her cubs take over. In this way, she helps them learn how to kill. Sensing that the fawn cannot run fast, the cheetahs toy with it, prodding it to move when it collapses, then chasing it when it tries to escape. They are totally absorbed in this activity, oblivious to any pain and stress they are inflicting on the terrified fawn. If I were to interfere to save the fawn, however benign my intentions, there would surely be an adverse impact somewhere along the chain of actions and consequences.

Late afternoon: The cheetah with three cubs is resting under a bush when a gazelle with a fawn walks by, totally unaware of the presence of danger. Some sixth sense alerts the gazelle to look back—she sees the oncoming cheetah mother followed by her three subadult cubs. In the confusion, the gazelle mother is caught while the fawn manages to escape. But the commotion has caught the attention of a hyena who shuffles in to investigate. It is four against one, but with the wisdom of age, the mother cheetah immediately gives way to the hyena. However, the brash youngsters, emboldened by hunger, decide to mount a challenge. First, they wait and watch. When the feeding hyena's back is turned, one of them creeps up. The hyena turns on the snarling, hissing cheetah only to find another one hard on its heels. As the third cheetah buzzes by, the second cheetah takes the opportunity to tap the hyena's rump. But the hyena quickly regains the initiative, leaving the trio momentarily indecisive. The confrontation is unusual, but the outcome is not: The cheetahs reluctantly withdraw to allow the hyena to feed in peace.

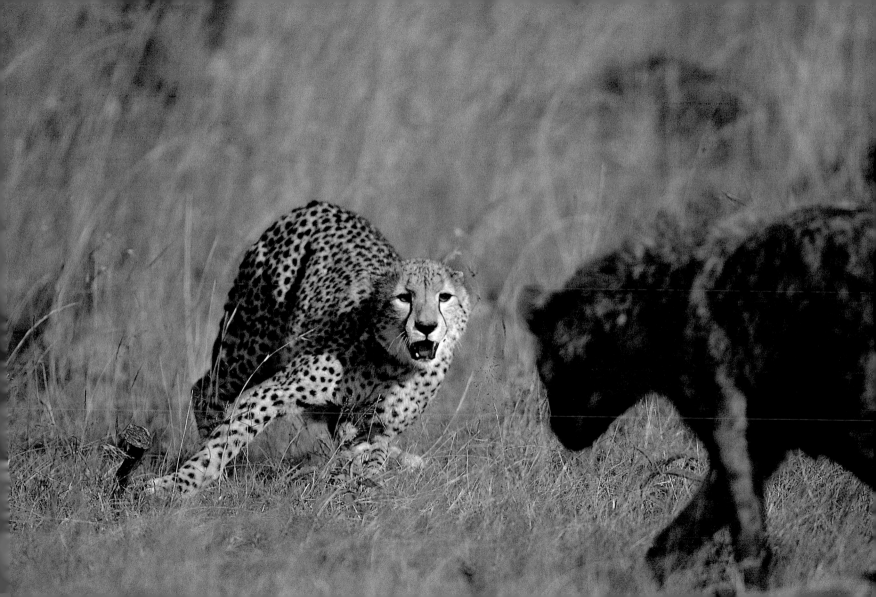

An ancient relationship among scavengers is enacted today. A hyena is dozing. Suddenly, she raises her head as if to listen to something, then gets up to take a look. Vultures are descending half a mile away. Is it possible that she heard the sound of vultures coming down in the wind while she was asleep? Off she goes to investigate. At first, the vultures give way to her. Vultures do not challenge large predators directly when they are alone or few in number; they wait for their numbers to build up to a hissing throng, at which point they will advance on the kill. On this kill, there is no peace for the hyena as the vultures persist in getting their share. Annoyed and frustrated, the hyena tears off a leg and trots away with it, abandoning the rest of the kill to the winged scavengers.

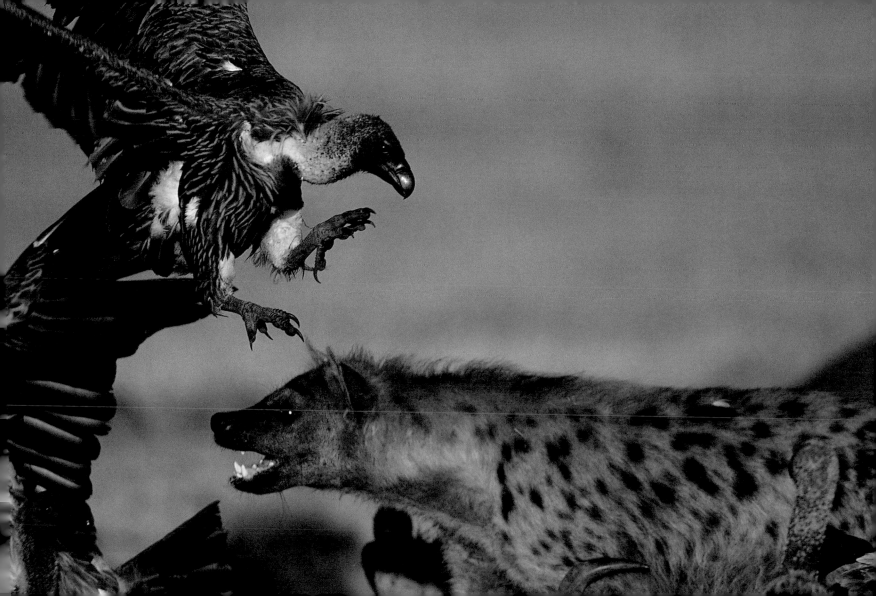

Another ancient rivalry plays out at Musiara Marsh. Shoulder to shoulder, a hyena clan faces down a young male lion. The two adversaries are assessing each other. Normally, hyenas are extremely astute in judging the resolution of lions. Although they are bold enough to try and drive lionesses from a kill, advancing aggressively with manes and tails raised, baiting them, provoking them, badgering them, driving lionesses beserk as they try to eat, they are usually prudent enough to leave the big males alone. The young male these hyenas are antagonizing, barely three years old, is a different proposition. The hyenas emit an eerie call of aggression known as a "low" as they edge closer, trying to psych him out. Their mob tactics, advancing and retreating repeatedly, are designed to unnerve. But the young male rumbles out a warning and stands his ground, signaling that he does not fear them. They move on, conceding defeat.

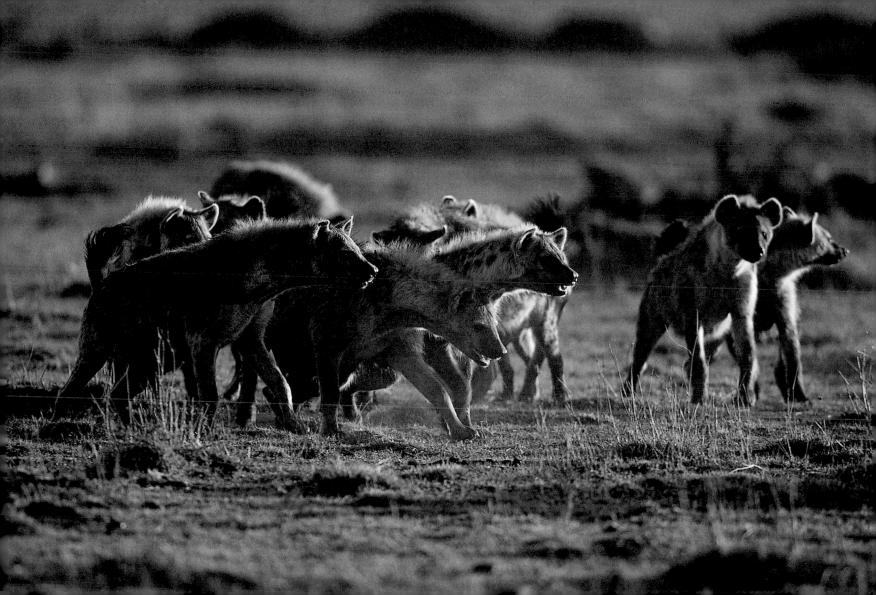

Yet another rivalry takes place today. Early in the morning on Paradise Plain near the Mara River, the two Paradise pride males, one of them pictured at right, have spotted a pair of intruding male lions. Without hesitation, they run to investigate. The two parties are evenly matched, but the pride males have territorial advantage, so when they accelerate, the intruders turn tail and head for the river. The strangers cross the Mara River—even when it is too deep to wade, lions swim with ease. The pride males slow down to a trot, then a walk. Like all cats, lions are powerful but lack stamina, but these two have made their point. Now they roar and engage in some vigorous marking. Then they head back to the pride, walking side by side, nuzzling, and rubbing their bodies. Upon coming to a large termite mound, they climb up, lie down, and keep watch. But they are male lions, and within fifteen minutes they are fast asleep.

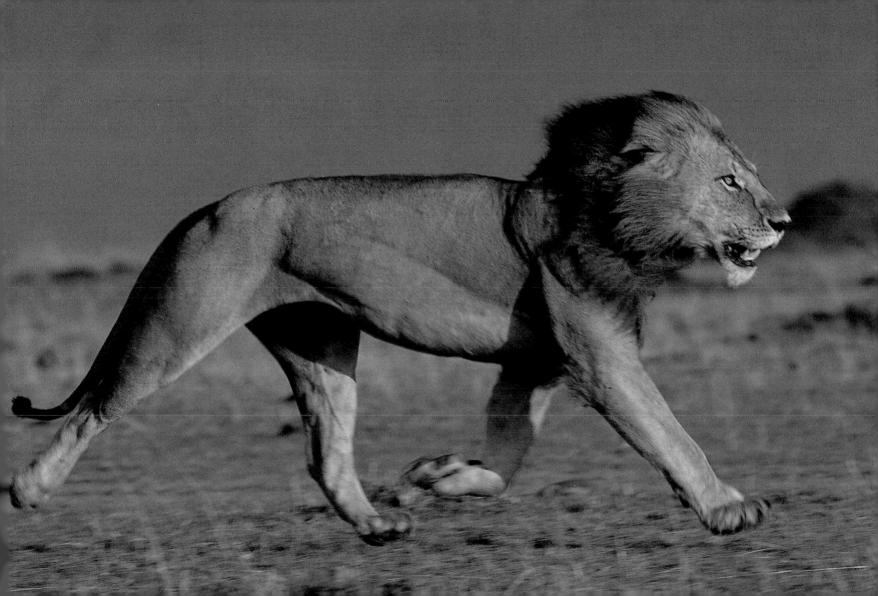

The rivalries continue. With the advance of the dry season, Musiara Marsh has developed treacherous, boggy patches. Churned to a thick morass by constant trampling, the shrinking pools have become soft quagmires. Hyenas are resting here but not for long. When two male lions from the Topi Plains pride arrive, they spot the hyenas and charge; the hyenas flee.

Hyenas assiduously avoid adult male lions, who have been known to chase and kill them for no apparent reason, but this unfortunate hyena has stumbled into a sticky patch in a blind panic. Trapped, the cornered hyena snarls in the face of certain death. After delivering the hyena a fatal bite, the male shakes the carcass, drags it clear of the marsh, and tosses it aside. The two males are clearly aroused—their eyes shine, their bodies are taut, they roll in the grass side by side, and embrace each other. The dead hyena is left uneaten.

Yet, in the natural world of this ecosystem, hyenas are the great levelers. No animal is so fleet or powerful that it might not one day be consumed by their voracious clans.

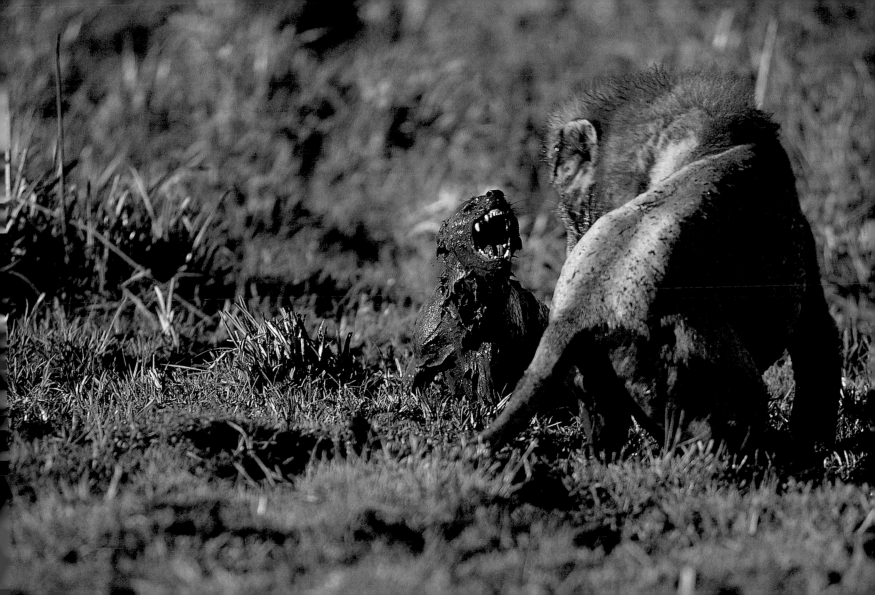

Last night, the sound of the wildebeests' melancholy calls surrounded our camp. Dawn finds them moving into new areas for grazing. They are fanning out, lines like tentacles probing into all corners of Mara and the adjoining Maasailand.

The migrants are spilling into pockets of woodlands where lion prides are also found. The woodlands are part of a desirable lion territory since prey animals inhabit these areas year-round. At sight of an approaching lion pride, these startled giraffes ran off and then stopped to turn and stare once they realized that the lions were not hunting. The giraffe seems endowed with an uncanny early-warning prescience. Its great height enables it not only to reach vegetation out of reach of most browsers, but also helps it look out for lions, which occasionally prey on giraffes. A giraffe's flight distance — the distance it will allow itself to be approached by a lion — is just inside 100 yards (nearly 100 meters), farther than any other animal on the savannah.

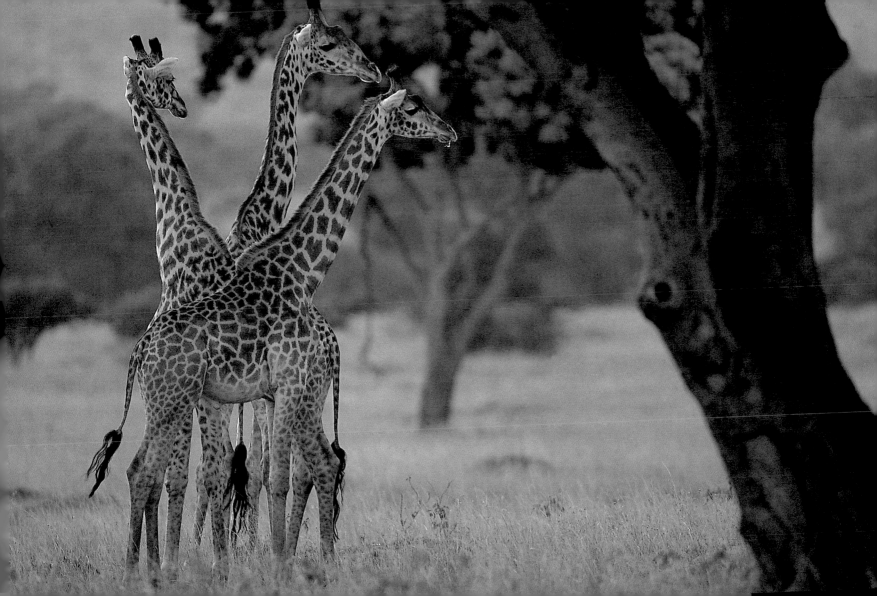

Two Maasai traverse the plains, just outside of the reserve. They stride easily yet purposefully past the grazing migrants. The ease with which Maasai and wildlife intermingle here in Masaailand is striking. This state of affairs contrasts sharply with numerous corners of our modern planet, where humans and wildlife often clash violently.

The migrants continue to blunder through the habitats of resident herbivores, who, if they are primarily browsing beasts like the giraffe, will remain indifferent and unaffected by the vast appetite of their seasonal visitors. They only suffer the noise.

In the woodlands, giraffe life continues as the fighting of two statuesque male giraffes carries on in slow motion. They stand close together, and one of them swings his head around in a wide arc, audibly hitting the other in the neck with his blunt, stumpy horns. The other retaliates in turn, and the two continue to hit each other for several minutes. Then they stop, as if surprised, and resume browsing as if nothing had transpired.

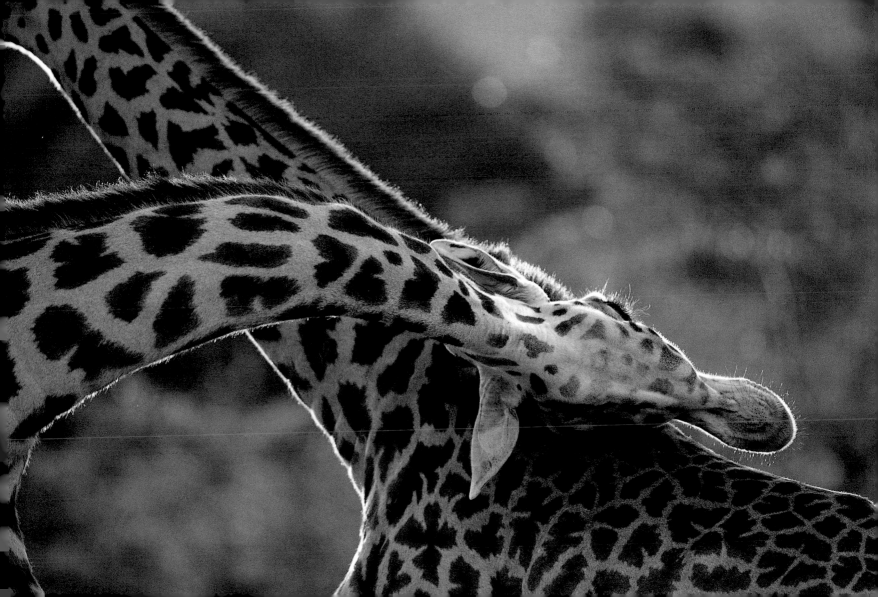

Evening time: Long ears and dark heads emerge from a bat-eared fox den, which was originally a burrow an aardvark built in the remains of an old termite mound. As they emerge, this pair first looks warily around and then settles on a tiny bare patch of earth, where one of them lovingly grooms the other. Indifferent to the comings and goings of the herds, life continues as normal for them. Bat-eared foxes live on insects and have a great fondness for harvester ants. They can locate, by sound alone (inaudible to human ears), insects feeding underground and, somehow, know exactly where to dig for them.

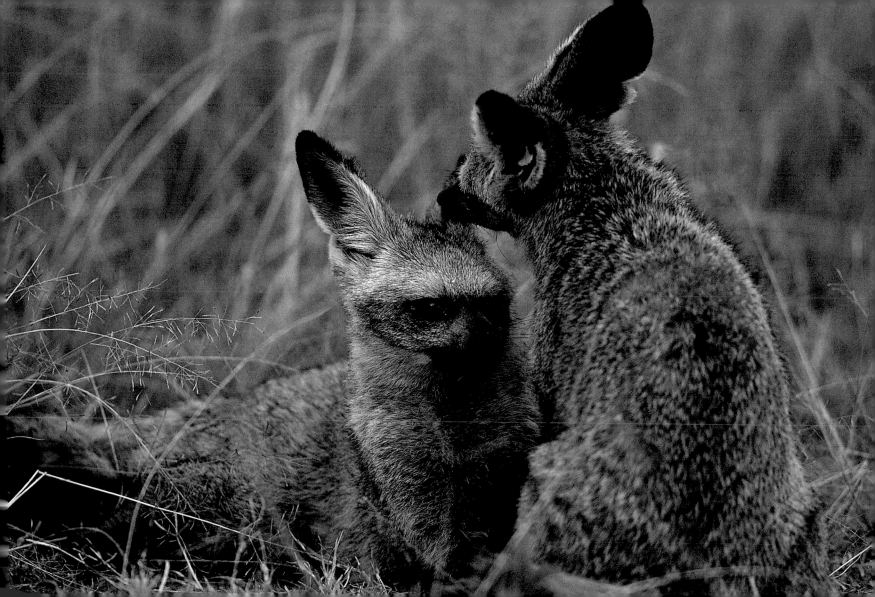

The migrants flow past a tree, and a few rest under it. Atop the tree, life goes on for a pair of avian residents—saddle-bill storks. One bird flies out to collect more material for the nest the birds are building somewhere near the top of the tree. The largest of the African storks, it is thought that saddle-bill storks mate for life.

The migration is taking over bushland where leopards lurk. Leopards are capable of killing seven- to eight-month-old wildebeests.

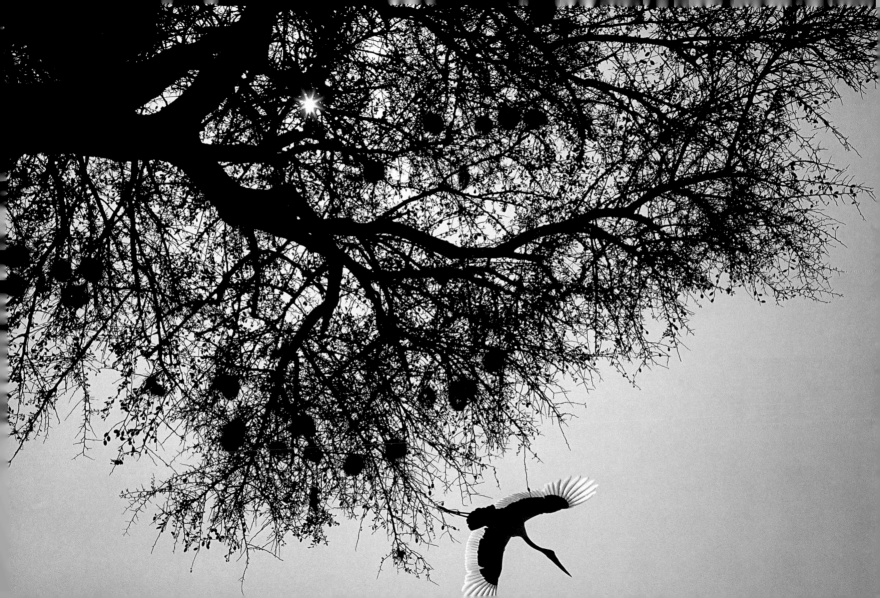

Picking her way over stone-covered ground, a female impala, whose herd has moved on ahead, dallies. This leopard mother watches her new quarry from a tree. The impala disappears behind a thicket. The leopard drops silently from the tree and stalks, using any cover that keeps her hidden, her senses focused on the impala she has logged into her hunter's computer. She is an unpredictable hunter who relies heavily on the element of surprise. At a small clearing, she flattens herself as close to the ground as possible, her elbowed legs pumping like small pistons as she moves forward in her stalk. Now she is all fluid grace, pouring through the grass, belly to the ground, tail held low, head flattened like a snake's. Some sixth sense seems to warn the impala. She stops for a few seconds, wide-eyed and alert. The wind gushes, grass moves, and the impala snorts before bounding away. That was a close call.

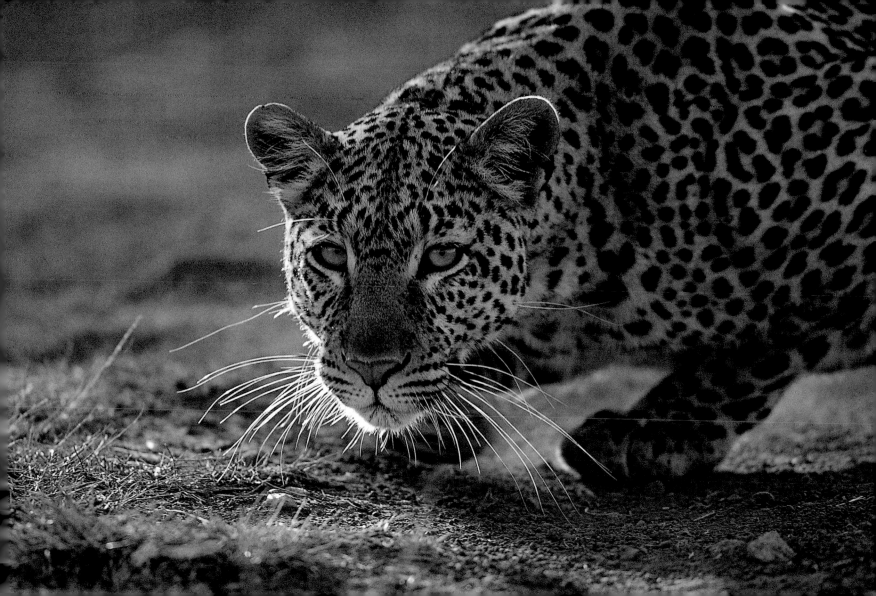

Engrossed in grazing, an impala herd drifts away from the woodland toward the plains where concealment is difficult. The impalas frequently raise their heads from grazing to scan their surroundings, and with so many sharp eyes and sensitive nostrils on alert, it is very difficult for a large predator to take the herd by surprise. But the impalas have not reckoned that a warthog minding its own business will suddenly appear. From a distance, the warthog resembles a small lion, so the herd explodes into many darting individuals, all running in different directions and leaping spectacularly into the air with soaring bounds three yards high. The warthog trots on unconcerned, but it takes some time for the impalas to regain their composure.

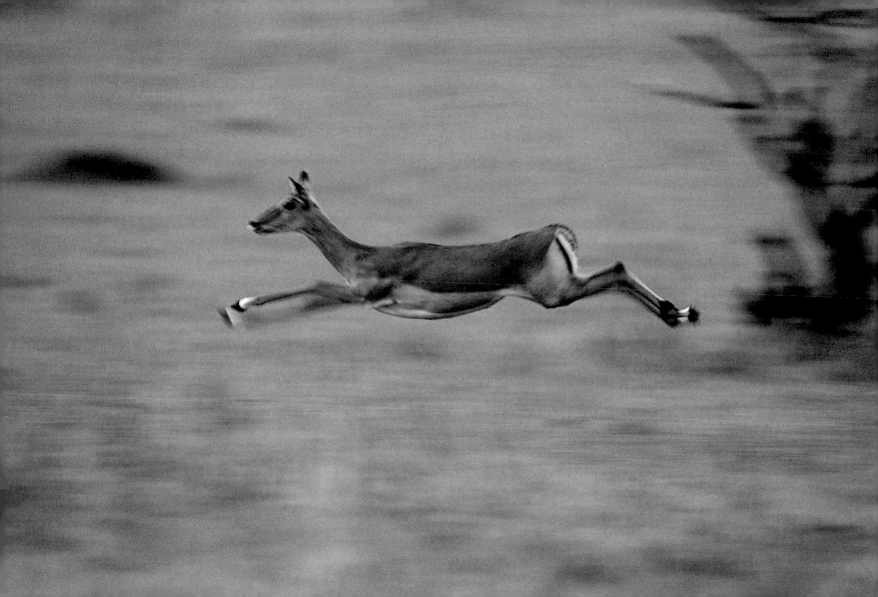

The mother leopard is stalking a male impala today at midday. She is in tall grass and the impala is browsing 20 yards (18 meters) away. Suddenly the impala stops and wheels to stare where he has sensed the presence of eyes. But the leopard has moved and is now less than 10 yards (9 meters) away. Yet even from so short a distance, she is invisible in the yellow grass. The impala resumes browsing. She slithers forward, hugging the ground, using the grass to conceal her approach. She is about seven yards (6 meters) away from her target.

They say that a leopard has every movement of its surprise attack planned in its head. She now wriggles her hindquarters, seeking the purchase from which she will launch herself forward. She springs out from under cover in an all-or-nothing bid to nail the impala. Her sprint is a blur—no impala can outrun a leopard over so short a distance—and in an instant, her body has hooked onto the fleeing victim, bringing him to a standstill. She, lying on the ground, quickly clamps her jaws on the impala's throat. The impala is bigger in size, but the leopard is the strongest cat on earth for its size. Locked in her fatal embrace, his struggles are in vain.

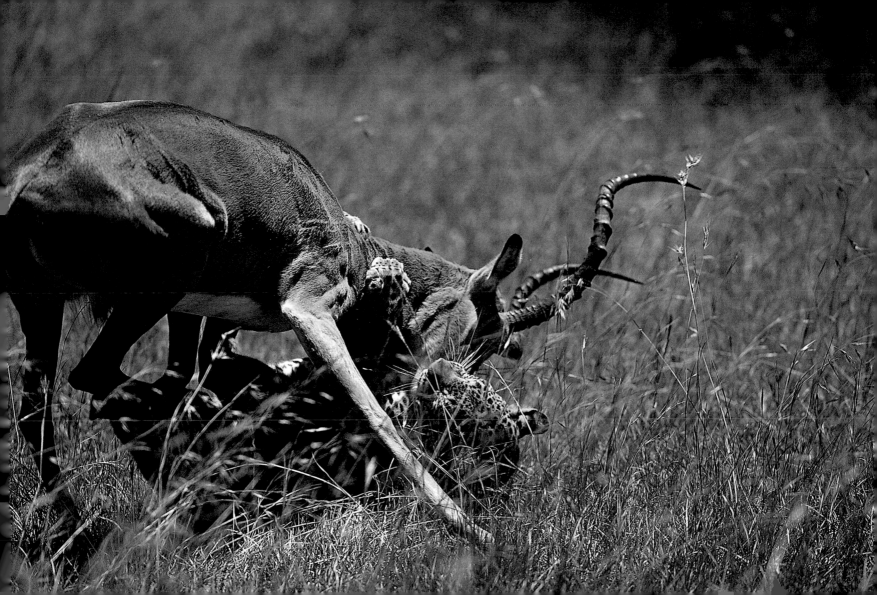

The impala carcass of yesterday is wedged in a tree fork and is half eaten. The two leopard cubs are playing at the base of the tree while the mother is sitting on a rock with a terrific view of the woodland below and the plains beyond. One adventurous cub walks over and pounces on mother's flicking tail—she pays no attention. The cub then mock attacks the mother in a clear invitation to play. The cub's tenacity finally gets the mother in the mood for fun, and the two of them play together, tumbling, play-biting, and grappling with claws sheathed.

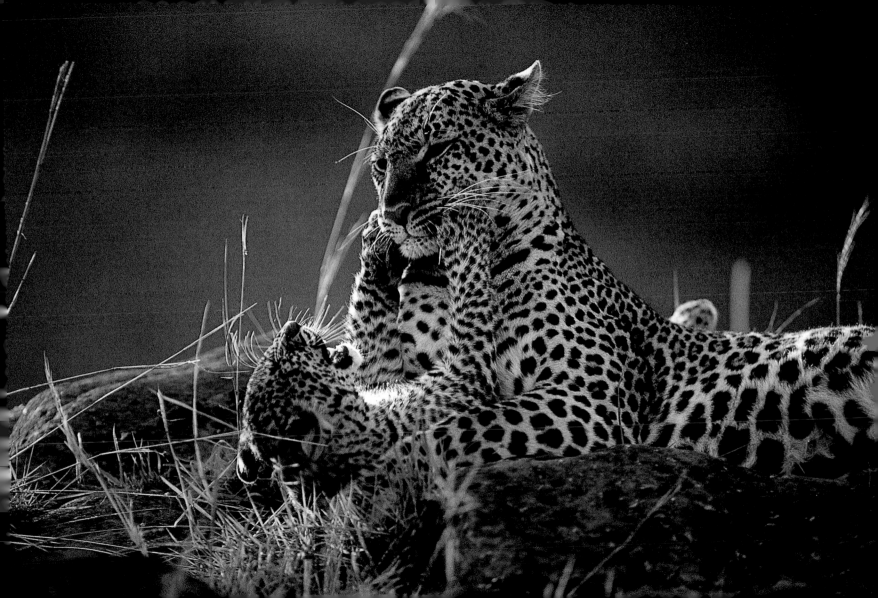

The morning is all clear skies, but hot weather is on the way. Two hours before sunset, as the heat leaches from the plains, game is on the move again after the afternoon torpor. Impalas emerge from the shade of trees. Zebras frisk and squeal in the cooling air. Near sunset time, the westering light dissolves in a golden glow. The wildebeests fall into a single file and move deeper into Mara—by the laws of the season they are bound to Mara for a few more weeks.

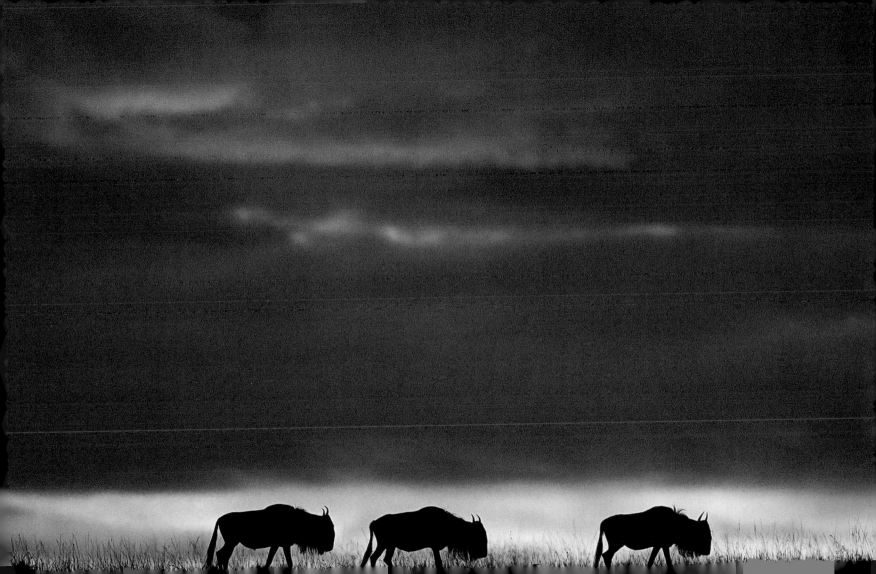

As another day draws to a close, the resident baboons prepare for bedtime. The troop takes refuge in high trees possessing long, slender branches where a baboon can wedge its rump and sleep. There is no need for a nest. A dog-faced male barks in alarm for it has spotted a prowling lion. But up in a tree, they are safe from lions. The major threat to baboons is a leopard, which is quite agile in trees, has acute night vision relative to a baboon's, and operates in secrecy. It is capable of climbing a tree without waking a single member of a troop. The migration means little to baboons in relation to a night attack by a leopard.

From her upside-down perspective, a baby baboon takes a keen interest in the world around her while her mother forages. When her mother sits down, baby quickly begins to walk and explore all around her mother. But when a dominant female approaches, the low-ranking mother quickly grabs her baby, places her on her chest, and resumes her quadrupedal walk. It's best not to give the higher-ranking female a chance to manhandle the baby, which she will often do.

OPPOSITE

A baboon troop has left last night's roosting tree behind and is out on the plains, foraging. Social disputes are a feature of this hierarchical society; females are constantly asserting their rank, and males are forever jockeying to climb the social ladder. A disagreement among two males breaks out, and the alpha male runs to the scene of acrimony. Upon seeing him running toward them in full cry, the subordinate males scatter. Peace is restored, if only for a few minutes, before the eruption of the next social fracas.

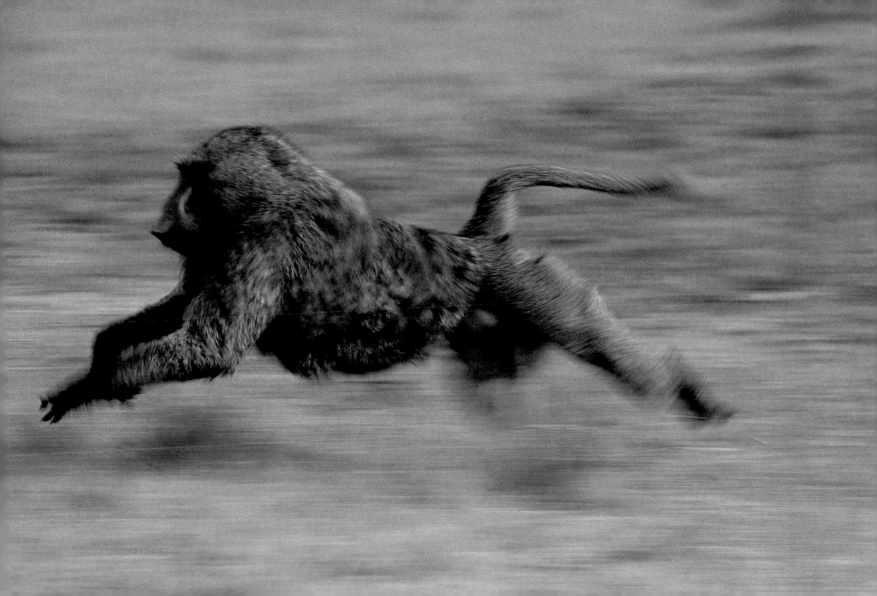

A lioness has managed to kill a baboon but does not feed on it. She stays with the kill under shade, and then abandons it. A hyena waiting in the wings takes the opportunity to grab the huge carcass and carries it easily to a nearby pool where it dunks it, and then, as if as an afterthought, jumps in to cool off.

The hyena's iron-clad stomach makes it the most efficient killer and scavenger in this land. It accepts nearly anything that is edible: fur, hide, razor-sharp chunks of bone, and meat so putrid that even vultures will not touch it. It will even attempt to digest chunks of wood, a mouthful of earth, dried grass, and leather so hard it cracks when the hyena bites into it.

OVERLEAF

The topi—a chestnut-colored antelope, with a long, sooty face and a habit of standing motionless on a termite mound for hours on end—is a feature of the Mara. Large numbers live in the reserve year-round. The topi favor grassland habitat where grass is high, but with the migrants moving through, mowing down the grass, they are forced to compromise.

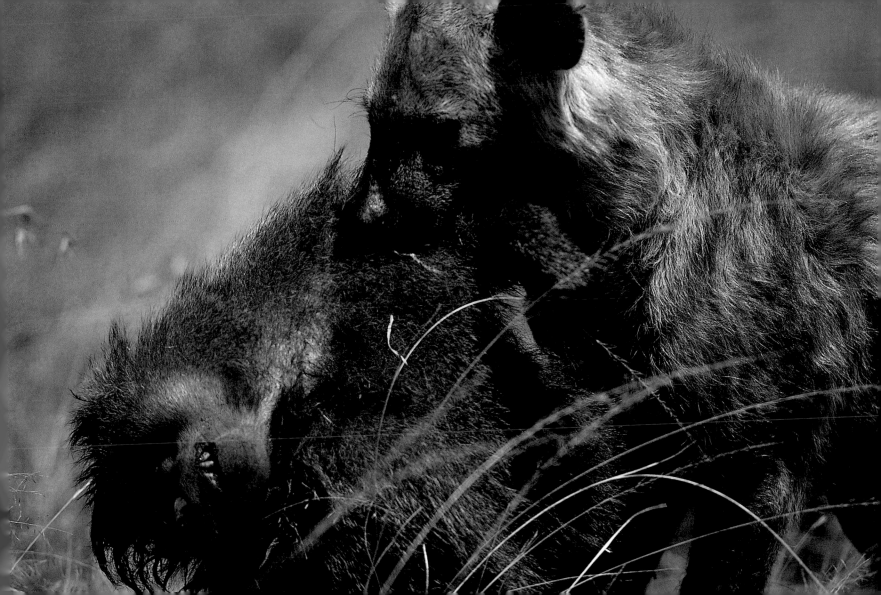

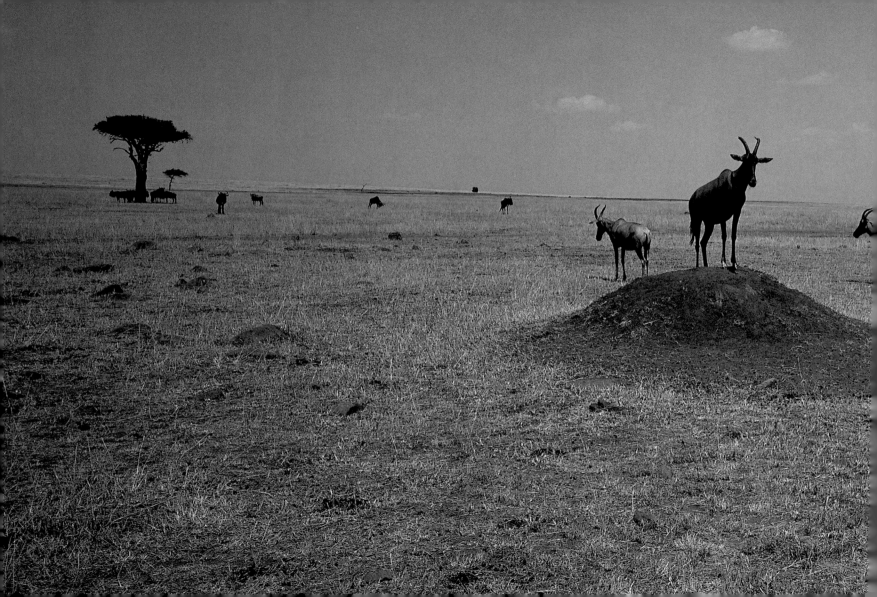

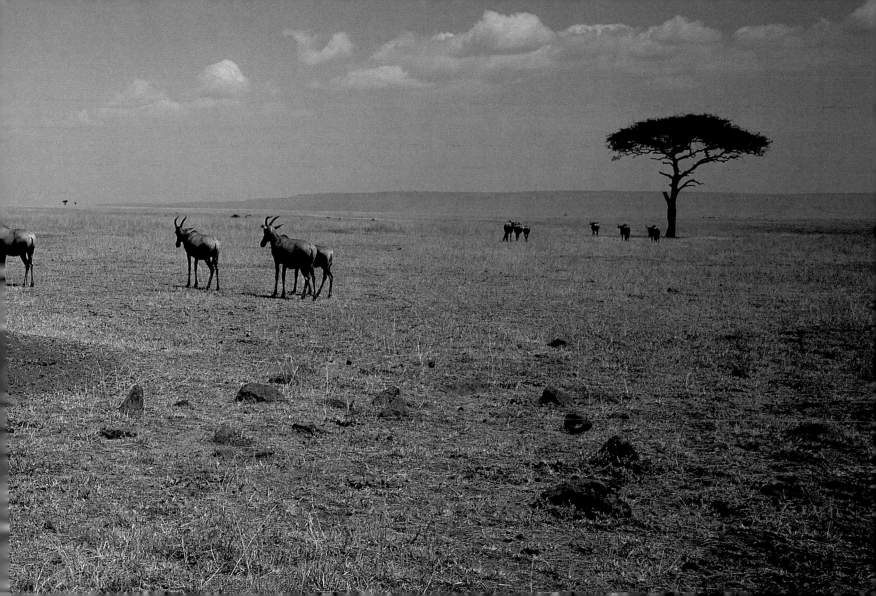

Dawn: From a pool, a pair of frog-like eyes watches a nomadic lion walking toward it. Absurdly small ears twitch, flicking away beadlets of water. As the lion comes to the edge of the pool, the hippo gives an ill-tempered snort. Its nostrils force a fine spray of water into the air as it sinks out of sight. After the lion leaves, the water becomes still and the pool looks serene. Until, that is, a form beneath the surface heaves and suddenly appears. Air whistles out of holes (the hippo's nostrils opening and closing), and the hippo sinks and disappears again. The sun rises, and the lion and the hippo succumb to daytime inactivity.

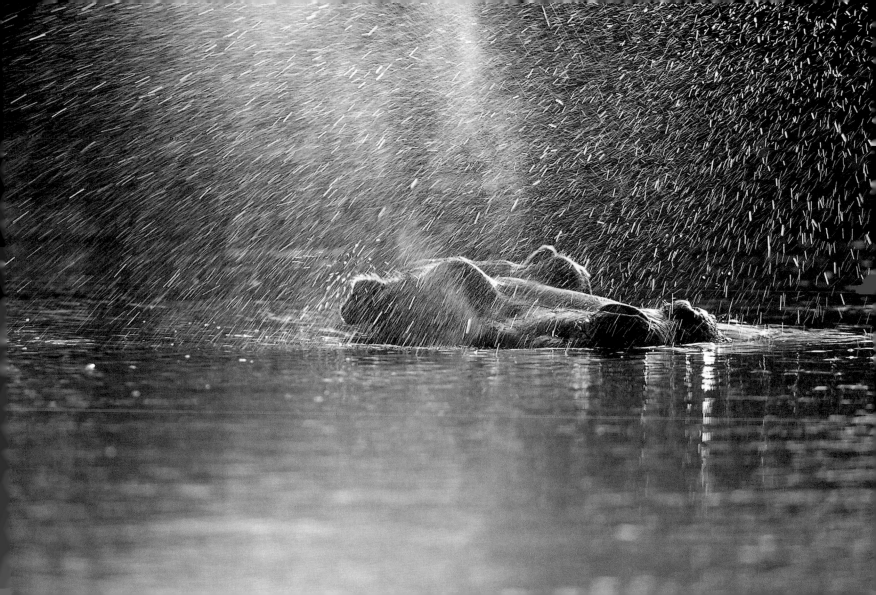

Driving toward Musiara Marsh before sunup, we see a hippo running frantically toward Mara River, pursued by the Musiara Marsh lion pride. The lions easily catch up and surround the hippo 100 yards (90 meters) from the river. Most of the lions are adolescents, and there is one fully grown male who is only mildly interested in the hippo. The excited adolescents have no idea how to bring down an animal whose body parts offer no grip and whose skin is too thick to pierce. Occasionally a hyperactive lion jumps onto the hippo's back to get at its massive neck from above without success. The traumatized hippo is not quite fully grown and is limping a little. It does not struggle or attack the lions but tries to break free in an attempt to get to the river. After an hour of harassment, the lions lose interest and leave the hippo to its fate. The hippo barely makes it to the riverbank, where it lies for a few days before dying.

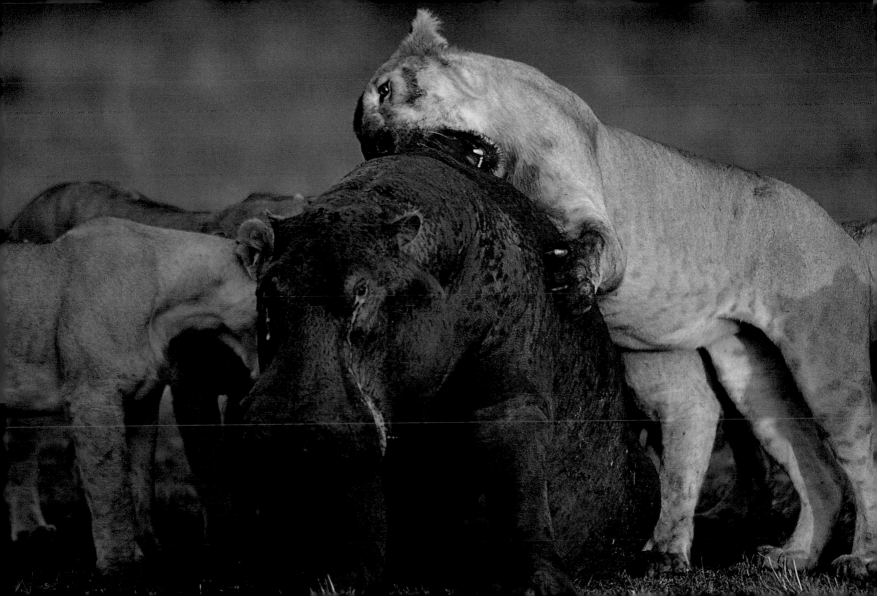

This morning, at a place called Double Crossing near the reserve boundary, hyenas have killed a wildebeest but are prevented from feeding in peace by five black-backed jackals who are circling them, looking for scraps.

The black-backed jackal is the master of the hit-and-run: It darts in, seizes scraps and bites off chunks of meat, then beats a hasty retreat. It will stand at the hocks of a hyena, confident of its nimbleness and ability to dodge any hyena lunges. The hyenas here eat whatever they can, and then, tiring of lunging at the jackals, tear off pieces from the carcass and walk away from the kill, seeking solitude. The jackals are left to feed on the rest.

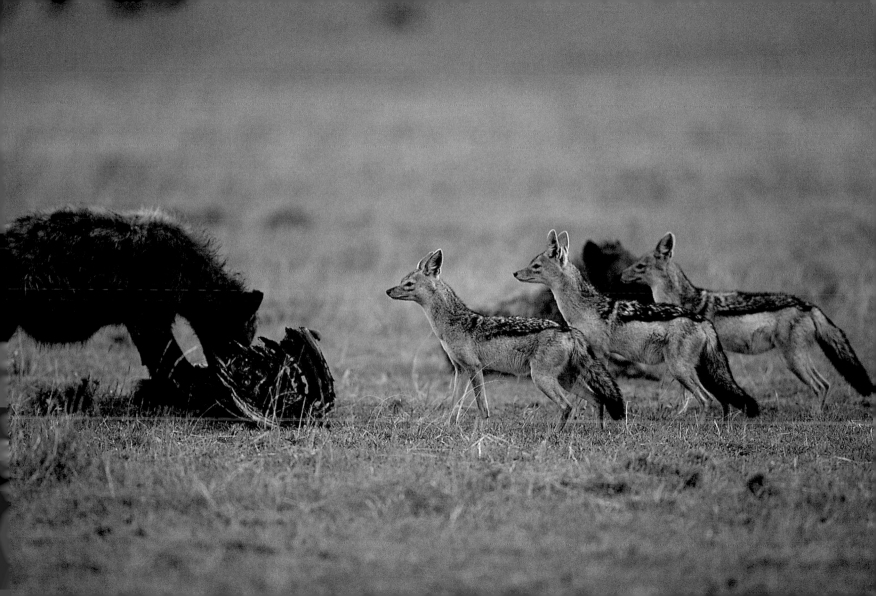

This early morning, the Topi Plains lionesses are still feeding on the topi they killed in the dark. A male lion waits at a prudent distance. When the lionesses leave, he gets up slowly and awkwardly. Hobbling, he looks an awful sight. His hide and legs are lacerated, and he is bleeding from scratched flanks. Flies are bothering him, concentrating on his open wounds. Perhaps they can sense the corruption within and are eager for a chance to deposit eggs. There are bound to be parasites swarming the lion's skin and ticks gathered in his groin, not to mention the countless parasites in his mane. He tries to sit, but the effort is such that he groans and gasps. Most likely he was an intruder attacked by pride males. Although his power is gone, it lives on in the lions he has sired.

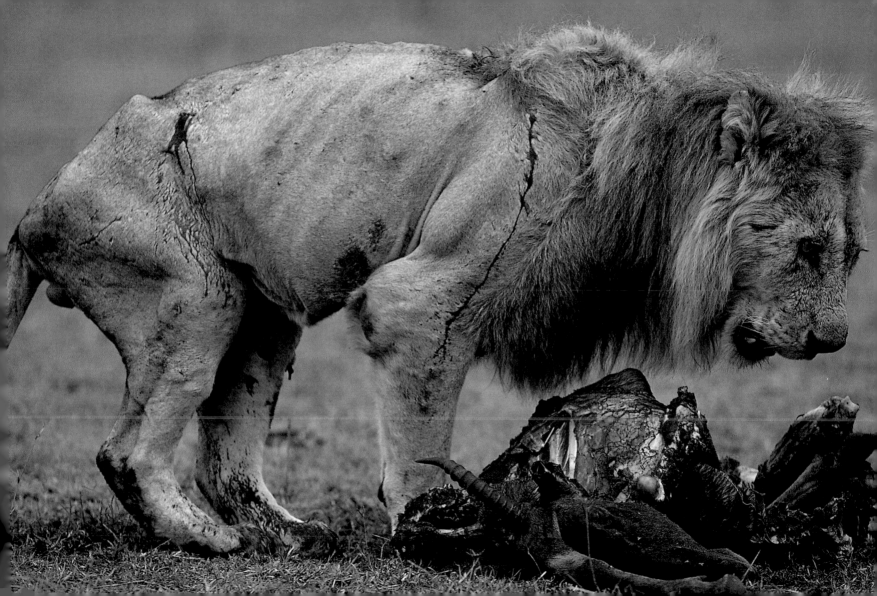

Daylight finds lionesses gathered around an old termite mound into which a warthog has gone hiding. One lioness wriggles her haunches as she digs, sending up spurts of dry earth as she claws her way deeper inside. She keeps on scrabbling furiously until her head and shoulders are completely inside the hole in the mound. After a frantic fifteen-minute session, she gives up and the cats move on. There is a decent interval of calm, then suddenly the mound bursts open in an explosion of brown earth as the fugitive shoots out of the hole and runs for its life. The warthog keeps on running until it senses it is not being pursued, whereupon it assumes a stately trot with tail held defiantly aloft.

A warthog sow trots past the cheetah with three adolescent cubs resting in the shade of a bush. A string of hoglets follows the sow as fast as their legs will carry them, but it is too tempting for the cheetahs, who immediately give chase. The hoglets scatter, and all but one escape. The adolescent cheetah goes for the throat and secures a solid grip on the windpipe. The cheetah's canines are small, but its skull is designed to give it a vice-like grip, which allows it to choke its victims to death.

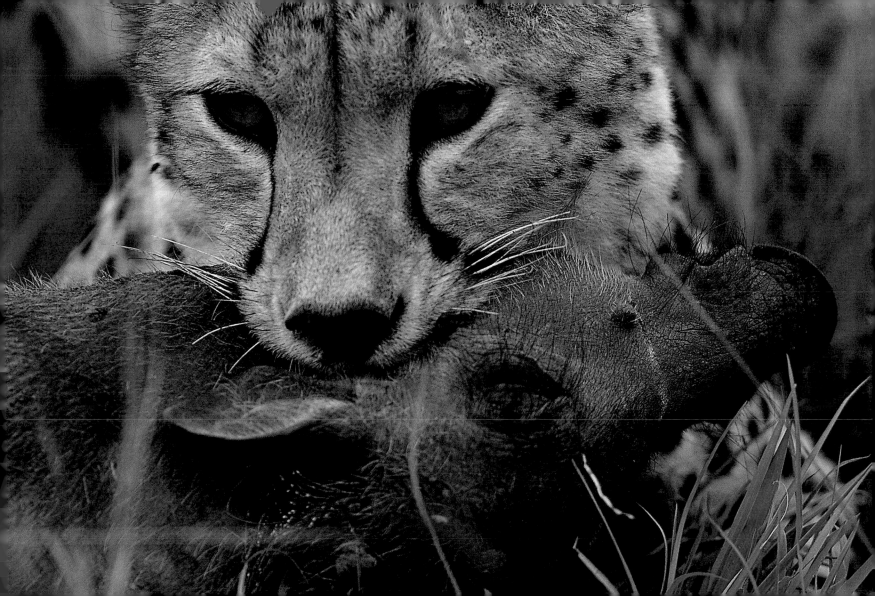

There are patches of burned grass on the lower slopes of Rhino Ridge, where gazelles have moved in, followed by the mother cheetah with the three adolescent cubs. Like all of her kind, she does not have a fixed home range; she drifts with the gazelles. If she were to encounter another female cheetah, they would simply stare at each other, then go their separate ways. We have encountered this particular feline beauty many times. I am fascinated by her black tearstains and her sad, enigmatic face.

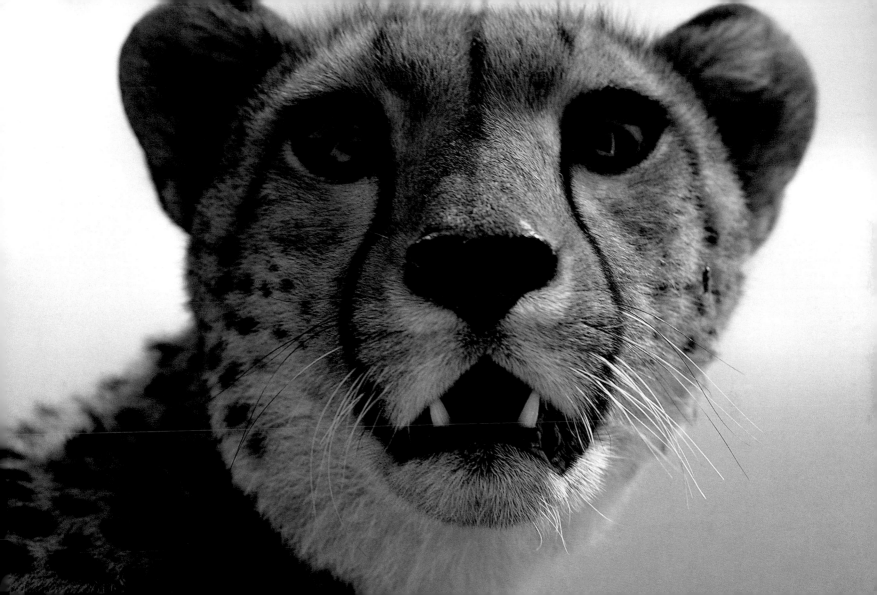

It is past midday and clouding over. The mother cheetah is actively looking for prey and catches one gazelle after a long, circuitous chase. When the cubs are almost upon her, she releases the gazelle, which tries to run rather groggily. The cubs catch up with it easily and attempt to bring it down, but instead of tripping it with a paw, the beginners merely slap its back. The cubs take turns trying to swat and bowl the gazelle over, but they fail to bring it down; mother finally sprints in and shows them how it's done. Even at fourteen months, the adolescents need more practice, but they'll probably have the hang of it by eighteen to twenty months of age.

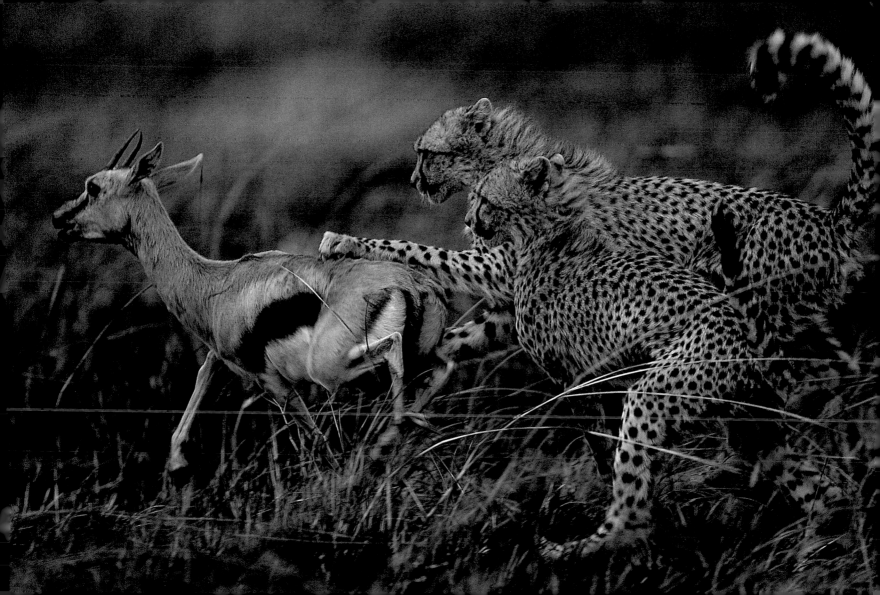

Mara's soils are more moist than those of the Serengeti short-grass plains. An area of burned grass can produce new grass growth with little more than a rain shower. The gazelles are pouring in, and the mother cheetah strikes again. She opens the carcass by shearing the skin at the tender rump with her cheek teeth, and the family settles down to feed silently and without rancor. Here, the mother is at the top, and the cubs are at three, six, and nine o'clock. Once in a while, a cheetah raises itself to scan, for there is a hyena den nearby. Fortunately for the cheetahs, the sky is empty of vultures and eagles so the hyenas have not been alerted.

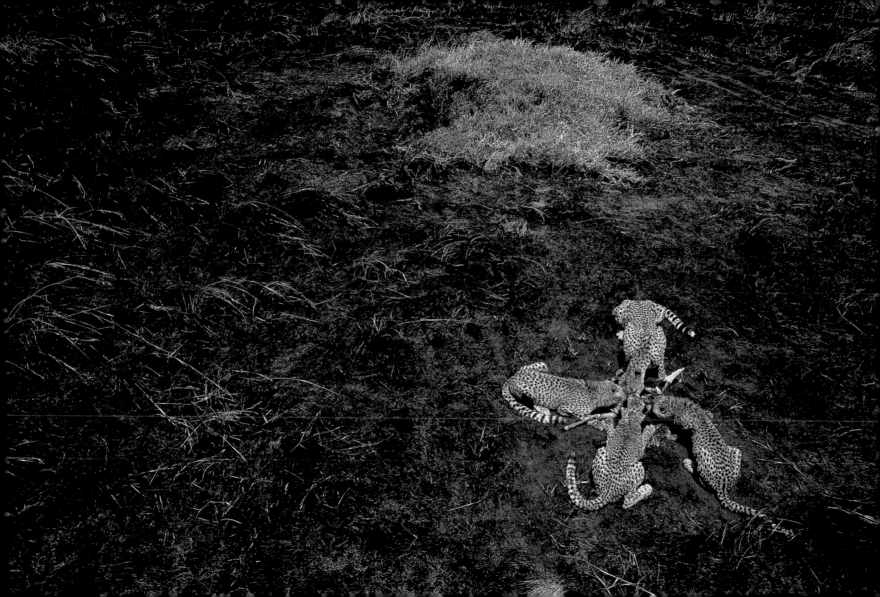

Bolder than his two sisters, this fourteen-month-old male cub stays put when the camera shutter clicks. Generally speaking, among the big cats, adolescents are bold and curious, males more so than females. At around eighteen months, the cheetah mother will abandon her subadults and they will have to fend for themselves. The subadults, will stay together until around twenty months of age, at which time the females strike out on their own. The males may stay together, in what is called a coalition, for life.

The ground has hardened. The bitter air of this dry period has not abated this morning. There is a breeze, but there is no moisture in it. The land aches for rain, and the animals are restless.

A python has coiled itself around a gazelle, killing it. The other gazelles have distanced them-
selves from this spot, looking back at it rather bewildered. A couple of black-backed jackals
make a detour to investigate. They circle around the entwined animals, probing for an opening
to snatch some flesh. A few vultures land and wait. One bold jackal inches forward to sniff, not
sure where danger lies. Perplexingly, its mate, who was at first attentive, now trots away. So does
this jackal as an adolescent lion charges in to investigate. Without hesitation, the lion snaps up
the carcass in his jaws, startling the python, which slides into the tall grass. The lion also heads
into the tall grass, taking the carcass with him. Before long, you can hear the tearing of flesh and
crunching of bones.

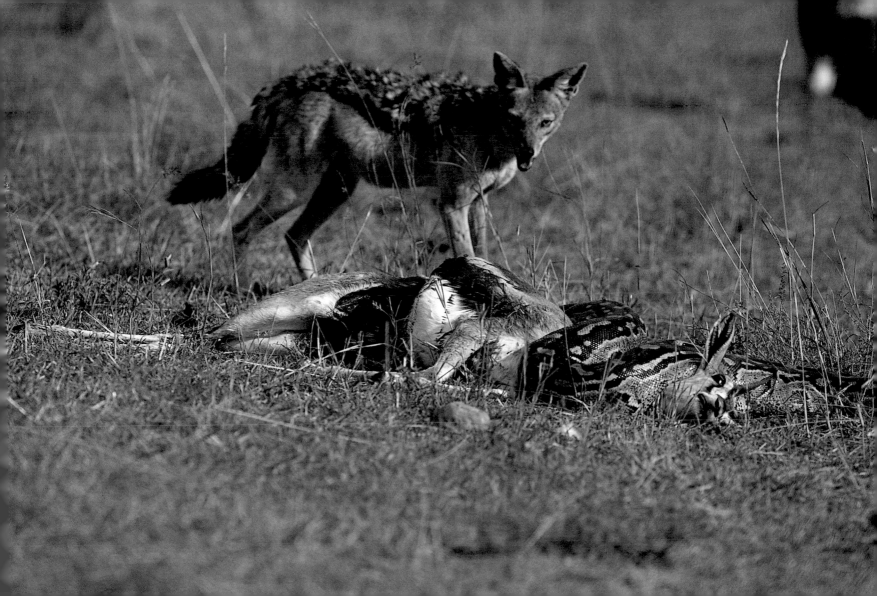

In their search for water and grass, the herds are running out of options. Today they have ventured into a narrow passage bordered by strands of bushes. The animals were slow to take this route—the bushes here have concealed lions in the past. It is no surprise then that following one snort of alarm, false as it turns out to be, the animals panic and thunder out of the narrow passage and into the comforting vistas of the open plains.

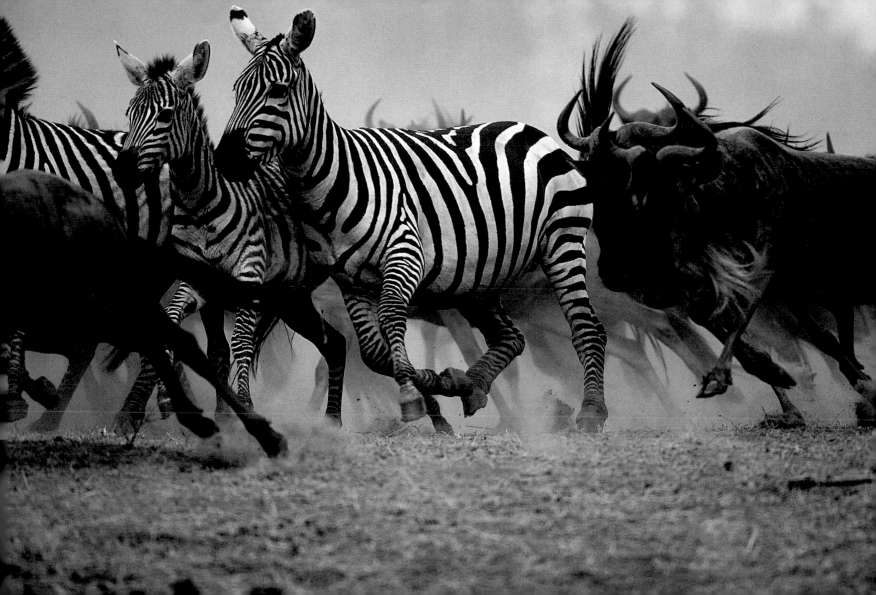

The easterly sky is already lightening. The sun first peeps over the horizon, climbs up dressed in orange light, and finally breaks free to illuminate the earth. It throws into silhouette a group of Coke's hartebeests. Similar in appearance to a topi, the Coke's hartebeest (a.k.a. kongoni) is a plains antelope that enters open woodland and tall-bush grassland more readily than the topi, and is more likely to be found on the edge of the plains rather than farther out. It migrates seasonally but only over relatively short distances.

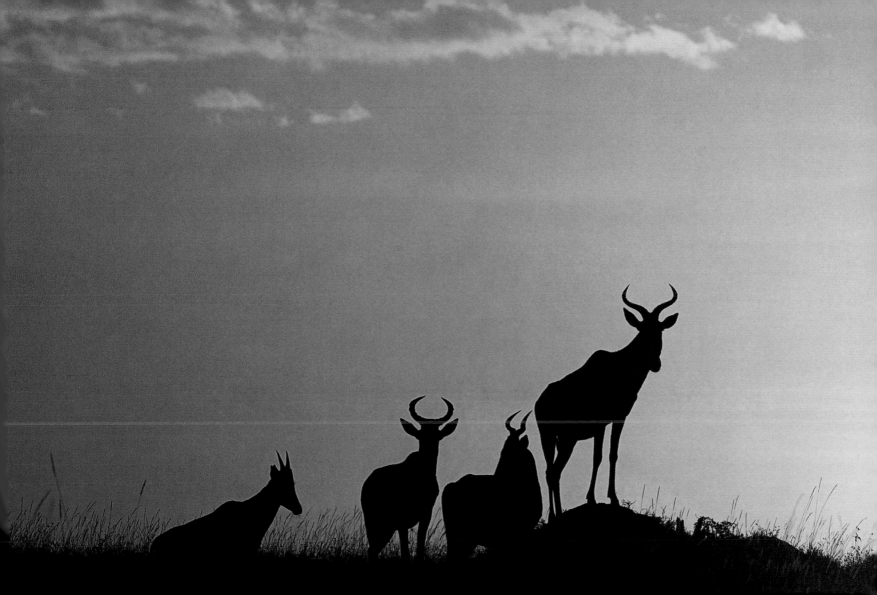

The dry season continues. A cheetah is caught in the glow of the bursting new sun. She stops and then slinks away. In taller grass, she flattens herself, concealed from a few lionesses walking toward a thicket. Caution and concealment are second nature to her, and even as she raises her head briefly to peer through the foliage, she does not change position until satisfied that the enemies have moved on.

Lions will not tolerate the presence of cheetahs in their range, which is a bit of a puzzle. After all, cheetahs hunt mainly gazelles, which lions usually do not. Moreover lions can get a free meal by driving cheetahs away from their kills. The complexity of their world is beyond human reasoning.

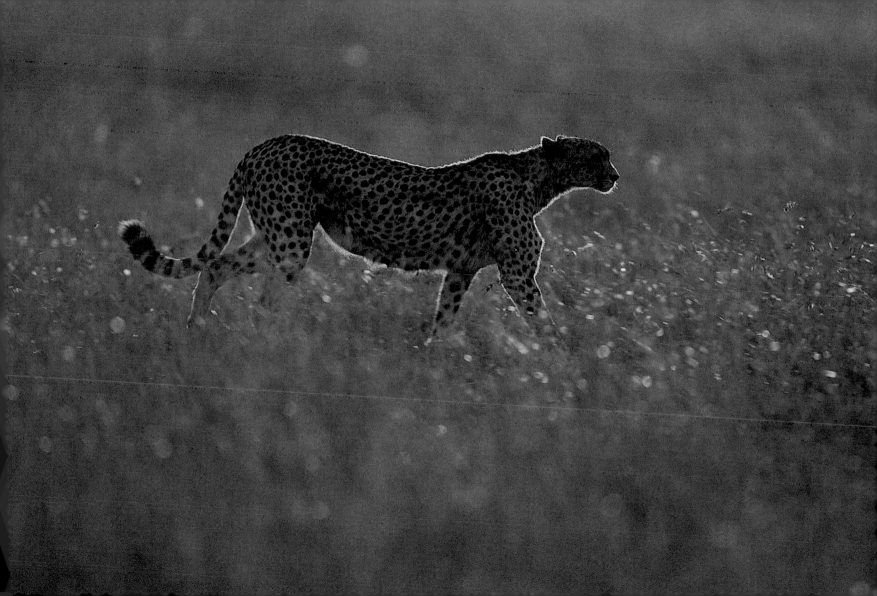

A cheetah has given birth for the first time in the same place where she herself was born. She has kept her cubs under a short bush. After nursing them, she leaves in search of food. These tiny bundles of fur are only a few days old. Unlike the infant gazelles that can run within an hour of birth, these cheetahs can only crawl, and that barely. They are entirely dependent upon their mother.

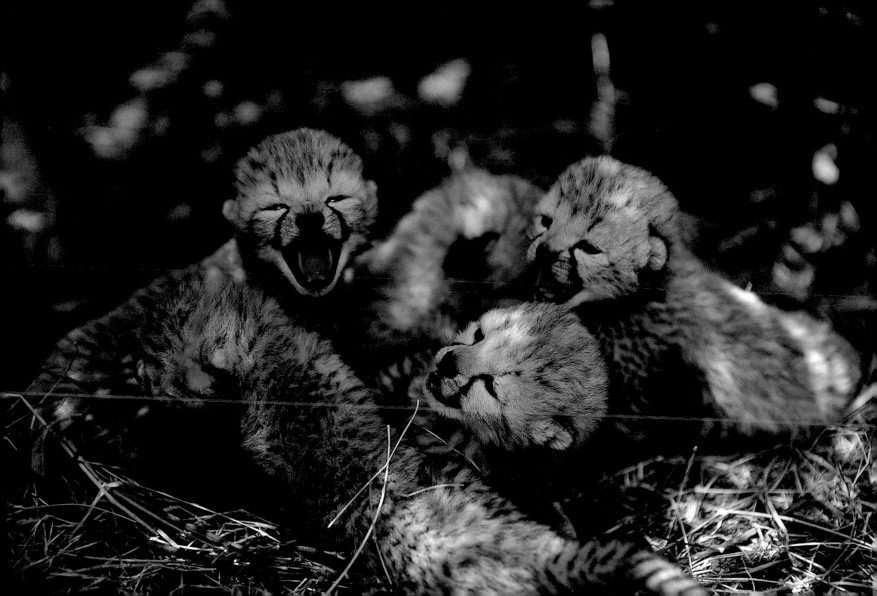

This morning begins with the cheetah suckling her tiny cubs. When the cubs are sleepy with milk, she picks them up and carries them to a new hiding place, a huge meadow of tall grass. If you do not know where to look, you will not be able to find them. All morning she lies beside her cubs, sleeping and suckling. She leaves in the afternoon, and when she returns in the evening, she does not go directly to the cubs — a slight movement at the edge of the plain has caught her eye. For a long time she stands, poised, her tail held out in a taut curve as she scans the trouble spot. A moment later the grass moves again, and she sees a lioness walking. The cheetah crouches — she dare not return to her cubs now. When the danger passes, she goes immediately to her cubs and finds them safe. Their smoky gray fur blends in well with the grass. She settles down next to the tiny infants, providing warmth, body contact, reassurance, and security.

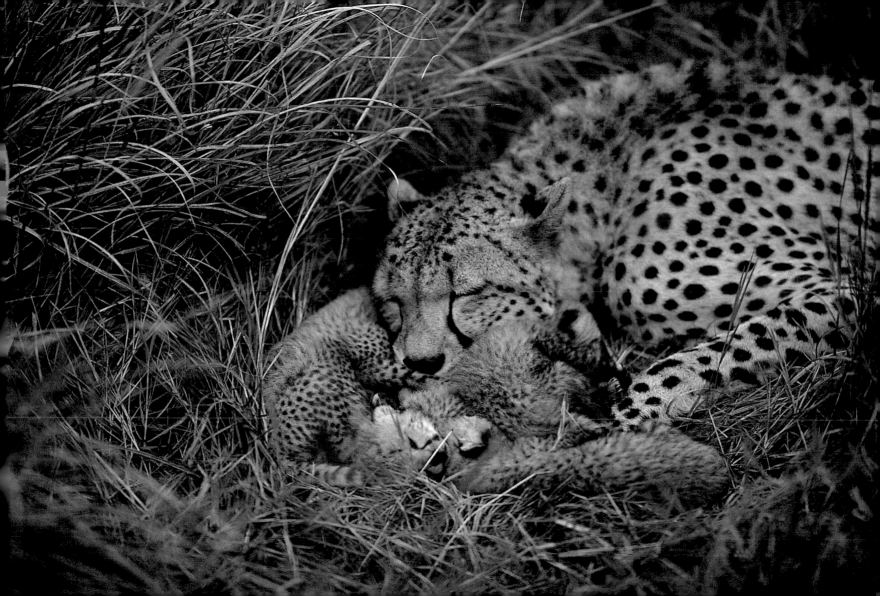

A few miles north of the Mara River, becalmed in an infinity of yellow grass, a statuesque topi stands on an old termite mound whose shallow dome rises from the grass like the burial mound of some long-forgotten necropolis. Alert on his watchtower, the topi stares across the red-oat grassland of Paradise Plain. The plains are thirsty for rain. A few miles farther north, another herd of migrants is grazing and drifting toward the river. The plains wait. The migrants wait to head south. The topi keeps watch, but the rains remain elusive.

Over the past few weeks, the combination of fierce sunlight, harsh wind, and high altitude have sucked the moisture from the soil. The herds, which had been scattered because of the wide dispersion of edible grass and drinkable water, are now coming back together. Multiple zebra families are joining up to form small herds, and their hooves click as they pick their way over stony ridges to Paradise Plain and thence the river crossings. Close behind, the wildebeest numbers are also building. Can the animals sense that the rains are on the way?

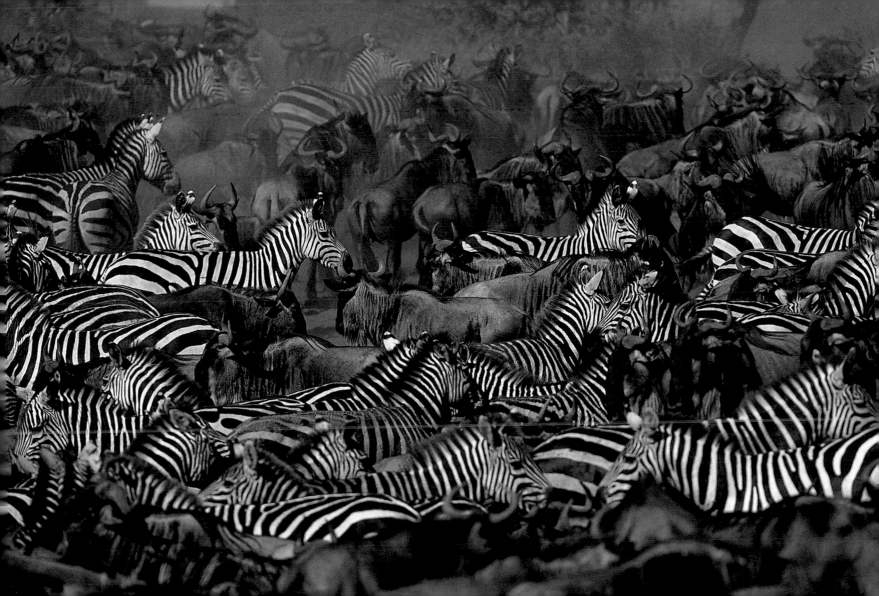

Surface water is long gone. Water can only be found now in the rivers, Musiara Marsh, and a few pools. At one such pool, the Murram Pits, a lioness has taken out an indefinite lease. While lying hidden near the pool, she has fallen asleep, but the calling of zebras awakens her. Presently, a few zebras appear, stepping gingerly. The big cat stays still, well hidden from view. Suspicion holds the zebras back, but thirst pulls them to the water. In due course, three zebras overcome their nerves, walk to the water, and lower their heads to drink. The lioness charges, covering half the distance between them before the zebras become aware of her. They flee, but one of them finds the determined assassin on its heels. It runs with a desperation born of its evolutionary memory of the dangerous lion.

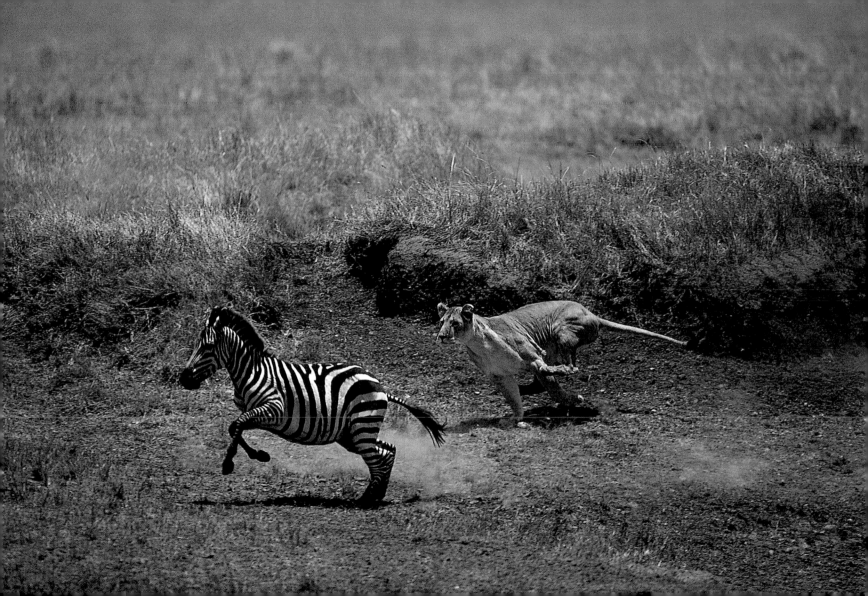

Near the river, the grass has dried up completely, disappearing in places so that only dusty, bare earth remains. There is a low rumble, like the sound of thunder, growing louder. The march of the herds is pulverizing the ground into a fine dust, which rises up in thick clouds as the animals approach. The herds, having made it through most of the dry season, are now pushing forward to the final hurdle before returning to Serengeti National Park, where this epic year-long journey began.

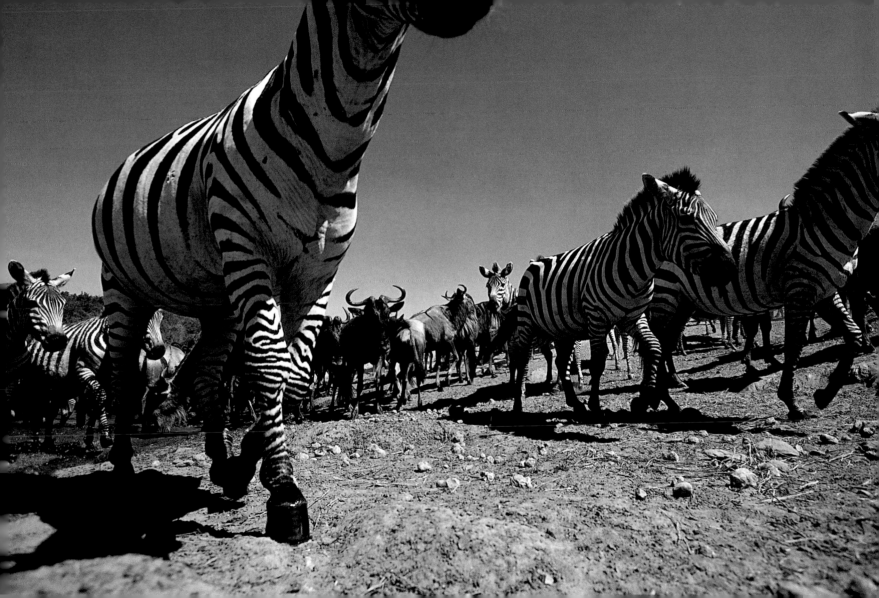

By mid-morning, the herds have massed near the Mara River, which is flowing strongly, thanks to the rains that fell at the source of the river in Mau Escarpment.

There is a traditional crossing point where the river bends, called the cul-de-sac. The banks are steep on both sides, except for one beach that is hemmed in between the river and a dense thicket. The wildebeests and a family of zebras arrive here hot and thirsty, eager to drink and get across. On the other hand, they must pass by that thicket, which may conceal lions. Cautiously, they make it to the beach where they stand and stare at the rushing water, not at all to the liking of land mammals. They are indecisive, and there is, as of yet, no momentum, no pushing of animals from behind. But something alarms them, and they all run back, away from the water. Within seconds, the beach is empty. There will be no crossing here today.

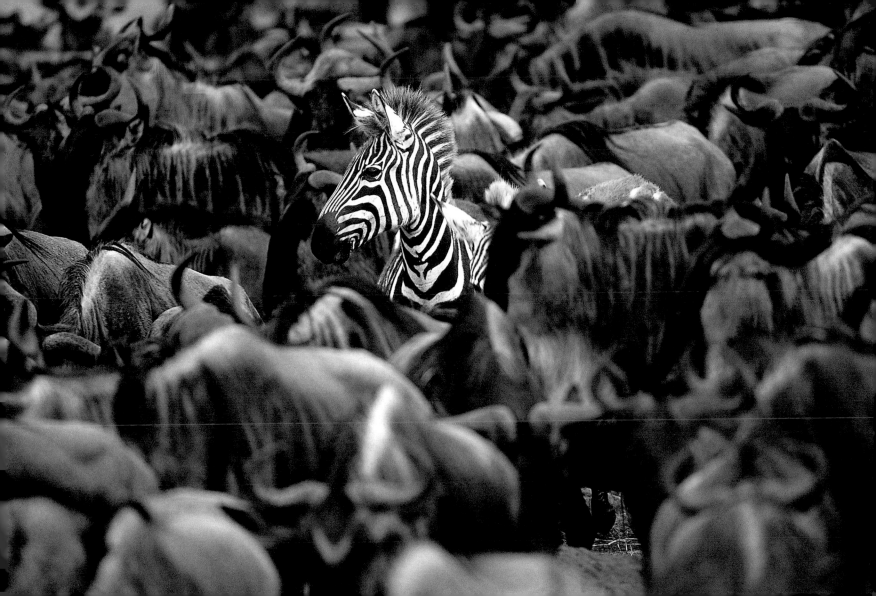

Today begins like yesterday. By noon, a herd has reached the beach, where it pauses. The animals vacillate again, but they are more restless than yesterday. The moaning sounds they make rise and swell, as more and more join them. The leaders look at the river, snort, and shake their heads at the flowing water, unwilling to enter, but they are being pushed by the burgeoning mass from behind. One wildebeest steps tentatively into the river. There is a pause, and then the rest wade in, like a gigantic entity with many moving parts. The river crossings have begun.

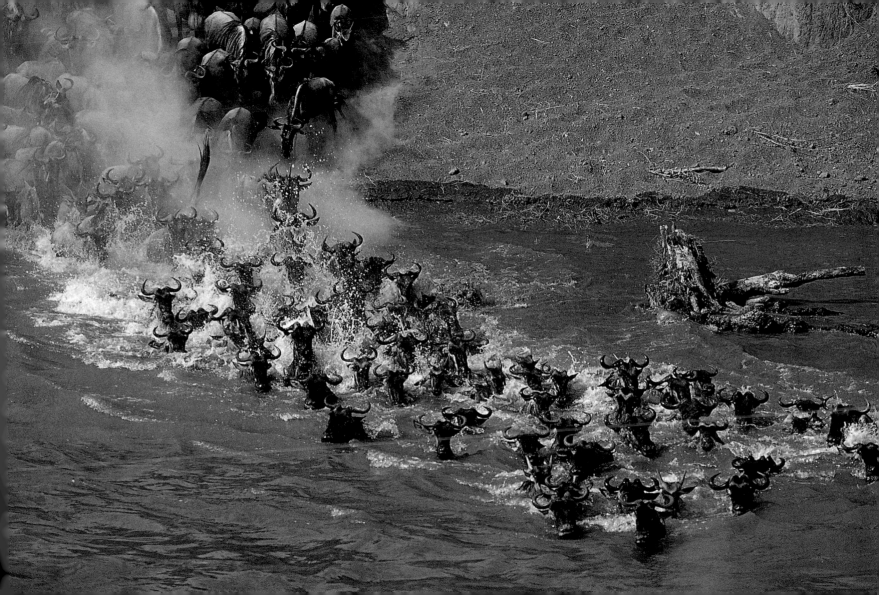

Today a new herd arrives on the beach. A brave wildebeest starts the crossing and the others follow. It quickly turns into an avalanche of horned animals crashing into the river. It is also a terrified advance of bewildered animals following their neighbors blindly — in this instance, fording a dangerous river. The wildebeests remain creatures of mass movement, a tendency imposed upon them by their herd instinct, always moving as one.

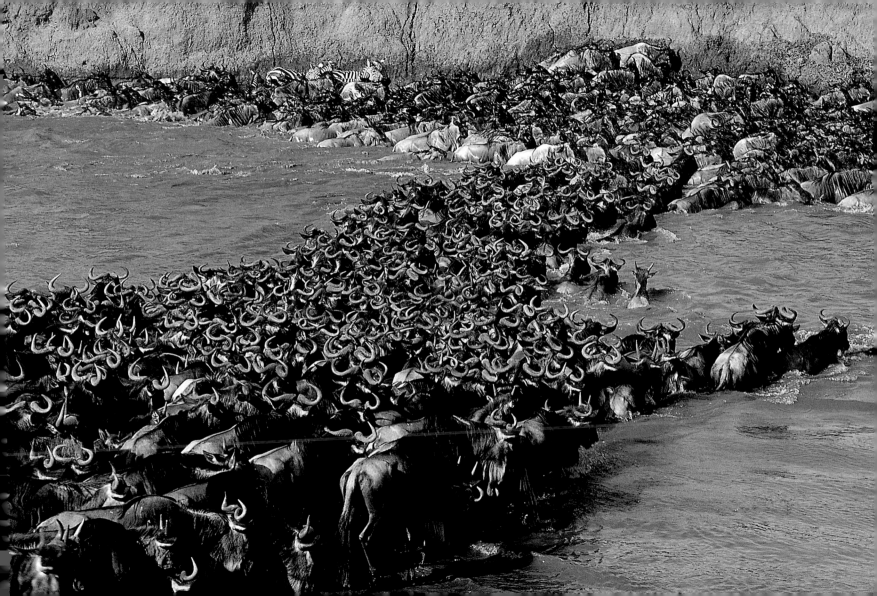

This morning, one wildebeest has chosen to cross at a point where the river is deep in places, and many others follow. Panic sets in. Some hook wildly at their companions in their desperation not to be pulled under by the current, while others draw back their lips in an anguished grimace as they are carried forward by the sheer force of bodies. The wildebeests, never calm in a crisis, have turned into maniacs. Yet they are born swimmers. After a few minutes, some semblance of order prevails as they swim strongly to the bank, churning across the river in a melee of tossing horns and heaving shoulders.

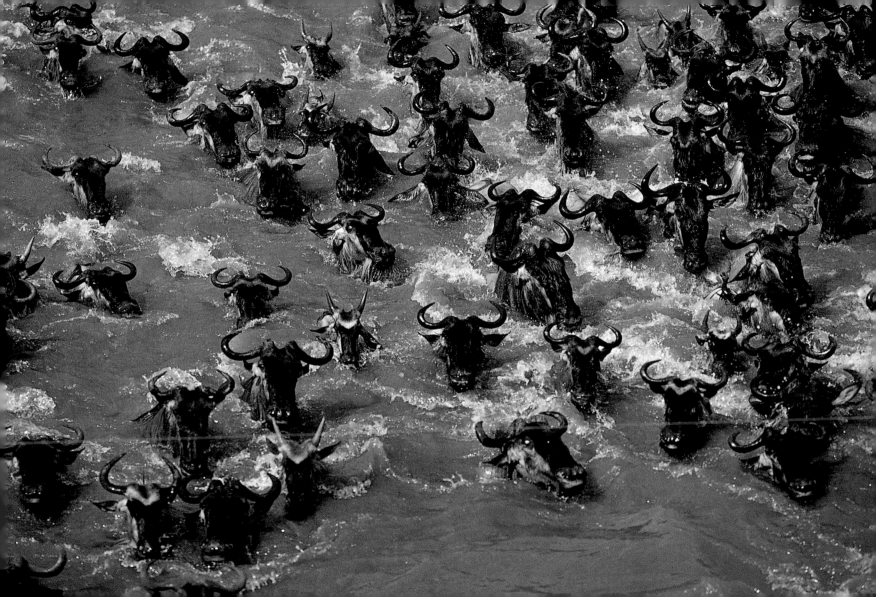

Today another herd makes it to the beach, and the lead wildebeests have chosen to exit from a steep and narrow passage up a slippery bank. It is as if they have chosen to commit mass suicide. The exit is dammed by panic-stricken animals. A pyramid of wet bodies clings to the sides of the bank, and those at the bottom get kicked and trampled. A few fall back into the current and float downriver. Bellows of the injured and bleats of calves fill the air. More die at the hooves of the herd than at the jaws of predators. Yet the crossing continues, such is the urge, the determination to keep the march going. Regardless of how many other animals died here in previous years, these individuals survived to try again. Older, more experienced animals probably return to places where they have successfully crossed in the past.

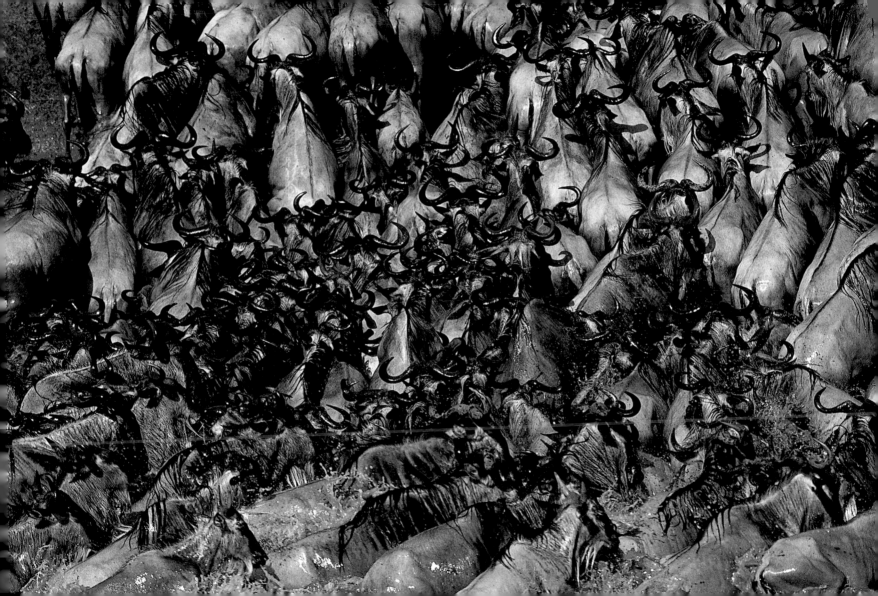

The river crossings are occurring daily. Today, a mixed herd of zebras and wildebeests have chosen an easier exit: a gully worn by hippos on their nightly foraging. The animals stream through it and canter away into the welcoming grasslands. Only a few are swept downriver by the swirling current, their scrambles in vain.

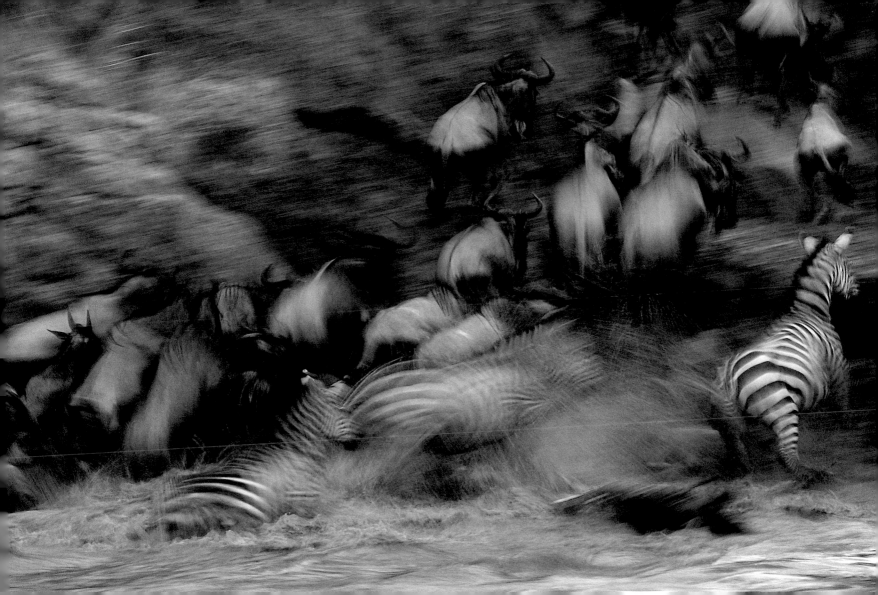

The wildebeests, seeking to cross, have arrived at a steep bank. The animals in front are hesitant, but there is a press of bodies from behind, making it difficult to turn back. They have no choice but to plunge into the river, a few yards below. Some take off in flying leaps, forelegs tucked under shaggy beards. Others tumble headlong into the water. They all survive.

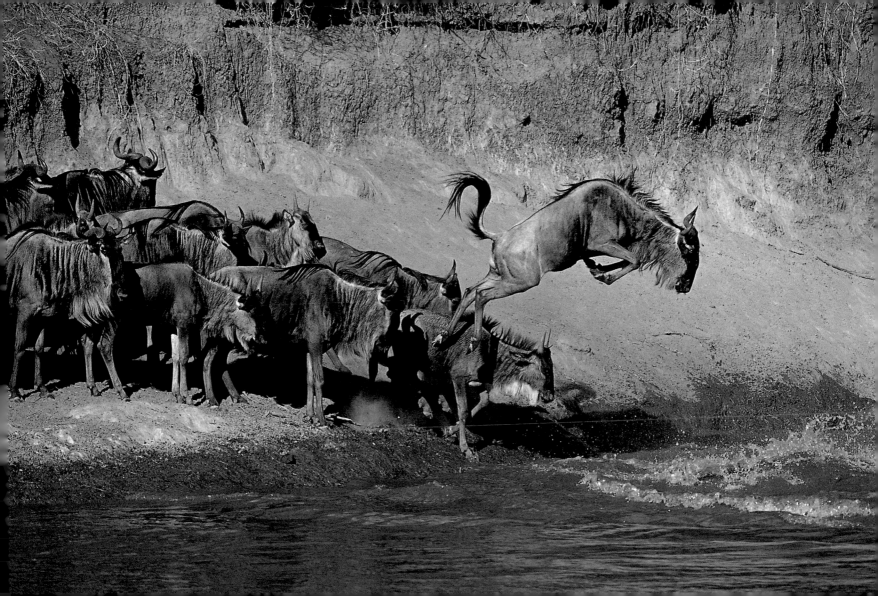

Zebras tend to keep separate from wildebeests at a river crossing, but often, in the heat of the event, it becomes impossible. On the far bank, zebras that have made the crossing call anxiously to family members that have yet to join them. These start to cross sedately, but soon all are caught up in a collective madness as the wildebeests join in. In reality, many more will die from the mayhem than from the jaws of crocodiles.

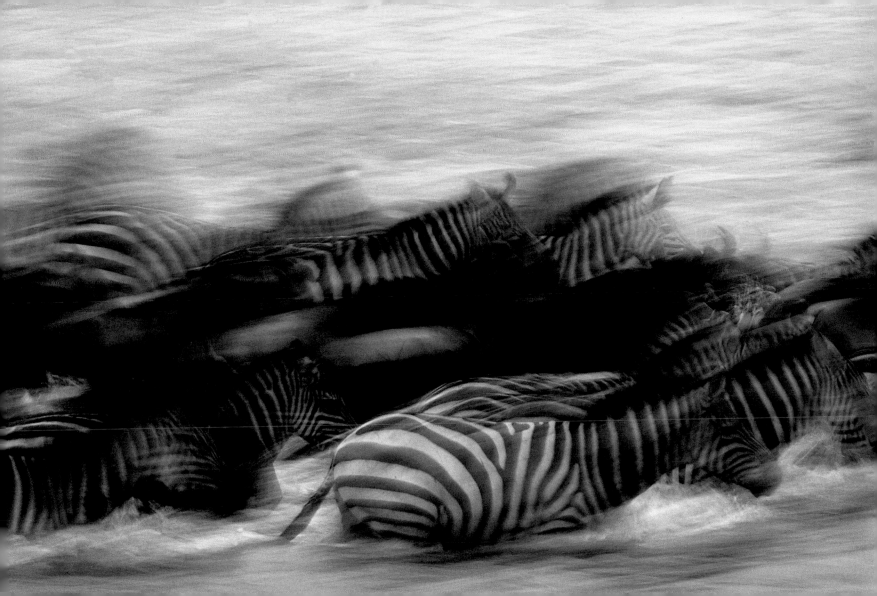

The crossing is chaotic today. Animals are losing their footing on the rocky riverbed, getting caught in a strong current, and being pushed and jostled. A young zebra gets too close to a crocodile, fails to see it, and loses its life; but the reptile is not hungry. Instead of eating, it swims with the carcass to the bank and caches the kill at a spot where there is no current. There, it guards its kill, watching the animals cross.

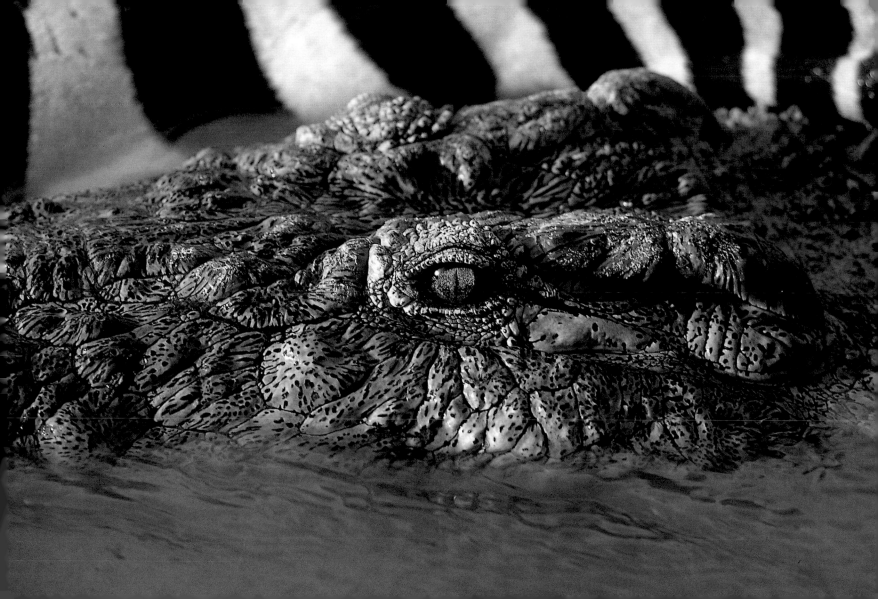

Just upriver from a place called the Rapids, there is a traditional crossing point that is being utilized today. After a lot of animals have crossed by simply wading into the river, a lone calf runs to and fro and somehow ends up on a high spot on the bank. From here, it dives into the river, expertly in fact, with front legs tucked in and back legs stretched straight for balance. It makes it to the opposite bank and canters after the other wildebeests, who took the easy way across.

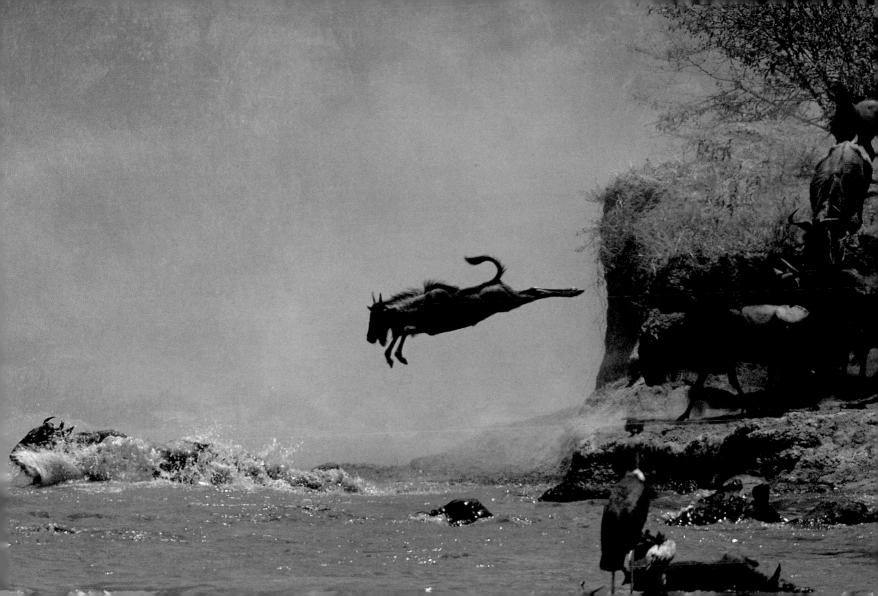

In the wake of the wildebeests, a herd of Thomson's gazelles has descended on the beach. The gazelles have been pulled here by the promise of grazing on the other side, but they are balked by the terror that is the river. They mill about indecisively, nervous and high strung. One male drinks and then takes a few tentative steps into the river. A crocodile slips into the water from the opposite bank. Frightened, the gazelle runs back to the beach, and the herd follows him, abandoning the attempt to cross the river.

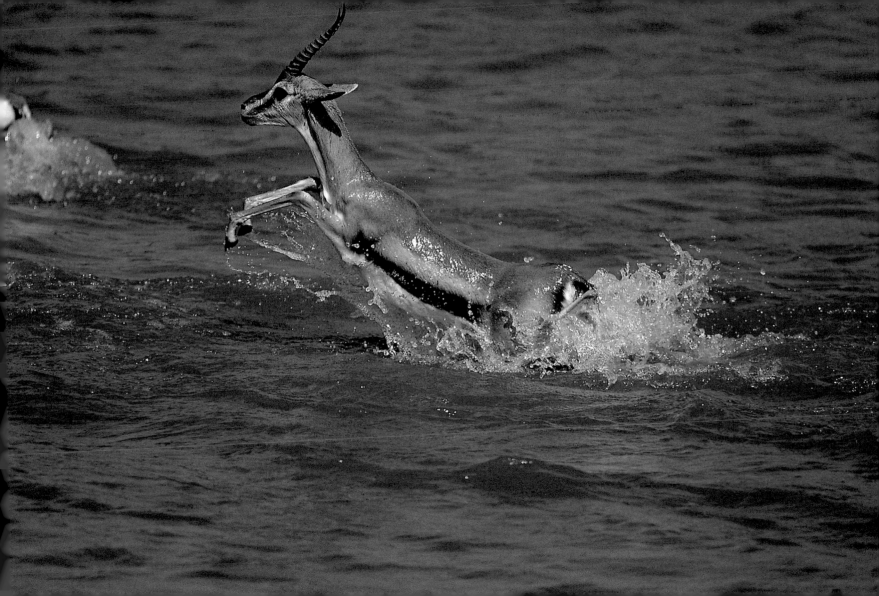

The gazelles are back on the beach this afternoon, and there are three crocodiles in the river, watching and waiting for them. The lead gazelle is made irresolute by the sight of its supine enemies. Yet, after a while, inexplicably, it jumps into the river—can the migratory urge be so strong, so reckless? With tail flicking, tiny body leaping, he runs straight into the jaws of death, his worst fear come true. To a crocodile, a gazelle is little more than a tasty mouthful, easy to catch in water.

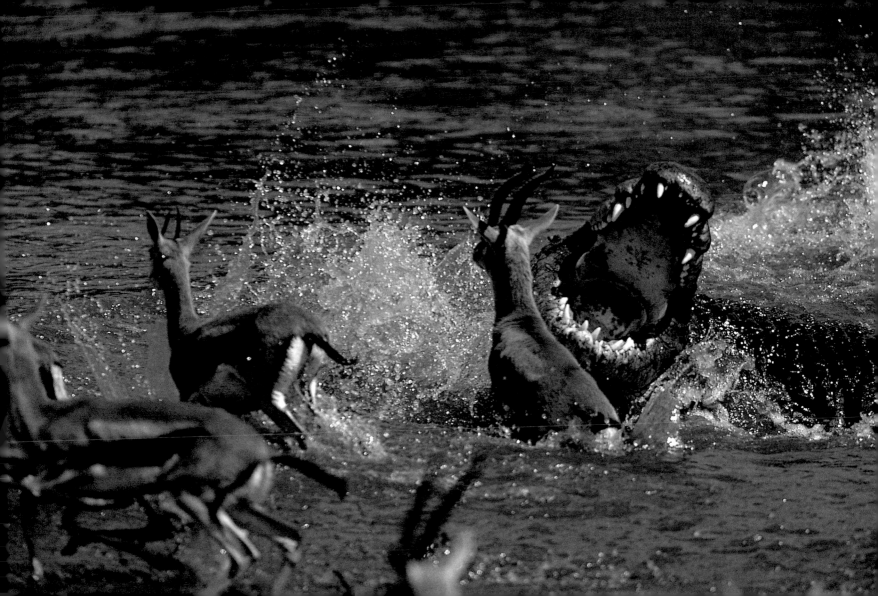

A few gazelles have assembled at another crossing point. One jumps into the river, followed by another. A swimming crocodile cuts across to intercept. Crocodiles are extremely agile in water. It flattens its limbs against its armor-plated body to give it a stream-lined shape; powerful sideways movements of its tail propel it through water at astonishing speeds. The gazelle has no chance whatsoever—the crocodile catches it by the neck, whereupon it cries out, then dies. The crocodile takes it to the bank, where it lifts the carcass and smashes it against the water several times, after which the gazelle is devoured. The essential drama of the wild remains that of the relationship between prey and predator.

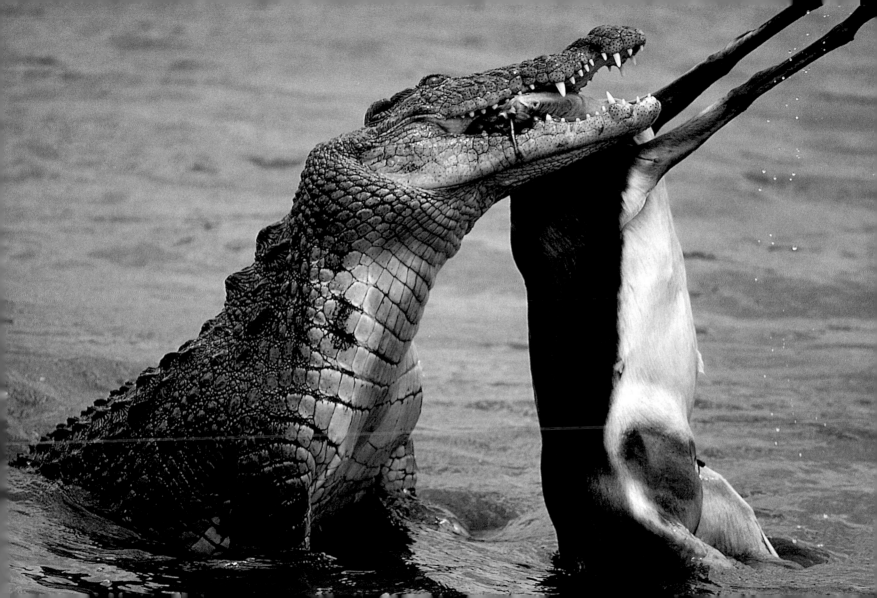

The majority of the migrants have crossed the river and are now on their way back to Serengeti National Park. Today, one of the last remaining herds plunges into the river. You can hear splashes of water as they cross — sometimes the wildebeests seem possessed by demons. The river takes its toll, yet the river crossings happen every year without fail. It is as if the benefits of hazardous migration outweigh the costs, but it remains essentially a mystery to humans.

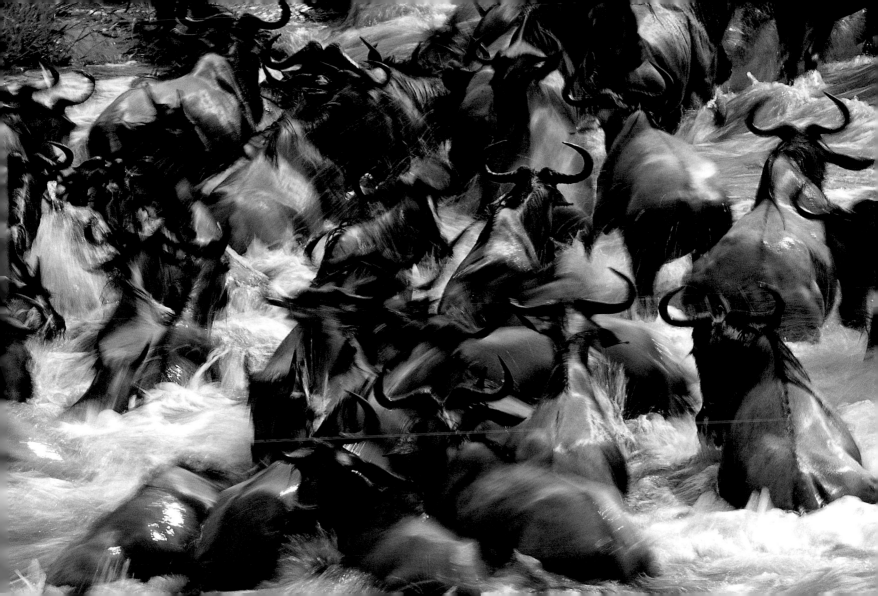

Beyond, long lines of wildebeests—shiny, gray bodies still wet from their river ordeal—are rocking away over the plains. Others hang back, as if waiting for the rest of the animals to swim across before resuming their journey. As the bulk of the herds head off into the distance, scores of cows and calves gallop to and fro at the banks, grunting and bleating, sometimes even reentering the river in their efforts to relocate each other. Some have drowned; others lie where they died. By early evening, calm creeps in. The wildebeests are gone.

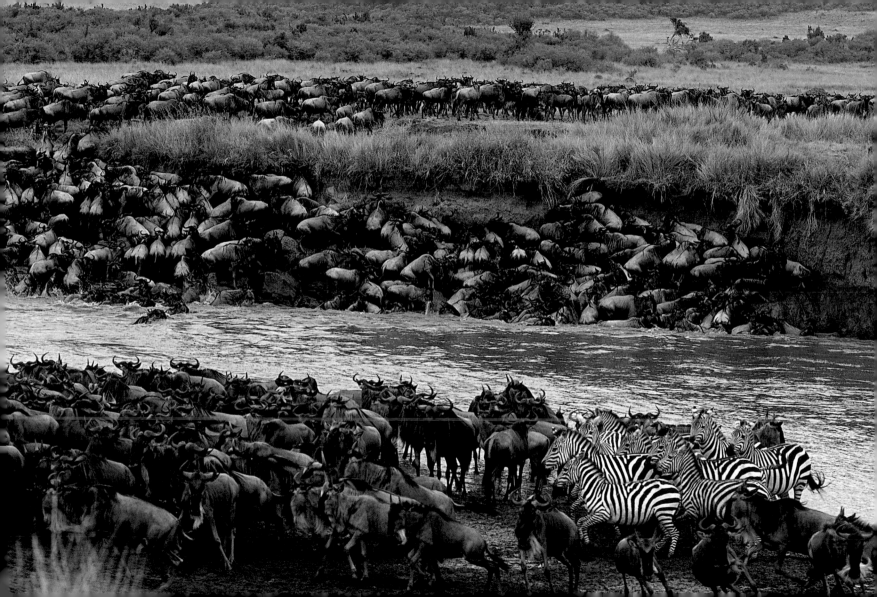

Today starts with the promise of rain: Clouds are filling up the sky. The clouds swell as the day wears on, crowding out the sun, hinting at rain. Two wildebeest stragglers canter on the horizon, taking the same southerly direction as the rest of the herds. Migration would be impossible if the animals possessed total recall of all the hardships they endured along the way. But it is no use predicting. It will rain when the rains are ready.

Mara Triangle, the southwest corner of the Mara. Last night was cold, this morning is cool. The shallow, patterned clouds clear up quickly, and the temperature shoots up. Paradoxically, as the promise of rain becomes stronger, the weather becomes more sultry and oppressive. The air quivers in the afternoon. Little moves. Everywhere, animals are resting, seeking refuge from the bludgeoning heat. Each pool of shade is filled with a patient herd of impalas. Giraffes stand motionless beside solitary acacia trees. Lions groan in restless sleep as flies torment them. Clouds start to build up and spread in late afternoon. The grazers make a pretense at grazing. As evening glides in, the clouds recede. The lions sleep on. When they stir, the night will belong to them.

Much of the grass in Mara Triangle is now coarse and dry. Under the intense heat of the sun, plant material that is not eaten quickly desiccates, its color sunburning to yellow. Up on a mound, a cheetah surveys the plains that seem drained of zebras and wildebeests. But the gazelles are still here. Toward noon, the air turns liquid and runs like molten glass along the horizons, shaking with mirages in which gazelles far out in the shadowless plains appear to be walking on lakes of blue water. Clouds build up through the sultry afternoon, cooling the air. Life stirs. Rain continues to threaten.

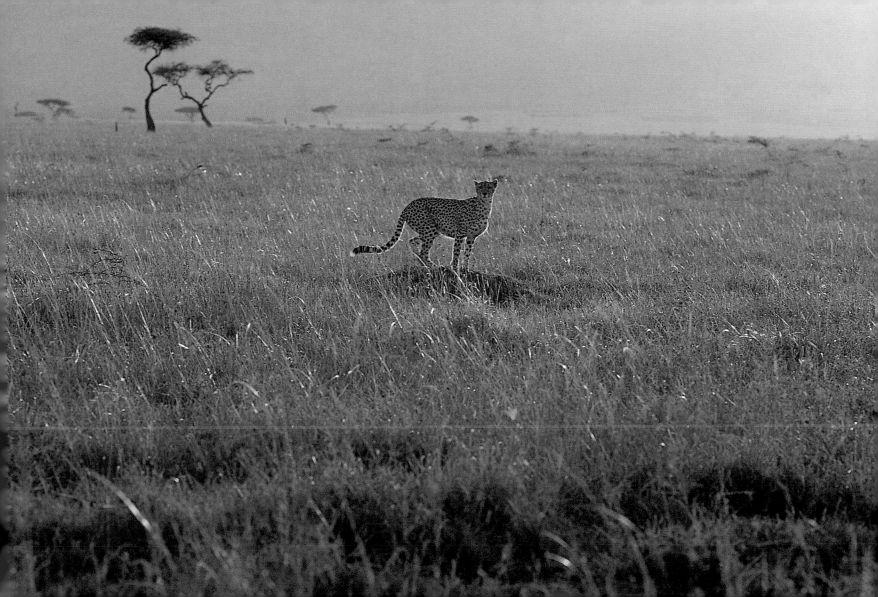

In the pre-dawn dark, the air feels damp and heavy, but with the gradual ending of the night, the air lightens. Iridescent orange and red bands of clouds stand out against those that stay stubbornly dark. As the morning progresses, the sun struggles to laser a hole through the blanket of low clouds clinging to the horizon. But the clouds win and spread out—there is moisture up there, but it is not being released easily. The herds tarry. The momentum to migrate south has fizzled.

OVERLEAF

In the morning, zebras graze and drift toward the Serengeti border. In the afternoon, cumulus clouds swarm in the sky, piling up in dark towers. The zebras linger. Two hours before sunset, a new breeze—cooler, more moist—comes sighing over the grass. The grazers resume feeding, and the clouds slowly dissipate. The promise of rain is withdrawn, but there is a distant rumble of thunder, or is that the roaring of lions?

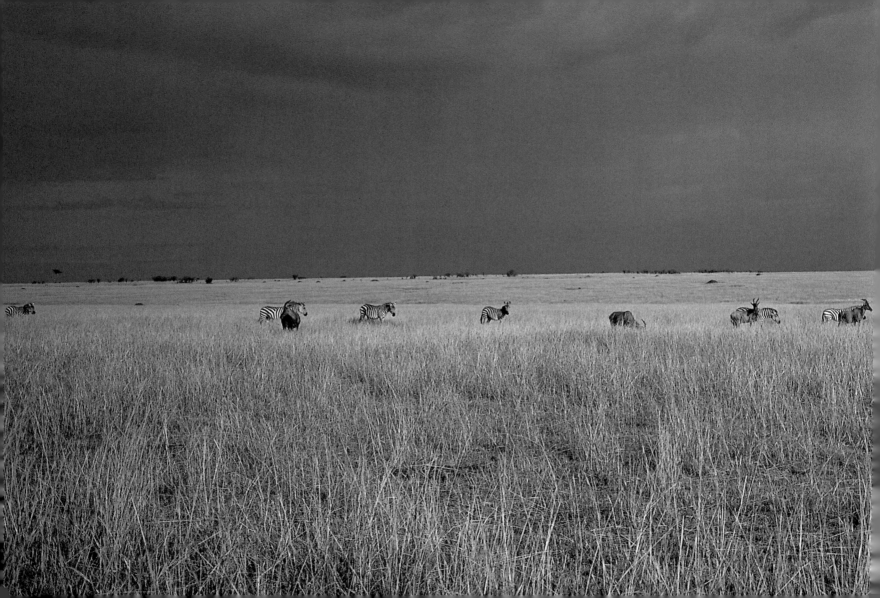

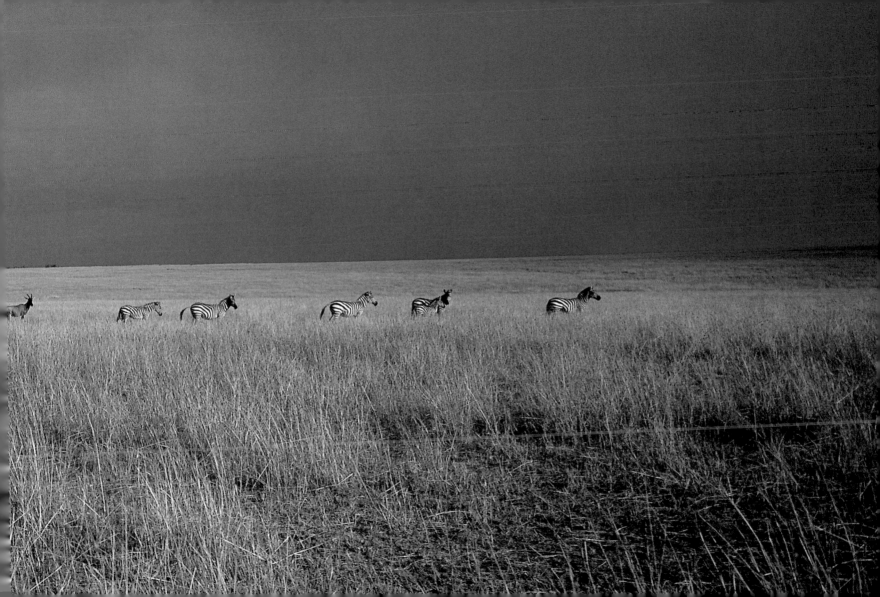

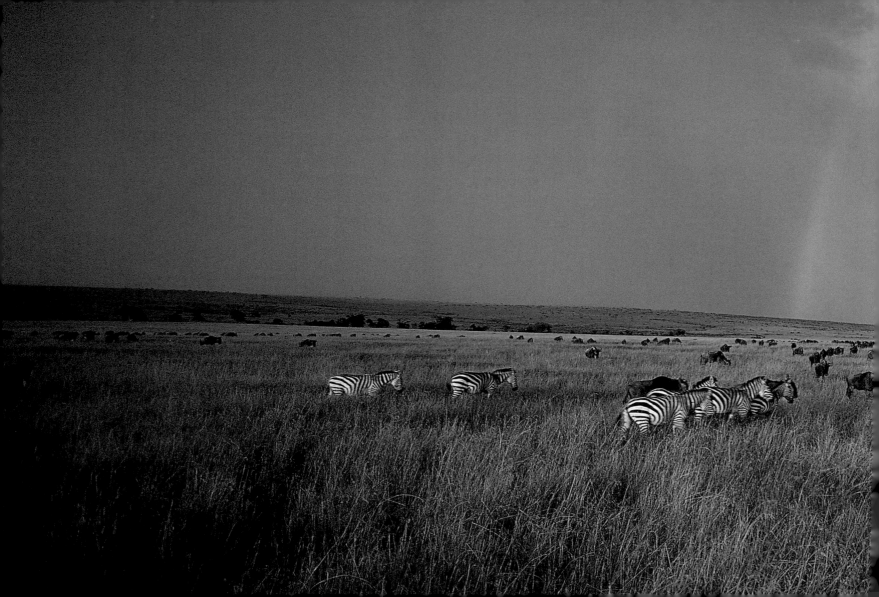

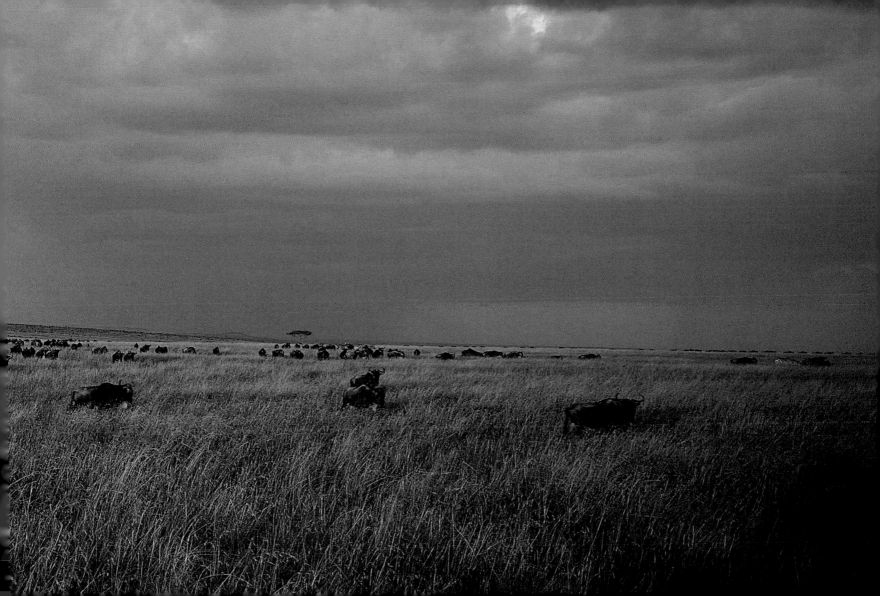

Many zebras and wildebeests are only a few miles away from the Serengeti border, at the edge of Mara Triangle. Flat-bottomed clouds sail across the sky, trailing islands of shadows over the land, but the temperature refuses to come down. Late in the afternoon, the air turns damper and heavier, speaking of rain. By six o'clock, a dark cap of cloud develops. Darkness spreads. Lightning flickers and forks across the horizon. This time, the clouds mean business. By dusk, they have started shedding their precious cargo, as if making up for lost time.

Today is unique in that it has brought the dry and the wet faces of the land close together. In late afternoon, a storm builds up, raising billowing thunderheads, beneath which lightning strikes along the darkening horizon. It begins to rain, the intensity increasing until the skyline is completely obscured and all sounds are drowned out by the falling rain. The rain stops after an hour. The storm passes over. The clean smell of wet earth arises. The first spasms of rain have put an end to the dry season, but the grass has yet to turn green.

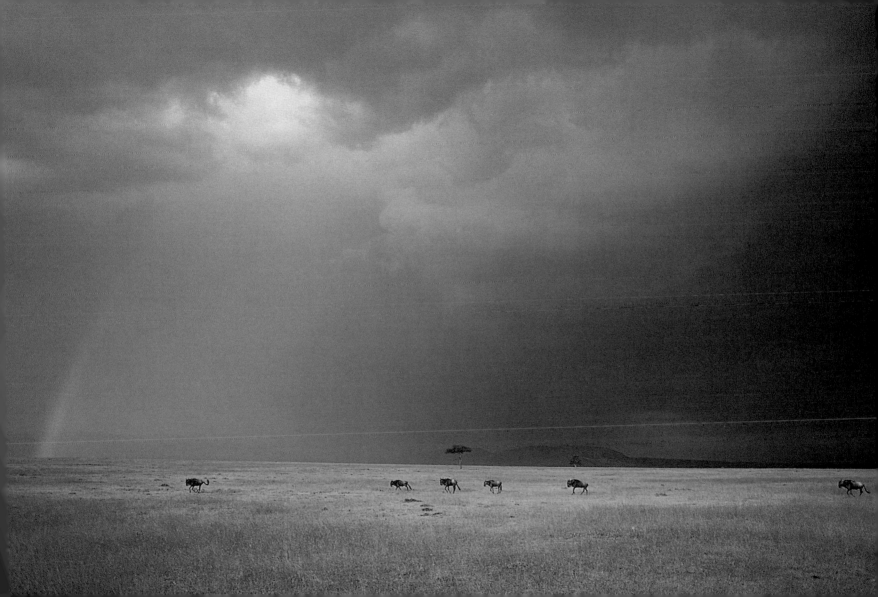

Northern Serengeti near the Mara border—a mosaic of streams, scrub, and grass, and home to a large number of resident species. It rains here this afternoon, not as heavily as it did yesterday, but it is another indication that the dry season is ending and the wet is gaining hold. An advance party of zebras waits the rain out in the company of resident impalas. While the impalas take the brunt of the downpour standing still, the occasional loud crash of thunder unsettles them, sending them running in a panic to nowhere, then back together again.

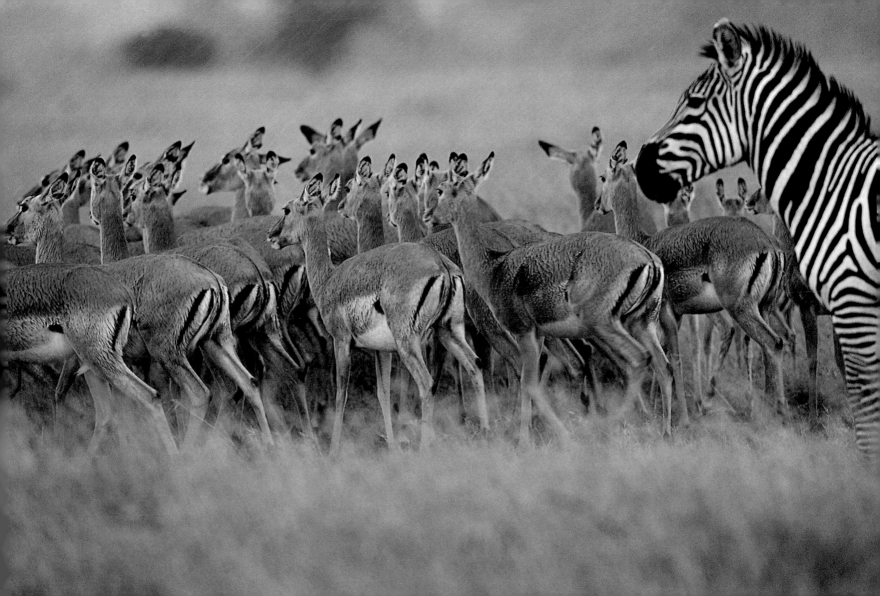

With the scent of rain, lethargy dissipates and energy sets in, at least in the cool of early morning, as a Grant's gazelle stots. Only the hardiest of creatures, such as the Grant's gazelle, have stayed on the Serengeti short-grass plains during the dry season. Grant's gazelles do not need drinking water, and by occupying the short-grass plains throughout the dry season, they avoid competition and capitalize on their ability to subsist on the food that is still available under arid conditions.

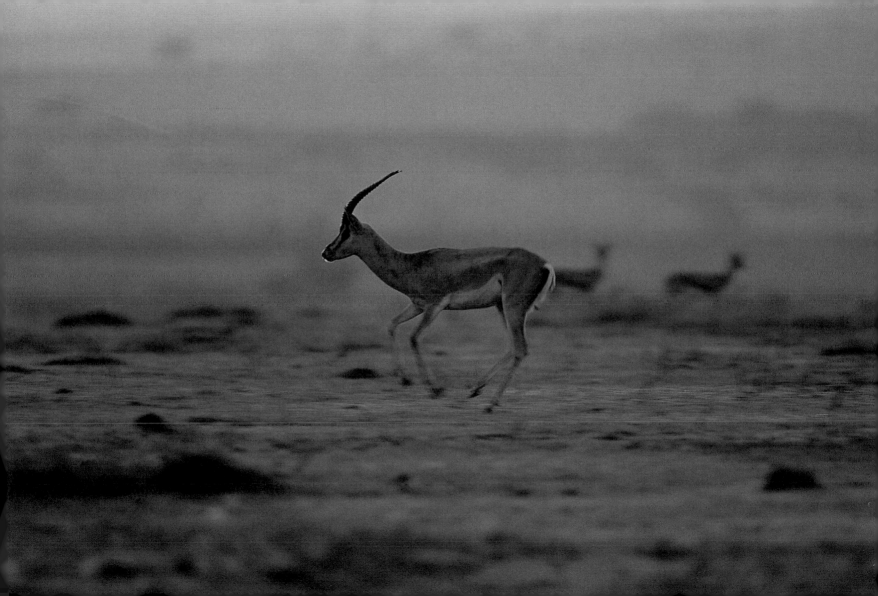

Northern Serengeti. This elephant baby was born in the dry season. For a year, until the beginning of the next wet season, it will remain small enough to walk underneath its mother's belly. Elephant babies remain in almost constant contact with their mothers. Even as late as nine years of age, a baby may spend more than half its time less than 5 yards (5 meters) from its mother. Furthermore, it is said that the close bond between mother and baby can endure for fifty years or more, basically until death.

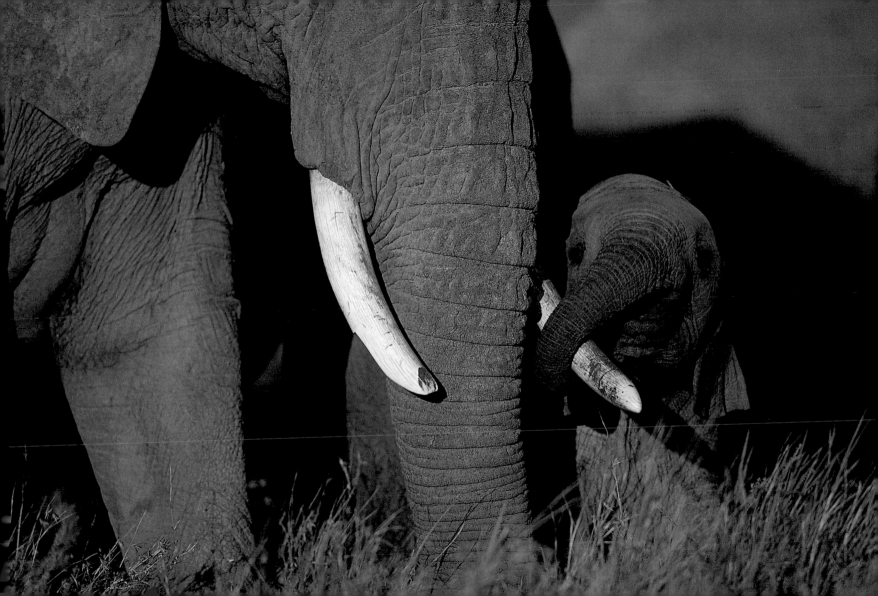

Elephants continue grazing and moving while it pours in the northern Serengeti. Now that it is wet and the land is turning green again, the elephants are no longer confining themselves to the woodlands—they have begun their wanderings out over the grasslands, too. They will start eating vast amounts of grass, but they will also seek acacia seedlings left untrampled by the migrating herds, deftly curling the tips of their trunks around the stems and snapping the roots with a powerful nudge of their forefeet. Once upon a time, elephants used to migrate across enormous distances, but that behavior is no more. Today, they work within familiar ranges, repeatedly moving in smaller, more confined areas than ever before.

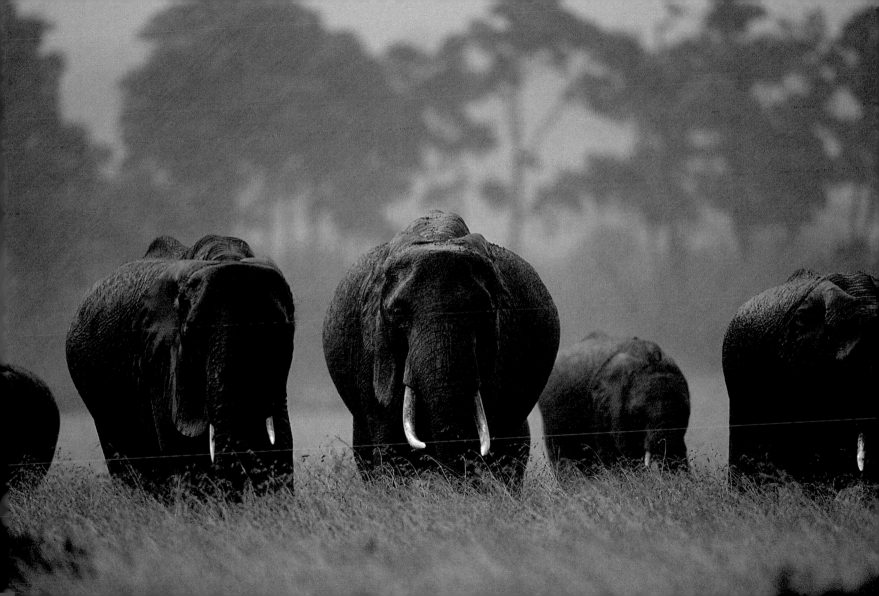

The general southward movement continues as the herds orient toward the Serengeti short-grass plains. The wildebeests have followed the zebras into the northern Serengeti — they do not relish going through the woodlands, but they have no choice. Today there is an inch of rainfall, a veritable torrent compared to the preceding dry period. It will keep the herds on the edge of the woodlands for a little while.

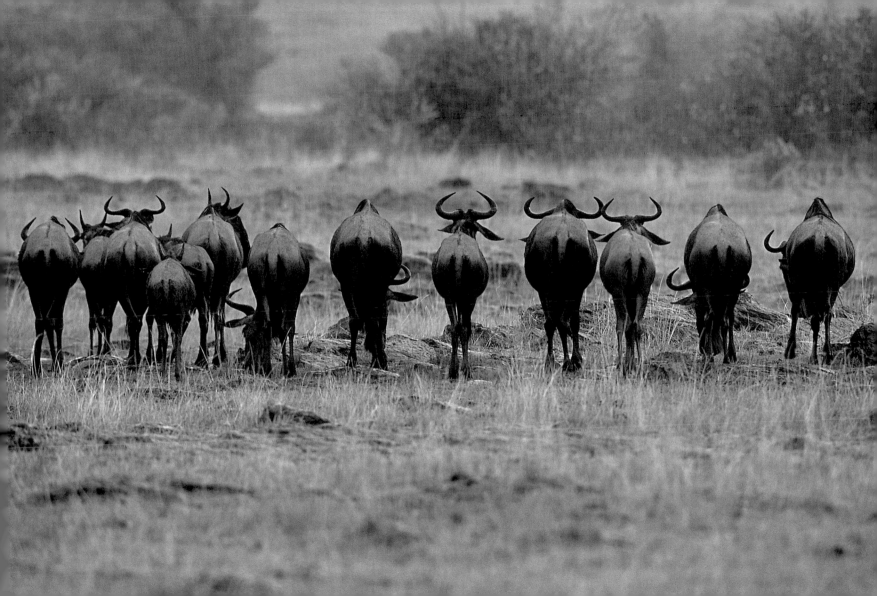

Halfway between Lobo and Seronera are the Tagora Plains, a vast stretch of open grassland amidst the northern Serengeti woodlands. Here, in their slow, dreamlike gait, giraffes glide, looking like leafless trees. The air is heavy with humidity and the darkening sky warns of more rain on the way. The giraffe's curious, unhurried, elegantly awkward gait belies the fact that an adult can initially outrun a horse. However, its lungs are small for its exaggerated body size so it cannot maintain that speed for very long. Like all the large animals of the savannah, such as the hippo and the rhino, it has evolved more speed than stamina.

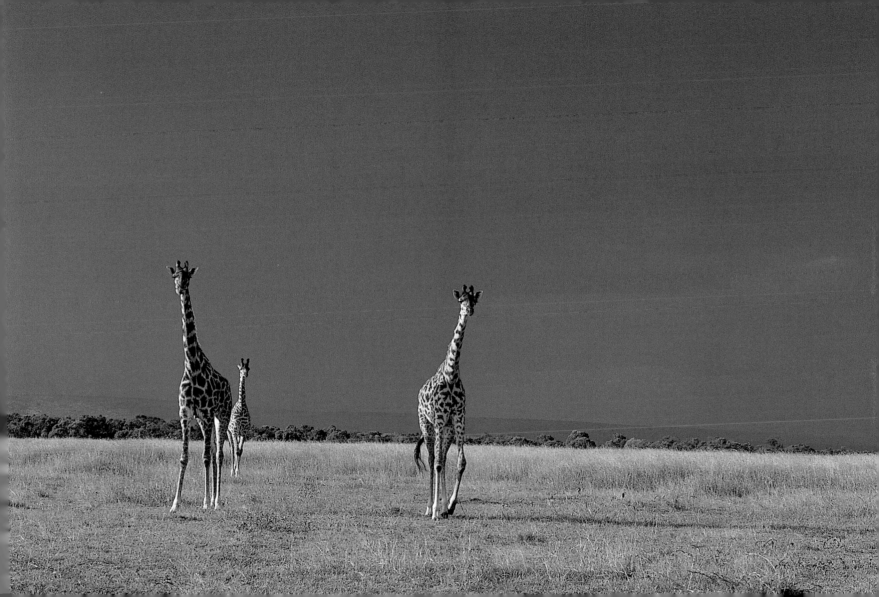

Grasslands and woodlands meet near Seronera. Here, caught in a ferocious downpour, a group of hartebeests sit out the lashing rain. For them, rain is not exactly a godsend. Wildebeests, topi, and hartebeests are all the same size and share a common, relatively recent ancestor, but they do not compete for grass. Wildebeests go for actively growing grass, topi prefer intermediate grass, and hartebeests like aging grass. Now that new grass has started to grow everywhere, hartebeests will have to compromise their eating habits.

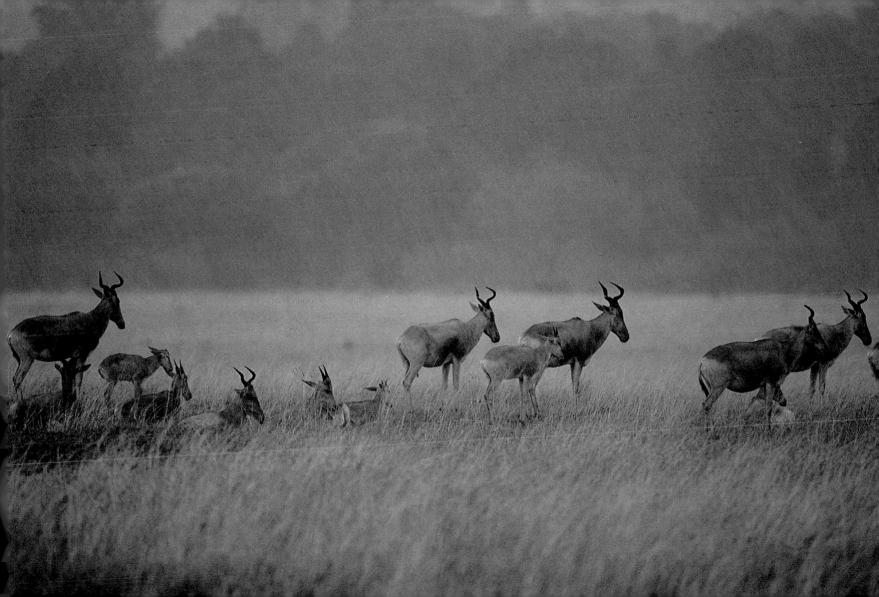

On the plains of Seronera, next to the woodlands, grass has sprung in fresh green flushes. Standing in a clearing, the resident impala herd takes the full brunt of a downpour. They browsed during the dry season; now they will turn to grazing new grass.

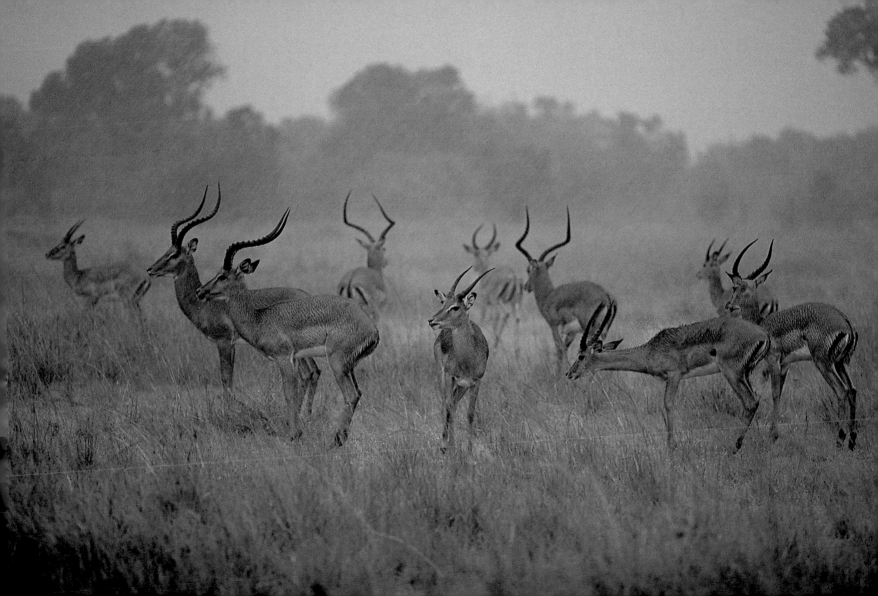

Two Seronera lionesses scan for prey from atop a termite mound. The herds are a couple of days' march from Seronera. For the Seronera lions, the dry season is more a period of scarcity than starvation. During this time, they manage to ambush a topi or an impala here and there and make life a misery for warthogs; they will even prey on buffalo but leave the elephants well enough alone.

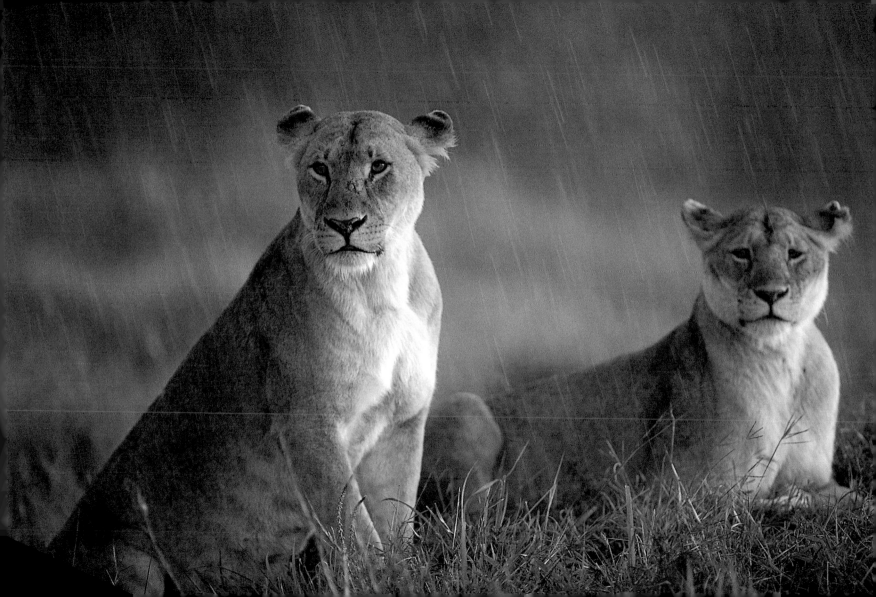

The Seronera pride has surprised a buffalo that has run, panic-stricken, straight into a sticky waterhole. The buffalo now is forced to multitask: It must extricate itself from the quagmire, act defiant, and keep facing the lions to protect its vulnerable back. When facing one lion, it lowers and swings its head and horns, which provides an opportunity for another one to leap onto its back. But this galvanizes the buffalo into such a frenzied effort that it is able, against all odds, to extricate itself from the muddy trap. Once on firmer footing, it doesn't linger a moment but goes crashing across the land and blunders into the riverine woodland where lions hesitate to pursue. The buffalo has escaped this time, but these Seronera residents are sure to meet again.

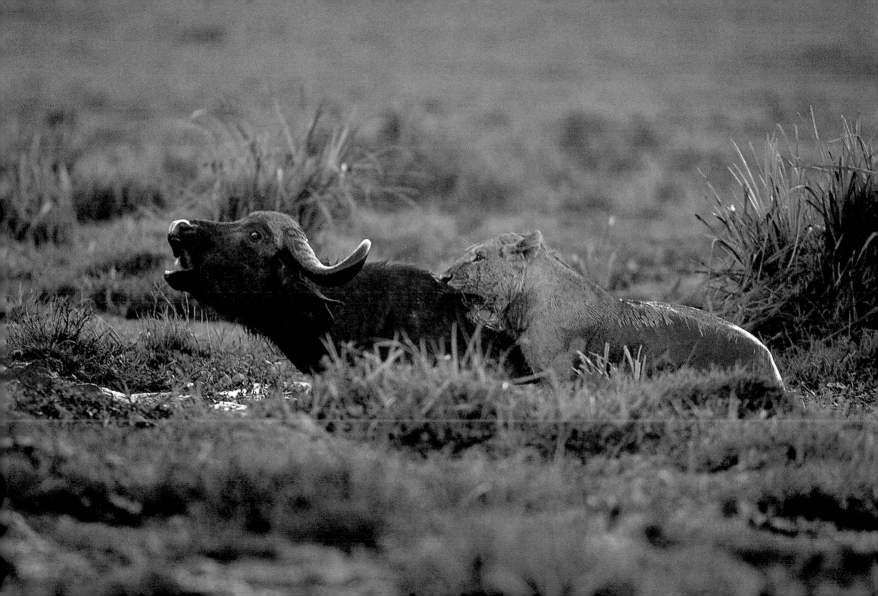

Today clouds fill the sky and more form in the afternoon. The rain begins gently, forming puddles, then grows heavier, turning puddles into pools. It increases in intensity, pounding the earth. Soon, the land everywhere is smothered in water. The ground doesn't absorb the water immediately, but it is still thirsty and will eventually take in all the surface water.

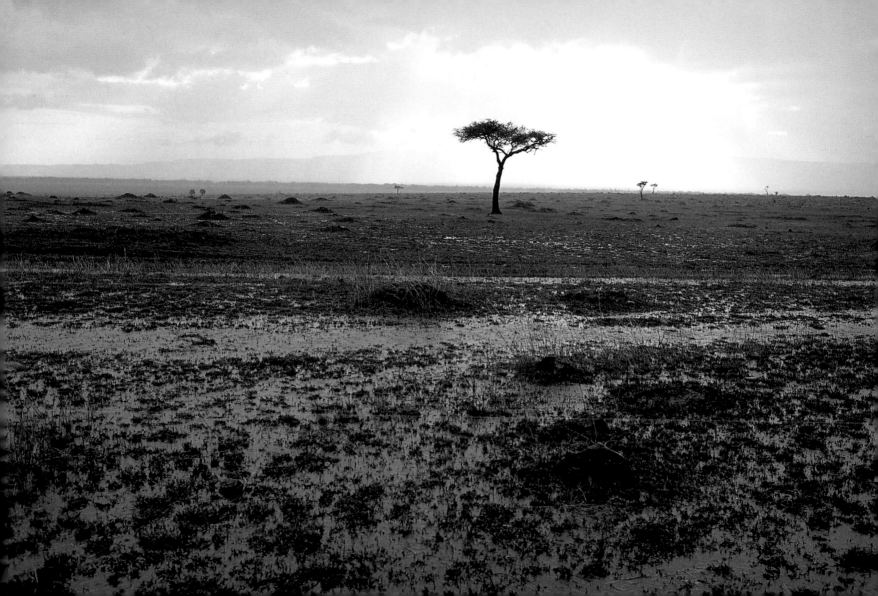

Splashing through new pools of water, the zebras have started arriving in Seronera. The wildebeests cannot be far behind. The two species coexist peacefully. But how do we know that there is no competition for grazing between the two species? One indirect piece of evidence is that when rinderpest disease, which affects wildebeests but not zebras, was eliminated in the 1960s, wildebeest numbers increased eightfold, but zebra numbers stayed constant. In fact, the main problem for the zebra is abrasive, dry grass, which can wear out its teeth, and when the teeth go, a zebra will starve to death.

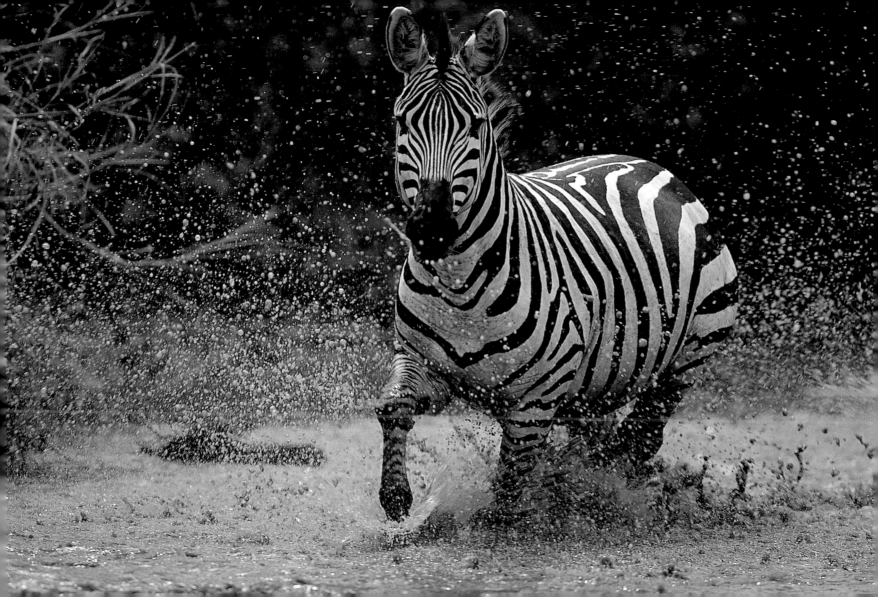

A rain pattern has set in. The rains do not fall continuously, but come in a series of showers and cataclysmic downpours, which cause the earth to steam warmly. Water cabbage covers the top of a pond, and beneath the green carpet lives a pod of hippos. They spend the day submerged, blowing great watery sighs through distended rose-pink nostrils.

Now that the grass is taller, lions have more spots from which to stage an ambush. One such ambush fails, sending the reprieved zebras, determined to put distance between themselves and the feline predator, crashing across a huge puddle of water.

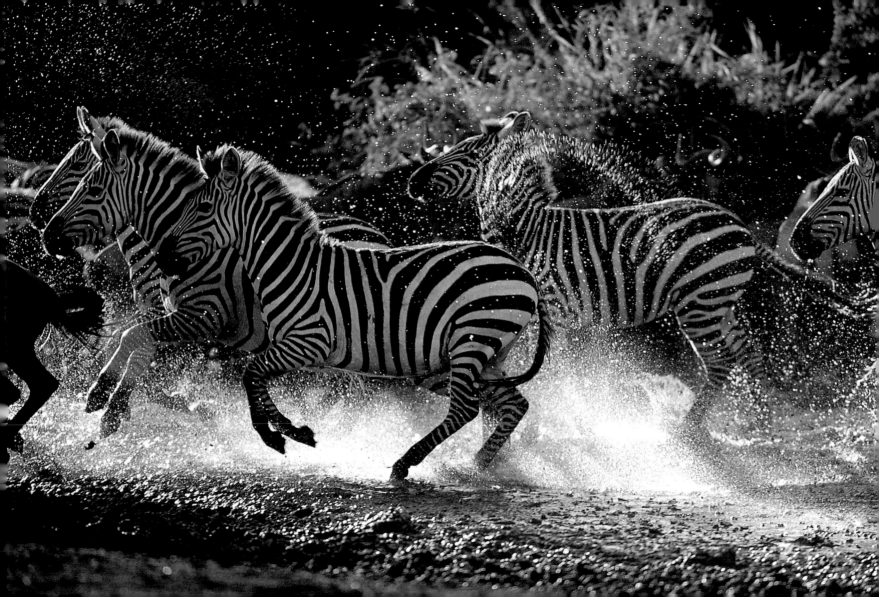

The pervasive rains continue, sinking gradually into the soft earth. A hunting cheetah is momentarily distracted by the rain, which lasts half an hour. When it fades, a silence steals over the land. Slowly, the patterns of life reestablish themselves here on the short-grass plains of Sametu. The cheetah shakes off excess water in preparation for the hunt. Next, she yawns, stretches, sits up, scans, and walks. There are no gazelles in the vicinity, and the gray air limits her acute vision. What will she employ to locate gazelles: memory, experience, knowledge, chance, or a sixth sense? Her face and demeanor are as inscrutable as nature itself.

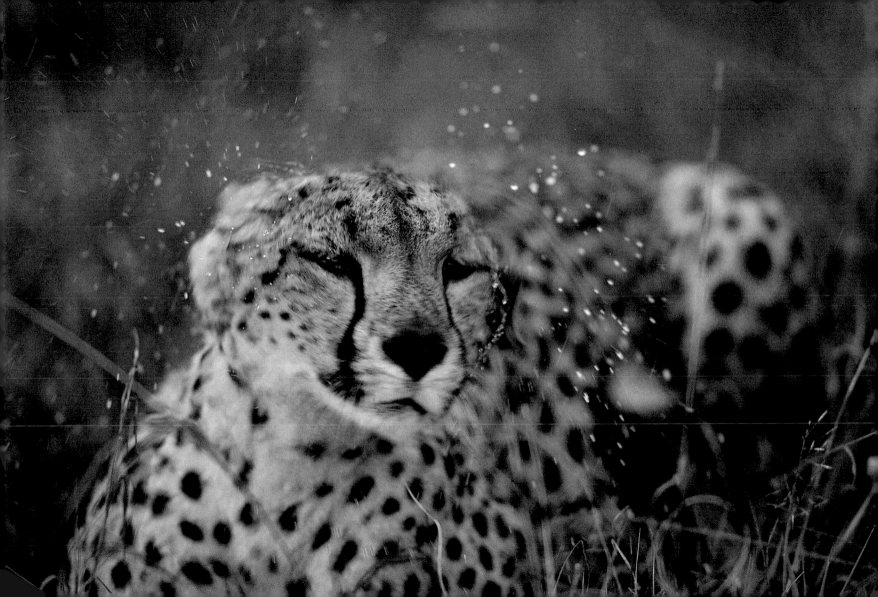

The drive from our base in Seronera to Sametu takes about an hour, and it takes yet another hour to find a cheetah, this time a cheetah with cubs. She is quietly looking for prey, but as the sky clouds over and rain seems imminent, she kicks her search up a notch. It is usually the case that predators have an advantage when it rains. This is partly because visibility is reduced and partly because the sound of falling rain dominates and both factors enable a killer to get closer than usual to its victim without being noticed. So when it starts raining, this cheetah seizes her chance and deals a death blow to an unwary gazelle. The cubs rush to the spot where the gazelle lies slain, and the family starts gorging.

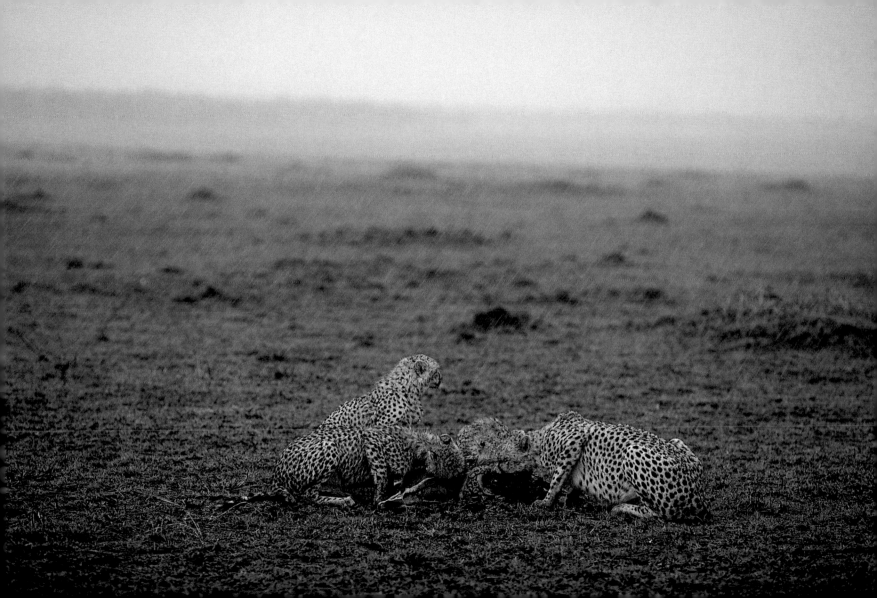

In a daylong break from the rains that have washed the dust out of the air, we drive from Seronera to the Western Corridor. The sun reflects off new pools and regenerated streams. A tortoise ambles along, not far from the Musabi Plains that, five to six months ago, hosted the herds on their passage to the Grumeti River. The river itself is now whole again, the scattered pools of the dry season reconnected. Swollen, in fact, it flows over a concrete bridge, daring us to cross. We head back to Seronera.

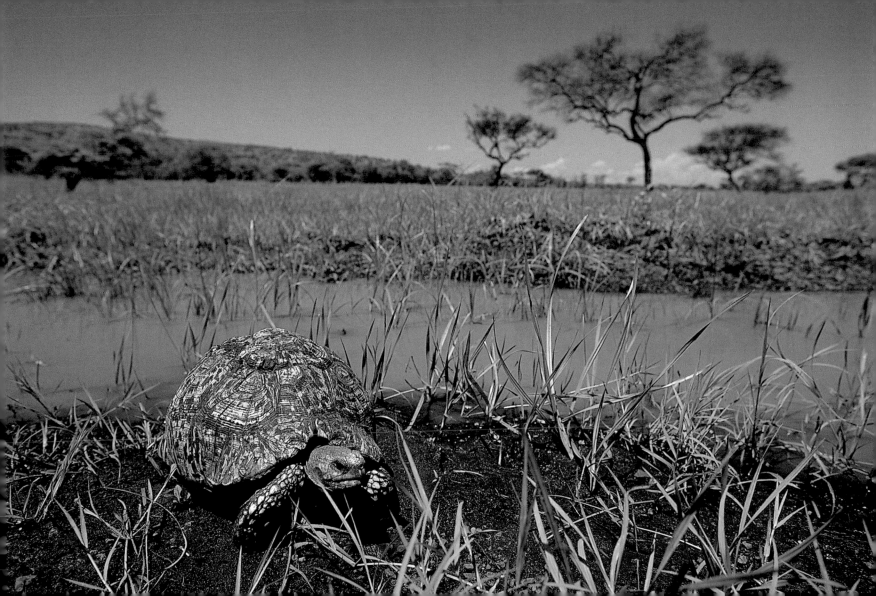

The rains have dramatically altered the landscape. Gone are the beiges and browns of the dry season. Lustrous green grasslands now shine with freshness. The rain is more than drinking water, it is a catalyst. The rains also release a legion of insects, which were quiescent during the dry spell. Mosquitoes hatch in rainwater caught in tree hollows; spiders pour out eggs; beetles, bugs, wasps, bees, and other flies rise from the damp earth in armies; winged termites prepare to make quests for new homes. Every corner buzzes, seethes, and pulses with life. Frantic days of rebirth and renewal lie ahead. It is springtime on the Serengeti.

In a landscape so eager for moisture, so well adjusted to exploiting every drop of water, the aftermath of the recent rains is prosperity. So although today the glass-blue sky stays clear, everywhere life continues to seize new opportunities. The rains have literally switched the plants on and provoked an explosive birth—lilies spring forth from the bare soil, trees flower, butterflies adorn trees, and the ground comes alive with bugs. Beetles, beetles, and more beetles emerge from the wet earth. It is beetlemania on the plains.

A spider prepares for the kill. The grazers of grass—caterpillars, grasshoppers, and crickets—are the prey. The predators are spiders, assassin bugs, robber flies, and hunting wasps—theirs is a world of murder, committed silently and unseen in the grass stems. But on the plains, I can see the wonderful magic of soil and rain that results in the generation of termites and beetles, and the frogs and snakes that eat them; the succulent grass and the returning herds that hungrily feed on it; the carnivores who feed on the herbivores; and up in the sky, the birds that feed on the leftovers. There is no niche for the speck of life that is me.

On our way to Sametu, past Maasai Kopjes, we see an aardwolf ambling leisurely on the plains. This hunter of insects finds easy victims in the wake of the rains. Millions of termites harvest the grass at night and are fed upon by a myriad of insect eaters. The triumphant survival of the aardwolf in the hostile world of lions and hyenas is another mystery in a place where the rhythm of life has not changed for hundreds of millennia.

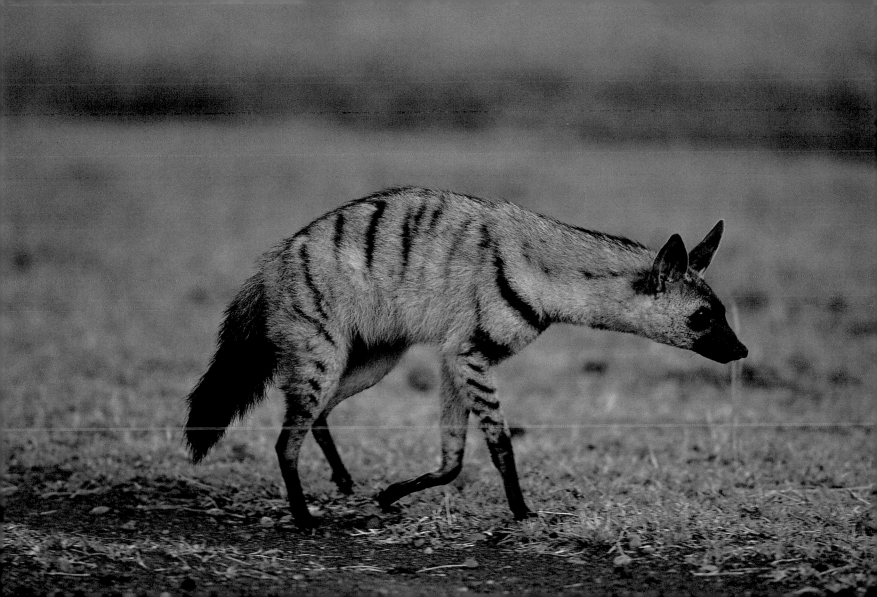

With the rains on the plains and an abundance of prey, the cheetahs have plenty of energy to play. The play of these two adolescent cubs is really a mechanism to promote body growth as they stalk, pounce, chase, box, and wrestle. Underlying life here is rainfall: More rain means more grass, means more grazers, means more predators. This one-way causality (bottom up) is easy to grasp, but until fairly recently, it was wrongly thought to go the other way around: More predators means fewer grazers, means more grass (top down).

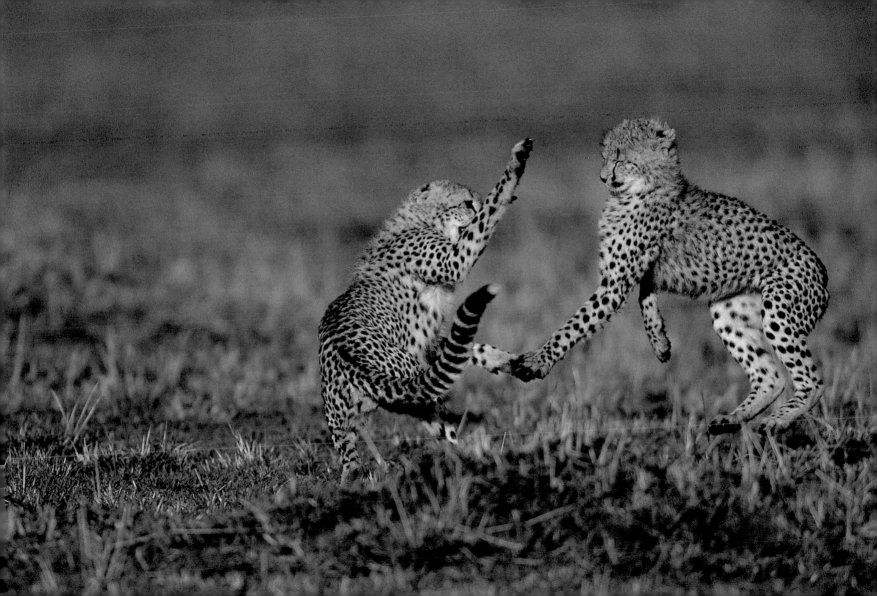

Watching a topi calf frolic makes you believe that life's capacity to regenerate is indomitable. Given less than half a chance, life bounces back in all its varied forms, so resilient is the eco-system of the Serengeti. It can take on droughts, epidemics, population crashes, and more, and bounce back almost instantly. It has been doing just that for over a million years—there is something inherently stable and reassuring about that.

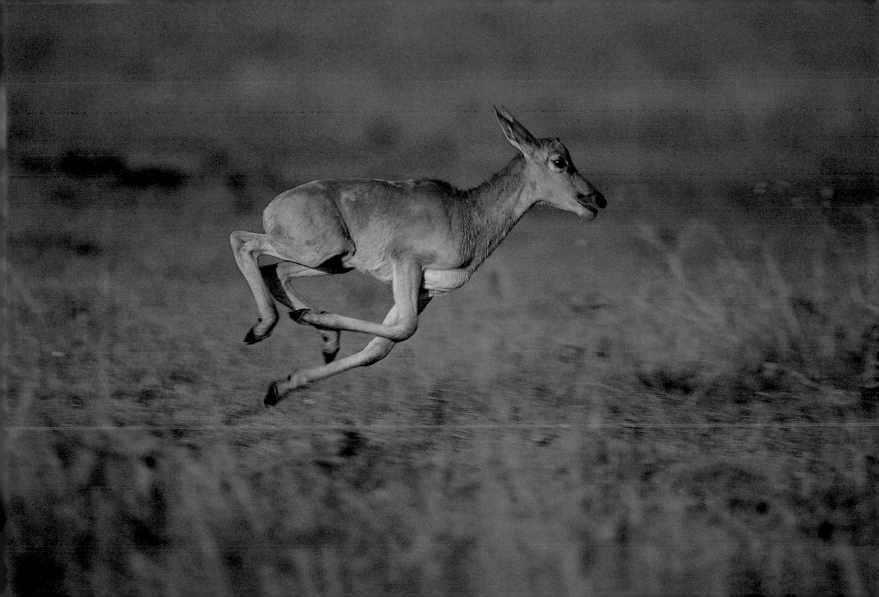

This river is still filling up. The lioness tests the depth of the water and grunts, a command for her cubs to follow and stay close to her. Acting on her orders, they cluster around her, but one of them lacks the nerve to follow her across the river and stays behind mewing loudly. From the opposite bank, the concerned lioness grunts and growls, but there is no shifting the cub. Finally, she makes the return crossing and picks the cub up in her jaws. With the listless cub dangling from her mouth, she picks her way back to the opposite bank and a joyous reunion.

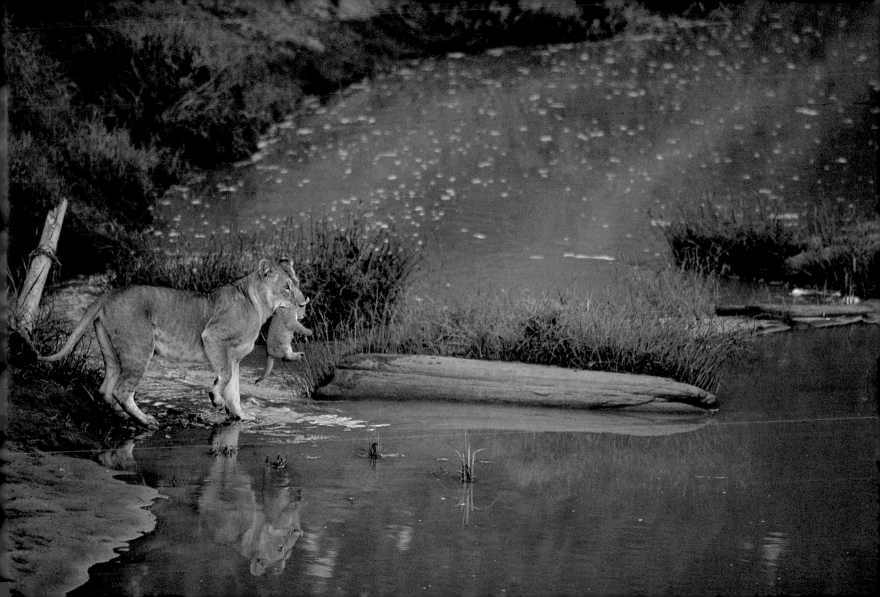

An elephant mother with her baby, members of a large group, walk across the plains, grazing on the new and abundant grass. The baby stays close to its mother's side, suckling, watching, and exploring. In most mammals, the young are born with brains close to adult size, growing very little after birth. Wildebeests, for instance, know most of what they need to know from the start. But the elephant baby is born with only 35 percent of its brain size and potential, the rest is added during the many years of dependency and social education.

This pregnant zebra made it to the short-grass plains and the nutritious grass she needed in her advanced state of pregnancy, but this morning she is dead, struck not by hyenas who will attack pregnant zebras, but by a mysterious, fatal illness. Inevitably, where life thrives, death abounds, inexorably completing the cycle of life. If it were otherwise, the ecosystem would be hopelessly overcrowded and unsustainable. Happily, you can also rely on the scavengers to tidy it up and hasten the return of the migrants' constituent parts back to the soil, ready to be used again.

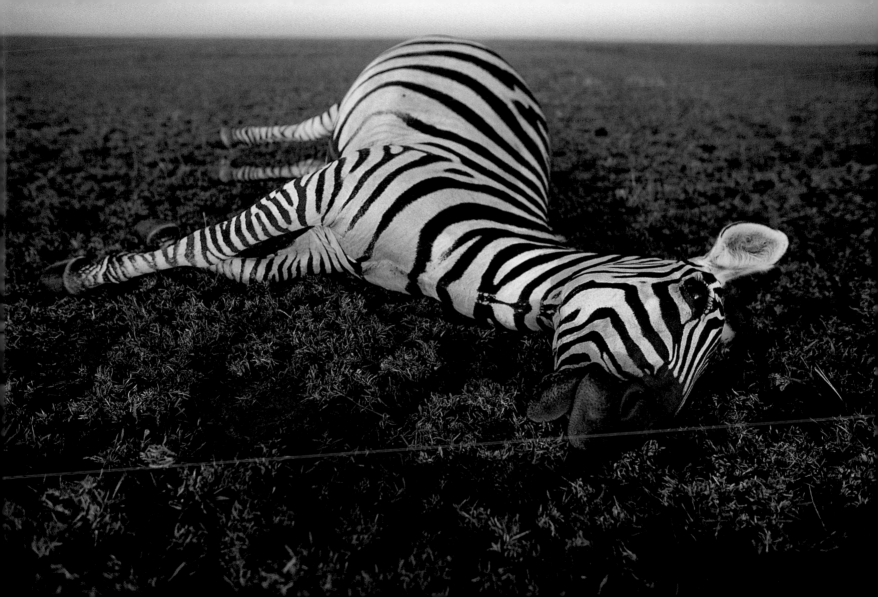

Having completed its first circular migratory journey, this eleven-month-old wildebeest is back on the plains of its birth, in the season of plenty. It moves with playfulness, leaping and cavorting with apparent joie de vivre. Its head goes down, its tail goes up, and it bounces about like a ball. Within a few weeks, its mother will give birth again, leaving the young one to fend for itself.

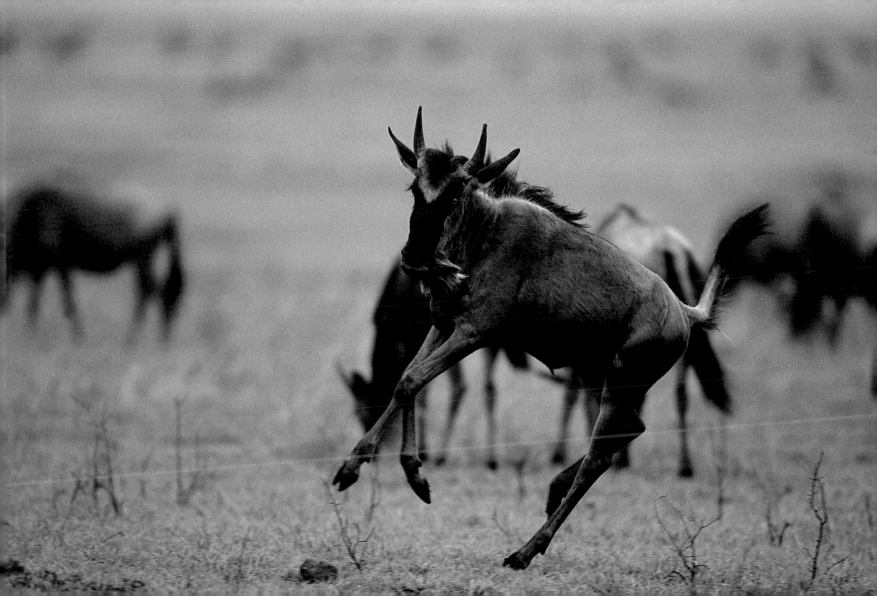

On the short-grass plains, the young lions have learned to recognize the taut postures and alert expressions of adults on the prowl. A hunt is on, and they neither meow nor romp ahead of the lionesses. The mothers stalk, sinking low to the ground and fanning out. A blur follows a rush, and a lioness has a stifling hold on the throat of a wildebeest. The youngsters race in, and one of them takes over. It wraps its huge furry paws around the victim as it grips it by the throat. It looks more like an act of love than the end of a life. In human terms, the life of a wildebeest seems pitifully short, for seldom does it undertake more than a dozen migrations in a lifetime.

OVERLEAF

The plains lions can look forward to living royally for a few months now that the herds are streaming back to the plains. The migrants move from day to day, the seasons change from year to year, the vegetation evolves from decade to decade, and species change from millennium to millennium, imperceptibly, of course. The very triumph of life depends upon change. The short-grass plains lion population will change, too, but in an unexpected way. Lion numbers in the woodlands have increased over the last few decades mainly due to the rise in buffalo numbers there. Excess subadult lions have spilled out onto the plains. Over the same period, the plains prides have not provided enough cubs to maintain the plains populations. Without the influx of lions from the woodlands, the plains population would fall. Such is one of many forces at play in lion-population dynamics.

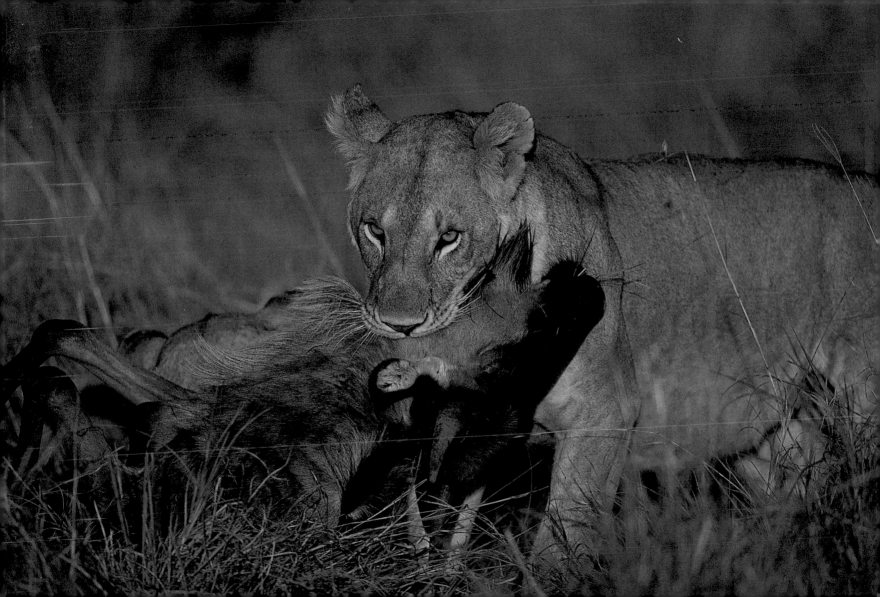

The pool at Sametu Kopjes has been replenished with fresh water. The reeds around the pool are thicker, taller, and lusher. The Sametu lion pride seeks the coolness of the reeds as the sun climbs to midday. In the arrival of the rains and the disappearance of the lioness in the reeds, it is just another measure of adjustment to another season, another year. The lioness has no real premonition of the meaning of the migration in relation to her condition; it exists only in the deepest recesses of her brain. She does only what she must to survive one more day.

With the arrival of the herds, the dung beetles are whipped into a frenzy of activity. Nature's refuse collectors, they navigate by scent instead of sight. There are millions upon millions of them, scrambling to collect and bury the dung of the returning migrants as quickly as possible, before it dries out, is blown away, or is otherwise lost. The females will then lay their eggs in the buried dung. Every living thing plays a role in keeping material moving, from soil to plant to herbivore to carnivore to scavenger and, inevitably, through death or excretion, back to the soil.

Yet another column of zebras within striking distance of the short-grass plains. They have marched hundreds of miles, their movement dictated by the elements that control the dispersion of grass and water. The rhythm of the migration, and hence the rhythm of many lives, owes much to the rhythm of the dry and wet seasons.

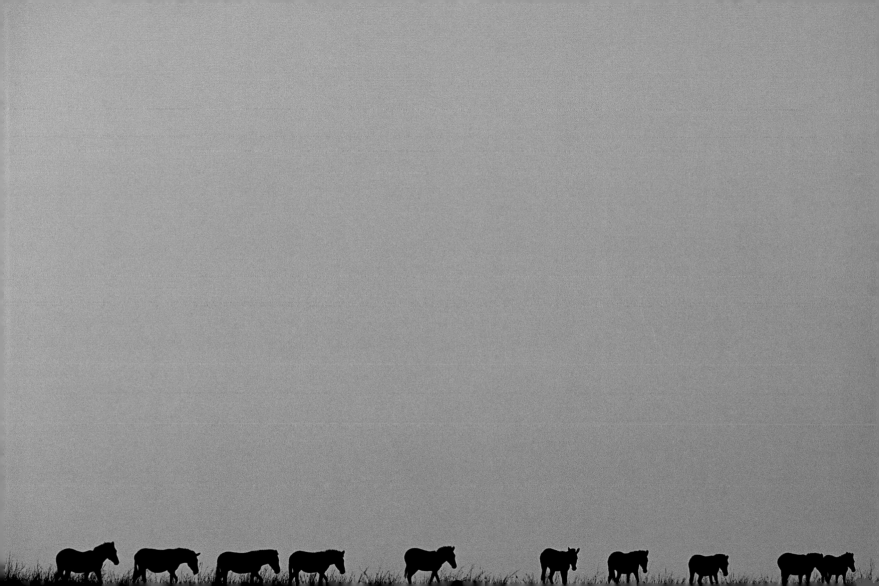

Another herd of wildebeests treks back to reclaim the short-grass plains, like the return of a victorious army. They have left the woodlands behind with its biting flies and ambushing lions. Here, on the short-grass plains, the ground is also less soggy, and less likely to give them foot rot.

What are the advantages of migration? The short grasses of the volcanic plains are much richer in protein, calcium, and phosphorous than the tall grasses to the north and west. The mineral levels are so low there that the herds would suffer lower fertility were they to stay year-round. Browsers can obtain minerals from tree leaves, but grazers need to migrate as soon as the rains regenerate the short-grass plains. It boils down to this: Migration implies superior nutrition, which raises reproductive success.

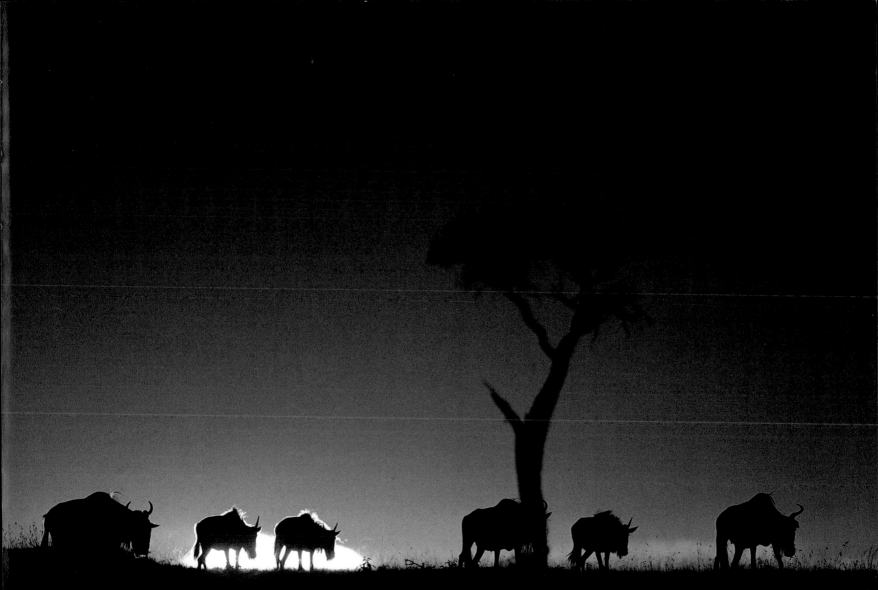

A Gol lion watches the returning migrants. The season has come full circle, the migration cycle, too. A circular story of birth and death, of the seasons, and of the march of the herds has been staged. In this ancient story, the predators and their prey are the featured players caught up in life and death tussles. Now the story will be played again, as it has for over a million years, with the same themes of despair and hope, tragedy and triumph.

We find ourselves, once again, at the blunt cone of Ol Doinyo Lengai. The sense of the past is powerful here. Its flanks are washed white with the ash from eruptions that occurred during its ancient history, a giant memorial marking the birth of the Serengeti plains. It has erupted before, it will erupt again, but not until it's ready. All we can do is watch with a sense of wonder and fall in with the patience of the skies and the rhythm of the land.

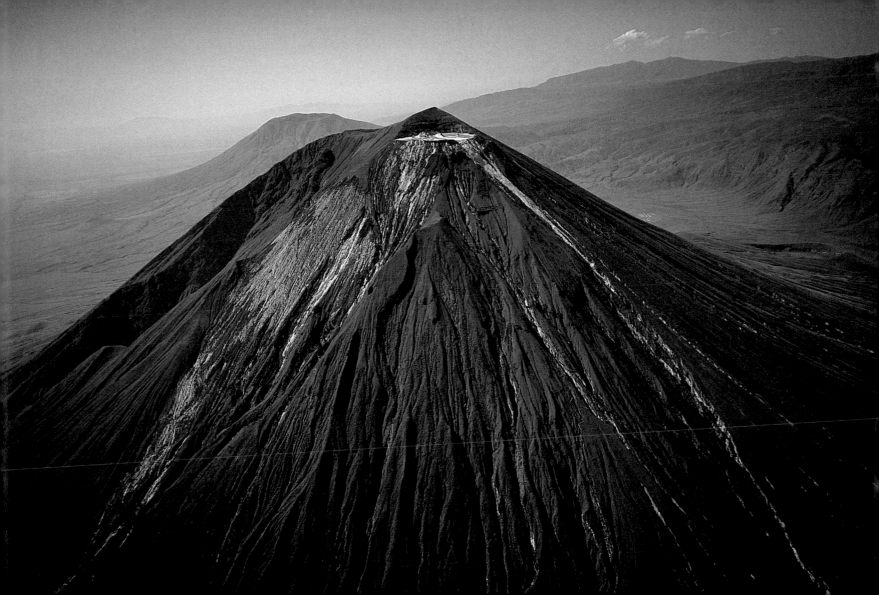

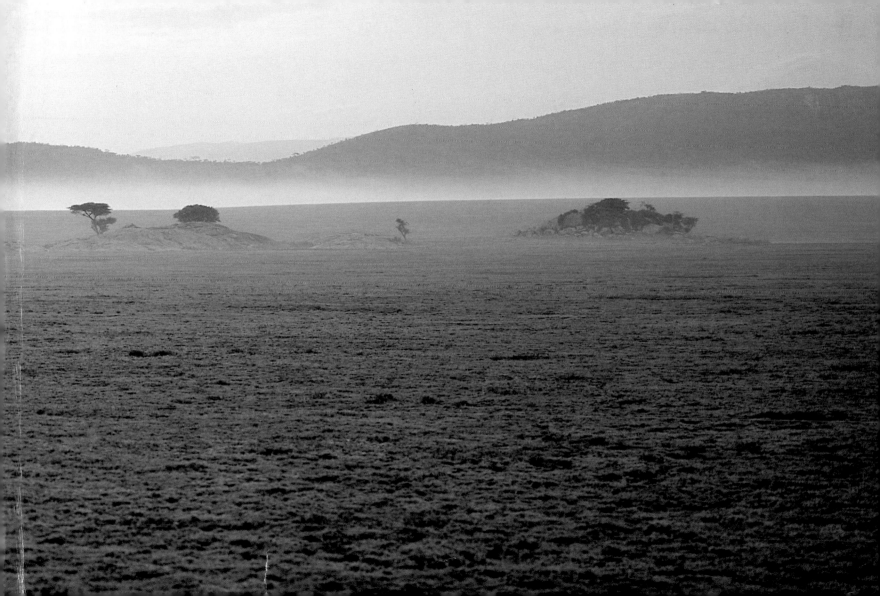

ACKNOWLEDGMENTS

This project was brilliantly guided from conception to fruition by senior editor Andrea Danese at Abrams, who was ably assisted by Laura Tam. Laura Lindgren's design is exceptional—we can't thank her enough for it. Sneh Shah skillfully coordinated between Andrea and ourselves in the field, where we received amazing support from Markus Borner, head of Frankfurt Zoological Society, and also the chief park wardens of Serengeti National Park and Maasai Mara National Reserve, Justin Hando and Michael Koikai, respectively.

All photographs were taken in the wild on film and none have been manipulated, electronically, mechanically, or otherwise. More of our work can be seen on www.shahimages.com.

Editor: Andrea Danese
Designer: Laura Lindgren
Production Manager: Jules Thomson

Library of Congress Cataloging-in-Publication Data
Shah, Anup.
 African odyssey 365 days / Anup and Manoj Shah; text by Anup Shah.
 p. cm.
 ISBN 13: 978-0-8109-9396-9
 ISBN 10: 0-8109-9396-1
 1. Gnus—Tanzania—Serengeti Plain. 2. Gnus—Migration—Tanzania—Serengeti Plain. I. Shah, Manoj. II. Title.

QL737.U53S223 2007
599.64'590967827—dc22 2007004732

Printed and bound in China

10 9 8 7 6 5 4 3 2 1

HNA ■■■■■
harry n. abrams, inc.
a subsidiary of La Martinière Groupe
115 West 18th Street
New York, NY 10011
www.hnabooks.com